PICTURES
AND
PASSIONS

AND PICTURES PASSIONS

A HISTORY OF HOMOSEXUALITY IN THE VISUAL ARTS

JAMES M. SASLOW

VIKING

VIKING
Published by the Penguin Group
Penguin Putnam Inc., 375 Hudson Street,
New York, New York 10014, U.S.A.
Penguin Books Ltd, 27 Wrights Lane,
London W8 5TZ, England
Penguin Books Australia Ltd, Ringwood,
Victoria, Australia
Penguin Books Canada Ltd, 10 Alcorn Avenue,
Toronto, Ontario, Canada M4V 3B2
Penguin Books (N.Z.) Ltd, 182–190 Wairau Road,
Auckland 10, New Zealand

Penguin Books Ltd, Registered Offices:
Harmondsworth, Middlesex, England

First published in 1999 by Viking Penguin, a member of Penguin Putnam Inc.

10 9 8 7 6 5 4 3 2 1

Pages 319–326 constitute an extension of this copyright page.

LIBRARY OF CONGRESS CATALOGING-IN-PUBLICATION DATA

Saslow, James M.
 Pictures and passions: a history of homosexuality in the visual arts/James M. Saslow.
 p. cm.
 Includes bibliographical references and index.
 ISBN 0-670-85953-2
 1. Homosexuality in art. I. Title.
 N8217.H67S27 1999
 704.9′49306766—DC21 99–19960

This book is printed on acid-free paper.

Printed in the United States of America
Set in Weiss
Designed by Jaye Zimet

CONTENTS

ACKNOWLEDGMENTS vii

INTRODUCTION:
FROM STONE AGE TO STONEWALL 1

CHAPTER 1
THE CLASSICAL WORLD: GREECE AND ROME 13

CHAPTER 2
THE MIDDLE AGES: DOGMA VERSUS DESIRE 55

CHAPTER 3
FROM RENAISSANCE TO REFORM:
EUROPE AND THE GLOBE, 1400–1700 79

CHAPTER 4
ASIA AND ISLAM: ANCIENT CULTURES, MODERN CONFLICTS 125

CHAPTER 5
FROM WINCKELMANN TO WILDE:
THE BIRTH OF MODERNITY, 1700–1900 151

CHAPTER 6
MODERNISM, MULTIPLICITY, AND THE MOVEMENT: 1900–1969 207

CHAPTER 7
POST-STONEWALL, POST-MODERN 259

FURTHER READING 311

ILLUSTRATION CREDITS 319

INDEX 327

Research for *Pictures and Passions* was funded in part by a travel grant from the Research Foundation of the City University of New York, and much of the book was written while on leave aided by a Scholar Incentive Award from Queens College of CUNY; I am grateful for this institutional support.

Special thanks to Ed Iwanicki, who conceived and shepherded the project with wry humor and sympathy; to my agent, Norman Laurila; and to my research assistants, Vanessa Rocco, Anna Vailas, and Maria Vailas. I owe a long-standing debt to the editors of *The Advocate* (Los Angeles) for commissioning the series that eventually grew into this book, especially Mark Thompson and the late Robert McQueen.

For their many acts of assistance, both scholarly and personal, thanks also to Robert Aldrich, David Alexander, Peter Awn, Robert Baldock, Barbara Bowen, Jeffrey Brody, Joseph Cady, Paul Cassidy, William Clark, Lawrence Cohen, Emmanuel Cooper, Tee Corinne, Ellen Datloff and Maarten Schalekamp, Ellen Davis, Martin Duberman, Stuart Elliott, Egmont Fassbinder, Joseph Geraci, Harmony Hammond, Rinaldo Hopf, Brandon Judell, Charles Leslie and J. Frederic Lohman, Xiaoping Lin, Gillian Malpass, Lawrence Mass, Arline Meyer, Theo van der Meer, Rosa von Praunheim, Cherry Smyth, Jonathan Spence, James Steakley, Andreas Sternweiler, Aubrey Walter, Michael Watkins, Susan Sherwood Wedemeyer, and Hiromi Yamashita; and to Libbe HaLevy, who was there from the beginning.

Backhanded thanks go to those institutions who refused permission to reproduce works under their control, including the Kiev Museum, one Roman Catholic abbey, Cluett Peabody (Arrow Collar), and Bacardi-Martini (Dewar's). Though gratifyingly few, they provided an inspiring reminder of the need for this book.

Last in print but first in my heart is my companion, Steven Goldstein. As always, the book could not have been written without his support and forbearance. I reiterate the promise that sustained this effort: Never again.

PICTURES
AND PASSIONS

FROM
STONE AGE
TO
STONEWALL

Overcome by desire to drink in the face of his beautiful beloved, the Renaissance sculptor and poet Michelangelo Buonarroti fervently prayed, "Make my whole body nothing but an eye." Because the eye, often called the window of the soul, is the source of both aesthetic and erotic delight, sex and art are Siamese twins. Pictures—all images that stimulate the eye—can arouse passions; in the "pillow books" or illustrated erotic handbooks of old Japan, art was literally part of sexual foreplay. But pictures can also provoke passionate opposition to the pleasures they depict, for these twins are inseparable from the parent society that gives them birth, ranking and controlling both desire and its image. Censors and bluestockings everywhere would nod approvingly at Michelangelo's lament that "the heart is slow to love what the eye can't see."

The dynamic interplay of sex, art, and society is nowhere more visible than in images related to homosexual experience, examples of which stretch from the Stone Age to the looming millennium, from the Andes to the Great Wall of China. Surveying the history of such a sprawling and variegated theme is not an uncomplicated task: while homosexual and lesbian behavior is nearly universal, its cultural forms have differed greatly over time and space. That diversity has heated a bubbling cauldron of controversial questions: What is art? What is homosexuality? What exactly constitutes what is now called gay and lesbian art, and how can we understand it through the ages? The best if frustratingly unfocused answer seems to be that gay art is no one thing exactly, but a constellation of many stars whose patterns and meanings are eternally shifting. To catch it in the historical telescope requires the broadest of lenses, polished with the tools of numerous disciplines, from psychology to sociology, economics, and urban planning.

One example by way of introduction. During many breaks from writing this book, I would stroll nearby to New York's Central Park and commune with the giant statue by Victorian sculptor Emma Stebbins that ornaments the beloved Bethesda Fountain: *Angel of the Waters*, a winged bronze woman who hovers over the picturesque waterside terrace like a protective spirit. Her stan-

dard neoclassical subject matter is allegorical, not erotic, but she is nonetheless a monument in the historical landscape of gay art, conjuring up endless questions and oracular reminders. On biography and iconography: Stebbins was the companion of actress Charlotte Cushman, a relationship that might have shaped her artistic vision of a tender and solicitous female. Or on patronage: the well-connected Cushman wangled her lover the commission, like other gays who have played multiple artistic roles beyond artist or subject. As I looked around at the urban and social setting, the guardian angel was visible across the lake from the Ramble, a wooded preserve popular as a gay cruising ground since World War II; and peering into the hearts and minds of the men prowling the bushes within range of her benevolent gaze evoked the shade of feminism, the modern critique of sex and gender that underlies all gay history. Until the city's Stonewall Riot of 1969 unleashed a new political wave, few of those men would have known or cared that her creator was a woman, much less a lesbian. Today's gays and lesbians may be united by their minority political status and taste in sex, but throughout history men and women of all orientations have been defined and divided by age-old hierarchies of male over female.

Although the exploration of homosexuality in culture took root even before such late-Victorian trailblazers as the German scholar-doctor Magnus Hirschfeld, it could only flower in our time. As the groundbreaking gay historian John Boswell observed, "One of the revolutions in the study of history in the twentieth century might be called 'minority history': the effort to recover the histories of groups previously overlooked or excluded." Chroniclers used to focus on public, not private, deeds; affairs of state mattered far more than affairs of the heart. Today we are more attuned to the primal ways that inner life inspires outward accomplishment, especially in the arts. In Greek myth, the sculptor Pygmalion fell in love with his own marble female and beseeched the gods to give her life, symbolizing that creativity is erotic, and the unconscious mystery of artistic inspiration is akin to divine revelation. Poignantly complicating the picture, many societies have classed both aesthetics and spirituality as "feminine" specialties, leading them either to idolize or ostracize any minority, including both homosexuals and artists, that violates expected male and female norms.

A parallel revolution in visual studies provided the second modern leg to support a comprehensive gay cultural history. Turf wars among traditional scholars long partitioned the visual record: the art of vanished primitive peoples fell to archaeologists, that of the living tribes to anthropologists, and the relatively few world civilizations that produced "fine art" to art historians. But homosexuality crosses all these borders, and the approach taken here is more inclusive, embracing the whole range of material culture—the myriad physical objects through which individuals and societies symbolize and communicate feelings and values. They range from American Indian basket weaving to

clothing, mass media, popular arts and advertising, and even buildings and cities—for, as the old saw pithily puts it, "We shape our buildings, and our buildings shape us."

If the net is thrown wide, the catch is spectacular: this book unearths and celebrates the richness of gay imagery and experience throughout history. Some, both outside the gay community and within it, would still find such a trawling scandalous, sinful, or misguided. If any defense is needed, the following pages claim the same justification as any chapter of the human saga: however we may squabble over the value and meaning of gay and lesbian art, it is, simply and eloquently, there.

TRIBAL SOCIETIES: WHERE IT ALL BEGAN
Variety both sexual and artistic emerged with the earliest stages of cultural evolution: the tribal societies, which still hold out today in shrinking territories of the Pacific islands, Africa, the Amazon jungle, and the reservations of North American Indians. The name "aborigine" recalls the life that developed when our apelike ancestors "originally" climbed down from the trees. Humans of the Paleolithic era, or Old Stone Age, named for their first crude tools and technology, were mainly hunter-gatherers, eking out a precarious subsistence in small bands of nomads or villagers; about ten thousand years ago, their descendants of the New Stone Age began to settle in farming communities. These tribes or clans had an oral, not written, culture and an animist religion in which controlling spirits dwell in all of nature, from lakes to people. Though they developed sophisticated crafts of pottery and weaving, they could spare precious few resources from the relentless struggle for survival in an environment they had barely begun to control. Art was a handmaiden of rituals performed to guarantee the fragile supply of food and labor. The charcoal outlines of wild game on the walls of the Lascaux and Altamira caves in the Pyrenees were painted to sway supernatural forces through sympathetic magic—the power of an image, like a modern voodoo doll, to control the thing it depicts.

Sexuality—the "urge to merge" that wells up in plants, animals, and people alike—seemed the supreme force driving the natural world, and sexual union a ritual that could assure universal fertility and the continuity of life itself. Eros made its artistic debut with the oldest surviving religious amulets, like the chubby stone figurine called the Venus of Willendorf. Most of these offerings are female, local versions of a Great Mother goddess worshipped throughout the Near East; her later temples provided prostitutes of both sexes for ritual intercourse that flattered the goddess through imitation. Latter-day feminists and Radical Faeries seize on these fragmentary remnants as evidence for a primeval matriarchy where women held the reins of a sex-affirming spirituality, which gradually lost ground to men and asceticism. Though this

mythic theory is appealing, without written records much about sex, society, and images remains shrouded in the fog of prehistory.

Among the widely scattered tribes of today, anthropologists' spadework has yielded a bumper crop of societies where homosexual and cross-gender behavior is common and publicly acknowledged—or was, until encroaching modernity increasingly contaminated them. Like most cultures ever since, tribal peoples divided labor along gender lines: men specialized in hunting and war, women in cooking, clothing, and tending the young. Because these spheres were segregated and often secret, society was deeply homosocial: it encouraged and glorified intimate same-sex comradeship, above all the male bonding vital to disciplined loyalty on the battlefield. At the same time, it treated the male and female spheres as separate but equal—or at least, more equal than in later civilizations—and accepted sexual variety, sometimes even building in alternative social slots for exceptions to the rule. Men might practice homosexuality as part of their group rituals, or take on a third gender through cross-dressing, or mix genders by doing women's work and taking the passive part in sex with other men. Their counterpart was the female warrior, or Amazon—a legendary Greek tribe whose name was bestowed on South America's immense river by Europeans who found "masculine" native women hunting and fighting.

In the native culture of New Guinea—typical of the Pacific island necklace known as Oceania, from Borneo to Australia to Hawaii—male-male sex was not merely permitted, but compulsory. In the male lodge houses, adolescents were initiated into adulthood by drinking the semen of their elders. Men were made, not born, by inoculating still girlish youths with the magical fluid of virility. These ritual couplings were by definition homosexual, though perhaps not erotic, at least for the junior partner. Nor did they create a minority identity: if everyone "does" it, then no one "is" it. A special building provided a physical setting for them, adorned with totem sculptures and paintings of the sanctifying spirits, but those images did not illustrate what went on inside; primitive art is symbolic, not narrative.

Unlike the Pacific cultures, many native peoples of North and South America, from the Great Plains Indians to the Yanomami of Brazil, singled out a distinct minority among them for mixed or third-gender roles, which mirrored the customs in their prehistoric Siberian homeland. These shamans, often called berdaches, were believed to possess extraordinary powers of healing, sorcery, and divination. Because receptivity to supernatural magic was often deemed a feminine trait, symbolized by sexual penetration, a male berdache might dress in women's clothes to enhance his/her spiritual prowess, and adopt the social and sexual roles of a woman, often marrying another man. Such a "two spirit" individual, whose androgynous character joined the twin earthly realms of male and female, provided an essential bridge between earth and heaven.

Also in contrast to New Guinea, berdaches were born, not made. A cross-gender identity was divinely ordained, a treasured part of the unique essence breathed into each individual. Anthropologist Walter Williams recounts how elders of the Papago tribe determined a boy's future by fencing him into a circle of branches containing two symbolically gendered tools—a hunting bow and a woman's basket—and then setting a torch to the enclosure; if the youth ran out saving the basket, his spiritual destiny had been revealed. The respect bestowed on such favorites of the spirits is captured in the sketch *Dance to the Berdache*, by the nineteenth-century American frontier artist George Catlin (fig. I.1): the standing figure in Pocahontas garb demurely accepts the tribute of his/her tribe's encircling menfolk. Similar homosexual shamans and transvestite dances persist in sub–Saharan Africa.

Because dance, a centerpiece of tribal ceremony, is a transitory art, whose woven costumes and fragile props barely outlast the performance, our visual records of this vanishing world are limited to outsider reports like Catlin's. Perhaps the most famous of these is the third-sex male *mahu* of Polynesia who takes center stage in French expatriate painter Paul Gauguin's mystical sanctification of 1890s Tahitian life, pointedly titled *Where Do We Come From?* Western visitors often view tribal peoples with romantic nostalgia as preservers of some primeval, "natural" human condition, blessed with an ideal harmony and tolerance shipwrecked by the wave of civilization. But the diversity among those societies suggests a less sweeping if more challenging lesson: not that any one pattern of sex and gender is innate, but that almost any cultural ideal is thinkable somewhere.

I.1. George Catlin, **Dance to the Berdache,** ca. 1830 (watercolor).

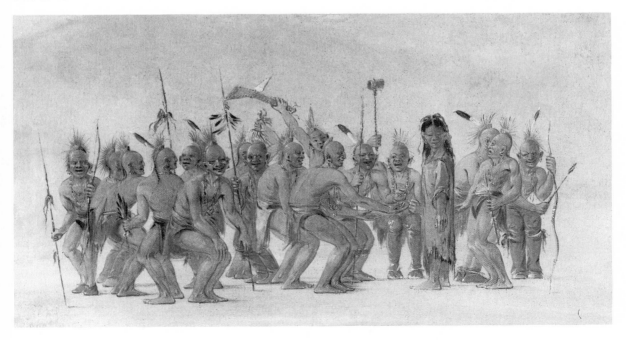

BIG QUESTIONS, BROAD ANSWERS

By the time Captain James Cook sailed around the globe in the eighteenth century to chart and claim the Pacific islands for Great Britain, burgeoning knowledge of the bewildering profusion of cultures overseas had led Enlightenment philosophers to conclude that nothing about European life, or any other, was natural or fixed. Rather—to borrow the title of Frenchman Jean-Jacques Rousseau's revolutionary essay on ideal government—values and personal identities are cultural creations, part of a hotly contested and ever-shifting "social contract." His present-day descendants aim to "deconstruct" the terms of that contract, to take it apart and expose it as artificial. For both historians and activists of gender and sexuality, this project has opened utopian vistas of potential for social change or, in the popular late-twentieth-century slogan, liberation: Margaret Mead, who made anthropology a household word with her fieldwork among Samoan girls, set off a feminist bomb with her claim that sex roles were based on ideology, not biology.

But this very awareness also poses a profound question for gay and lesbian studies: Do men and women who have sex with their own kind—those whom we now call homosexuals and lesbians—share any essential and universal personality traits that unite them as a group across the colorful spectrum of social history? Is there anything to study? Social scientists have mapped at least four radically different axes along which cultures organize homosexual acts and feelings: age (pederasty and initiation, from Oceania to feudal Japan); gender (the berdache); profession (shamans, entertainers, and artists); and equal comradeship (the modern gay ideal). So shared behavior does not guarantee shared identity, or even, in many worlds, any sense of being "homosexual" in modern terms.

All the same, acknowledging local variations does not eliminate the fact that sexuality is a physical drive, built into and acted out by the human body. It can hardly exist apart from some biological potential, which, though still imperfectly understood, is more or less the same throughout the human race. Society struggles valiantly to direct that primal energy into approved channels of gender—the psychic traits, attitudes, and tasks assigned to men or to women. But millennia of world literature and art obsessed with the conflict between desire and decorum, between love and duty, remind us that the rational walls of culture are forever besieged by the anarchic force of unthinking desire—which often wins. Like Shakespeare's Juliet when Romeo climbs into her garden, lovers everywhere, besotted by longing for a forbidden partner, are likely to echo her protest at mere social categories, "What's in a name?"

K. J. Dover, a pioneer historian of Greek sexuality, resolved this dilemma with an all-inclusive definition based on a biological analogy: homosexuality is a genus with many species. The tapestry of gay history is woven of many threads of desire between members of the same sex, and, more broadly, any activity that illustrates the infinite possible combinations of eros with anatomical

sex (male or female) and cultural gender (masculine or feminine). Though male and female homosexuality are often treated differently within the same culture, this book weaves both strands together: attitudes about one cannot be unraveled from the other, and the relative scarcity of art by or about lesbians reflects male domination of the cultural record. And the pattern sometimes embraces transvestites, hermaphrodites, and other third-sex types who may not have been homosexual but whose lives and identities are tangled in the same web of social expectations.

This book also widens the scope of what counts as homosexual relations. Older scholars minimized homosexuality by limiting it to behavior, not feelings. But what matters for us today is less "who did what to whom" than who wanted whom—not just physical acts, but the nature of same-sex desire itself: how it feels, how it may combine or conflict with heterosexual passions, blossom or wither in various social climates. "Homosexuality" here embraces a continuum of emotions between people of the same sex, from homosocial friendship to homoerotic intimacy to genital passion, whether or not they culminate in sexual union. The boundaries between them are vague and easily crossed, as revealed in the ambiguous word "love": in English as in many languages, it can mean either spiritual affection or physical desire.

If homosexuality is more than sex, then homosexual art is more than images of sex. The continuum of subject matter ranges across the whole of homosexual experience, from casual affection to battlefield heroics, palace intrigue, and political persecution. And looking beyond subject matter, art is produced by a triangle of patrons, creators, and consumers (the viewers, including historians and critics who shape audience response). Each of these may or may not be attracted to their own sex, and the countless permutations of insider and outsider, male and female, may celebrate such passions or condemn them, spy on them through a keyhole, or overlook them as beneath notice. This book chronicles the manifold ways that homosexuality has contributed to visual culture, from bisexual Greek men who paid neighborhood potters to turn out gifts for their beloved boys to the homophobic propaganda of Adolf Hitler.

One nagging question remains: How accurately do surviving images tell us about life as it was actually lived? Art does not just passively reflect reality: ever since the cave painters, we have believed that images possess the power to shape it, for both good and evil. So society does not just passively permit art, but actively enlists it in a broader propaganda campaign that is closer to fiction than documentary. When depicting sexuality, that fiction sometimes romanticizes what in life is more complex, or tawdry, or farcical. At the opposite extreme, cultures that deem the subject obscene control its visual story by censorship and vandalism, hoping that only what gets "imaged" will be "imagined." But in the history of sexuality, as in all human affairs, there is a yawning gap, often comical and sometimes tragic, between official pronouncements

and everyday behavior. Art straddles the ideal and the real, variously describing what is, what should be, or what should not.

EARLY URBAN SOCIETIES: THE FIRST IMAGES

Art began to treat homosexuality explicitly as the Stone Age gave way to the Bronze and then the Iron Age, a technological quantum leap that first erupted in the Fertile Crescent of western Asia. Burgeoning agriculture led to larger permanent settlements whose citizens learned to work metal about 4000 B.C.E., to bake pottery by 3500, and to write on clay tablets about 3000. This momentous transition to recorded history, often called "the dawn of civilization," sprang from a complex urban life that required specialized jobs, ruling elites, and bookkeeping. The very word "civilization" derives from the Latin root for "city" and "civic": culture in the artistic sense could arise only when a critical mass of population and resources provided some surplus that could be channeled into words and pictures—and the leisure to think of pleasures beyond bare survival. A handful of surviving examples reveal that male homosexuality was far from unknown, though attitudes toward it were mixed and soured over the centuries.

Mesopotamia, along the lush banks of the majestic Tigris and Euphrates Rivers of modern Iraq, was the cradle of urban cultures at Sumer and Babylon. These societies worshipped the goddess Ishtar, a Venus-like patroness of guilt-free eros whose temple prostitutes included homosexual males—who carried a weaving spindle, symbol of women's work, as an emblem of their cross-gender status. The public sometimes sneered at these sacred but effeminate men, while idolizing passionate devotion among masculine warriors. The second-millennium Babylonian epic of Gilgamesh, among the oldest surviving literary classics, glorifies into romantic legend the ancient hero-ruler's love for his comrade-in-arms Enkidu, for whom he rejects the seductions of Ishtar herself. The men are more like spouses than brothers: after his beloved dies, Gilgamesh soothes his extravagant grief by ordering a statue of Enkidu cast in precious metal. If the historical Gilgamesh ever erected such a colossus, his touching love-monument was long ago melted down, but tiny cast-lead figurines of sporting male couples have come down to us, suggesting that real people did what the king's story leaves unspoken.

A few seals from the Persian empire in central Asia, dating back to the eighth to seventh centuries B.C.E., depict anal intercourse (fig. I.2). These seals, tiny stamps for signing clay documents, depict an endless array of characters and episodes from sacred or royal history; while it is graphically clear what the bearded couple who bend their knees to ease penetration from behind are up to, whether they are mythic heroes or everyday mortals is lost to us, and so is the moral of their little fable. The passive partner holds what could be a sacred

spindle, but spiritual beliefs were shifting ground: about the time this seal was molded, the prophet Zarathustra preached his new Zoroastrian faith, the most virulently homophobic of world religions, which decreed the death penalty for sodomy. This severity grew from a disapproval of all sex acts counter to fertility and from the increasing polarization of good and evil known as Manichaeanism; the identification of good with male and bad with female gradually demoted women's moral status, so that entering a man "like a woman" most literally and flagrantly "fucked up" the natural order. Persia overran three continents, from Egypt to Greece to India, spreading these values far and wide—most prophetically, for later Western beliefs, when it carried off the Jews from Palestine into their Babylonian captivity.

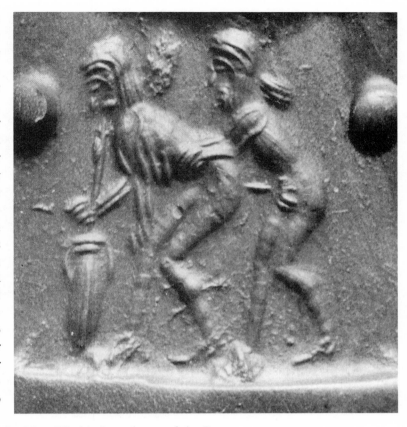

I.2. Perso-Median,
Two Men Copulating,
8th–7th century B.C.E.
(seal impression).

On the far side of the globe, in the New World, the cultures of the Peruvian Andes created painted ceramics by 1500 B.C.E. Only a fraction of their surviving pots depict sexual acts, and a tiny fraction of those are male anal intercourse: one from the early Vicus society (about 1000 B.C.E.), showing a standing man penetrating another who lies on his back, and a handful of Mochica wares from the classic period (first centuries C.E.). Most of these frank frolickers were unearthed from graves, and some are skeletons, suggesting a connection between sexuality and the spirit world, but without a written record the link remains obscure. From such scattered and scanty evidence, all we can conclude is that homosexuality was widely known across the first civilizations, though it probably interested only a minority of men, and its status varied from ritual to taboo.

COMING ATTRACTIONS: SCOPE AND STRUCTURE

In the following chapters, this book examines the descendants of these early civilizations among the high cultures of Europe, the Europeanized West, Asia and Islam. It provides a bird's-eye view of what is currently known about major

works, themes, and theories concerning homosexuality in art—a map, not a close-up. To pan over such a sweeping territory, the treatment of individual cultures and personalities is necessarily brief; every chapter in this study could fill its own book, and several already have. Readers interested in pursuing particular topics may consult the suggested "Further Reading" for each chapter, at the end of the volume.

The main theater for this historical pageant is the West, whose long-running drama from the Greeks to the present is divided into acts by three epochal twists in the plot: the advent of Christianity, which challenged pagan eroticism with a deep-seated hostility to sex; the revival known as the Renaissance, which in turn challenged religious domination of the Middle Ages; and the upsurge of technology, urbanization, and individualism that, beginning about 1700, catapulted the West to world dominance and led to the modern gay identity and culture symbolized by Stonewall. Asia and Islam join the cast after the West's medieval period, when the world stage expanded in a series of mutually transforming dialogues that continue to echo around the globe. Though outsiders approaching non-Western cultures face formidable road-blocks of distance, language, and access, these societies must be acknowledged, both for their own creative achievements and for the telling contrast they offer to homegrown assumptions. How homosexuality has been represented across all world cultures cannot be separated from how they perceived and organized eros; but this is a history of art, not of all sexuality. What does not appear in images cannot appear in this book, though at times the reasons why homosexuality is missing from the visual record are themselves part of the story.

The images that have been made are legion, covering many media and many modes. They range from public monuments to private turn-ons, from durable architecture to fragile clothing that protects the body but also decorates, seduces, disguises, and defines it. In subject matter, the images shown here include many aspects of homosexual experience, from portraits to everyday scenes to illustrations of scripture and literature. But they also extend much further, embracing images by homosexual artists; images influenced by homosexual critics, historians, and theorists; and images for a homosexual audience, who may—like the cruisers opposite the Bethesda Fountain—ignore official meanings or creatively subvert them in hidden or coded ways. Sex has been treated within the epic modes of myth and tragedy, the realm of timeless heroes and heroines whose exploits model high ideals and destinies; the realistic modes of comedy, genre, and satire, which document or attack the foibles of ordinary mortals; and the lyric mode, the celebration of beauty and feeling that underlies romance, fantasy, and erotica. An affordable one-volume survey could not discuss every known work, nor illustrate every work discussed in the text; I have tried to select examples that typify the breadth and variety of materials, issues, and cultures.

As with any survey, one purpose of this book is to create a usable past. "History" shares the same root as "story," revealing the basic human need, dating back to the earliest myths, to frame our experiences within collective epics that loom larger than our individual lives. Many of those stories tell about love, some of them about love among men or among women. Writing the history of that love dates back to *Records of the Cut Sleeve* by a Ming dynasty Chinese scholar and, in the West, to the eighteenth-century German Johann Winckelmann, the gay founder of archaeology and art history. Historians once sought to recapture the past—especially the golden age of Western antiquity—as a timeless utopia justifying the dignity of same-sex passions. Though we no longer worship the past as precedent, control over knowledge of it still matters. The eternal tension between the pleasures of the flesh and the duties of society, between nature and culture, animates all of history—especially the history of sexuality, and, above all, of homosexuality. Though great strides in the past generation allow a book like this to be written, the ghosts of homophobic scholarship still linger over our visual heritage, whose reconstruction must take into account how sexual concerns have shaped the writing of history itself. If there is a new prayer here, it is this: That learning how the past was not like "us" might open our hearts to appreciate human diversity over time and space, and thus to appreciate diversity within our own present world.

The anonymous Chinese author was extolling an affection that was accepted and even admired from his emperor on down; Winckelmann was writing from Rome, epicenter of the Christian faith that long declared homosexuality—in the words of a poem read at the sodomy trial of the infamous nineteenth-century aesthete Oscar Wilde—"the love that dare not speak its name." This book continues their labors, folding them into a new version of a continuing story that remains, as always, temporary. It is both a coda to the first generation of gay art studies and a prelude to the next. In humanity's endless effort to understand our collective past and its implications for the future, the historian's fondest hope is to have, not the last word, but the first.

THE CLASSICAL WORLD: GREECE AND ROME

Classical antiquity—the world of ancient Greece and its cultural god-child, the Roman Empire—was saturated with a positive appreciation of eros, itself the Greek name for the god of love. As early as the eighth century B.C.E., the poet Hesiod extolled the primacy of passion: his account of creation declared that the first two divinities to arise from the primeval chaos were "broad-breasted Earth, and Eros, most beautiful among the immortals." In Plato's dialogue on love, *The Symposium*, Phaedrus delivers a long oration on Eros, concluding that "he is the most venerable and valuable of the gods, and that he has sovereign power to provide all virtue and happiness for men." Fear of that awesome power wove a contrasting thread of Stoic asceticism into the checkered tapestry of sexual values: Plato himself, whose long life (428–347 B.C.E.) embittered him about human frailty, later condemned most forms of sexuality. But the underlying warp was strung from the acceptance and celebration of erotic desire, especially the bonds that united man to man: Phaedrus exalts the passionate comradeship between warriors, which ranked highest in the amorous hierarchy, with the mythic lovers Achilles and Patroclus (fig. 1.1). So it is hardly surprising that we today use Greek terms for "platonic" (male) and "sapphic" or "lesbian" (female) homosexuality.

Nor, of course, are these the only concepts inherited from the Greeks, long revered as the Western world's fountainhead of human reason and its civilizing application to mathematics, philosophy, government, and the arts. The statue in Athens to the warrior-lovers Harmodius and Aristogiton, commemorating their rescue of democracy from a dictator (fig. 1.3), memorializes both their devotion to civic duty and their mutual love, two ideals that intertwined and reinforced each other. Today we are perhaps less inclined than earlier generations to place these Greeks on a pedestal, or to overlook the gulf that separates us: they kept slaves, limited education and public life to wealthy males, and organized sexual life into very different categories. But they were the first to imagine political and artistic ideals, such as democracy and "classic" visual harmony, whose echoes have reverberated from the Italian Renaissance to the Lincoln Memorial in Washington, D.C., a transplanted Athenian Parthenon.

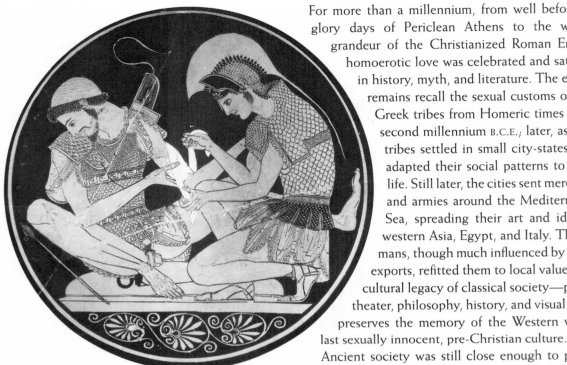

1.1. Sosias Painter,
**Achilles Binding the
Wounds of Patroclus,**
late 6th century B.C.E.
(painted pottery).

For more than a millennium, from well before the glory days of Periclean Athens to the waning grandeur of the Christianized Roman Empire, homoerotic love was celebrated and satirized in history, myth, and literature. The earliest remains recall the sexual customs of rural Greek tribes from Homeric times in the second millennium B.C.E.; later, as these tribes settled in small city-states, they adapted their social patterns to urban life. Still later, the cities sent merchants and armies around the Mediterranean Sea, spreading their art and ideas to western Asia, Egypt, and Italy. The Romans, though much influenced by Greek exports, refitted them to local values. The cultural legacy of classical society—poetry, theater, philosophy, history, and visual arts— preserves the memory of the Western world's last sexually innocent, pre-Christian culture.

Ancient society was still close enough to prehistory's animistic nature-worship to celebrate sexuality as a beneficent universal force encouraging strength and fertility. The penis was revered as an emblem of virile power, and every Greek doorway featured a herm, or phallus sculpture, to ward off evil. While ideally reason and moderation were to govern the passions, sexuality was as much a part of human nature as of the rest of creation, and only a cause for shame or censure when it overstepped higher social priorities. The gods themselves, who personified the forces of nature, were athletically amorous; their mythic exploits provided archetypes through which mortals could understand the wide range of desire and its dilemmas. Jupiter (Zeus to the Greeks), Apollo, and Bacchus (Dionysus) all enjoyed bisexual adventures, while Venus (Aphrodite) was the patroness of heterosexual passion; and the moon goddess Diana (Artemis) turned her affections toward a band of female followers who were "virginal" only with regard to men, not to one another.

Ordinary mortals, like their celestial counterparts, were presumed to be potentially bisexual: numerous painted drinking vessels, such as the famous Peithinos Cup in Berlin, show young men simultaneously courting both boys and women. Aristophanes, another orator in *The Symposium*, told a historical fable to justify what Sigmund Freud later called "polymorphous perversity." Human beings, he explained, were originally doubled creatures, fusing two heads and two bodies into one; the angry gods split each couple in half, so that ever since each of us fractured mortals has yearned to restore lost wholeness

through erotic union. Those primeval pairs came in three types—male-female, male-male, and female-female—accounting equally for heterosexual, male homosexual, and lesbian longing. While attitudes toward homosexual love varied, the image of the hermaphrodite, a creature combining both sexes who became especially popular in Hellenistic times, suggests how all permutations of beauty and desire held a place in the Greek scheme of nature. Individuals might display a stronger appetite for one or the other, but the modern dichotomy between heterosexual and homosexual meant little to antiquity. The Roman historian Suetonius reports a revealing question from Marc Antony to the emperor Augustus, "Can it matter where or in whom you put it?"

As Antony's remark reveals, sexuality was organized, discussed, and illustrated largely from the viewpoint of men, who dominated a patriarchal society. From the classical era onward, women of the citizen class were segregated from men in most Greek cities, denied a written education, and secluded at home. As female status waned, the appeal of male homosexuality waxed brighter. Seldom available before marriage, valued but subservient within it, and deprived of access to public life or literary culture, women were not equipped for a friendship of equals rooted in common interests; men could passionately share ideas and aspirations only with other men. Plato dismissed the love of women as merely physical and procreative; only intimacy with men could serve higher spiritual goals. The Greek author Strato of Sardis put it more crassly: "Animals, being mindless, only couple with females, whereas men, having the advantage of intelligence, do it differently. Therefore any man who goes out of his mind for a girl is an animal." His fellow writer Lucian concurred: "All men should marry, but let only the wise be permitted to love boys, for perfect virtue grows least of all among women."

The Greeks and Romans did not rank erotic acts by the sex of the partners, but according to who played the active and passive parts, a compelling metaphor for the proper gender roles of men and women in social life. Adult males considered anyone lower on the totem pole of sex, age, and class to be fair game, and reserved the dominant role of insertor exclusively for themselves. Only women, slaves, and (under certain conditions) boys could submit to phallic penetration without surrendering the physical and moral integrity indispensable to a warrior and a citizen. Ditto for economic dependency: Timarchus, an Athenian who was accused of having prostituted himself as a youth, ran the risk of a lifetime ban from political participation on the grounds that he had abdicated male autonomy.

Greek and Roman art visualized these sexual values and activities across a variety of genres, or types of art, usually associated with particular groups of patrons. Monumental public art depended for patronage on the secular government, whether the democratic city-states of earlier Greece who commissioned public buildings and sculptures or the autocratic regimes of Alexander's Hellenistic monarchy and imperial Rome. Religious art, ordered by the

priestly caste or grateful worshippers, included cult statues and temple decorations. Wealthy patrons paid for private art ranging from pottery to jewelry to interior decoration; in Roman times, a smattering of images catered to a less comfortable clientele, including the merchants and laborers who frequented bathhouses and brothels.

The subjects chosen, and the attitudes depicted, range from the epic glorification of selfless devotion to lighthearted hedonism, bawdy humor, and satirical exaggeration. Readers hoping for graphic images of sexual acts may, except for some vase paintings and silverware, be disappointed: the ancients were actually rather reticent about illustrating physical intimacy of any kind. And when art does treat homosexual characters or episodes, eros is often the background of the plot rather than the foreground. Mythic drama was concerned above all with civic and martial virtues; while viewers understood that the bonds between many great heroes were homosexual, the principal reason to depict these men was their glorious public deeds, not their private behavior—though the two were hard to separate, as in the touching image of Achilles binding the battle wounds of his beloved Patroclus (fig. 1.1).

ARCHAIC AND EARLY CLASSICAL GREECE: FROM HOMER TO SAPPHO

The Greeks' glorification of heroic male bonding dates back to their earliest written records: Homer's sprawling verse epic the *Iliad*, recounting the Trojan War (along with his *Odyssey*, another anthology of exemplary characters and episodes, the nearest Greek equivalent to the Bible). As written down about the eighth century B.C.E., Homer's poem, set in the twelfth century, is the final flower of a vine of oral myth and legends rooted in the even earlier Mycenaean period. Homer extolled the passionate friendship of his central character, the young warrior Achilles, handsomest and noblest of the Greeks, for his older lover Patroclus: when Patroclus was slain by Hector, son of the Trojan king Priam, Achilles' grief was wildly inconsolable, like a good classical widow. Although Homer never discusses their sex life, later commentators took erotic attraction between his warriors for granted.

Achilles and Patroclus first appeared in art toward the end of the sixth century, when illustrations of Achilles dragging Hector's corpse behind his chariot around the tomb of Patroclus were popular in Athenian black-figure vase painting. While not overtly erotic, this avenging farewell depends for its tragic pathos on the viewer's awareness of the intense bond that unites the lovers even after death. Red-figure vases from the late sixth through the fourth centuries depicted an earlier and more physically intimate episode of the myth, Achilles' bandaging Patroclus' wounds (fig. 1.1). In this example the artist follows Homer in depicting Achilles as the junior partner, not yet bearded like

Patroclus on the left (later authors called Achilles the senior partner). Behind the public ideal of heroic comradeship, which harnessed male passions to the military bandwagon, we can glimpse mutual devotion and tenderness.

This warrior eroticism had its roots in the male initiation rituals central to many tribal societies whose survival depended on hunting and warfare. Our earliest evidence of such rites in Greece is a small bronze cut-out plaque from the seventh century showing two hunters (fig. 1.2). Although most of the city-states linked male homosexuality with military training, it is not surprising that this incised relief comes from the island of Crete, settled by the Dorian people who brought to Greece the prehistoric rites of their Indo-European ancestors. The sculpture illustrates a critical moment in the Dorians' elaborate rite of passage: When he reached maturity, an aristocratic Cretan boy was ceremonially abducted by a sympathetic older man who took him on a two-month expedition in the forest for training in the use of arms. To bond this emerging adult to the males of his tribe, both of them feasted together on what the young man caught, and the youth submitted to intercourse with his elder; upon their return to civilization, the youth was admitted to the rituals of the adult elite, including the men's mess hall banquets at which he would first perform as cupbearer to his mentor.

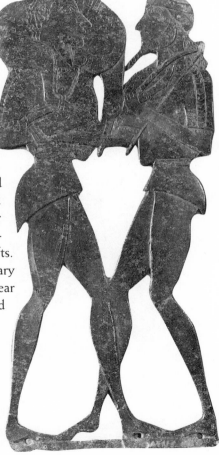

1.2. Crete, **Two Hunters**, ca. 650–625 B.C.E. (bronze plaque).

The younger man is bearing a wild goat (ibex) on his shoulders, perhaps a trophy of his fledgling skills to be presented to the bearded bowman at the right, who grasps his arm in affectionate greeting. The activity that will further unite them is hinted at by their short tunics, which reveal the boy's genitals; this male-male contact ritualized the boy's separation from the childhood sphere of women and magically impregnated him with the adult potency symbolized by semen. Although the plaque emphasizes the young apprentice's gifts to his teacher, the older benefactor in turn rewarded his successful trainee with armor and a drinking cup, which would both symbolize his graduation into adult society and equip him for its responsibilities; the famous Chieftain Cup and other splendid vessels showing two men of different ages may be examples of such gifts. Several plaques similar to this one were unearthed at a rural sanctuary on Crete, where they had been nailed onto trees in a ritual grove near the couples' seclusion, as offerings that commemorated and sanctified the rites of passage enacted there.

Athens and many other city-states prescribed a similar form of pederasty (from the Greek "love of youths"), in which the older partner, called *erastes*, took a young *eromenos*, or "beloved," under his wing for training, inspiration, and sexual initiation. These citified folk no longer sent their couples into the bush, but the ideal of imparting masculine skills and values remained. A sculptural group erected in Athens to commemorate Harmodius and his eromenos Aristogiton

for their attack on tyranny in 514 B.C.E.—the first public statue to honor mortal, rather than divine, heroes—demonstrates how highly classical society revered male comradeship as an inspiration to civic duty. The target of their assault was Hipparchus, brother of the dictator Hippias. Hipparchus tried to seduce Aristogiton, who was "in the flower of his youth," detonating a quarrel in which the offended lovers killed him; during the fracas, Harmodius was himself slain, and Aristogiton imprisoned and tortured. Although Hippias was not actually expelled from the city for four more years, popular legend quickly enshrined the martyred couple as tyrannicides.

The grateful citizenry erected the original *Tyrannicide Monument* in 510; Persians looted it, but once the Athenians expelled the invaders they commissioned a replacement (fig. 1.3) by the influential sculptors Kritios and Nesiotes. The couple stand side by side in the nude—the conventional un-dress for heroes—striding purposefully toward their invisible foe just before the climax: Aristogiton raises his sword arm to strike as the older, originally bearded lover lunges forward, his outstretched arm and cloak providing protective cover for the younger man. No longer archaic in style, the group is enlivened by the early classical concern for idealized realism and movement. Both figures, powerfully defined through accurate and expressive depiction of skeleton and muscles, perform dynamic yet restrained actions; although the impassive faces are too generic to be portraits, the sculptors differentiated the thinner and less developed body of Aristogiton from the rippling torso and bulging veins of his mature companion. This popular monument became a trademark for heroic action, repeated on vases, coins, and sculptural reliefs; later sculptors adapted its venerable poses whenever other subjects called for a similar grandeur. It remains our most eloquent witness to the moral dignity associated with pederasty, which inspired lovers to deeds of valor in the public good.

The political implications of this love were clear to later

1.3. **Harmodius and Aristogiton.** (Tyrannicide Monument, 477 B.C.E.) Marble copy after original by Kritios and Nesiotes.

classical writers: Pausanias, in *The Symposium*, labeled it a pillar of democratic government. In regions where the people live under foreign domination, he noted, laws often discourage male love, along with training in philosophy and sport, "because of their despotic government; since, I presume, it is not in the interests of their princes to have lofty notions engendered in their subjects, or any strong friendships and communions; all of which Love is preeminently apt to create." Taking as his example the very couple whose statue had by then stood in his city for nearly a century, Pausanias comments, "This is a lesson that our [Athenian] despots learned by experience; for Aristogiton's love and Harmodius's friendship grew to be so steadfast that it wrecked their power."

The spur of such intimacy was deemed the key to success for armies like that of Sparta, where the erastes' responsibility for his young charge and bed-mate lasted from puberty until adulthood. The crack Theban battalion mustered in the fourth century by Epaminondas and Gorgidas, with 150 pairs of lovers, was called the Sacred Band because each couple swore an oath of mutual devotion on the tomb of Iolaus, a mythical beloved of the demigod Hercules, patron of Thebes. At the shrine to Harmodius and Aristogiton, young Athenian lovers similarly pledged loyalty to each other and to the tyrannicides' ideals, and before battle soldiers made sacrifices to the god Eros. The historian Plutarch commented that a sanctified cadre like the Theban Band, its disciplined morale "cemented together by friendship grounded upon love, is never to be broken, and invincible; since the lovers, ashamed to be base in the sight of their beloved, willingly rush into danger for each other's relief." The regiment in fact remained undefeated until the Battle of Chaeronea (338 B.C.E.), in which they died to a man, each beside his own beloved, to demonstrate their worthiness of their companions' love. A portrait of Epaminondas by the artist Aristolaus might claim the honor of the first painting to celebrate a man for achievements directly related to male love, but it is, regrettably, long vanished.

The literary and visual heritage of lesbian love is far scantier than for males; the written record is limited to a single female voice. Sappho, the renowned poet of love between women, whom Plato acclaimed as "the tenth Muse," was born about 612 B.C.E. and was probably an old woman by the time an archaic plate (Thera, Archaeological Museum) was painted with the popular scene of two women courting. Both figures carry garlands, perhaps setting their encounter at the all-female festivities for Diana, goddess of unmarried women; one chucks the other's chin affectionately in a gesture that universally spelled seduction, regardless of gender.

Lesbian love, which Plato included without comment in his tripartite myth of the origins of sexual desire, was nowhere condemned in Greek law. Intimate relations between women were permitted, and were even institutionalized in Sparta where, Plutarch tells us, the most respectable women loved girls. These amorous dalliances blossomed within the *thiasoi*, educational and social

communities where older women trained teenage girls in music and dancing, charm and beauty. Sappho was often described as a "schoolmistress" of the *thiasos* she ran, in competition with several others, on the island of Lesbos, but these were more than finishing schools. They paralleled male initiation customs: like boys with their erastes, girls were segregated from society and performed rituals honoring Diana, goddess of virginity, in which they wore garlands, played music, and sang. Although thiasoi theoretically were preparing girls for marriage, during this phase of their lives, at least, they paid homage to their woman-centered patroness through eros among themselves. Girls thrilled to passionate crushes on their contemporaries and their mutually smitten elders; thanks to their refined education, they could express those passions in poetry, now known only from the epistles of Sappho herself.

Sappho's specialty was the love lyric, often addressed to various amours, including her own pupils. Her ecstatic verses pour out both delight in longing and despair at being overwhelmed by the tempest of desire and its dark twin, jealousy. Perhaps the paired women on the Thera plate are like the two young students Sappho egged on: "I bid you, Abanthis, take your lyre and sing of Gongyla, while desire once again flies around you, the lovely one—for her dress excited you when you saw it." Or perhaps one is a teacher, confessing as did Sappho herself the infatuations that repeatedly left her feeling that "Love shook my heart like a wind falling on oaks on a mountain"—or bidding a bittersweet farewell to a young beloved who is leaving against her will to get married and urging her to remember "the good times we had," which included decking each other with floral wreaths and anointing themselves with perfume.

1.4. Group of Polygnotos (attributed), **Sappho and Attendants,** ca. 450 B.C.E. (painted pottery).

Sappho fast became a cultural icon, receiving tribute in numerous statues and paintings, engraved gems, and even the coins of her native city of Mytilene; a red-figure vase from the mid–fifth century (fig. 1.4) typically depicts her seated among female admirers who wave a symbolic lyre and garland. Love between women was part and parcel of Sappho's exalted reputation, but in these portraits, her sexuality is more background than foreground. The scene acknowledges implicitly that female homosexuality, like its male counterpart, could inspire the highest creative flights; but it memorializes a generalized symbol of genius without delving into the content of her work. In any case, no one would have thought of her as a lesbian in today's sense of the word: she was married, and her bisexuality was no more remarkable

than that of prominent men and gods. Only in modern times has the term "lesbian," which began as a geographical label for residents of Sappho's homeland, been attached to the primary sexual interests of its best-known daughter and made the basis for an exclusive erotic category; ancient viewers would have read this image as representing a woman who, among a range of common experiences, loved other women.

Both as an author and as an independent educator, Sappho had no successors. In her own day, women could still exercise some cultural leadership, at least within the female domain. But after the sixth century, as Greek women were increasingly confined at home with limited education, the thiasoi faded away, and with them the social and intellectual support for female creativity. Although the Roman compiler Pliny listed a handful of obscure women painters, virtually all the art and literature after Sappho was produced by men, who had little interest in a world that did not include them and had no public consequences. So it is hardly surprising that they rarely illustrated or wrote about lesbian love—or that later playwrights and poets, finding an imaginative anchor for their own male viewpoint in Sappho's bisexuality, kept inventing male lovers for her. Women very probably carried on intimate relationships with others of their sex within the domestic sphere, preserving some vestige of the thiasos tradition, whose lyrical passion and emotional reciprocity could hardly be sought in marriage with its built-in disparities of age, power, and experience. But except for scattered and tantalizingly vague glimpses of women alone together (fig. 1.21), we are blind to their experience, and the literary sources are deaf.

THE CLASSICAL AGE: PERICLES, PEDERASTY, AND POTTERY

When the Athenians replaced the *Tyrannicide Monument* stolen by the retreating Persians, the new sculpture symbolized both their renewed political independence and the dawn of a cultural golden age, the classical period of the fifth and fourth centuries. As the biggest gun in a defensive alliance temporarily, at least, uniting the Greek city-states, Athens under the statesman Pericles commanded the power and resources for an outpouring of art, literature, drama, and philosophy that still represents a "classic" moment at the wellspring of the Western tradition. Homosexuality was an integral part of that legacy, from the comedies of Aristophanes and the dialogues of Plato to painting and sculpture. It was also integral to society: pederasty was key to the Athenian educational process, and the dominant model against which all male sexuality was judged. This ritualized urban courtship had its own stage sets in the gymnasiums, schools, and banquet halls where the male elite gathered. The gymnasium was both a school for young men and a social center for grown-ups; activities ran

the gamut from nude athletics, infused with a tacit celebration of male beauty and physical contact, to the erotic intimacy that might follow such public displays.

Our widest window on this physical and emotional comradery, as on much of classical Greek life, is the only form of early painting to survive, on vases and pots. Vessels of terra-cotta (baked clay) were staples for storing grain, oil, and wine, as well as for serving food and drink. Neighborhood craftworkers mass-produced bowls, cups, and pots that they hand-painted, often to special order, for a middle- and upper-class clientele both locally and as far afield as the Greek overseas colonies and their Etruscan neighbors in central Italy. The wide repertory of subjects ransacked mythology, theater, and genre or daily life. Several hundred from the sixth and fifth centuries show men in a variety of erotically charged activities, from athletics to courtship to copulation; but even the less graphic themes testify to an unabashed admiration for bodily perfection and enjoyment. Though these amount to only a fraction of the known heterosexual scenes, homosexual taste was neither uncommon nor exclusive.

1.5. **Three Men Courting a Youth,** ca. 6th century B.C.E. (painted pottery).

Many scenes depict the stages of courtship between boys and men, including the rivalry between two or more suitors illustrated in figure 1.5. The rules of this social dance, restricted to the leisured class of freeborn citizens, were elaborate and high-minded. Older males wooed boys, who ranged from puberty to age seventeen, for an intimate mentorship in physical, moral, and intellectual skills that initiated the eromenos into adult society; as part of that initiation, the boy would gratify his erastes as a passive sexual partner. At age eighteen, when pubic hair and beard sprouted, a boy graduated to an *ephebe*, or young adult, at which point he performed military service and was expected to shift from passive to active, himself pursuing younger men. This intermediate category lasted until age twenty-five, when he grew a beard and was generally expected to marry, though mature men could also continue to take younger male lovers.

An erastes who was attracted to a boy was expected to approach him with tact, flattery, and generosity—to prove himself not merely lustful, but willing to give as well as receive. One obligatory sign of honorable intentions was a courting gift, often depicted as an animal such as a cock, a hare, or the stag carried by the suitor in the illustration. Men approaching youths in pictures also make standard gestures of interest; often, like the central suitor here, they combine two common gestures in the "up-down

pose," one hand chucking the boy under the chin, the other fondling his genitals. Pottery not only illustrated such seductions, it abetted them. A lover might have a portrait of his eromenos painted on a cup, or some subject that expressed his feelings, often accompanied by a witty inscription including the beloved's name or simply the words *eros kalos*, "the boy is beautiful." The youth could then use the gift at banquets, showing off the man's conquest to mutual friends.

Images of seduction seldom detail their physical setting, but the boy in figure 1.6 is brandishing a lyre, suggesting that this unwelcome encounter takes place at a gymnasium or a banquet, two commonly illustrated courting grounds. We can well understand why the adult suitor would stretch out his arm imploringly to the youth, who must often have been doubly desirable: the curriculum aimed to combine physical excellence, developed by exercise and competitive training, with intellectual and artistic accomplishment, encouraged by parallel instruction in music. The palaestra, or wrestling court, was one main attraction (shown above the main scene in fig. 1.5), while the boy in figure 1.6 has perhaps been interrupted while practicing. Either a lyre or a ball or other athletic gear may also appear as a courting gift, translating the hunt-related offerings of tribal times into more refined urban pursuits.

1.6. Aegisthus Painter, **Youth Brandishing a Lyre at a Suitor,** 470–460 B.C.E. (painted pottery).

These vases visualize a consistent ideal of virile masculine beauty: broad shoulders, well-defined muscles in the chest and above the hips, the torso tapering to a narrow waist above prominent buttocks and massive thighs. Bodies almost never sport pubic hair, since the perfect pinup was adolescent and smooth-skinned, a preference that seemed to carry over to adults (except for their beards). "What I love above all else is a boy at the palaestra," wrote Strato, "his dusty body, his sturdy limbs, his soft skin." Depictions of such youths, victorious in their games, being honored by their trainers and judges spotlight the erotic undercurrent of a space where men were expected to gaze upon handsome boys—a spectacle in which "looking after" their charges could easily slip into "looking them over." As homoerotic architecture, structured to accommodate sexual activity within the rituals of male bonding, these gathering places were often dedicated to Eros or the demigod Hercules, the archetype of physical and sexual prowess. Ancient authors credit Hercules with more male conquests than anyone; the tomb of his beloved Iolaus, where Theban lovers exchanged vows, was located next to the gymnasium.

Besides real people, vases often illustrate mythology, equally rich in ho-

moerotic characters and affairs. The most prestigious was Jupiter's pursuit of the mortal shepherd Ganymede, which was painted continuously and was also popular on mirrors and floor mosaics. We have already observed Achilles and Patroclus; other vases depict Hercules or the sea god Neptune pursuing Pelops. Most poignant of all was Apollo, whose love for the mortal youth Hyacinthus was spitefully derailed by his rival, the wind god Zephyrus. Figure 1.7 shows this winged troublemaker embracing the youth himself, so closely as to suggest airborne sexual congress, in an idyllic moment before the jealous climax when he blew Apollo's discus off course to kill Hyacinthus (Apollo consoled the dead boy by transforming him into the hyacinth flower). Bacchus, the god of wine who loved both the nymph Ariadne and the youth Ampelus, appropriately cavorted on many drinking vessels, along with his rustic retinue of goatlike satyrs whose exuberant randiness and freedom from civilized norms were often humorously portrayed, as in this scene of polymorphous group sex (fig. 1.8).

1.7. Douris Painter, **Zephyrus and Hyacinthus**, ca. 480 B.C.E. (painted pottery, detail).

Ironically, the flowering of homoerotic pottery in later sixth-century Athens may be due to the very dynasty that Harmodius and Aristogiton overthrew. Despite Pausanias' theory that tyrants disliked homosexual love, male

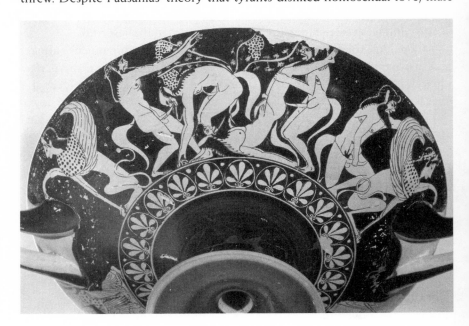

1.8. Circle of the Nikosthenes Painter, **Satyr Scene**, ca. 5th century B.C.E. (painted pottery).

passion ran in the family: Pisistratus, father of the tyrannicides' victim Hipparchus, was reportedly the beloved of the great lawgiver Solon, and Hipparchus, who provoked the couple's violence, had an erastes of his own. The Pisistratids set an erotic fashion for the city's elite, epitomized by Hipparchus' inviting to Athens the poet Anacreon, already famous for lyric verses whose celebration of wine, women, and song blithely included boys. The Athenians lionized the author, ordering his portrait on vases and later setting up a statue of him on the Acropolis, wine cup in hand, next to Pericles.

Besides hymning the hothouse atmosphere of early classical Athens, Anacreon's verses expose the link between psychology and aesthetics that inspired the artistic outpouring of his time. One heavy-breathing poem gives first-person testimony to how the desire for male beauty triggers the parallel urge to enjoy it in art: he implores an artist to "draw for me my companion Bathyllus, as I instruct you; make his ringlets shining and as dark as midnight." Moving beyond subject matter to nepotism, desire also swayed artistic life behind the scenes. Phidias, the sculptor who decorated the Parthenon—the sumptuous temple Pericles erected to the city's patroness Athena—had a pupil named Agoracritus who, Pliny tells us, "pleased him because of his youthful good looks, and consequently Phidias is said to have allowed him to pass as the author of several of his works."

THE BANQUET: RULES AND EXCEPTIONS

The banquet, or symposium, equaled the gymnasium as a breeding ground for intergenerational flirtations. Although the menu at these wine-drenched stag parties might include sophisticated conversation, the feasting, drinking, and music eventually led to an equally important segment of the program. Images such as figure 1.9 make the sexual agenda explicit: a reclining older man takes a break from playing the lyre with the young man at the foot of his couch and turns to fondle the genitals of a smaller boy behind him, who gently adjusts his garland, while a youth at the rear serves wine. Although, as always, bisexual desire was presumed, the few women present were paid entertainers, including musicians and courtesans, whose position at the margins of this scene parallels their secondary role.

Plato's famous dialogue on love, *The Symposium*, reports the debate at a particularly dazzling banquet whose guests, including Plato's teacher Socrates, memorably expound the ideal philosophy of pederasty. The speakers exalt the appreciation and enjoyment of physical perfection, but stress that earthly satisfaction is merely the lowest rung on a ladder rising toward communion with a transcendent truth. Socrates declares that "the object of love is a creative union with beauty, on both the spiritual and physical levels," and calls himself "the erastes of Alcibiades and of philosophy." In practice, this supremacy of

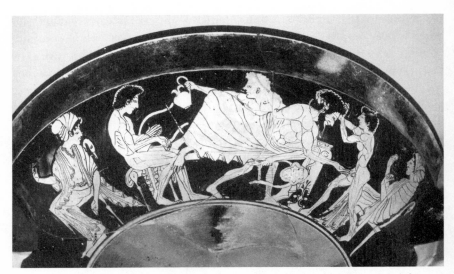

1.9. Hegesiboulos Painter, **Symposium Scene,** ca. 500 B.C.E. (painted pottery).

mind over matter was hard to maintain, as acknowledged by Pausanias' denunciation of "the love we see in the meaner sort of men, who are set on the body more than the soul." In his later treatise, *The Laws*, a disillusioned Plato preached total chastity except for procreation, and "platonic love" now often implies a nongenital affection. But in his own time, and after, the name of antiquity's paramount moral theorist also symbolized an age-old approval, however carefully qualified, of passionate attraction between men.

Actually, to be more precise, the man's desire for the boy. Wherever a potential eromenos might be approached, etiquette required him to play hard to get—both to test the suitor's sincerity and because the youth was not yet expected to reciprocate the heat of passion. As Xenophon put it bluntly in his *Symposium*, "the boy does not share in the man's pleasure in intercourse, as a woman does; cold sober, he looks upon the other drunk with sexual desire." But the poet Strato complained, "I hate resistance to my embrace when I kiss, and violent opposition with the hands," and indeed a repertory of painted gestures illustrates the possible responses: from a "no" that means "no," like the threatening lyre of figure 1.6, to a "no" that may mean "not yet," like the youth in figure 1.5 who merely grasps the forearm of his seducer to slow him down. But in other scenes the suitor is more fortunate—or the moment shown is a little later—and the boy responds favorably, turning toward his pursuer, accepting his gifts, caressing him. The pair may then be shown clasped in a mutual embrace, which could lead to being wrapped together in a single cloak (probably copulating "undercover"), and to openly depicted sexual consummation.

Intercourse between erastes and eromenos was highly standardized. The most commonly depicted activity is intercrural sex, in which the erastes rubs his penis between the standing youth's thighs, as the man is preparing to do in figure 1.10—a position, to judge from his bent knees, that must have caused some discomfort. Thighs were a powerful erotic stimulus: Sophocles wrote

that Ganymede's "set Zeus aflame," and Aeschylus has the grief-stricken Achilles elegize the thighs of Patroclus. Anal sex is scarce in images of men with boys, though sometimes youths do it with each other. The practice was hardly unknown, since playwrights lampooned it and many vases show its heterosexual variety; this visual reticence about male penetration may stem from its association with the passive or womanly role, which was shameful for male citizens. For the same reason fellatio, or oral sex, was not accepted in the pederastic repertory. The Greeks only illustrated it among satyrs, whose half-animal nature exempted them from the requirement that real men avoid demeaning and distasteful acts: in figure 1.8 they indulge indiscriminately in both anal and oral sex.

In theory, each male kept to the role assigned to his particular age and status; but in fact, as Plato fretted, the surging torrent of sexual desire sometimes overflowed the bulkheads of social convention. A few images show boys approached by a man toting a money bag; these purses, also prominent in scenes of female courtesans, may hint at breaches of the taboo against aristocratic male prostitution. Other erotic scenes reveal chronological transgressions, particularly affection between two or more youths of approximately the same age. Sometimes an adolescent pair embrace intimately, as if imitating their elders. The later stages of such caresses are suggested by one scene in which a youth clambers onto the lap of another who has an erection, probably preparing for anal intercourse, and by pictures in which clusters of youths are having group sex. These images suggest that an informal transition period permitted those who straddled the border between child and adult to "try out" their future identity among themselves. Illustrations of Eros, himself an adolescent, embracing a beloved youth stamped such boy-boy loves with the seal of heavenly approval; elsewhere the god encourages mortal couples of similar ages, such as by crowning a youth who is singing to his lover.

Sneaking the prerogatives of adults is probably universal, but once grown to maturity, some men chafed against new emotional limitations. Theocritus, in his *Idylls*, recounts the ill-fated love of Hercules for the young Hylas, who was seduced by female nymphs and drowned; the poet is attempting to console his friend Nicias for the imminent loss of his maturing eromenos by point-

1.10. Brygos Painter, **Man and Youth Initiating Intercrural Intercourse,** ca. 500–480 B.C.E. (painted pottery).

ing out that younger lovers are inevitably drawn away from their erastes and toward women. A few men brazenly permitted emotion to circumvent custom: Plato's Pausanias, unwilling to let go of his eromenos Agathon after the telltale beard, followed him to Macedonia and remained his lover until the younger poet was over thirty. Although touching to read about, such violations of the formal ideal were never dignified by illustration.

THE THEATER AND THE TEMPLE: MEN, WOMEN, AND GODS

The theater, a public ritual in Greek society that fulfilled both sacred and civic purposes, enjoyed its heyday during the fifth and fourth centuries, featuring dramas by Euripides, Aeschylus, and Sophocles, and comedies by Aristophanes that were revived well into Roman times and are still performed today. The plots of numerous tragedies pivoted on their heroes' male passions. Most of the scripts have vanished, but thanks to the popularity of theatrical illustration, painted scenes from this repertory provide secondhand glimpses of homosexuality onstage. By embroidering on epic legends and humanizing their mythic leading roles, the playwrights presented archetypes of male love among a familiar and beloved cast.

Euripides' *Chrysippus* of 410 was still popular some seventy-five years later, when it was illustrated on a red-figure vase (fig. 1.11). The charioteer at bottom center is Laius, king of Thebes, who fell head over heels for the title character, son of Pelops. Laius is forcibly abducting the distressed youth, who

1.11. Scene from Euripides' "Chrysippus," ca. 350–325 B.C.E. (painted pottery).

gestures frantically backward to his father rushing in helplessly from the right; above, seated gods look on. Euripides named Laius the first human to love another of the same sex, making him the ancestor of the Theban Band, though hardly a positive role model: Pelops called down a curse that Laius would die at the hand of his own son, who turned out to be the ill-fated Oedipus. The popular appeal of Greek drama spread across the Mediterranean: scenes from this play decorate vases from south Italy and an Etruscan cista, or urn.

The other popular heroic couple in drama are Orestes and his lover, Pylades. Both Aeschylus and Euripides recounted the

chain of disasters that befell the family of Orestes and his sister Electra, who killed their mother, Clytemnestra, to avenge her murder of their father, Agamemnon; the devoted Pylades, who followed Orestes into exile and shared intimately in his fate, is often depicted close to his companion on vases and terra-cotta reliefs. Though these pairings are never overtly erotic, at least one patron understood their parallel to his own passion for a young beloved: he ordered the boy a vase showing the two nude heroes over whom is inscribed the customary courting term "kalos."

The theater, where men played all the parts, was as much part of the "man's world" as the banquet and the gymnasium. Not surprisingly, then, female homosexuality is all but invisible on stage or in painting. A rare vase painting of two women together in a moment of physical intimacy (Tarquinia, Museo Nazionale) typically represents them from the male artists' and patrons' point of view. Two naked *hetaerae*, or professional courtesans, are preparing for a public appearance—public meaning before the eyes of men. The standing woman holds a perfume bowl while the woman crouching before her strokes her thigh and genitals, probably anointing her companion. Some women doubtless exploited these "offstage" opportunities for the mutual affection and pleasure denied them in relations with men. But male writers were uniformly uninterested in what might transpire beyond closed doors, much less in what this physical and emotional contact might mean to the participants themselves. Only Plato analyzed female-female sexual desire, but his parable of the primeval androgynes presents lesbianism in abstract philosophical terms; he says nothing about it in everyday practice.

1.12. **Jupiter and Ganymede,** ca. 470 B.C.E. (painted terra-cotta).

Outranking its role in the theater, homosexuality also starred in the temple, whose cult images, like other monumentally scaled public sculptures, held the highest rung on the artistic ladder. About 470, an unknown patron thanked the king of the gods by offering a meter-high painted statuette of Jupiter abducting Ganymede (fig. 1.12) to his sanctuary complex at Olympia, renowned for its size and costly decoration as one of the Seven Wonders of the ancient world. One wonders just what sort of supplication the insatiably bisexual god must have fulfilled to deserve this exceptionally large portrait of himself with the most beautiful of mortal boys. Jupiter is striding forward purposefully after plucking the princely shepherd up from among the flocks; in a moment he will take flight, carrying the boy aloft in his arms to become his heavenly cupbearer and bedfellow. The god's ac-

tive pose and body-revealing drapery mark the same quickening naturalism as the nearly contemporary *Tyrannicide Monument* (fig. 1.3). But the facial expressions are still impassive, and the stiff boy's reaction to this surprise embrace is unclear—though he puts up no struggle.

Plato claimed that the Cretans invented the Ganymede myth to justify their fondness for pederasty, but the relationships between myth and life were more complicated and ambiguous. This votive statue calls into play three overlapping levels of interpretation. Theologically, these tales explain the origins of the cosmos, validating the human role within it by appeal to divine precedent. Anthropologically, they may preserve the memory of long-vanished social practices that, while much altered and half-forgotten, still shaped everyday behavior. And psychologically, by mirroring real-life situations, they provide timeless parables for understanding the passionate dilemmas that confront ordinary folk. Earthly men understood these parallels and exploited them, buying vases for their beloved youths that celebrated analogous episodes of divine courting, such as Apollo's rivalry with Zephyrus (fig. 1.7).

Discrepancies between the mythic accounts of Ganymede and this sculptural presentation suggest how blurred the boundaries were. Although the literary sources all specify that Jupiter swept down from the clouds disguised as an eagle, the statue shows him walking the earth, in human form. The rooster clutched in Ganymede's left hand played no part in the shepherd's tale but is grafted onto the myth from Athenian men's custom of proffering gifts of birds or other small animals to the boys they were courting. In some paintings Ganymede rolls a hoop—another activity associated not with fantasy shepherds, but with urban boys at the gymnasium. Images like these bear out the familiar adage that the Judeo-Christian god made humanity in his own image, but the Greeks made their gods in the image of themselves. The unknown patron for the Olympia statuette certainly knew that the gods' escapades figured on an ideal plane the same gamut of desires that tormented their human counterparts, and he must have felt that Jupiter's love for a youth intersected somehow with his own deepest yearnings.

THE NUDE IDEAL AND THE IDEAL NUDE

In addition to temples, a variety of secular buildings and public spaces—gymnasiums, theaters, market squares—were embellished with monumental sculptures (the originals, normally cast in bronze, are now known from later copies in marble). Some statues memorialized exemplary mortals like Anacreon and the Tyrannicides, others paid homage to the presiding deity who symbolized the functions and ideals of an edifice: appropriately, the first public altar to Eros in Athens was dedicated by Charmus, an eromenos of the dictator Pisistratus, at the entrance to the gymnasium known as the Academy. The *Do-*

ryphorus, or "Spear-Bearer," (fig. 1.13), by the classical sculptor Polyclitus probably also adorned a gymnasium or training ground, epitomizing male physical accomplishment. Although this handsome, powerful figure is too old to qualify as an eromenos, he has not yet grown the beard of maturity, making him an ephebe between the ages of eighteen and twenty-five, equipped for military training. The nude male fully emerges here as the paradigm of the classical style, which elevated human beauty to quasi-divinity by coupling realism with mathematics; the sculptor in fact modeled this figure to illustrate his book outlining an artistic canon, or system of ideal human proportions. The preference for nude subjects partly reflected real life—Greek men's propensity for going without clothes struck foreign visitors as exceptional—but the nude also embodied a metaphysical ideal, in which the physical perfection of the exterior would be matched by an equal spiritual and moral perfection within. And this doubly sublime lancer is putting that hard-won perfection at the service of the state, answering the call to military duty with supreme strength, skill, and bravery.

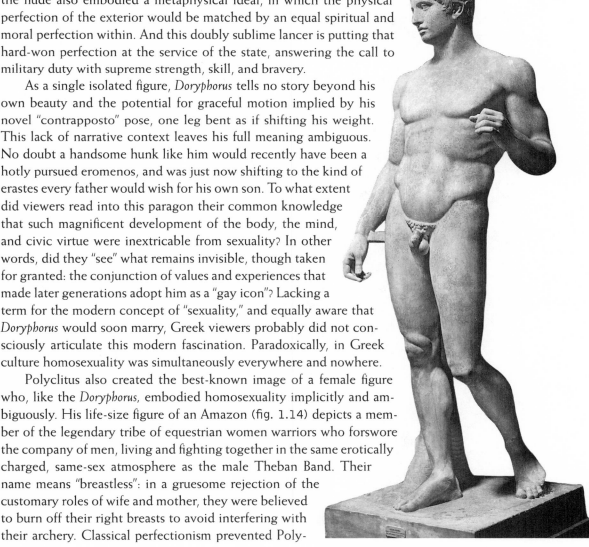

1.13. **Doryphorus** (Spear-Bearer) (marble copy after original by Polyclitus, ca. 440 B.C.E.).

As a single isolated figure, *Doryphorus* tells no story beyond his own beauty and the potential for graceful motion implied by his novel "contrapposto" pose, one leg bent as if shifting his weight. This lack of narrative context leaves his full meaning ambiguous. No doubt a handsome hunk like him would recently have been a hotly pursued eromenos, and was just now shifting to the kind of erastes every father would wish for his own son. To what extent did viewers read into this paragon their common knowledge that such magnificent development of the body, the mind, and civic virtue were inextricable from sexuality? In other words, did they "see" what remains invisible, though taken for granted: the conjunction of values and experiences that made later generations adopt him as a "gay icon"? Lacking a term for the modern concept of "sexuality," and equally aware that *Doryphorus* would soon marry, Greek viewers probably did not consciously articulate this modern fascination. Paradoxically, in Greek culture homosexuality was simultaneously everywhere and nowhere.

Polyclitus also created the best-known image of a female figure who, like the *Doryphorus*, embodied homosexuality implicitly and ambiguously. His life-size figure of an Amazon (fig. 1.14) depicts a member of the legendary tribe of equestrian women warriors who forswore the company of men, living and fighting together in the same erotically charged, same-sex atmosphere as the male Theban Band. Their name means "breastless": in a gruesome rejection of the customary roles of wife and mother, they were believed to burn off their right breasts to avoid interfering with their archery. Classical perfectionism prevented Poly-

clitus from showing such mutilation, though he appropriately endows her with short riding-clothes and a muscular physique much like *Doryphorus*. Myth located these warriors in Asia Minor, near the Black Sea, where they revered the huntress Diana, the virginal moon goddess whose devotees, like the Amazons themselves, enjoyed only the company of other women. In fact, Polyclitus' statue, along with Amazon images by several other sculptors, was dedicated in the temple of Diana at Ephesus in Turkey, another wonder of the ancient world and center of her widely popular worship.

1.14. **Wounded Amazon** (marble copy after original by Polyclitus, ca. 440 B.C.E.).

Like the *Doryphorus*, much is not shown here, leaving the same ambiguities: How much did viewers read her sexuality into this lone icon, and what attitude did they take toward it? Although the Amazons' assumption of masculine prerogatives and scorn for femininity would certainly have foregrounded the sexual aspect of their legend, they were not exclusively lesbian: once a year they condescended to mate with men from a neighboring tribe, solely in order to perpetuate their own race. And, as in so many male images with a homosexual background, the primary focus is on public virtues, not sexual subtext. Having fought valiantly against the Greeks, the Trojans, and other enemies, the Amazons were often honored in public sculpture; Amazon battles are one of the few female subjects in high classical art, reflecting how male interest in women perked up only when they acted like men. In real life, of course, such aspirations by a contemporary Greek woman were unthinkable. The Amazons' imaginary gender deviance was thus both fascinating and threatening, and men's admiration at best grudging. This isolated, powerful, yet languid woman raises her arm over her head, perhaps exhausted by a wound—a reassuring indication that however admirable, she is not invincible. The Amazon may be acknowledged, but she always loses.

Unfortunately, the public art that occupied the rung next below sculpture—monumental paintings, both wall frescoes and freestanding panels—is all but obliterated. Like sculpture, these far more fragile images often celebrated mythological or religious themes; but we will never know how frequently, or in what form, the loves of Apollo for Hyacinthus, or the nymph Callisto for Diana, may have been frescoed in Greek temples and private homes (though some Roman examples survive). A faint afterimage of these lost pictures persists in the late literary tradition of *ekphrasis*, the written description of works of art. The author Philostratus, in his *Imagines* ("Pictures," third century C.E.), outlined in detail several dozen paintings, about a fifth of which illustrated homoerotic myths. Describing a tableau of Apollo stunned by the death of Hyacinthus at the hand of Zephyrus, Philo-

stratus fleshes out the skeleton of plot and characters with emotional sympathy and art criticism: "You will say he is fixed here, such consternation has befallen him. Zephyrus is a lout, who was angry with Apollo and caused the discus to strike the youth, and he taunts the god." Hyacinthus was especially popular; Pausanias says of another version by Nicias that the painter "portrayed him as an ephebe, hinting at the love of Apollo for him." Also surviving through such texts are images of Neptune's love for Pelops and Hercules' for Abderus.

GREEKS ABROAD

The spread of Greek customs to overseas colonies, and attitudes toward earthly desires and the afterlife among these emigrants and their far-flung neighbors, are revealed by artistic remains like an underground burial chamber at Paestum in southern Italy. Called the Tomb of the Diver after the graceful male figure who, perhaps, is plunging into the watery frontier separating the living from the land of the shades, it was frescoed about the first quarter of the fifth century. The horizontal wall frieze depicts a dozen men enjoying a banquet. They recline on couches, their torsos bared, sporting the leafy wreaths that were standard attire at these sensuous entertainments; one young ephebe pours wine. One adult smiles invitingly as he puts his arm around a younger lyre player to draw him closer, while his neighbor looks on, curious to see how the seduction will turn out. This vignette, charming rather than funereal in mood, preserves the pleasures of this world, perhaps with the hope of conjuring the same tender delights for the deceased to enjoy in the afterlife.

Such earthy conceptions of life after death, unknown in mainland Greece, may have been absorbed from contact with foreigners. When colonists landed on the peninsula they encountered the native Etruscans, who dominated central and northern Italy between the ninth and third centuries B.C.E., and who were already decorating the multiple compartments of their underground vaults with complex memorial cycles. The Tomb of the Bulls at Tarquinia, an Etruscan city near Rome, was frescoed about 530 B.C.E. with an elaborate allegory topped by two frank scenes of copulation (color plate 1). The left group is heterosexual, while on the right one man anally penetrates another who crouches over, apparently wearing horns, as a bull lowers his horns to charge at the couple. The lower zone depicts a mythical exploit of Achilles against the Trojan Troilus, whom some say he fell in love with.

Unfortunately, the Etruscan language remains undeciphered, so we can only conjecture about the meaning of such images, which probably visualize mystical links between eros, military valor, and death. A Roman source claimed that homosexuality was unusually common among the Etruscans, and other tomb frescoes, sculptures, vase paintings, and smaller decorated objects

like mirrors and toiletry boxes (cista) depict nude men in suggestive poses as well as erotic couplings and male banquets with nude cupbearers similar to those of Greece. In fact, Greek painted vases were a popular import to the region, suggesting strong mutual influence; both cultures in turn exerted a formative influence on their conquerors, the Romans.

THE HELLENISTIC ERA: ALEXANDER AND ANDROGYNY

By the time he died in 323 B.C.E., Alexander the Great (fig. 1.15), originally the king of Macedonia in northern Greece, had conquered the entire Greek peninsula and much of the eastern Mediterranean, as far as Egypt and the borders of India. He forged a short-lived but cosmopolitan empire that ushered in the period called Hellenistic, or "Greekifying," because it intensified the spread of Greek culture already begun in Italy—although, especially to the east, they borrowed as much as they lent. He founded new urban centers throughout the sprawling monarchy, most notably his namesake Alexandria in Egypt, which continued to propagate Greek civilization even when, following the founder's early death, his empire broke up into smaller independent kingdoms.

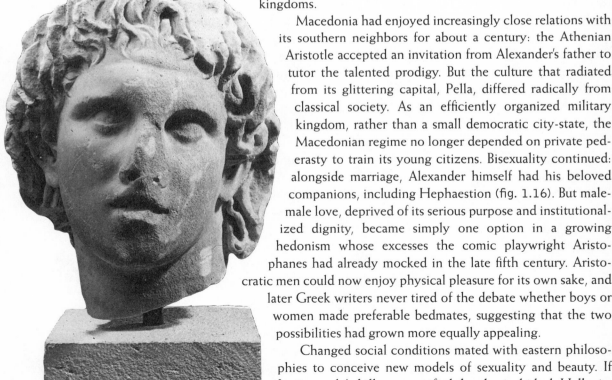

1.15. Alexander the Great, ca. 330 B.C.E. (late Hellenistic copy after Lysippus, marble).

Macedonia had enjoyed increasingly close relations with its southern neighbors for about a century: the Athenian Aristotle accepted an invitation from Alexander's father to tutor the talented prodigy. But the culture that radiated from its glittering capital, Pella, differed radically from classical society. As an efficiently organized military kingdom, rather than a small democratic city-state, the Macedonian regime no longer depended on private pederasty to train its young citizens. Bisexuality continued: alongside marriage, Alexander himself had his beloved companions, including Hephaestion (fig. 1.16). But male-male love, deprived of its serious purpose and institutionalized dignity, became simply one option in a growing hedonism whose excesses the comic playwright Aristophanes had already mocked in the late fifth century. Aristocratic men could now enjoy physical pleasure for its own sake, and later Greek writers never tired of the debate whether boys or women made preferable bedmates, suggesting that the two possibilities had grown more equally appealing.

Changed social conditions mated with eastern philosophies to conceive new models of sexuality and beauty. If Jupiter and Achilles personified the classical ideal, Hellenis-

1.16. Roman Syria, **Alexander and Hephaestion with Hercules,** ca. 200 c.e. (marble).

tic art gave pride of place to Venus, as in that well-known armless wonder, the *Venus de Milo.* This novel attraction to the voluptuous soft curves of the female nude accompanied a shift in the preferred body type for men: the muscular bulk of the *Doryphorus* gave way to a slender elegance, both younger and more feminine, and androgynous deities, notably Apollo, Dionysus, and Hermaphroditus, grew in popularity. Along with feminization came infantilization: the adolescent Eros of classical vases grew younger and younger in Hellenistic sculpture, ending up as the winged cherub, more naughty than awesome, who survives in modern Valentines. These changes—paralleled in literature by the bawdy humor and lighthearted romanticism of short epigrammatic poems gathered into books like *The Greek Anthology*—imagine love as a game, irresistible perhaps but not to be taken too seriously. These Hellenistic sensibilities strongly influenced Roman culture, whose military expansion was by then rapidly advancing into Greek territory.

Hellenistic public art featured a new genre in which homosexual love held an acknowledged, if never overtly erotic, place: official statues of Alexander himself, which were erected by the thousands throughout his domains. Once Alexander declared himself the son of Jupiter, his twin titles of emperor and god supplanted the classical city-states and their secular heroes with far-flung absolute power cemented by a propagandistic cult of sacred personality. The first portraits were taken from life by the celebrated sculptor Lysippus, whose compelling image of divine rulership captivated a millennium. Elevated to mythic status in the memory of the Hellenized East, Alexander was invoked

for centuries by his royal successors as the paragon of the warrior-prince, adopted by the Romans who overran them, and transmitted through medieval knighthood into the Renaissance.

Alexander provoked fascination and wonder at the historical impact of a singular personality, inspiring Hellenistic artists toward individualized portraiture in the modern sense. Sometimes they grafted onto the emperor the features of another divinity, such as the horns of Pan that grace his forehead in a fragmentary bronze found at Pella, lending erotic associations appropriate to this handsome and passionate man. The more naturalistic marble portrait head in figure 1.15, commissioned by the last Macedonian king in the second century B.C.E., derives its basic features from Lysippus. The energetic twist of his head and the upward glance of his eyes suggest receptive alertness and dynamic reaction. His tousled hair, swept up off the forehead as if by a whispering breeze, and his sensuously parted lips further evoke the romantic mantle of divine inspiration first wrapped around him by Aristotle, who believed his young pupil the chosen missionary for the Greek spirit.

Alexander's greatest love was his comrade Hephaestion, whose early death he mourned with extravagant grief. Public portraits of the emperor alone did not, of course, acknowledge such private bonds; but Hephaestion did merit inclusion, as a separate portrait statue, in a series created by Lysippus illustrating the life of the monarch. The two men were once pictured together, but Hephaestion played merely a supporting role in a bisexual scene: a painting by Aëtion depicting Alexander's marriage to the princess Roxana. In Lucian's ekphrasis of this lost work, Alexander hands his waiting bride a ceremonial crown as two handsome nude men bear witness: Hephaestion, described as "their best man," leaning on Hymen, the god of marriage, who was himself an eromenos of Apollo.

Much later, Alexander and Hephaestion finally appeared without the bridal complication, in a complex allegorical relief carved about 200 C.E. in the Syrian part of his empire, by then under Roman rule (fig. 1.16). The marble panel, which may have decorated either a sarcophagus or a building, shows Alexander standing nude in the center, in the same pose as the Lysippan statues, while the draped Hephaestion stands close behind him looking off into the distance. Seated at the left is Hercules with his club, also backed by a male companion (perhaps Hylas or another young lover). Hercules was the mythic ancestor of the Macedonians, and the handsome quartet no doubt constitutes an apotheosis of Alexander, his companion, and his political descendants in the region—including the Roman overlords of this late date, who wanted to position themselves as legitimate heirs to that lineage.

Alexander's herculean homosexuality influenced his visual legacy on another level as well, since it could be exploited by artists maneuvering for patronage. A Macedonian architect named Dinocrates, seeking Alexander's support for a scheme to carve an entire mountain into a human figure contain-

ing a new city, grew frustrated when court officials blocked his request for an audience. Deciding to attract the ruler's attention on his own, Dinocrates, who the Roman architectural writer Vitruvius informs us "was of very lofty stature and pleasing countenance, finely formed," decided to "trust in these natural gifts." He stripped naked, oiled his flesh, and costumed himself as Hercules, with the requisite lion skin over his shoulder and holding a club, then stationed himself where Alexander was holding audience. Astonished at this apparition, the emperor ordered him to approach and grilled him about his purpose. The emperor rejected the architect's proposal as impractical, but was sufficiently impressed by his mind and body to give him an even better commission, the design of his new Egyptian metropolis, Alexandria.

1.17. **Apollo Belvedere** (marble copy after Hellenistic original, ca. 300 B.C.E.).

THE GODS AS METAPHOR: APOLLO AND DIONYSUS

Alongside Alexander himself, Hellenistic religion continued to worship the traditional pantheon of gods, though it sometimes changed their visual form, and even added new deities. The androgynous aesthetic found its preferred subjects in divinities like Apollo, the sun god and patron of the arts. The life-size marble surnamed the Belvedere since it was unearthed in the Renaissance (fig. 1.17), a Roman copy after a bronze from about 300 B.C.E., was among the most influential of all antique works. It depicts the beautiful god clad only in sandals, cloak, and the strap of a quiver crossing his chest, as he strides forward while looking sideways toward his outstretched left hand, which probably held a bow. In contrast to the bulky physique and martial equipment of the *Doryphorus*, Apollo's slimmer proportions and smooth flesh suggest a more refined upbringing spent in the pursuit of gentler sports, such as archery, and of music and poetry, whose association with a lingering femininity is heightened by his upswept braided hairstyle. Although he is virile enough

to play the erastes role—and was credited with more male lovers than any other god—he is still a beardless ephebe, in the perpetual bloom of unmarried late adolescence.

Imposing sculptures like this one, or the famous *Jupiter and Ganymede* by Leochares, were erected in temples as objects of prayer. Worship of the god sometimes invoked his sexuality, though the evidence is fragmentary or obscure. Close to a temple of Apollo at Thera, graffiti scratched into rocks as early as the eighth or seventh century B.C.E. memorialize homosexual exploits in the grove, following the formula, "By Apollo, Krimon here copulated with a boy." It's hard to tell whether these testimonials are sacred or profane: they may honor acts performed in the temple itself—ritual sex, often provided to pilgrims by official prostitutes, was considered a form of homage to the god—or simply boast about frivolous secular couplings among tourists who met briefly on a pilgrimage holiday.

1.18. **Pan and Olympus (or Daphnis)** (marble copy after Hellenistic original).

Other temples to Apollo provided more patently homoerotic spaces, such as the complex at Amyclae where, Pausanias recounts, a colossal statue of the god stood atop a building containing an altar chamber sacred to his beloved Hyacinthus (and, for girls, another to Hyacinthus' sister). Two festivals held there venerated the god and his ill-fated eromenos as patrons of education and initiation rituals: the Apollo Carnea which, not surprisingly for a Dorian city, included sexual elements, and the Hyacinthia, in which the tragic death of his lover may have symbolized the psychological death of every child at adolescence in order to be reborn as an adult.

The polar opposite to the "Apollonian" cultivation of reason, education, and divinely ordered creativity was the "Dionysian" realm of the god Bacchus. The bisexual patron of wine and its ecstatic corollaries, drunken abandon to desire and orgiastic release, grew ever more popular in Hellenistic (and late Etruscan) times; though earlier depicted as a bearded adult, he was transformed into an androgynous ephebe. His inner circle of tipsy attendants, including the satyrs, fauns, and sileni, extended outward to his delirious female devotees, the Maenads, and further to related deities of ambiguous or excessive sexuality like Pan, Priapus, and Hermaphroditus. The trademark of these forest denizens, close to nature both geographically and in their often half-animal bodies, was their perpetual

erection, whose satisfaction, as we saw in the comic satyrs of figure 1.8, demanded all erotic outlets, even the forbidden or degrading. "Beastly" creatures though they may be, ruled by their impulses, they were boisterous but good-natured; often, as in the bawdy satyr plays performed at Bacchic festivals, their constant yearning after nymphs and shepherds led to tragicomic frustration.

A marble group of Pan fondling a youthful human musician (fig. 1.18) displays the characteristic subjects and mood of the Dionysiac realm. The god's hybrid nature is manifest in his goatlike features—shaggy legs, cloven hooves, horns, beard, and neck goiter—and his penis is larger and more erect than the standard for humans. Pan fashioned the first musical pipe and promptly used it to entice mortal shepherds—here, either Olympus or Daphnis—into becoming his disciples and lovers. If Pan's intentions are not clear enough from his leering gaze and more than pedagogical embrace, Philostratus describes a lost painting of Olympus in which "a band of satyrs gaze lovingly upon the youth, ruddy grinning creatures, one desiring to touch his breast, another to embrace his neck, another eager to pluck a kiss."

A slightly later Dionysian subject, known as the *Barberini Faun* (fig. 1.19), represents a single nude faun or satyr sprawled out on his back, carelessly exposing his muscled but limp body. His languid pose, with one arm crooked back behind the head, conventionally signaled fatigue or sleep, often suggesting the lassitude after lovemaking. Although the panther skin protecting him from his rocky bed clearly evokes the world of pastoral fantasy, aside from his pointed ears and hornlike forelock the recumbent creature is barely distinguishable from a mortal. As the Hellenistic period wore on, all the Dionysians came to look less exotic, and mythological subjects offered a vestigial pretext for the realistic display of eroticized human beauty.

1.19. **Barberini Faun** (marble copy after Hellenistic original, ca. 200 B.C.E.).

Though the erotic appeal of this figure has often been noted, in so thoroughly bisexual a culture its meaning would have shifted depending on the observer. A female viewer might read in it a desirable heterosexual partner, while a male viewer could see either an object of homosexual attraction or an opportunity to identify with another virile male relaxing after successful conquest of some nymph. If images of bodily pulchritude were popular with male spectators, it was because they offered visual stimulation that could rival the real thing. Pliny marvels at two statues by the late classical sculptor Praxite-

les—one female, the Cnidian Venus, the other a nude male Cupid—both showered with the ultimate tribute to their erotic potency: semen stains left by an overwhelmed visitor.

Through Bacchus' female acolytes, the Maenads (or Bacchantes), the Dionysian realm intersects with the musical enchanter Orpheus. When his wife, Eurydice, died accidentally, the lyrist and singer descended to Hades to charm its monstrous guardians into releasing her, a quest that failed at the last moment. Back on earth alone, he consoled himself with the love of boys, introducing homosexuality to his land of Thrace; some vases show him surrounded by handsome ephebes transfixed by his music. Enraged by jealousy when adult men, converted to Orpheus' new creed, rejected them, the vengeful Maenads tore him to pieces; his slaughter was a grimly popular subject from classical vases to Roman murals (color plate 2).

Like his patron Apollo, Orpheus embodied the close—and not entirely favorable—associations between music and poetry, prophecy, magic, and adolescent androgyny. In their ongoing debate over the merits of the active versus the contemplative life, the Greeks contrasted Orpheus to soldiers like Achilles who stood for the masculine virtues of work. While they valued Orpheus' realm of intellect, arts, and leisure—more broadly, creative imagination and spirituality—its gender ambiguity made them nervous. Men who doted on androgynous boys—who, as we saw, learned musical performance at the gymnasium and are often depicted with a lyre—raised suspicions of effeminacy and even debauchery, a "womanly" loss of control. In his celebrated speech attacking the morals of Timarchus in 346 B.C.E., the Athenian orator Aeschines accused another man, Misgolas, of "an extraordinary enthusiasm" for male lovers, snidely noting that he also kept singers and lute players to accompany them. This character assassination is more baldly stated in *The Symposium*, where Plato compares Orpheus unfavorably to Achilles, who was willing to die to avenge Patroclus in battle, whereas Orpheus' musical propensities marked him as less than a man. Belittling Orpheus for merely descending into Hades while still alive, Plato finds poetic justice in the fate of the singer, who "having gone upon a coward's quest, like the minstrel that he was," suffered "the penalty he deserved, to meet death at the hands of women." Although classical society built

1.20. Sleeping Hermaphrodite (marble copy after Hellenistic original, ca. 200 B.C.E.).

no further, it had laid the foundation for the stereotype of the homosexual as weak, tragic aesthete that arose in Victorian times.

Not a part of the Bacchic entourage, but intersecting its pansexual theme, was Hermaphroditus (fig. 1.20), whose union of male genitalia with female breasts and hairstyle bespoke an ambiguous eroticism far removed from the pectoraled athlete. Named for his/her parents, Hermes and Aphrodite (Mercury and Venus), Hermaphroditus was worshipped as a god of marriage from the fourth century B.C.E. This sculpture, after a bronze original from about the second century B.C.E., typifies numerous cult images in its elongated proportions, soft contours, and its coiled hairstyle with a topknot, which was worn by both female heroic figures and the *Apollo Belvedere*. The reclining figure seems to stir lazily in a light sleep, kicking off the covers to suggest languorous warmth and reveal both sets of organs; as with the *Barberini Faun*, the alluring passivity of sleep evokes postcoital exhaustion. The figure's blissful union of male and female simultaneously arouses all desires yet seems to transcend them by a fantasied return to the presexual unity of Plato's human hermaphrodites, who contained and reconciled all opposites. Over time this god lost much of his/her spiritual meaning, declining into a more generic mythological character whose sexual ambiguity led to comic confusion on the part of Dionysian pursuers like Pan and the satyrs.

Despite the period's feminization of subject and style, women together are as conspicuously absent from Hellenistic culture as they were in the classical era. One suggestive exception is the many representations of female couples engaged in games or intimate conversation (fig. 1.21). These miniature terra-cotta figurines, named for the city of Tanagra in Boeotia that specialized in their manufacture, offered widely affordable depictions of characters and activities from everyday life. In this scene (probably made in the second century B.C.E. in Asia Minor), two richly dressed and veiled ladies lean toward each other on a draped couch, their heads almost touching, in affectionate intimacy. Basing their interpretations on amusing literary stories about friendships between housewives, scholars

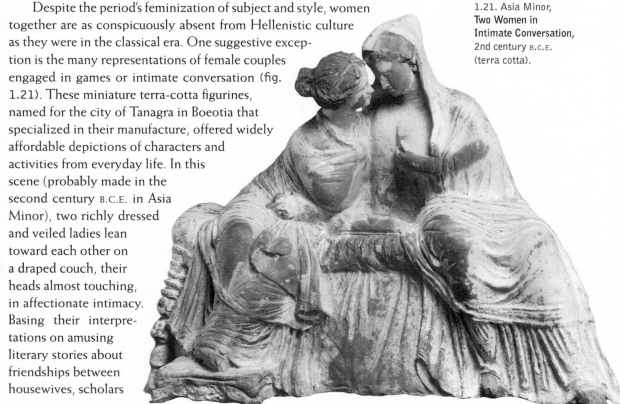

1.21. Asia Minor, **Two Women in Intimate Conversation,** 2nd century B.C.E. (terra cotta).

usually give such works titles like "Women Gossiping." Some classical ladies undoubtedly went far beyond gossiping, at least by the time of Saint Augustine, whose epistles sternly warned his Roman contemporaries that "the things which shameless women do even to other women in low jokes and games are to be avoided." But no Greek male writers recorded what else went on between women in private, leaving the full meaning of such intimacies adrift in a cultural vacuum.

ROME: REPUBLIC TO EMPIRE

The Romans, who dated the history of the world from the mythic founding of their own capital in 753 B.C.E., grew from a small Italian republic overshadowed by their Etruscan and Greek neighbors into a vast multinational empire straddling Europe, north Africa, and western Asia, which persisted until the ignominious fall of the mother city to barbarian invaders in 476 C.E. Rome swallowed Greece politically in the second century B.C.E., but the older rival had by then exacted its cultural revenge; in the words of the Latin poet Horace, "Vanquished Greece vanquished its savage victor." The Romans modeled much of their religion, literature, and art after those of the Greeks, siphoning off not only art and artists but tutors, nurses, and slaves. However, although wealthy Romans even sent their sons to Athens for higher education, homosexuality was not, as some defensive Latin moralists claimed, a foreign import; as we have seen, it was already celebrated among the Etruscans and took its own distinctive local form.

The Romans took over the Greek pantheon of gods and their bisexual habits, along with the belief that mortals should follow in divinity's erotic footsteps; the poet Virgil outdid the Greeks' enthusiasm with his cajoling proverb, "Omnia vincit amor": "Love conquers all: let us, too, yield to love." Male bisexuality was still taken for granted: wealthy men commonly kept mistresses, slaves, and boys for sexual pleasure, and prostitution was legal. Pagan Rome never punished homosexuality as such: disapproval was reserved for violations of role, class, or fiscal decorum. But these constraints were tighter than those imposed by the Greeks, since the overriding goal of Roman culture was to produce an adult male elite imbued with the domineering aggressiveness necessary for an expansionist military power. Sex, as always, was a metaphor for society: a man was taught to emulate the phallic god Priapus, actively, even brutally inserting his phallus-weapon wherever he pleased, but never submitting himself to penetration, either anally or orally. In all relations with those who were socially beneath him, the Roman male was always to be "on top."

This taboo was so strong that even freeborn boys, as embryonic citizens, were off-limits. Having dammed up the very basis of Greek pederasty, in which submitting to an adult contributed to a young man's education, the Ro-

mans choked off the philosophical stream that could have nourished any flowering of idealized male love. The width of this cultural chasm can be measured through a shift in language: the name of Ganymede, which once stood for the potential of the finest youths to be uplifted by the passionate attentions of an adult, godlike erastes, became in Latin *catamitus*, meaning simply a lower-class boy who provided sexual services. The pastoral poetry of Virgil, in which lovesick shepherds and other rustics poetically woo each other, is exceptional: Romans seldom romanticized or philosophized about homosexual love, simply treating it, like other forms of eros, as a physical appetite.

As Rome's territory and wealth mushroomed, the demand for art grew insatiable. Marble-encrusted public forums, temples, government buildings, theaters, bathhouses, and gymnasiums were adorned with sculptures and lined with paintings, as were private residences. The wealthy and middle classes built richly decorated homes and villas and stuffed the interiors with ornate furnishings, from lamps to jewelry. While male homosexuality appeared on all these creative stages, its role was less prominent than in Greece; Roman artists never developed anything to match the genre scenes and frank eroticism so popular on classical vases. Behind this visual reticence lay Roman *gravitas*, the austere code of moral seriousness cultivated since the republic, which frowned on all frivolous or undignified excess—not enough to prevent it from happening, but enough to exert a pervasive moral pressure against illustrating it. Male-male sex was not morally uplifting, merely tolerable, all the more unworthy of representation since it was relegated to a demimonde of prostitutes, slaves, bathhouses, and brothels. As for women, although they were less rigidly secluded than in Greece, they still labored under legal, social, and artistic restrictions that severely limited their self-expression. As Augustine hinted, like their Greek counterparts they had a private world of passionate affections, but lesbianism in Rome could never have produced a Sappho, and female eros is all but invisible in the work of male writers and artists.

One important avenue for homosexual subject matter ran through Greece. Cosmopolitan Roman patrons avidly collected Greek art, even importing Greek artists to work in Italy. When the supply of originals dried up, they commissioned reproductions of popular Greek "classics." Artists made every effort to assure the accuracy of marble copies, even shipping plaster casts of prestigious bronzes to Italy for the guidance of local craftsmen: a cast of Aristogiton's face from the *Tyrannicide Monument* was excavated in Naples, no doubt from a copyist's workshop. These artists also catered to their patrons' antiquarian tastes with new statues that worked free variations on Greek themes or eclectically mixed venerable motifs and styles.

As in Greece, the most prestigious category of art was monumental public works, both sacred and secular. Temple statues of the handsome male gods, though still understood as bisexual figures, seldom show their subjects performing any action, let alone an erotic one. A few interesting exceptions are

recorded: one Roman sanctuary featured a lost sculpture of the god Pan wrestling with his beloved Olympus, which according to Pliny held the title of the second most famous wrestling group in the world. Civic art commemorated epochal historical events, as in reliefs of military campaigns, and exemplary individuals, through portraiture celebrating philosophers, athletes, and government officials. Sexuality had little impact in this arena except for that of the emperors, whose private lives often had public consequences.

THE LOVES OF THE CAESARS

Most homosexual imagery, not coincidentally, survives from the imperial period. Augustus overturned the republic, declaring himself emperor in 27 B.C.E., and the new dictators, with vast resources at their disposal, enthusiastically advertised their deeds and loves through public portraits, as well as commissioning erotic art for private enjoyment. Although many chroniclers exaggerated their accounts to suit their own moral and political agendas, they testify to an unmistakable drift away from the sober republican morality, which began to loosen as a tide of cosmopolitan influences and wealth flooded the realm with more temptations and more income to indulge them. By the beginning of the first century C.E., the strong taboo against passive men had eroded, and laws against sex with citizen boys were virtually ignored. Of the twelve early Caesars chronicled by Suetonius, only Claudius seems to have been exclusively heterosexual; Augustus' uncle, Julius Caesar, was jokingly described as "every woman's husband and every man's wife." This flamboyant and often unsavory crew violated every norm of respectable sexual behavior with both sexes. Before burning Rome, the adulterous Nero had been publicly married to a youth named Sporus in a common ceremony aping a heterosexual wedding, and later became the passive partner of another boy; Galba submitted to men his own age; and Gaius dressed effeminately. The ridicule and invective hurled against this omnivorous sexual repertory by Juvenal, Martial, and Horace remained a vocal countercurrent, but these moralists' need to rail against it so repeatedly suggests how little anyone listened. Sex became just one of many outlets for an increasingly materialistic and debauched society, familiar from such scathing satires as Petronius' *Satyricon*, of Federico Fellini film fame.

The extensive, homoerotically tinged patronage of Augustus' stepson Tiberius (r. 14–37 C.E.) was motivated in part by filial piety: in the temple he erected to his father in the new Roman forum, Tiberius dedicated a statue of Apollo's beloved Hyacinthus, which had so captivated Augustus that he hauled it back from Alexandria after defeating Cleopatra. But over time Tiberius' own personal desires got the upper hand. Pliny tells us that "although at the beginning of his reign Tiberius kept some control of himself," he lost it when tempted by a copy of Lysippus' *Apoxyomenos*, a nude athlete scraping off

the oil used to highlight muscles, which had been set up in one of the capital's public bathhouses. He ordered the sculpture removed to his own bedroom, which set off such a public outcry that "the emperor, although he had fallen quite in love with the statue, had to restore it." Tiberius consoled himself by installing a collection of erotic paintings, sculptures, and sex manuals in a special suite at his pleasure retreat on the island of Capri, in part as on-the-job training for his staff of female prostitutes and the fleets of boys trained to kiss his groin and suck his penis in the swimming pool.

A touching exception to all this imperial depravity was the sober, intellectual Hadrian (r. 117–38 B.C.E.), whose beloved Antinous, a moody but devoted beauty from Bithynia, drowned in the Nile during their visit to Egypt in 130. Otherwise so different from his sleazy predecessors, Hadrian shared their tendency to royal excess. Within days of the eighteen-year-old's death, devastating grief impelled Hadrian to deify him (as were the emperors themselves after death), establish a cult to honor his memory, and found a memorial city, Antinoopolis, at the tragic riverbank site. For the rest of his life, he ordered endless portrait statues of the handsome deity to be erected, in the awestruck words of the historian Dio Cassius, "throughout what one might almost call the entire inhabited world."

These memorials wrought infinite variations on the ancient Greek theme of the androgynous ephebe. The colossal example in figure 1.22, more than eleven feet in height, endows an unmistakable portrait, characterized by the pouting mouth, with a pose and attributes recalling the youthful Bacchus: a grapevine wreath and a thyrsis, the pinecone-tipped weapon of his Maenads. The statue's retrospective symbolism and style are part of a pattern: Hadrian devoured Hellenic art and ideas, setting a fashion trend for centuries by growing a beard in emulation of Greek philosophers. He also wrote poetry and dabbled in the visual arts, probably even designing some buildings such as his famous country retreat at Tivoli; figure 1.22 was originally displayed there, marking the villa as a "gay space," at least in the emperor's own mournful eyes. The classical revival he promoted in art—the first of many historical appeals to the arcadian Greeks—was motivated by his nostalgic yearning to recapture an Edenic era when wisdom and beauty were still valued over mundane economic and political pursuits, and a love such as his for Antinous could claim a nobler justification.

Classicizing works had begun to appear in the

1.22. Roman, **Antinous,** after 130 C.E. (marble).

time of Augustus, as the emperors sought to legitimize themselves by association with age-old authority. The marble sculpture known as the *Ildefonso Group* (Madrid, Prado), which depicts an athletic yet still boyish couple leaning together in a casual embrace, typifies this taste. The affectionate youths of nearly the same age could represent Orestes and Pylades, or perhaps Castor and Pollux, twin sons of the nymph Leda. In Greek, "brother" could also mean "lover," and this inseparable pair, later transformed into the constellation Gemini, came the closest in all mythology to the primeval couple—two male figures joined in one body, later halved—that Plato consecrated as the ancestor of all men who love other men. In a further display of Roman casualness about iconography, the head of one figure was replaced by a portrait of Antinous— perhaps by the bereaved Hadrian himself, who then owned the gardens where the sculpture was later excavated. Remodeled into yet another commemoration of the emperor's lost love, it fittingly associates his mortal passion with an immortal archetype of mutual devotion.

AT HOME AND IN THE THEATER

So far we have been looking at the aristocratic and largely public sector. Compared to our narrow social slice of Greek artifacts, however, the Romans left a broader cross section of their material culture, permitting us to glimpse the differences between the public and private realms as well as between social classes. While public art offered only limited scope for homosexuality, somewhat more of it appears in the private sphere, which ranged downward from the palaces of the emperors to wealthy and middle-class homes and villas. Private patrons covered the walls of their residences with elaborate fresco cycles and the floors with intricate scenes in mosaic tile, filled their gardens with statuary and their cupboards with decorative arts—lamps, mirrors, jewelry, textiles—illustrating themes from myth, daily reality, and other genres that were often erotic. A uniquely sharp and detailed snapshot of this domestic opulence was taken at the thriving ports of Pompeii and Herculaneum near Naples, miraculously preserved when the disastrous eruption of Mount Vesuvius in 79 C.E. buried both cities under a layer of ash and lava that was not penetrated until the eighteenth century. Alongside upper- and middle-class patronage sits a public and semipublic architecture of shops, bathhouses, and bordellos hinting at the erotic and artistic life among more modest classes.

Upper-class domestic Pompeii was plastered with graphic depictions of actual lovemaking, all of them heterosexual; the few scenes that treat homoeroticism are mythology rather than journalism, and sex itself is often implicit or underplayed. This asymmetry is surprising, since in other respects male and female love objects were treated as interchangeable: in a fresco of Ganymede and the eagle from the House of Meleager, Ganymede's seated pose, with a

staff in hand, exactly mirrors a figure of Venus from the nearby House of Mars and Venus. Several other works draw on familiar homosexual themes from the Dionysian or pastoral realm, such as Narcissus gazing at his reflection in a pool. Although this fable, in which the handsome but cold youth is so captivated by his own image that he kills himself for unrequited love, is mainly a warning against autoerotic self-absorption, it takes for granted that one young man could be bewitched by another.

One well-preserved wall painting (fig. 1.23) depicts Hermaphroditus no longer as the idealized Hellenistic nuptial god but in a more playful and comic incarnation. In a scene popular since Hellenistic times, he/she is being awakened by the proverbially lusty Pan, who recoils in shock when the bedclothes reveal that his planned conquest is not quite the woman he had been anticipating. Pan was of course bisexual, so the comedy of mistaken identity implies no disapproval: he's not disgusted, merely surprised.

Observing this episode at the far right of the scene is a statue of Priapus, another sexualized deity associated with the Bacchic entourage, who occupied a favored niche in Roman architecture. Son of Venus and Bacchus, and thus a half-brother of Hermaphroditus, the satyrlike Priapus epitomized unbridled and crudely aggressive sexuality, typified by his outsize and insatiable phallus (source of the medical term for chronic erection, "priapism"). A real version of this painted statue probably stood just outside the room containing the fresco: just as the Greeks placed a herm at the door, so the Romans set wooden images of Priapus in their gardens to ward off trespassers. They often attached poems

1.23. **Pan Uncovering Hermaphroditus,** ca. 50–79 C.E. Pompeii, House of the Dioscuri (fresco).

to the statues, written as if the god himself were threatening male and female intruders alike to rape them anally—"This scepter will go into the guts of a thief all the way up to my crotch"—or force the men to perform fellatio, that most humiliating of sexual acts. His coarsely hostile language links male sexuality and brutal aggression much like modern English, where "fucking someone" may describe either a sex act or an act of vengeful damage. Encolpius, the hapless main character in Petronius' *Satyricon*, sets out on his bawdy misadventures to escape the anger of Priapus, making this nasty god the driving force behind what might be called the first gay novel.

Fantasies of gruff masculinity provoked lighthearted laughter, but Roman humor could turn derisive when faced with real-life effeminacy, which Roman society mocked much more severely than the Greeks—probably because they saw so much more of it. In Athens, the active homosexuality of the mature *erastes* was so widely diffused within pederastic bisexuality that it barely registered as an "orientation" in the modern sense, but the Latin sexual vocabulary acknowledged that some adult men had an identifying predilection for submitting to other men. *Cinaedus*, roughly corresponding to "faggot," was not a complimentary term; Plutarch asserted tartly that "those who enjoy playing the passive role we treat as the lowest of the low, and we have not the slightest degree of respect or affection for them." As in Greece, fellatio was the exclusive province of wild creatures like satyrs, who live outside the bounds of propriety; decorative sculptures on erotic themes included scenes like a lost relief copied by a follower of the Renaissance artist Squarcione, in which a circle of the woolly beasts look on excitedly while one of them bends to suck his seated playmate's penis.

In contrast to such humorous vulgarity, a Pompeiian domestic fresco showing Orpheus about to be torn apart by the Maenads (color plate 2) indicates the persistence of more uplifting links between homosexuality, prophecy, death, and spiritual rebirth first depicted in the tombs of Tarquinia and Paestum. As the musical enchanter who had visited Hades and lived to tell about it, Orpheus was believed to possess a mystical wisdom expressed in oracular hymns that continued to flow from his mouth even after the Maenads, avenging his turn to homosexuality, severed his head. Elevated to a demigod, he was adopted as patron of the enigmatic religious societies known as the Orphic cults, dedicated to achieving spiritual enlightenment through secret rituals based on his recorded oracles, illustrated in the celebrated frescoes of another nearby building, the so-called Villa of the Mysteries.

Romans loved the theater, which offered another popular subject for domestic frescoes like color plate 3, showing the pivotal confrontation scene from Euripides' drama *Iphigenia in Tauris*. Extending the Greek tradition, Romans presented plays in large outdoor amphitheaters; the elaborate though unstructurally lacy architectural setting of this painted scene resembles the *scenae frons*, or tiered backdrop, of the typical stage. Within it the cast includes the

king of Tauris looking on from the left as Iphigenia, in the central pavilion, interrogates the bound captives Orestes and Pylades on the right. Euripides' play brings to a close the bloody and histrionic saga of the family of Agamemnon and Clytemnestra; it recounts the adventures of their son, Orestes, when, driven mad by the Furies for having slain his mother, he sought release from their curse in a pilgrimage to Tauris with his beloved companion. There, in the land of the Amazons, they were captured and brought before the priestess of a local temple. Unbeknownst to both parties, she is Orestes' own sister, Iphigenia, whom Diana had earlier rescued from a sacrificial death at her father's hand, spiriting her off to serve, with poetic justice, in a cult that sacrificed male intruders.

In the course of grilling her prospective victims, Iphigenia is deeply moved when both offer to die in place of the other. The couple's bond was not traditionally pederastic since, swearing an oath of eternal fidelity before the gods, they "sailed through life together as though in one boat" (Lucian); all the same, Greek teachers held them up to young boys as a shining ideal of selfless affection. They were as popular in art as in school: the poses of the lovers in this fresco turn up in other Pompeiian paintings, probably derived from the pattern books that Roman artists used for standard subjects, suggesting that these widespread role models were in sufficient demand to merit a kind of mass production. Appropriately, their tale has a happy ending: discovering their true identity, Iphigenia helps them escape and sails home with them.

In Roman as in Greek theater, all the roles were taken by male actors. Satirical literary attacks reveal that this gender-crossing lit the stage with a homosexual tinge, part of the already ancient assumption that entertainers were not much different from prostitutes. Artistically, however, the sexual ambiguities and social tensions of this artificial situation were simply ignored: the painted Iphigenia looks like a real woman, and whatever desires her transvestite impersonator incited were, like all socially marginal worlds, deliberately kept "offstage" by Roman painters.

SEX AT THE MARGINS: WORKERS AND WOMEN

The sexual and artistic life of lesser citizens unfolded in humbler settings. For laborers and shopkeepers who could afford neither the domestic decoration of the upper classes nor their expedient of buying a slave for sexual services, sex was available in the public streets, barbershops, bathhouses, and brothels. The plainest form of plebeian self-expression was the graffiti they scrawled on the walls of these buildings, boasting indiscriminately of heterosexual and homosexual prowess or mocking those who satisfied it. A few of these included a visual image, like the scratched outline of an ostrich on a gladiatorial training center in Rome, with the lewdly suggestive caption, "Once you could not di-

gest cucumbers; now you take them all the way in." John Clarke has identified a couple of more ambitious wall paintings that reveal erotic life among these anonymous urbanites.

A panoramic mural in the dressing room of the Suburban Baths outside the city walls of Pompeii, for example, depicts a series of numbered cubicles, over each of which hovers a scene of frankly human, not mythological, lovemaking meant to be read as if it were taking place within the private booth below. Amid a variety of actions, mostly heterosexual, one group depicts a kneeling man about to enter a woman while another man kneeling behind him has entered him. The numerals accompanying each scenario may refer viewers to the relevant chapters of ancient sex manuals; although these books are lost, other sources list at least nine. Significantly, their authors were female: although women could not participate in "high" Latin literature, they seem to have found some opportunity at the margins of official culture. Not only was their literary genre of questionable respectability, but the bathhouse where such writing was illustrated was itself located both physically and economically at the margins of society: like many such paintings, it was brushed quickly onto dry plaster, a cheaper but less durable technique than the true fresco of wealthier homes.

Another, nearly ruined, fresco from Ostia, the bustling port city near Rome, dominates an unusually large suite in an apartment building that was remodeled between 184 and 192 C.E., perhaps to serve as an inn for visiting merchants with homosexual tastes. The edifice is known as the House of Jupiter and Ganymede after the central fresco of its largest room, which represents the king of the gods reaching from his throne to chuck the nude shepherd's chin in the familiar seduction gesture; in the background sits a female figure, relegated in the picture, as in the customers' priorities, to a secondary position. The possibility that this paramount symbol of homosexual eros presided over a hotel-cum-brothel is suggested by graffiti on walls throughout the establishment, which testify to various male couples and threesomes and include drawings of single figures and dueling gladiators. The house's low-rent atmosphere is confirmed by its decoration's slapdash technique.

Modest frescoes like these suggest that Rome spawned the rudiments of a homosexual subculture, organized for men with distinct sexual preferences that, at least in the case of the ridiculed cinaedus, marked them as a recognizable personality type and market. The traveling salesmen who patronized the Ganymede hotel were not poor, though they were perhaps accustomed to somewhat rough-and-ready accommodations while "on the road" and in search of male diversion. Less wealthy stay-at-homes found sexual company at the theater and the baths. Some of these networks were formally recognized: the Roman calendar featured a public holiday for male prostitutes, back-to-back with an equivalent day for females, and both sexes paid taxes on their profits.

The erotic functions and decor of Roman buildings, from homes to bordellos, were complemented by the manifold decorative arts used inside them—which, like architecture and painting, varied in materials and craftsmanship to suit different pocketbooks. Wealthy patrons commissioned silver or gold drinking vessels and serving pieces, illustrating many kinds of scenes, sometimes erotic, to amuse banquet guests who might soon imitate the actions portrayed. The most striking male example is the six-inch-high, oval-shaped silver flagon known as the *Warren Cup* (fig. 1.24), a luxury object for a provincial home under the early empire. As in sculpture of the time, the cup's Augustan figure style and Polyclitan proportions deliberately cloak the present in the venerable mantle of classical Athens.

Its imagery, however, is blatantly contemporary: the cup's two sides each depict a domestic interior, complete with draperies and architectural details, in which a male couple is making love. On one side, a young adult steadies himself with a trapezelike strap while settling gymnastically onto the penis of a bearded, mature man; on the other, a youth who is the same age as the younger partner in the first scene reverses role to penetrate a younger adolescent from behind. (In contrast to Greek painting, where intercrural intercourse is most common, Roman vases show almost exclusively

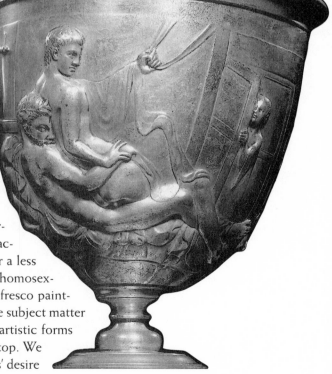

1.24. Roman, **The Warren Cup,** 1st century C.E. (silver).

anal intercourse.) The boy peeking at the first couple around the half-open door of their room might suggest an attendant in an establishment like the Ostia hotel, but otherwise there is little to indicate the social context. Theoretically, at least, male youths of citizen status were still off-limits sexually, so either the younger partners are socially inferior, or the artist has made the unusual choice, for a Roman, to show real people breaking a taboo. In either case, the observer neither leers nor sneers: all four participants are rendered with a beauty of form and finely detailed craftsmanship that elevate male eros to an idealized dignity.

Similar vessels in unpainted clay, called Arretine ware after the Italian center of their manufacture, Arezzo, were mass-produced from molds for a less affluent market; some alternate heterosexual and homosexual erotic scenes around the same piece. As with fresco painting, these modest cups and bowls often imitate the subject matter and figure style of luxury works, indicating how artistic forms and perhaps social values trickled down from the top. We do not know whether the Augustan middle classes' desire

to ape their betters extended to an increase in bisexual behavior, but they certainly developed a taste for images of it.

Textiles, another highly developed decorative art, were too fragile to survive except in literary references. In the Romans' national epic, *The Aeneid*, the poet Virgil imagines a remarkable needlework created at the time of the Trojan War. The poem chronicles the destiny of Aeneas, who fled burning Troy to found Rome; along the way, he stages funeral games among his troops and rewards one winner with a purple cloak embroidered in gold. The fabric arts were greatly esteemed, and such a richly worked prize represented, as Virgil himself put it, "special honors." It was stitched with an illustration of the rape of Ganymede, an appropriate nod to the religious auspices of the competition as well as a flattering comparison of the victor to the all-conquering king of the gods. With an eye for drama and anecdotal detail, Virgil envisions "the young prince starting the fleet stags, casting his javelins . . . and then seized and carried aloft in hooked talons by the bird which is armor-bearer to Jupiter, and which had swooped down from Mount Ida to capture him; there were the aged tutors, vainly stretching their hands toward the sky, and watch-dogs too, barking after the prince and spending their fury on the air." No doubt there were real embroidered images similar to this, all now lost, that wove homosexual eros into the literal as well as symbolic fabric of everyday life.

Lesbian imagery is all but unknown in Roman art. The myths surrounding Diana and her entourage offered some scope for depicting female intimacy, but artistic treatments always stressed a male viewpoint. Jupiter's seduction of Diana's faithful acolyte Callisto, for which he cross-dressed to impersonate Diana herself, was illustrated on a silver cup, but as it is only one among a series of otherwise more obviously heterosexual amours, its homoerotic implication (from Callisto's standpoint) is muted. Illustrations of Diana and Actaeon appeared as late as the third or fourth century in provincial floor mosaics, emphasizing the grisly fate of the male hunter who, stumbling upon the goddess and her nymphs bathing together, was changed into a stag for his intrusion and torn apart by his own hounds. Some versions suggest that the myth also provided a pretext to represent a bevy of frolicking nude women for the sensuous delight of a male viewer. On balance, though, the prospect of women together independent of men seems to have excited more fear than attraction.

THE PAGAN WORLD: DEATH AND AFTERLIFE

Homosexual subjects persisted in Roman art at least through the end of the second century, the period of the Alexander-Hephaestion relief and the Ostia hotel. But by then the intellectual and moral impulses and the social and political structures that had created and sustained classical homosexuality, as well as the mythic, literary, and visual languages through which it was expressed,

were all on the defensive. Ganymede's flight on the wings of Jupiter, once the preeminent symbol of the ecstatic, uplifting passion of both the body and the mind, was now as likely to stand for ascent of the immortal soul, on late antique sarcophagi, or of the body politic, on coins where Antoninus Pius rides the eagle to his own deification.

Early in the fourth century, the emperor Constantine declared the mushrooming cult of Christianity the official state religion, issued the first laws against homosexuality as such, and withdrew his capital to Constantinople, abandoning increasingly beleaguered western Europe to decline and conquest. His successor in the eastern remnant of the empire, Justinian, codified the same religious prohibitions for the Byzantine Orthodox world—ironically, in the Greek tongue of Plato and Sappho. These rulers set the stage for the next chapter in our story, the Christian Middle Ages, in which attitudes toward homosexuality grew far more hostile and images of it far scarcer: later Byzantines, attempting to obliterate what they deplored as an immoral influence, successfully burned all but fragments of Sappho's poetic legacy.

It would be unfair to lay all the blame for this about-face at the feet of the new religion. The pagan world already had its own ascetic traditions, from Plato's late disillusionment to Rome's Stoic Seneca. For all their hedonism, the Romans remained at heart moralistic, willing to tolerate sexual transgressions (and their representation) only around the edges of a core (admittedly fraying) of family, male power, and decency. As early Christianity, a persecuted minority seeking converts, worked out its own sexual mores, the new religion may have accommodated its neighbors as much as it influenced them.

All the same, this ambiguity should not overshadow the profound differences in underlying attitudes. When pagan law and custom limited homosexual behavior or its artistic expression, their motivations were less metaphysical than pragmatic—or, in the case of women, chauvinistic. Ironically, we know about lesbianism among Roman females not from their pagan male contemporaries, who blandly considered it beneath notice, but from the early Christians in their midst, starting with the apostle Paul, who couldn't help acknowledging it in order to preach against it. To the ancients, as with any other human behavior, there was "good homosexuality" and "bad homosexuality." The latter resulted when individual participants broke wider taboos about age, class, or effeminacy, and was best kept out of sight. But "good" homosexuality, exemplified by brave Harmodius and Aristogiton or loyal Antinous, deserved its public monuments as much as any other exemplary virtue.

The guilt-free acceptance and institutionalized dignity that classical antiquity accorded to at least the "higher" forms of homosexuality have persisted as a nostalgic symbol of lost arcadian ideals in nearly every later Western civilization less comfortable with what we still refer to as "Greek love." And if, as the late gay historian John Boswell put it, "Roman society is universally regarded as the cultural matrix of Western Europe," one cell in that matrix is ho-

mosexuality. Together, Greek and Roman history, myth, and images have provided an inexhaustible storehouse for later artists and apologists of love between men—and, to a lesser degree, between women. Even when the cultural treasury that minted that heritage was under prolonged siege, as we shall see in the next chapter, the assailants could not hope to undermine its influence without confronting antiquity on its own ground.

THE MIDDLE AGES: DOGMA VERSUS DESIRE

S ometime in the ninth century, a lovelorn churchman in the Italian city of Verona put into verse his bittersweet longing for a beautiful boy whom a rival lover had lured away from him:

> *O you wondrous apparition of Venus,*
> *Not one part of whose substance is less than perfect!*

Flare-ups of such fervent poetry, as well as passionate love letters and even lighthearted humor, throughout the medieval West bear eloquent witness that the flame of homosexual desire continued to burn during the millennium between the fall of Rome and the Renaissance. But the bereft cleric's term for his beloved aptly conveys the difficulties that hemmed in homosexual behavior and visual expression. "Apparition" translates the Latin *idolum,* derived from Greek *eidolon;* both mean "image," but an evanescent one—the fragile specter of an elusive ideal, as ungraspable as the smoke from a flickering candle.

The Latin term "medieval," from the words for "middle period," might seem neutrally chronological, but it carried from the first a derogatory overtone of barbaric ignorance and ascetic repression. While unfairly simplifying a long and eventful timespan and its richly varied cultures, the label sticks. Artistic images of homosexuality were generally far scarcer than in classical times, and what little did appear was often hostile and of minor importance. This near-invisibility hardly meant that passionate love between people of the same sex was unknown or universally condemned, nor did it stave off a flood of celebratory literature. All the same, for homosexuality, especially among women, and for its acknowledgment in visual images, in both quantity and content this period was literally the Dark Ages.

Two climatic shifts in social life contributed to the visual drought: shrinking cities and the mushrooming Christian church. By the time invading Goths forced the last emperor to abdicate in 476 C.E.—burying a thousand years of Roman rule around the western Mediterranean—the urban societies that had flourished in the great metropolises of pagan antiquity already had one foot in their grave. Their collapse knocked the foundations out from under tra-

ditional patterns of homosexuality as well as its networks of artistic patronage.

Constantine, who legalized Christianity in the early fourth century, founded a new eastern capital, renamed after himself (now Istanbul). Although the Greek-speaking Byzantine Empire survived there until the fifteenth century, this remnant of Rome pulled up the drawbridges and abandoned the Latin-speaking western territories. Outside Constantinople, while pagan influence lived on in languages, literature, and customs, the state did not. From the fourth to the tenth centuries, cosmopolitan life gave way to rural farming villages and feudal isolation. The underworld of bathhouses and prostitutes shrank to the point where, if it existed at all anymore, it became invisible to historians—and of little concern to weak civil authorities. Small-town life combined with the difficulty of travel deprived the homosexually inclined of the numbers and anonymity needed even to meet one another, still less to assemble an audience for the arts. Western commentators from rural areas, like Saint Jerome, dismissed homosexuality as a rare oddity; only in such eastern cities as Alexandria did moralists attack a social problem that seemed all too familiar.

Over the same centuries, religion seized the lion's share of cultural power. In Byzantium, the church acted in tandem with the state; in the west, it dominated by default, taking over functions of the dwindling civil order, from land control to welfare and education. The bulk of art was produced under church patronage, and even private commissions tended to religious themes. Although the church did not always actively attack homosexuality, it never considered any form of eros fit for illustration. Where pagan art had long celebrated sexuality in myriad forms, Christianity looked away, focusing on heavenly rather than earthly rapture. When erotic themes are heard in medieval art, they are but a faint and intermittent obbligato to the period's swelling hymn of solemn spirituality and ineffable mysteries.

However loud the church's cultural resonance, medieval society could still hear the continuing counterpoint of pagan values and images, a tension that has remained fundamental in Western culture ever since. The two traditions had grown up together in late antiquity and could not be easily untangled. On one hand, the church shared its hostility to sexuality, and particularly homosexuality, with late Roman asceticism—also its misogyny, which deplored homosexuality for crossing gender boundaries. As in ancient times, lesbianism was known, but less reported than male homosexuality, perhaps because it flew beneath the radar of male authorities. On the other hand, the educated elite, who still spoke Latin, could read the lyrically passionate legacy of classical writers: Ovid, Horace, and Virgil were continuously quoted and widely imitated.

Christianity attempted to solve this dilemma by slotting all homosexual desire into two polarized pigeonholes: the classical ideal of *amicitia*, an intimate friendship now theoretically chaste, and *sodomia*, a shifting term condemning a

range of sexual sins. Beginning with the apostle Paul, theologians fixed love in the center of the moral universe but banished physical expression of that love to the outer darkness. About 400, Saint Augustine codified this dualistic opposition between earthly flesh and heavenly spirit, in which the merely material body ever tempted the immaterial soul. This attitude launched an attempt to censor or "correct" pagan myth in revealingly named books like the *Ovide moralisé,* or "Moralized Ovid."

The archetype of Christian opposition to sexuality was the biblical tale of two cities, Sodom and Gomorrah (Genesis 19), in which two angels visit Lot. When a crowd of men demand that Lot send these strangers out of his house so that "we may know them," Lot offers his daughters instead; enraged by the Sodomites' sins, God destroys their town with flaming rain. The plot suggests multiple offenses—heterosexual and homosexual, plus cruelty to guests; adding to the ambiguity, sodomy encompassed various nonprocreative acts, from bestiality to heterosexual anal intercourse. But even in Augustine's time the same-sex meaning stood out, and "sin of Sodom" gradually became the standard euphemism for male-male intercourse. Later theologians and lawmakers combined the biblical reference with a classical allusion that left their meaning unmistakable: in a poem written about 1150, the French cleric Bernard of Morlaix complained that "the law of Sodom obtains in a land that is teeming with Ganymedes."

Around the time that the theologian Peter Cantor wrote his treatise *On the Sodomitical Vice,* the tragic fate of Sodom was depicted in a mosaic decorating the cathedral at Monreale in Sicily (color plate 4)—a theme later repeated at Pisa and Canterbury. Designed about 1170 to 1190, Monreale's vast cycle was sponsored by the Norman kings, who adopted Byzantine art's elongated, stiff figures and the didactic device of written captions. At the right, virtuous Lot and his family are fleeing their hometown, which is shown at the left engulfed by fire and brimstone as divine retribution; Lot's wife, who disobeyed God's command not to stare at the carnage, stands in the center, transformed into salt. Cantor interpreted her fate as a sign of the divine will to obliterate even the sight of such forbidden acts: "For just one look back at Sodom, Lot's wife was changed into a pillar of salt, as if the Lord were saying, 'I wish that no memory of this crime should remain, no reminder, no trace of its enormity.' " This belief in the danger of gazing on sinfulness had a chilling effect on art. The mosaic depicts the horrifying blaze and the disobedient glance, but not sex itself: the sinners are seen as charred skeletons, not in flagrante delicto. To illustrate the participants' own viewpoint, to evoke even a trace of the potential for delight, would have been considered "flagrant." Homosexuality was not only morally unspeakable, but artistically "un-image-inable."

Despite such aesthetic policing, neither homosexual emotion nor behavior was unknown. Like classical antiquity, medieval society was deeply homosocial: it rested on, and glorified, intense emotional bonds between men

and, less widely, between women, which remained a powerful ideal both secular and sacred. Politically, feudal lords and their vassals were linked in a chain of loyalties and personal support, which also bound knight to knight in devoted comradeship, all ennobled by the code of chaste military honor known as chivalry. The church extended this ideal to monastics of both sexes, who lived together for life in segregated, celibate communities sworn to a fraternal devotion modeled on the love of John, the "beloved disciple," for Jesus—the paragon of both human *amicitia* and the passionate love of mortal for God.

In real life, however, medieval men and women found it as difficult as frail mortals anywhere to toe the line between high ideals and everyday temptations. No class or social group was immune from suspicions of sodomy, and moralists inveighed against it with a ferocity that suggests they were not just preaching to the converted. The two most notorious dens of iniquity were the castle and the church. Even when not thrown together in the brotherhood of combat, the nobility had the leisure and wealth to indulge any and all appetites; and Saint Basil admitted in the fourth century that homosexuality was a problem among monks.

However, both moral fervor and punishment varied considerably, going through three broad phases. During the decline and disorder that prevailed in the West from the fall of Rome until the time of Charlemagne—early medieval times, which most deserve the epithet "Dark Ages"—homosexuality was seldom noted or represented and, while officially condemned, tacitly tolerated. By the year 1000, stability and prosperity had rebounded to a point where we can once again glimpse homosexual networks in the burgeoning cities, and a flourishing love literature, much of it written by clerics in the great intellectual centers; images of homosexuality in Romanesque art, though negative, indicate that it was a matter for occasional concern. By the beginning of the thirteenth century, this increasing visible subculture collided with a widespread and unprecedented campaign by both church and state to assert greater control over individual lives and enforce conformity, including a stricter code of sexual morality. Only then did sodomy become *the* unnatural vice, one target of a program of anathema and repression aimed at deviant minorities, from heretics and witches to Jews. The thirteenth to fifteenth centuries produced more images of homoeroticism than either earlier phase, both hostile propaganda against sodomy and presentations of a sublimated and spiritualized alternative.

The scanty homosexual imagery of this period almost never occupied center stage in monuments of high culture; when acknowledged at all, sodomy was relegated to the margins, both artistically and geographically. Visually, it was tucked away in the grotesque miniatures decorating the borders of illustrated manuscripts (fig. 2.7) and in minor features of church architecture and furnishings, such as sculptural corbels, choir stalls, and column capitals (fig. 2.2). Geographically, Europeans felt surrounded by sodomy: it was rife among

their hated and feared Islamic neighbors in Spain, Africa, and the Near East, who celebrated boy-love in a venerable literary tradition, and among the Germanic tribes to the north. Socially, it loomed along the local frontier of nonconformist belief that the later Middle Ages strove so vehemently to stamp out.

LATE ROME, EARLY BYZANTIUM, DARK AGES: 323–1000

As the western empire crumbled, Constantine converted to Christianity on his deathbed in 337. Succeeding emperors codified the hostility of the new state religion toward sexual deviance in a series of increasingly draconian laws—although there is little evidence they were enforced. At first, the law took on only the passive partner, traditionally mocked by pagans. In 342, Constantius and Constans sentenced such men, whom they labeled "infamous," to "exquisite punishment," probably castration; in 390, Theodosius decreed that passives who prostituted themselves deserved burning, a penalty later extended to those who did it for pleasure rather than money. The Byzantine emperor Justinian tightened the noose still further, outlawing all male prostitution and, finally, condemning both partners in any homosexual act to death.

The theological underpinnings of this sexual ethic dated back to Saint Paul's condemnation of men who, "leaving the natural use of the woman, burned in their lust toward one another" (Romans 1:26), and were elaborated by Saint Augustine, Saint Jerome, and other early church fathers appalled at pagan libertinism. Their disgust at homosexuality incorporated the ancients' misogynistic distaste for gender inversion within a comprehensive attack on all nonmarital sex. To Augustine, whose shadow looms longest over the sexual attitudes of the Christian West, intercourse was inherently sinful, and its only justification was children. Heterosexual wedlock was the only acceptable outlet, and even there he frowned on overindulgence. In a popular manual of moral precepts, the *Speculum doctrinale*, Vincent of Beauvais cited both Pythagoras and Jerome to support his dictum, "Too much love for one's own wife is shameful."

Bestiaries, or encyclopedias of animal lore, provided a supposedly scientific basis for condemning sexual variety. These perennially popular books, though often wildly fanciful, drew on authoritative classical writers such as Aristotle and Pliny, who described the unusual sexual traits of the hare or the weasel, and on the church fathers who associated these freakish deviations with homosexuality. Particularly heinous was the hyena, which was believed to change sex, growing alternating genitalia once a year—a kind of hermaphrodite, whose fluid gender aroused deep anxiety.

A twelfth-century manuscript of one of the oldest and frequently copied

2.1. **Two Hyenas Embracing.**
12th century (manuscript
illustration, **Physiologus**).

zoological texts, the *Physiologus*, illustrates a pair of hyenas embracing (fig. 2.1). The lesson is clear: Not only are men who indulge their desire for other men animalistic in their uncontrolled lust, but those who "turn themselves into women" spurn their husbandly role. As Bernard of Morlaix complained, "The fires of Sodom flicker around us . . . marriage is rejected and virtue despised . . . man forgets manhood to be like the hyena." Another *Physiologus* manuscript accompanies the entry for the hyena by a rendering of Lot and the angels of Sodom, tangling scientific and biblical metaphors together in a knot of disapproval.

Unraveling this knot exposes a psychological thread motivating medieval homophobia: dread of physical destruction. Like the anomalous hyena, the "sin of Sodom" was increasingly also condemned as "against nature." Strictly speaking, anything that occurs in nature is "natural"; but theologians were not referring to the material universe, but rather the moral "nature" or "essence" of that world—which, since it was made and controlled by God, they held to be saturated with divine purpose. As with Sodom's brimstone, the very substance of earth and sky could and would logically "strike back" to reestablish the stable order disrupted by unnatural behavior, threatening not just individual sinners but their entire community. Justinian invoked the same fear in his legislation decreeing death by burning for homosexuality, in effect anticipating God's punishment lest this monstrosity, which he also labels a disease, "may provoke the good God to anger and bring ruin upon us all."

Lesbian sexuality was equally familiar, though less menacing. Saint Paul attacked "vile affections" among women before those of men; and Augustine, who knew the bisexual demimonde from his wanton youth before conversion, condemned "the things which shameless women do even to other women," specifically accusing maidens, nuns, wives, and widows. But later churchmen paid scant attention: lesbianism was not even listed in penitentials (confessors' handbooks suggesting penances for sins) until late in the seventh century, and penalties were generally less severe. What men do simply mattered more, since (as Augustine put it) "the body of a man is as superior to that of a woman as the soul is to the body."

The only illustrations of same-sex intimacy in this period are religious subjects where the erotic is present, if at all, by implication. The earliest examples are Byzantine devotional pictures of Saints Sergius and Bacchus, Roman soldiers martyred around the year 300. Icons showing the two together were painted within a century of their death, and by the 600s the couple enjoyed a

huge cult following in the eastern (later Orthodox) church. Their ambiguous fusion of classical passion and modern faith appealed to Byzantine culture, where an urban court preserved pagan institutions and where, despite Justinian's punitive laws, reports of homosexuality were widespread. The church even sanctioned a kind of homosexual marriage, suggesting that some worshippers, at least, would have viewed the twin saints as celestial paragons of their own earthly passion.

Sergius and Bacchus were the best known of several "paired saints"—mostly military men, but also women like Perpetua and Felicitas—whose mutual devotion epitomized the ideal of self-sacrifice. These couples, often illustrated in tender embrace, transposed into a Christian key the pagan theme of committed lovers like Harmodius and Aristogiton or the Theban Band, whose sworn brotherhood strengthened their willingness to die for a heroic cause. As the saints' biographer wrote, "Being as one in their love for Christ, they were also undivided from each other in the army of the world." When they refused to recant their beliefs, the emperor ordered Bacchus flogged to death, whereupon Sergius lamented his lost comrade as a "brother," a term then charged with sexual potential; later Bacchus appeared in a vision, prophesying that after Sergius' death he would receive Bacchus as a heavenly reward for his suffering.

The couple's intense bond was recognized as akin to marriage: in one icon (Kiev Museum) their twin halos are joined by Christ's head, which occupies the central position customarily assigned to the matron of honor or best man at Roman weddings. In turn, the blessing of Sergius and Bacchus was invoked in a religious ceremony frequently performed throughout the Middle Ages, usually in Greek, to formalize a same-sex union. This ceremony, which closely paralleled contemporary heterosexual nuptials, joined two men (less often, two women) in a sacred bond of mutual affection and support, after which they would set up house and share their lives together.

The historian John Boswell unearthed dozens of texts for these rites, which included binding the couple's right hands with a strip of cloth (as in the modern expression "tying the knot"), placing crowns over their heads (as Orthodox weddings still do), and a feast after the ritual to declare the union publicly. Gradually, like marriage, the liturgy was enriched with candles, communion, and a ceremonial kiss. The partnership thus solemnized was acceptable even at the pinnacle of society: color plate 5, illustrating a twelfth-century manuscript from Byzantine south Italy, depicts no less a personage than the ninth-century emperor Basil I. At the right, Basil and his beloved, John, are being united by a priest in a church; at left, John's mother hosts the postnuptial banquet, sitting between the men like Mary between Jesus and John.

The service asks God's grace that the couple may "love each other in joy all the days of their lives." But "love" retains a tantalizing ambiguity: Did these

rites establish merely a platonic fraternity, or did they tacitly sanction some physical relationship? On one hand, the ritual emphasizes the soul, not the body: the two are to be "joined together not by the bond of nature but by faith." Classical amicitia here takes on the same chaste homoeroticism that motivated the clergy: imitating Christ's love for his disciples. But it seems unlikely that such unions were only spiritual. All Christians were exhorted to brotherly love, so the ceremony must mark something more than ordinary fellowship—especially since it was forbidden to monks, perhaps because of their vows of celibacy. Such unions were considered the equivalent of marriage, at least in the general sense of sharing a life with a beloved partner; what private physical dimensions that sharing had, and how specific couples dealt with any conflict between official ideals and their own desires, is lost to us.

At about the time of the first recorded same-sex unions in the east, a similarly ambiguous conflation of spiritual and physical desire flared briefly in the west. In the year 800 the Frankish king Charlemagne attempted to revive a Christianized "Holy Roman Empire" with its capital at Aachen in Germany; his model was distant Byzantium, whose chronic political losses never tarnished its prestige as the direct heir of antiquity. Like other communities of learned clerics, Charlemagne's courtiers wrote lyrically about male friendships. In Latin letters and poems, their leader Alcuin poured out his ardent yearning to embrace and fondle both pupils and superiors. His images, full of quotes from the classical authors Charlemagne encouraged, evoke a nostalgic moment when succumbing to the ever-present temptation of pederasty, though an unseemly lapse of clerical vows, was an understandable and familiar peccadillo.

The boundary of the permissible, if not yet tightly patrolled, was already clearly marked: emotional attachment was enthroned inside, any physical expression of that love was beyond the pale. The carnal implications of same-sex unions must have troubled the medieval church, which eventually forbade them, but vestiges of such rites and customs lived on long afterward all across Europe. Between the eleventh and thirteenth centuries, the Greek ritual manuals were widely copied, and unions performed from Ukraine to Ireland. Revised versions of the ceremony appeared through the fifteenth century, and remarkably widespread accounts record that same-sex unions survived in Renaissance Italy until outlawed in the 1600s, and sporadically in the rural Balkans down to a hundred years ago. But unlike the emperor Basil, semiclandestine rustics could not afford to commemorate their lives in pictures.

A FIRST FLOWERING: THE ROMANESQUE ERA, 1000–1200

Between Charlemagne's time and the year 1000, western Europe dramatically recovered some of the social and economic ground lost over centuries of inva-

sion and anarchy. Food, wealth, and population expanded together, along with urbanization: some existing towns quintupled in size and many new ones were founded. Homosexuality was more widely reported among all classes of society—nobility, clergy, and commoners—and passionately expressed in literature. Moralists complained, but as yet the church took little action beyond occasionally representing sodomy in church sculptures as forbidden and grotesque.

Increasingly, the cities—where many prominent clerics lived, as bishops or educators at cathedral schools—began to rival the castle and monastery as centers of culture. Not since Roman times had cities offered the critical mass and freedom from nosy neighbors to develop homosocial networks. Moreover, once freed from feudal despotism, the secular urban authorities cultivated an atmosphere of liberty and toleration, turning a blind eye to the subculture of male prostitutes, bordellos, and taverns. By the twelfth century, London's stews were notorious, and French poetry alluded frequently to prostitution in Paris, Chartres, and Orléans; in 1270, the poet Guillot named the Rue Beaubourg in Paris as a favorite trysting place.

This thickening compost fertilized an unprecedented flowering of homoerotic poetry, mostly in Latin, between 1050 and 1150. Many authors were churchmen, from saints like Anselm to Marbod, bishop of Rennes (master of the cathedral school at Chartres) and his pupil Baudri de Bourgueil, a Benedictine abbot and archbishop. While much of their writing treats standard religious themes, a significant portion frankly celebrates love between men. Members of this loose network, conscious of their difference from the majority, shared their feelings in images drawn from classical and biblical precedents. They even argued their case against mainstream tastes: one recurrent topic was the duel of the sexes, a debate over their relative merits as lovers, with Ganymede often speaking for the desirability of men and Venus or Helen of Troy for women. The tone of these competitions was often jocular, and the homosexual apologist seldom defensive, as if readers accepted such rivalry as an inescapable fact of social life.

The burgeoning homosexual subculture produced much literature but little visual art, a discrepancy due to differences in patronage and audience. Poems are private and cheap: anyone who is literate can write them and circulate them discreetly among sympathetic readers. But painting and sculpture were costly and laborious, requiring collective workshops that functioned in the public eye. Even Paris, the largest western city, had only one-tenth the population of ancient Rome, so its sexual underworld still lacked the size, wealth, and social acceptance to commission any visual expression. Among traditional patrons, the church would not dignify such feelings, and wealthy nobles feared that advertising their personal passions would scar their reputation: English chroniclers imputed homosexuality to King William Rufus; his brother Robert Curthose, duke of Normandy; and Richard I the Lion-Hearted,

2.2. **Rape of Ganymede,** 1096–1137, Vézelay, Ste. Madeleine (column capital).

and denounced their suites of foppishly dressed boys. A few castles may have displayed tapestries such as the one depicting the rape of Ganymede imagined by Baudri de Bourgueil in his "vision" paying homage to the countess Adela of Blois; but the writer, who delighted in the same myths in his own private poetry, felt constrained in this more public forum to point out his moralistic condemnation of the subject.

In those rare cases where homosexual content was represented—a cluster of small sculptures from the period known as Romanesque, in the eleventh and twelfth centuries—it was confined to minor elements within large church projects, usually intended as criticism or at best as comic relief. Perhaps the best known of these carvings is in the French pilgrimage church of La Madeleine at Vézelay, built between 1096 and 1137, where the capital of one nave pillar (fig. 2.2) illustrates the rape of Ganymede with details taken from Virgil's *Aeneid*. The shepherd boy who appeared so often in poetry as the archetype of youthful nude beauty and homosexual desire is here shrouded in contemporary dress, flailing upside down in bug-eyed panic as he is seized by Jupiter's eagle, while his helpless tutors or parents at the left and his barking dog frantically protest.

This sculpture's attack on male-male sexuality exemplifies the ongoing transformation of classical myths into parables conveying Christian morals. Perhaps it constituted a warning to the resident monks against sodomy, since many reformers of the day, including Saint Peter Damian, expressed outrage over rampant clerical pederasty, especially the abuse of oblates (boys committed to the care of monks at an early age). Around the right flank of the carving, a devil looks on, identified in Damian's *Book of Gomorrah* (ca. 1051) as the instigator behind such lascivious transgressions. The creature's grimace, pulling the sides of its mouth with the fingers and sticking out its tongue, is one of a repertory of grotesque gestures, drawn from the biblical prophet Isaiah, that denoted sexual wickedness.

Alongside such condemnation of physical lust, the church continued to idealize amicitia, though as always some clerics blurred the line between pure and impure almost to disappearance. The Cistercian monk Aelred of Rievaulx, who traveled in libertine Anglo-French court circles, wrote two essays on male friendship for the brothers under his care. His *Speculum caritatis* (1142) praised passionate friendships between them and, unlike other abbots, he allowed monks to hold hands as a sign of affection. Borrowing justifications from classical literature as Alcuin had earlier, Aelred addressed his students by pet names from Virgil's homoerotic *Eclogues* and wrote a letter to a fellow churchman in which he yearned to "clutch the neck of your sweetness with the fingers of my desires," just as the eagle does to Ganymede. Classical myth remained a double-edged sword: the learned clerics who rewrote it to attack antique practices could not help spreading its original meanings with every stroke.

Other architectural sculptures of the eleventh and twelfth centuries, scattered across France and Spain, provide more graphic illustrations of homosexuality. In such northern Spanish hamlets as Santa Marta del Cerro and San Pedro de Cervatos, corbels (carved brackets along the upper edge of church walls) depict male couples performing sodomy. In southwestern France, the column capital of Vézelay is mirrored by other capitals at Sémelay, on which a male couple commit sodomy, and at La Chaize-le-Vicomte, which symbolizes the bestiality of such lust by a pair of copulating male monkeys. At Châteaumeillant, a sculptured capital depicts two bearded men embracing and kissing, one with his erect penis exposed; carved above them is the Latin caption *hac rusticani mixti*, which might loosely translate as "Look at these crazy peasants." And at Cahors, sodomy was among the sins depicted in the archivolt blocks carved over the doorways.

These often bizarre images are related to a larger family of sculptures that have long puzzled scholars. Romanesque churches from Ireland, England, and the Continent sport a panoply of grimacing and acrobatic men, women, and beasts, often with prominent genitalia or buttocks, performing an astoundingly inventive range of sexual and scatological acts. Best known is the sheelah-na-gig, a leering female spreading her legs apart to display her enlarged

and gaping vagina. Were these creatures mere comic relief, sermons against social evils, or subversive survivals of pagan deities? While they may indeed bring a smile to modern eyes, it seems most consistent with the vast cycles of moralizing sculptures covering these churches to read these minor elements, too, as an attempt to make sinners seem monstrously unappealing.

Another interpretation sees them in folkloric terms, as an "outsider" commentary by unlettered craftworkers who thumbed their noses at orthodox theology by sly references to pagan rites still practiced at the fringes of authority. In this view, the carvings are vestiges of pre-Christian matriarchal fertility cults that were positive toward sexuality in myriad forms. This "old religion," gradually driven underground by church condemnation of Diana worship, would have survived mainly among isolated country folk—as the Châteaumeillant capital labels them, "rusticani." If not an actual idol, a figure like the sheelah might have been a magical charm against danger, similar to the phallic Pan statues of ancient Rome. This theory is perhaps more an appealing "myth" than a historical reality; in any case, if such a tradition did persist, being rural and oral it is largely lost to the historical record.

But even the most faithful Christians saw or heard of homosexuality—especially those who, emboldened by the optimistic expansion and religious fervor of the time, traveled away from home to the distant borders of their own world. Many of the sculptures just discussed were produced for the international routes along which pious pilgrims trudged into southern France, over the Pyrenees, and across newly recaptured northern Spain to the shrine of the apostle James, or Santiago. In France they were entertained by local musicians, the troubadors, whose Provençal tongue sang often of same-sex love; once in Spain, they brushed against similar traditions in the neighboring Islamic zone. At the opposite end of Christendom's contested frontier, the Crusaders' repeated attempts to recapture the Holy Land also exposed them to the cosmopolitan sexuality proverbial in such cities as Baghdad. Reports from the First Crusade in 1096 attacked Muslim homosexuality; from their side, twelfth-century Islamic writers in Spain returned the volley by observing that Christian clergy were inordinately fond of boys. Desire could even leap the border: in the tenth century, the German nun Hroswitha repeated a report of a caliph of Cordoba, capital of Muslim Spain, who, "corrupted by the vice of the Sodomites," fell in love with a Christian youth.

Despite the Koran's disapproval of homosexuality, a long and rich literary tradition glorified the love of men for boys. The classical period of Arabic writing began in the eighth century with Abu Nuwas, who extolled the delicate beauty of boys by comparing them to a fawn or gazelle; parallel passions inflamed the Persian poetry of Sadi and Hafiz. Jewish authors, who flourished under the tolerant Muslims, wrote similar homoerotic verse in Hebrew, among them the well-known Judah Halevi. But the ban on graven images was still strong enough in both religions to prevent visual renderings of such passions.

1200–1400: CONFORMITY, REPRESSION, NEGATIVE IMAGES

Perhaps because sodomy had grown so visible, by the late 1100s the twin swords of church and state authority became obsessed with rooting out both sin and crime. Mounting theological pressure began with the church's third Lateran Council in 1179. Secular legislation matched the pace: in 1250 sodomy was still legal in most of Europe, but by 1300 a majority of new civil laws decreed the death penalty. Homoerotic poetry virtually disappeared, but the effect of such rules on sexual behavior is unclear; they set a moral standard, but prosecutions were limited to offenses that were flagrant or had political consequences. Art, too, was enlisted as a deterrent: ironically, this period of social repression created more images than before and depicted taboo behavior more frankly.

Sexual regulation was only one prong of a broad strategy through which both secular and ecclesiastical authorities, increasingly powerful and centralized, attempted to extend control over all aspects of their subjects' lives, enforcing conformity of both thought and deed. The Roman church codified numerous sexual offenses: in 1123 it formally demanded celibacy of the clergy, and went on to forbid divorce. Besides extending the ban on clerical sodomy to laypeople, the third Lateran Council outlawed the widespread Cathar heresy; in 1215 the fourth Council required every believer to make regular confession to a priest, a benchmark in surveillance not just of behavior, but even of imagination. Heretical beliefs were also the target of the Papal Inquisition, made permanent in 1233.

Pressures contributing to the crackdown on sodomy included the demographic needs of an expanding urban economy, which couldn't tolerate non-procreative sex; religious pietism, spearheaded by new orders of monks founded by the popular Saints Francis and Dominic; and political rivalry, especially the breakdown of feudalism as the towns outstripped the castles in importance. The urban middle and lower classes, championed by the preaching monks, adopted a more rigorous sexual code to distance themselves from a vice associated with the rural aristocracy and the church hierarchy. Nobles and clerics were suspect by their economic status: discussing the seven deadly sins, *Piers Plowman*, a long English poem of the later fourteenth century, classified sexual transgressions as a form of gluttony abetted by sloth, blaming "the awful catastrophe that came upon the Sodomites" on "laziness and abundant bread [which] fostered the worst sin," and pointing out that lechery was a particularly expensive vice, and only the richest could afford the sin against nature.

The single greatest religious force of this period was Saint Thomas Aquinas, whose *Summa theologica* reigned for centuries as the standard authority on Catholic moral theology. A member of the Dominicans, who ran the Inquisition, Aquinas typified the order's implacable aggression against heresy

and sin: he methodically and exhaustively codified the arguments against sodomy (as for all sins), ranking it second only to murder as "against nature." Inspired by this official hostility, zealous reformers deliberately tore out of several prayerbooks the pages containing the ancient rites of same-sex union; they even destroyed a strongly disapproving description of one such ceremony in the *Topography of Ireland* by Gerald of Wales (ca. 1200), which apparently included a drawing of the event.

Replacing the older view that sin was an individual failing in the face of universal temptations, church and state now scapegoated nonconformist groups, including sodomites, heretics, and witches, whose stigmas all overlapped. Infidels, attacked by the Crusades, headed the list; Jews were expelled from most western countries beginning with England in 1290. Some heretical sects may indeed have tolerated homosexuality or given women near equality with men: the French term *bougre*, originally referring to a heresy imported from Bulgaria, became the English *bugger*, or sodomite. Whatever the facts, the linguistic shift reveals the popular perception that such activities were multiple tentacles of a single threat: all were forms of treason, betraying the most sacred pillars of social order. Such violations were the work of the Devil, and if he could draw you to one, you might fall into the others.

In this siege mentality, the discreet silence of earlier art gave way to propagandistic works, which grew more frequent from the 1200s through the mid-1300s. Sometimes these images sought to offer uplifting examples of the chaste spiritual tradition, both religious and knightly, though such loves remained susceptible to a more physical reading. Far more often, the images were bluntly negative: where Peter Cantor had wished to blot out the very sight of sodomy, a more defensive century found it necessary to represent the forbidden act in order to specify its condemnation.

The permissible ideal of male intimacy was epitomized by Christ and Saint John the Evangelist, "the beloved disciple," who were paired in manuscript illuminations by the twelfth century and became popular in German sculpture after 1300 (fig. 2.3). This typical carving, perhaps illustrating the Last Supper, captures the poignant physical tenderness between an older contemplative Jesus, who wraps his arm about the young apostle, and the androgynous John,

2.3. German, **Christ and Saint John the Evangelist,** ca. 1320 (painted and gilded wood).

who rests his hand trustingly in his lord's while, as his own biblical account tells us, "leaning on Jesus' breast" (John 13:23, 21:20). John's gospel is unique in its deeply personal emphasis on love; his passionate devotion to Jesus prefigures the bond between the saintly comrades Sergius and Bacchus, and in fact John was commonly invoked along with them in the blessings read over same-sex unions.

Jesus and John symbolized spiritual amicitia everywhere in society, but especially in religious life. Sculptures like figure 2.3 often watched over the entrances of monasteries—where, as we have seen, spiritual and carnal love were not always neatly separated. Aelred invoked the intimacy of Jesus and John, which he called a "heavenly marriage," to justify love between monks, of which he wrote feelingly, "It is a great consolation in this life to have someone with whom you can rest in the sleep of peace, in the embrace of love, in the kiss of unity." Well aware that such effusions might imply sexual consequences, he went on, "Lest this sort of sacred love should seem improper, Jesus himself transfigured it" by allowing only John to lean upon his breast—where, as in the many images of this moment, "the virgin head was supported in the flowers of the virgin breast."

Apart from a few such biblical "role models," however, negative images of homosexual eros were far more common, especially in the vernacular writing that began to supplement Latin in France, Italy, and Geoffrey Chaucer's England. Ancient literature, both mythology and scripture, was translated and adapted with commentaries and illustrations meant to reinforce orthodox interpretation. Titles like the *Ovide moralisé* and the *Bible moralisée* proclaim their goal: to "moralize" their venerable sources, to square them with modern values either by condemning their superseded sexual ethic or purifying it through allegory.

The most explicit broadsides occur among the thousands of images in various manuscripts of the *Bible moralisée*, a lengthy compendium devised by thirteenth-century French royal theologians and copied or revised over the next hundred years. Each section of this "moralized Bible" juxtaposes a scriptural event with a contemporary activity, the twin illustrations paired in adjacent circular frames to highlight a moral parallel. One edition now in Oxford links the story of Sodom with two couples: a monk kissing a layman, and two women embracing, pointedly located in the mouth of Hell. The inclusion of lesbianism is almost unique, perhaps reflecting the increased concern for all sexual aberrations: from the thirteenth century onward convents sought to prevent what were euphemistically called "special friendships" among nuns by requiring that they leave their doors unlocked and avoid one another's cells. Another version of the *Bible moralisée* in Vienna (fig. 2.4) also spotlights male and female homosexual couples equally, linking both with the sin of Adam and Eve: just as our first parents sinned through the mouth by eating from the Edenic tree (at the top), the kissing sodomites lying on their beds below take

2.4. **Adam and Eve and Sodomites,** French, 13–14th centuries (manuscript illustration, Bible moralisée).

in the forbidden fruit of another's body. The beastly devils who urge them on mirror the serpent in the garden, suggesting the same overlap seen at Vézelay between homosexuality and witchcraft (fig. 2.2).

The secular equivalent of this book was a popular French poem, the anonymous *Ovide moralisé,* which took on the troubling ethics of Ovid's *Metamorphoses.* Its method typifies the medieval splitting of classical culture, which preserved antique forms but filled them with sharply contrasting content. The page devoted to Jupiter and Ganymede in one fourteenth-century manuscript (Paris, Bibliothèque Nationale) accurately illustrates Ovid's conception of the enthroned king of heaven, awaiting the eagle's delivery. But the text below

tartly slaps the god's wrists, acknowledging that "Jupiter saw him, young and fair" only in order to point out in Aquinas' terms that the desire inflamed by that sight was "against law and against nature." Artists and authors were no longer interested in ancient literature for its own sake, but as a source of negative examples for didactic rhetoric.

These Ganymedes admit the homosexual content of their original source in order to reject it, but it was possible to carry purification a step further. In a fourteenth-century Latin commentary similarly titled *Ovidius moralizatus*, the monk Berchorius conflated the myth with a parallel Christian symbol to transform it into an allegory of acceptable religious yearnings. Bechorius saw Ganymede as a prefiguration of Saint John the Evangelist, both visited by the heavenly eagle as a token of divine inspiration and thus symbolizing the pure childlike soul seeking after God. Other gods received the same whitewashing: the boys surrounding the enchanter Orpheus after he rejected Eurydice's female company were declared to represent yet more enraptured souls attracted to purely mystical wisdom.

Almost from the moment it was completed in 1321, the most universally beloved text of the Middle Ages was Dante Alighieri's *Divine Comedy*, the fountainhead of Italian literature and the premier epic poem of Christianity. This sweeping three-volume visionary tour through a richly allegorized hell, purgatory, and heaven, its Inferno of descending rings precisely graded by severity of sin and penance, offered a visual counterpart to Aquinas' systematic theology. Dante knew classical literature intimately—he makes the Latin poet Virgil his imagined escort—and he absorbed all its creatures, from Minos to Charon to the centaurs, into a grand religious synthesis whose vividly detailed imagery inspired frequent illustration.

Dante's images of homosexual love somewhat inconsistently embrace both poles of contemporary attitudes. Cantos 14 through 16 of the Inferno consign male-male lust to the near-bottom of hell, the seventh circle of the violent. The wretches there are subdivided into five groups by the object of their violence: against the self (suicides), others, God, art (usurers), and nature—meaning, of course, sodomites. Following his propensity to make punishments ironically fit crimes, Dante condemns the latter to run ceaselessly among a rain of fire reminiscent of Sodom itself. The largest Dante illustration, Nardo di Cione's fresco in Santa Maria Novella, Florence, from the 1350s, lays out the specialized compartments of the Inferno with maplike precision and gives them written labels. But Nardo grows uncharacteristically vague in the seventh circle: four of Dante's five categories are depicted undergoing precisely the tortures he prescribes, but where the sodomites should be the artist shows only generic sufferers and omits the one caption, "Violent against nature." Nardo's evasiveness may reflect mounting revulsion against sodomy in the wake of the Black Plague that devastated Europe in 1348, panicking reformers to seek scapegoats for God's wrath against humankind.

The sodomites were illustrated in some smaller, less-public manuscript copies of Dante's poem, often with learned glosses. Guido da Pisa's commentary, written and illustrated about 1345 (fig. 2.5), depicts the poignant conversation among Virgil and Dante at the left and Dante's much-admired fellow Florentine, the notary and author Brunetto Latini, who turns aside for a moment from the endless racing of his fellow sinners. Most of them are tonsured, and one wears a bishop's miter; Latini explains to his listener, "all were clerics and great men of letters"—another testimony to the reputation of the learned classes for sodomy.

Despite the dismal setting, Dante reveals a sentimental fondness for Latini that overrides his moral repugnance. His attitude had further softened by the time he wrote *Purgatory*, where he grouped sodomites who had made atonement with the other sins of lust—the least serious category, just one step below salvation. This terrace holds heterosexual and homosexual lovers without distinction; contrary to Aquinas, here all forms of desire are equally "natural," though excessive. Moreover, in both volumes Dante is sensitive to the emotional and spiritual rewards of male *amicitia*. Virgil's repeated comforting embrace of the terrified author, often illustrated, is touchingly homoerotic, especially in light of the historical Virgil's exaltations of earthly male passion. And in *Purgatory IX* Dante dreams of an eagle with golden feathers; like Berchorius, he interprets this Ganymede-like vision as a symbol of the human soul purified by ascent to divine love.

For noblemen, like churchmen, the chaste ideal of affectionate *amicitia* that permeated their ranks cohabited ambiguously with sexual passion. "When knighthood was in flower," the feudal hierarchy and its code of chivalry bound the male warrior class both vertically—through a great chain of authority in which each vassal pledged loyalty to his superior—and horizontally, through

2.5. Dante and Virgil Meet the Sodomites (Inferno 15), ca. 1345 (manuscript illustration, Guido da Pisa, Commentary on Dante).

the vows of soldiers to love one another in a sacred brotherhood dedicated to earthly justice. Knight and lord owed each other personal service, including support in battle, an intimate dedication sealed through the *osculum feodale*, or ritual kiss. This embrace was an illiterate culture's sign of contract, not courtship, but its powerful sexual undertow washes through the Old English epic poem *Beowulf*, written down about the year 1000. When good king Hrothgar kisses and richly rewards the young hero for bravely slaying the monster Grendel, the anonymous bard tells us that these valorous deeds made Beowulf dear to Hrothgar "to such an extent that he could not restrain his emotion" and "a secret longing for the dear man burned in his blood."

Northern Europe and Scandinavia, converted from their pre-Christian ways later than the south, preserve intriguing evidence that such language was no mere metaphor. Ancient Greek and Latin writers reported that Celtic and German warriors were avidly homosexual; medieval records in their own languages suggest that these tribes continued to accept the active male while mocking his passive partner. In Icelandic proverbs, such womanliness casts doubt on a soldier's prowess, and fighters traded ceremonial taunts accusing other men of having submitted to them. These customs must have inspired a lost genre of wooden sculpture: an Icelandic law passed before 1262 prohibited carving images of one's enemy submitting to male penetration—presumably a popular way of adding visual insult to injury.

Christian chivalry, which considered itself more refined, exhorted knightly equals to love one another in yet another version of the warrior-couples of antiquity. Just as Orestes and Pylades both offered to die for the other, so the passionate devotion of the male heroes in a popular French tale from the thirteenth century overrode all other obligations. Amis and Amile, whose physical resemblance mirrored their twinned souls and twinned names (from *ami*, "friend"), lay together passionately in bed, and Amile willingly sacrificed his own children to cure Amis of leprosy. Another archetype for such friendship was biblical: the attachment between Jonathan, son of King Saul, and David, the heroic shepherd boy and musician whose slaying of the giant Goliath foretold his destiny to wrest Saul's throne (I Samuel 16–20, II Samuel 1). The two youths were inseparable: "The soul of Jonathan was knit with the soul of David, and Jonathan loved him as his own soul." But Saul turned against them, the pair kissed before David fled, and in the ensuing battle Jonathan was killed. The grief-stricken David's heartrending funeral song lamented a "very pleasant brother" whose love for him "was wonderful, surpassing the love of women."

David and Jonathan served as the paradigm of friendship in a popular spiritual manual called *Somme le roi*, frequently recopied with similar illustrations (fig. 2.6). Originally assembled for the French king Philip III by his confessor, it became a layperson's guide to the moral issues treated more scholastically in Aquinas' *Summa*, whose name it adopted. The treatise listed and discussed

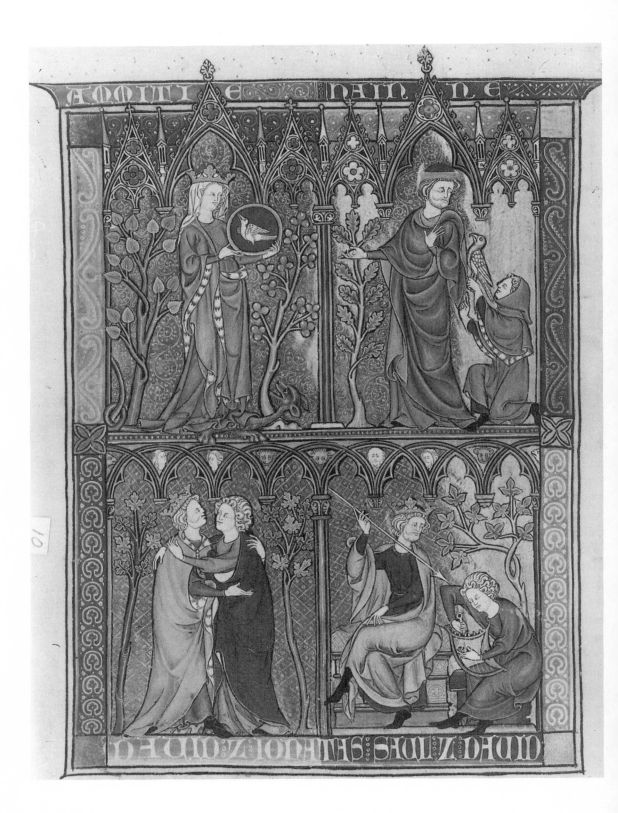

virtues and vices, pairing them as opposites, or antidotes, useful for memory and sermons (like today's seven deadly sins). In this particularly elegant French version from about 1300, the elaborate Gothic architecture frames David and Jonathan hugging at the lower left beneath an allegorical figure labeled *L'Ammitié*, and sets them against the right scene showing Saul's violent envy of David, captioned *Hainne*, "Hatred." The left vignette continues David and Jonathan's long-running starring role in medieval literature. Even Peter Abelard, legendary for his doomed passion for the woman Héloïse, could sensitively evoke the love between the two men: in his sixth *Planctus*, or "David's Lament," he imagines David crying over Jonathan as "more than a brother to me, one in soul with me."

While these writers never overtly characterized the men's relationship as sexual, as in the days of Sergius and Bacchus the term "brother" carried an undertone of "lover." And sometimes, at least, a biblical blessing was conferred on noble lovers who obviously crossed the threshold of sodomy. The barons of England were enraged to revolt by the prodigal passion of Edward II (r. 1307–27) for Piers Gaveston, a mercenary commoner whom the smitten king showered with wealth and titles. One romantic chronicler flattered their intimacy by comparison to David and Jonathan as "beyond the love of women," but politicians and moralists took a dimmer view. The peers, angered as much by the king's touchingly obstinate loyalty to a drain on the public purse as by the couple's private sins, devised a murder weapon at once symbolic and practical: they thrust a redhot poker up Edward's rectum, avenging his offense against nature while leaving no visible evidence of their treason.

Not surprisingly, the sexual transgressions of nobles and churchmen, who commissioned most art, were illustrated only occasionally and in minor forms. In a tiny drawing adorning the margins of a French manuscript from the mid-1300s (fig. 2.7), a knight whose tall hat identifies him as a member of the Templars, a crusading order who protected pilgrims in the Holy Land, plants a kiss on the buttocks of a comically contorted figure with the shaved head of a monk. The humor hinges on current events: between 1307 and 1312, Edward II's contemporary Philip IV of France had successfully crushed the Templars by accusing them of the long-linked sins of heresy and sodomy, including the charge that their initiation rites demanded the *osculum infame*, a kiss upon the anus or penis that supposedly signaled blasphemous disrespect for religious taboos. But even under torture, only a handful of knights confessed to sodomy. Philip, who coveted the Tem-

2.6. (opposite) **Jonathan, David, and Saul,** French, ca. 1300 (manuscript illustration, **Somme le roi**).

2.7. **Templar Kissing Cleric,** Franco-Flemish, ca. 1350 (manuscript illustration, Jacques de Longuyon, **Les Voeux du Paon**).

plars' wealth, may have embellished his case to tar his opponents; as with Edward's courtiers, moral outrage cloaked more worldly motives.

Like the erotic or scatological carvings on the choir stalls where monks sat, such border decorations, called "droleries" because they were amusingly grotesque, were segregated in a literally "marginal" artistic arena. Their obscurity freed them to illustrate taboo subjects all but banned from the main cultural stage, including nudity, bodily functions, violence, and sexuality. Their bawdy license might be whimsical or moralizing: a common motif shows one figure shooting an arrow into the backside of another, a humiliating punishment for sinners that was sometimes extended, with Templar-like sexual overtones, to cowardly knights. But these satirical embellishments always ceded center stage to the book's principal subject matter. Like the charges of sexual deviance that could clinch a political grievance, sexually frank marginalia were icing on the visual cake; their patrons' appetite was mostly for more orthodox fare.

THE FIFTEENTH CENTURY: "THE AUTUMN OF THE MIDDLE AGES"

The fifteenth century witnessed stark contrasts, with Renaissance humanism triumphing in Italy during the same decades that Germans published the first manual for persecution of witchcraft in 1484. Research into antiquity began with the fourteenth-century Florentine authors Boccaccio and Petrarch, and accelerated with the westward flow of Greeks and their manuscripts after the Turkish conquest of Byzantium in 1453. Alarmed by the secular knowledge and pagan spirit lapping at its shores, medieval society redoubled its efforts to stem the tide. Aristocratic excess continued, but even the nobility were more vulnerable: the Frenchman Gilles de Rais, origin of the legendary Bluebeard, was hanged in 1440 for the sexual abuse and murder of hundreds of children, mostly boys, while King Henry IV of Castile was burned in effigy as a *"puto,"* or "male whore."

Public enthusiasm for such punishments produced what may be the first "news report" of contemporary homosexuals. Figure 2.8 is an illustrated page from a chronicle of the times, showing two men being burned to death outside the Swiss city of Zürich in 1482; the German text above and below the picture says one of the criminal pair, a knight, is a *"Ketzer"* ("sodomite"). It represents the fate of Richard Puller of Hohenburg, a hedonistic and unscrupulous nobleman often in trouble with the law for his flagrant sexuality, who took refuge in the city about 1480. Watchful enemies got him imprisoned for sodomy with his page, and both were sentenced to the stake. The massed observers at the left of the illustration correspond to the unprecedented crowd reported by von Hohenburg's own biographer, but he placed the executions in the market

square, not outside the gates as shown here—perhaps artistic license to high-light the men's expulsion from society. The image vividly attests to the public disgust with such misbehavior: prosecutions grew more frequent into the next century, and civic authorities, no longer content to sweep sodomy under the rug, now proudly wove their battle against it into the very fabric of history.

The symbolic curtain fell on the Middle Ages in the epochal year of 1492, when Ferdinand and Isabella recaptured the whole of Spain from the Muslims and, in an even more world-shattering offensive of Europe's scientific renewal, sponsored Columbus's voyage to the Americas. Ironically, in that same year the newly confident Catholic monarchs, doing their part in the long-standing campaign for conformity, also forced the Jews to convert on pain of expulsion. But the tolerant new spirit that produced Columbus had already made unstoppable advances: in the Italy of 1492, a young Michelangelo was sculpting illustrations of homoerotic Greek myths recited to him by a professional translator.

2.8. **Richard Puller Burned at the Stake, Zürich, 1482,** ca. 1483 (manuscript illustration, Diebold Schilling, **Die Grosse Burgunder-Chronik**).

Painted as late as 1500, the great triptych by the Flemish artist Hieronymus Bosch, *The Garden of Earthly Delights*, was a late sunburst in the long twilight of grotesque and marginalized medieval humor (color plate 6). This three-paneled folding altarpiece, crammed with hundreds of tiny figures, may function on many levels of symbolism; broadly, its three scenes represent time past, present, and future. Paradise, out of which lust drove humanity, gives way to the central unit depicting every imaginable form of orgiastic abandon; the third panel completes the sequence with a Dantesque Hell, flaming like Sodom. Most of the nude couples and groups who fondle and grope in the main panel are heterosexual, but several at the lower center and left seem to satirize homosexual activities in the language of popular proverbs and slang. Here one man inserts a sprig of mayflower into the anus of another crouching before him; three men to their upper left cavort inside a curly dried thistle also hosting a titmouse and butterfly, both associated with unsavory sexual excess. These actions seem to inspire little joy on the impassive faces of either sex, and their spindly, awkward bodies are dwarfed by giant strawberries, whose short-lived lusciousness symbolized the transience of all worldly sensuality.

By the time Bosch began this painting, two generations of Italian humanists had come and gone. Just like the Veronese cleric's *idolum* with which this chapter began, Bosch represents homosexual desire as something ephemeral, an "apparition" barely perceptible through the fog of disapproval. But the work of Italian humanists and artists had begun to brush aside that fog, letting in patches of a classical sun that was dramatically altering the cultural climate.

FROM RENAISSANCE TO REFORM: EUROPE AND THE GLOBE, 1400–1700

Less than a century after French Gothic manuscripts pictured David as a chastely clothed allegory of pure Christian amicitia, the Florentine sculptor Donatello created a bronze statue of the biblical hero (fig. 3.1) whose androgynous nudity and classical eroticism heralded a radically new art and society. The historian Jules Michelet characterized the Renaissance spirit as "the rediscovery of the world and of man." He might well have added that the surge of social and technological change that began in late-fourteenth-century Italy, and its splendid outburst of intellectual and artistic creativity, also rediscovered man with man—and coined the phrase "woman with woman."

Renaissance means rebirth: specifically of Greek and Roman literature, art, philosophy, and science, and more broadly, of a thirst for secular and empirical knowledge. Beginning with Francesco Petrarch and Giovanni Boccaccio, the classically trained humanists, so called for their focus on human affairs, turned European eyes from the supernatural back down to the natural world: from the afterlife to this life, and how to run it efficiently as a society and live it well as an individual. With all their digging into the past, some of what they unearthed inevitably exposed the homosexuality prominent in pagan myth, chronicles, and art. These rediscoveries revolutionized the European vision of time itself. Until then, the Christian West had recognized only two periods of history—before and after Jesus. In coining the term "medieval," Renaissance thinkers recast the Christian era as the barbarous interruption of a Golden Age whose lost wisdom and erotic innocence they yearned to restore in a third, modern age. The knowledge explosion aggravated the chronic tug-of-war between Christ and classicism, setting off nostalgic pangs of loss over the medieval campaign of whitewashing ancient stories. Humanists insisted on reuniting classical forms and subjects with their original meanings, however challenging to current morality. The central energizing tension of the era was the attempt to reconcile Catholic heritage with the knowledge and values found in paganism and science—an ultimately impossible task that profoundly reshaped every cultural sphere, from politics to sexuality and art.

Such a momentous shift could not materialize overnight: the Renaissance was a crossroads, where new forces and ideas long intersected with entrenched institutions that continued to dominate the paths of thought and action. While all periods are transitions, the Renaissance was a uniquely fateful fork in the historical road. The Europe that sprouted from its dual compost, no longer simply one among many roughly equal and widely separated societies, spread its tendrils across the globe, overgrowing and intertwining with world cultures in a spurt unchecked until the past half century.

For this cultural germination, classicism was necessary but not sufficient. While the painter and art historian Giorgio Vasari mused whether Christianity might in the long run prove "a mere interlude in the history of Hellenic religion," humanism scarcely percolated below the educated elite, and even there its heyday was brief, declining from a High Renaissance peak after the 1530s. The flower of revival had to be fertilized by the many political, social, economic, and technological innovations that, because they looked forward in embryo to our present world, earn these centuries their alternate title of "early modern period."

Between the fifteenth and early eighteenth centuries, Europe only gradually altered the outward forms of society inherited from the Middle Ages. Most countries preserved the feudal system even as centralizing kings overpowered the local nobility from above and bourgeois capitalists eclipsed both king and courtiers from below. The Catholic Church remained in theory universal and independent, but its power was weakened and its unity eventually shattered by the Protestant Reformation. What came to be known as the ancien régime, or Old Regime, hung on defensively until the French Revolution of 1789, but church and state gradually lost the conviction of their own symbols. Since they continued to be major patrons of art, their loss of faith can be seen in the fate of classical mythology. The humanists enthusiastically raided that venerable storehouse for pretexts to dignify their own homosexuality, but by the long eighteenth-century twilight of the Renaissance, viewers could make out little in those stale stories beyond titillating fairy tales.

Traditional authority eroded as large centralized states gobbled up the lesser feudal domains and founded huge overseas empires. The economic and industrial system of capitalism was pioneered by Florentine bankers, who came to rival the courtly clients dependent on their loans. Spurred by this prosperous bourgeoisie, urban growth shot up exponentially: by the mid-1700s medieval London, a town of less than fifty thousand souls, had swollen to a half million. The urban sexual subcultures that had sprung up in the later Middle Ages kept pace, becoming an ever more diverse and familiar part of social life, large and open enough to begin to create and exchange art.

Not surprisingly, visibility triggered alarm. Official repression of homosexuality formed one prong of a campaign to increase state power through police surveillance, and religious power through the Inquisition. Civil and

religious penalties were often death, though enforcement was irregular. Thanks to court records, we know that sodomy (usually meaning anal intercourse) cut across all classes, from royalty to clerics to writers and artists, Venetian barber-surgeons and gondoliers, Genevan printers, English laborers and sailors, and the universal prostitute. For many men, these passions were only one part of what we would call bisexuality, and they involved mainly, though not exclusively, adult men with adolescent boys.

This expanding subculture was shaped by developments in both of Michelet's spheres of rediscovery. Intellectuals thrilled with excitement at humanity's potential for knowledge, which could multiply mastery over our selves and our earthly home. From the celebration of human reason—in René Descartes's phrase "I think, therefore I am"—emerged a distinctly modern glorification of the individual. In his *Oration on the Dignity of Man*, the philosopher Giovanni Pico della Mirandola (beloved companion of the poet Girolamo Benivieni) imagined God telling Adam: "Other species are confined to a prescribed nature. No limits have been imposed on you, however; you determine your nature by your own free will, so that, like a free and able sculptor and painter of yourself, you may mold yourself wholly in the form of your choice." Human nature was no longer a cog in Aquinas' rigid universal order, but a personal essence, and each person could fashion an identity like a work of art. If (to use a Renaissance commonplace) the world was a theater, God remained the all-seeing and ultimate audience, but mortals increasingly saw themselves taking center stage, as the actors and even the playwrights of their own destinies. The urge to record and understand the psychology, deeds, and appearance of exemplary individuals inspired the writing of biographies and autobiographies and the rise of portraiture.

One corollary of individualism was the return of homosexuals' subjective viewpoint, not seen in art since Roman times and rare in literature outside the twelfth century. That first-person voice was intermittent—and as yet lacked any lesbian strains—and its vocabulary, borrowed from classical and biblical sources, was a far cry from modern gay cohesion. But occasional acts of defiance indicate some group consciousness, emerging with the Italian sodomites of the 1420s who, according to Saint Bernardino's outraged sermons, defended their unorthodox sexuality by quoting the scriptural verse praising "eunuchs who castrate themselves to achieve the kingdom of heaven." The increasing art dealing with homosexuality was thus divided into two opposing streams, one expressing the viewpoint of "outsiders" like Bernardino, who attacked it as alien and distasteful, the other created by "insiders" with some sympathetic knowledge.

Among artists, major Renaissance figures who were homosexual—including Leonardo da Vinci, Michelangelo, and Benvenuto Cellini—kept journals or penned poems and autobiographies, leaving behind both art on homosexual themes and the evidence to relate it to their own psychological lives or those of

their patrons and audience. For the first time in Western art, we are able to make out the emotional dynamics of male homosexual experience, the often strained relations of homosexual artists with society, and the earliest buds of a self-conscious cultural tradition passed from one generation to the next.

The "rediscovery of the world" also affected art and sexuality. Empirical science and technology, though still in infancy, were taking their first momentous steps toward the goal of understanding and manipulating physical matter, from the mathematics of Isaac Newton and the astronomy of Galileo Galilei to practical applications in warfare, agriculture, and shipbuilding. Art proceeded hand in hand with science in its efforts to reproduce natural appearances. In learning how to create the illusion of bodily presence—of anatomy and natural light, of emotional gesture and expression, of three-dimensional depth through linear perspective, and of texture and color through the new medium of oil paint—artists magnified their ability to evoke the sensuous surface of physical reality.

The most far-reaching technological innovations were in printing and navigation. About 1450 the German Johannes Gutenberg extended the existing method for printing art images from wooden blocks to make books set in movable type. Mechanical reproduction of both texts and images gave birth to what we now call the mass media, democratically increasing the spread of ideas previously accessible only to a privileged few. In the explosion of relatively inexpensive books and pictures that ranged from poetry and philosophy to satire, propaganda, pornography, and genre, a babel of alternative voices could now speak in the intellectual marketplace to a multiplicity of subcultural audiences, including those with homosexual tastes.

In Gutenberg's day, Portuguese seafarers were inching down the coast of Africa in search of a passage to India, which they found just a few years before Columbus accidentally discovered the Americas in 1492; by the 1520s, Ferdinand Magellan's Spanish crew had sailed around the world. This expansion of knowledge over space had the same effect as humanism's expansion of knowledge over time: it sharpened awareness of diversity among world cultures, which held potential for both mutual influence and conflict. As Europeans colonized the globe, sexual mores and art played an important role in the often hostile beginnings of today's international civilization. From this point onward, then, our story includes the cultures of the Americas, whose homosexuality the Westerners largely wiped out, and of Islam and Asia, whose own golden ages of homosexual art were flowering just as the Europeans arrived.

FLORENCE: DONATELLO AND COSIMO

Every art historian cites the technically and artistically ambitious bronze of *David* (fig. 3.1), cast by Donatello between 1430 and 1440, as a milestone in

Western art: the first freestanding life-size nude male since Roman monuments, it was widely acclaimed for restoring the perfection of ancient sculpture. It is also a milestone in gay culture: created by one of the first modern artists known to be homosexual, in a city where homosexuality was infamous among artists, patrons, and audiences, it turned a traditional religious subject into a pederastic hymn to pagan ideals of bodily beauty and grace. The very advantages that made Florence the cradle of Renaissance art and philosophy— its size, wealth, and creative talents—also made it the fountainhead of modern homosexual expression. In a revealing coincidence, Donatello was probably at work on the *David* in 1432 when the city magistrates set up a new court, the Officers of the Night, to prosecute the mushrooming sodomy charges.

3.1. Donatello, **David**, 1430–40 (bronze).

Donatello images the slender, androgynous biblical hero standing triumphantly, with one foot on the vanquished older giant, holding the sword with which he has just severed Goliath's head and contemplating his deed with a self-satisfied half smile. His easy contrapposto pose, inspired by classical art, animates the youth physically and emotionally. He is not ideally nude but naked, having stripped for battle to his boots and hat; his sleekly polished torso and legs and exposed genitalia revel in the new precision of anatomy. The cloaking of Hebrew content in Greek form, of moral beauty in corporeal beauty, was startling in its novelty.

The artist's own personality stimulated his unprecedented erotic interpretation. The apprenticeship system, in which adolescent boys lived with craftworkers as student assistants, created an intimate homosocial environment, and Donatello, who never married, was only the first of several artists known to choose apprentices more for beauty than for talent. The feathery wing of Goliath's helmet caressing the boy's thigh almost to the groin recalls Jupiter's eagle, as the boy recalls Ganymede: metaphorically, Goliath, like Jupiter and Donatello, has "lost his head" over a handsome youth. Underscoring this symbolism, a classical relief on the giant's helmet shows a chariot full of putti parading in a triumph of Eros. Many other religious works by Donatello show boyish angels or cherubs in provocative poses; their erotic appeal remains implicit beneath spiritual themes, but the ambiguity is present for those who, like the artist, were susceptible to it.

And there were wide circles ready and able to read the sculpture in this way, centering on Cosimo de' Medici, the fabulously wealthy banker, art patron, and behind-the-scenes ruler of the city, who commissioned it. Cosimo was not ashamed to be seen in public with friends of a sodomitic reputation, an openness that extended to his mutual love and constant support for Donatello, with whom he shared enthusiasm for antiquity and art. Their knowledge was dramatically increased by

the influx of Greek learning: Cosimo brought Byzantine diplomats to Florence to negotiate an alliance in their losing battle with the Turks, and more Greeks fled west after Constantinople fell in 1453, lugging manuscripts and art. Cosimo entertained many humanist intellectuals in his palace, where the *David* stood in the courtyard; often sympathetic to ancient homosexuality, they created an atmosphere of sophisticated toleration.

Literate viewers like these took for granted a knowledge of the classics, which offered suggestive parallels to Donatello's image. In his treatise *On Painting*, the art theorist Leon Battista Alberti decreed that painted bodies should suit their subjects, using an example that could equally apply to *David*: "It would be absurd if Ganymede's forehead were wrinkled or his thighs those of a laborer." In 1423, the city's chancellor Leonardo Bruni translated Plato's dialogue on love, the *Phaedrus*, which characterizes the human soul as winged and compares its reaction at the sight of a beloved to a phallic erection: "The lower end of the wings begins to swell and grow from the root upwards," like Goliath's rising helmet feathers. Another member of this circle, Antonio Beccadelli, dedicated his bawdy poem imitating the Roman Catullus, "The Hermaphrodite," to Cosimo in 1425. His title alludes to the bisexual desires of male adults, and he devotes separate sections to the charms of women, boys, and men. Praising the power of a handsome youth named Carlo, Beccadelli tells how the boy "holds me captive and presses his foot on my neck," just as Donatello's *David* does to Goliath.

The bookish humanists could mingle in public streets and church porticos with an expanding subculture of homosexual networks and trysting places that understood its passions in less learned terms. Since men married late, often into their thirties, young bachelors turned to other outlets during enforced adolescence, crossing class lines and including both female and male prostitutes. An extended youth, spent in largely homosocial surroundings, created breeding grounds for male sexuality in artisans' workshops and in more elite schools of math, music, fencing, and gymnastics. Although most men eventually married, most also passed through this stage of illicit bisexuality that made the city proverbial for sodomy: a Zürich legal accusation of 1422 used the verb *"florenzen,"* meaning to commit "the vice of Florence."

Moral mouthpieces both clerical and civil acidly condemned the rising tide of such behavior, now viewed as not only against nature but also as a practical threat to fertility and even to political order. The chorus of religious outrage swelled to fever pitch in Saint Bernardino of Siena, whose campaign of fiery sermons against sodomy in 1424 to 1427 charged that subversive fraternities cemented by homosexual bonds were fomenting factional strife between political parties. As the state stepped up its policing of moral conduct, the legal systems in both Florence and Venice continually increased vigilance and penalties.

Over their seventy-year tenure, Florence's Officers of the Night heard an average of three or four cases every week—probably only the tip of a social

iceberg. Historian Michael Rocke has shown that two out of three Florentine men were hauled into this court at some point in their lives, although many got off with warnings or minor fines. In Venice, whose sodomy tribunal dated back to the fourteenth century, the number of cases also jumped suddenly after 1400. By 1450 authorities set a curfew at music schools, to get young pupils out of harm's way before dark, and limited the size of intergenerational dinners in private homes, revealing their suspicion that this embryonic subculture was staging modern-dress versions of the Greek symposium.

If civil legislation could not stamp out such flagrant behavior, at least it registered the limits of open expression and inculcated caution, guilt, and self-repression. The church collaborated in damage control: religious artworks of the midcentury, even when they adopted the new Renaissance style, continued to propagate the medieval notions that sodomy was marginal and indecent, and that homosexual myths were pure allegory. On the great bronze doors of Saint Peter's, the papal basilica in Rome, cast in the 1440s, the sculptor Filarete inserted many tiny border scenes using mythical motifs like Ganymede and Narcissus as properly moralized fables. The main panels show Filarete fully aware of mythology's erotic implications: an imitation classical relief shows baby cupids playfully tugging at the penis of an old satyr who has fallen into a drunken stupor. The scene is lighthearted, but its location—on the throne of the emperor Nero who has condemned Peter to crucifixion—relegates it to an ungodly antiquity.

Frank condemnations abound in painting, such as the *Cook Tondo*, or *Adoration of the Magi*, produced about 1445 by two monks, Fra Angelico and Fra Filippo Lippi. In the background cityscape, male figures clad only in towels, as if they had just run out of a bathhouse, scamper onto ruined walls to catch a glimpse of the savior. Two link arms and stand together, one provocatively clutching his groin: benighted souls still living out a superseded morality, they contrast graphically with the new age born in the foreground. Slightly later, the painter of the *Presentation of the Virgin* (fig. 3.2), probably another monk, placed a tiny male couple in modern dress in the same scene with the young Virgin Mary. The men stand close together, facing each other (on the left side of the detail), as one chucks the other affectionately under the chin in a gesture of erotic solicitation—a more contemporary, and more explicit, foil to biblical purity. While these official statements are clearly hostile, we cannot help wondering how the Florentine youths active in the homosexual subculture viewed images so evocative of their everyday pleasures.

THE LATER FIFTEENTH CENTURY

Florentine humanism continued to blossom under the patronage of Cosimo de' Medici's grandson Lorenzo the Magnificent. Its lyrically positive alternative to

religion is best captured by the painter Sandro Botticelli's poetic fantasies for the Medici: his *Primavera* ("Spring") and *Birth of Venus* evoke wistful nostalgia for a pagan fairyland of spiritualized sexual innocence, where elegant deities and nymphs in fluttering veils cavort gracefully through a flowered arcadia. The treasure trove of classical subjects provided artists with explicit pretexts for erotic male beauty. Sympathetic artists from Donatello onward illustrated the popular mythic lovers Apollo, Narcissus, Bacchus, and especially Ganymede, who best fit the Florentine version of Greek pederasty.

Botticelli's images were shaped by the glittering literary circle around Marsilio Ficino (1433–99), who presided over an informal academy in imitation of Plato. Their Neoplatonic philosophy, at heart almost a religion of love, strove to reconcile Christianity with pagan lore. It allegorized myths into a ladder of love: the rapture excited by earthly beauty was but a first rung leading upward to chaste spiritual communion, which offered a foretaste of the ultimate ecstasy, union with the divine. Ficino translated and commented on Plato's *Symposium*, which provided an eloquent, if misogynistic, precedent for passionate intimacy between men that could awaken mutual creative inspiration: "Some men are better equipped for offspring of the soul than for those of the body and therefore, naturally love men more than women, because men are much stronger in the mental keenness essential to knowledge." Ficino found his own "platonic" beloved in Giovanni Cavalcanti. These idealized unions were often the emotional equivalent of marriage: the devoted authors Pico della Mirandola and Benivieni were buried in the same tomb, like husband and wife.

Ficino's pupil Angelo Poliziano (1454–94), who reportedly died from a compulsion to leave his sickbed to serenade a handsome youth, most directly influenced the arts. A scholar, author, and fluent translator, Poliziano wrote epistles in Greek begging kisses and caresses from golden-haired boys, and his Italian poetry and theater held up the ancient gods as justifications for homosexual love. In the first known case of an older homosexual passing on his creative tradition to a younger disciple, Poliziano played mentor to Michelangelo Buonarroti (1475–1564), the most renowned homosexual artist of this (or any) period, who studied as a teenager among Lorenzo's collection of ancient sculptures. The biographer Ascanio Condivi recalled that Poliziano, "recognizing in Michelangelo a superior spirit, loved him very much and was always explaining things to him and providing him with subjects." Among those subjects, the young sculptor carved such suggestive antique males as a faun, a battle of centaurs, and Hercules—whose love for Hylas, extolled in Poliziano's groundbreaking Italian verse drama *L'Orfeo* ("Orpheus"), its author doubtless shared with him.

Michelangelo was also shaped by Florentine painters from Poliziano's generation, including Botticelli and Leonardo da Vinci—and by his knowledge that both were denounced to the city's sodomy tribunal. Botticelli, who

3.2. (opposite) Fra Carnevale (attributed), **Presentation of the Virgin in the Temple** (detail), ca. 1465 (tempera and oil).

once awoke in terror from a nightmare that he had been forced to marry, was the quintessential Neoplatonic painter but avoided directly homoerotic myths. His sensibility surfaced mainly in religious works, where he imbued such nude young saints as Sebastian with the same androgynous grace and implicit physicality as Donatello's *David,* and his delicately intimate adolescent angels look like choirboys, often the object of real-life adult affections.

Luca Signorelli's *School of Pan* (fig. 3.3), painted for the Medici about 1490, was more explicitly sexual and, based on a tale of multiple unrequited loves by the Greek poet Moschos, included all of passion's permutations. Its central figure is the goat-footed god, enthroned over a pastoral gathering that includes the handsome nude pipe-player Olympus, whom he made his musical disciple and lover. Pan holds his own instrument, the reed-pipes, alluding to his frustrated heterosexual desire for the nymph Syrinx (who escaped him by turning into a reedy plant). The catalog of orientations is rounded out by a rare lesbian episode in the left background: the nymph Lyde sits downcast near her female beloved, who has turned her back in rejection.

3.3. Luca Signorelli, **School of Pan,** ca. 1490 (tempera).

A backlash against such carefee sexual and artistic license was spearheaded by the crusading Dominican monk Girolamo Savonarola, who ruled Florence after a popular uprising expelled the Medici in 1494. One of his puritanical sermons threatened the city's priests: "Abandon, I tell you, your concubines and your beardless youths. Abandon, I say, that unspeakable vice, that abominable vice, or else: Woe, woe to you!" Even half a century later Michelangelo swore he could still recall the friar's terrifying voice, and under its mesmerizing sway several painters consigned their nudes and other lascivious subjects to the flames of his public "Bonfires of Vanities." Botticelli abandoned classicism for sacred, even mystical subjects, dedicating his later years to illustrating Dante's *Divine Comedy*; his drawing of the sodomites running through infernal fire perhaps reflected his own fearful change of heart.

While Savonarola struck terror and repentance in many souls, he also made enemies, and his regime was short-lived: one gang of youths called the Compagnacci, whose leaders had been prosecuted by the Officers of the Night, attacked his supporters. Though technically outlawed, their pleasures enjoyed some official sympathy; after Savonarola was condemned and burned in 1498, one city councilman sighed to a colleague, "And now we can practice sodomy again!" The monk's relieved enemies exorcised his puritan spirit in graphic cartoons that imagined him coupling with young novices. Botticelli was among those who relapsed; when arrested in 1502 he was aging and somewhat frail, but apparently not immune to a May-December flirtation.

His old schoolmate Leonardo da Vinci (1452–1519), the paradigm of the "Renaissance man," avoided these upheavals by working for several decades in the northern city of Milan. Before leaving, this universal genius—artist, engineer, scientist, and inventor—entered the history of homosexuality when an anonymous informant accused him and several other young craftworkers of consorting with a youth of seventeen named Jacopo. Although the complaint was twice dismissed for lack of evidence, Leonardo later developed a weakness like Donatello's for good-looking assistants and models. In 1490 he took in a strikingly graceful ten-year-old, whom he nicknamed Salai, or "little devil," because he stole from the master and loitered in the streets rather than working. Though Leonardo fumed over this "thief, liar, pighead, glutton" in his notebooks, he kept Salai on for twenty-five years, obsessively drawing his soft features and blond curls.

Like Botticelli, Leonardo painted no homoerotic myths but poured his acute sensitivity to male beauty into the mysterious androgyny of his angels, saints, and Christ. Several times he depicted John the Baptist and his cousin Jesus together as children, affectionate twins whose deep Narcissus-like devotion in later life is rendered innocent by their age. In his late *Saint John* (fig. 3.4), the baptist is older and alone, though his gesture points to his beloved lord, kept discreetly "offstage." Fusing masculine features with rounded feminine flesh, this image beatifies the ideal embodied by Salai. Yet it remains am-

biguous: while John's sensual appeal is heightened through the smoky shadows and warm golden glazes possible with the new medium of oil paint, his enigmatic smile (brother to Leonardo's *Mona Lisa*) and coy gaze bespeak both seduction and an epicene asexuality.

Fortunately, this prolific artist is the first we can examine on the psychoanalyst's couch. Leonardo left two thousand pages of notes, from which Sigmund Freud reconstructed his complex interior life, including his horror at any passion that threatened to overpower his rational, scientific mind. Despite the artist's weakness for boys, he found sexual organs and all bodily functions repulsive, repressed his emotions, and sublimated his yearning for beauty into a fantasy of self-contained escape from desire. An isolated figure like Saint John recalls Plato's myth in the *Symposium* of those Edenic double humans whose androgynous unity transcended any need for sexual completion outside oneself; Freud too borrowed from the Greeks to label such fantasies "narcissism."

On top of his own internal inhibitions, Leonardo knew from experience the external social dangers of acting out, or even letting on, homosexual desires. His notebooks complain bitterly about his youthful sodomy scrape: "When I painted Our Lord as a boy, you put me in jail; if I were now to paint him as a grown man, you would do worse to me." This cryptic remark might refer to a painting of Christ done at the time of his arrest, suggesting Leonardo's suspicion that revealing his sensitivity to male beauty somehow "tipped off" his anonymous accuser. Regardless of such risks, Leonardo's many followers aimed for the same softly sensuous ambiguity. Giovanni Boltraffio's *Narcissus* depicts a Salai-like youth transfixed by his own reflection— the archetype of self-sufficient eros (though ultimately tragic, since Narcissus drowned in his watery mirror).

Like the tiny episode of Lyde in the *School of Pan*, lesbian eros was largely relegated to the background of art and literature, still produced almost entirely by and for men. As in ancient Greece, Renaissance Italy segregated women at home or in con-

3.4. Leonardo da Vinci, **Saint John the Baptist**, ca. 1515 (oil).

vents, with minimal education. Enforced chastity in all-female environments could lead, as men occasionally admitted, to sex "woman with woman." Women are hardly absent from the arts—indeed, they are men's favorite subject—and a few scenes depict suggestive physical intimacy between them, beginning with prints like *Woman and Her Maid* (fig. 3.5) by the north Italian engraver Zoan Andrea. Alone together, the older woman throws her arm affectionately around the younger one, who reaches intimately beneath her mistress's revealingly lifted gown.

Being produced by "outsiders"—men who could know nothing firsthand of women's private lives—such pictures leave us unsure how accurately they reflect real behavior, or how women interpreted images of themselves. Female artists and patrons emerged only gradually; apart from pioneering exceptions like the French author Christine de Pisan, who first protested women's restrictions about 1400, and a handful of Italian noblewomen who managed to obtain a classical education, before the sixteenth century few could even write down accounts of their lives. Art historian Patricia Simons has suggested that it is possible to imagine, if not to document, a "lesbian viewer" who, if she saw such pictures, would look past the male artist's intent to titillate or joke and take surreptitious pleasure in the image of her own experience. While this viewer remains a tantalizing speculation, many subjects seem ripe for lesbian readings, from genre scenes of women bathing to the perennially popular myth of Diana and her all-female band.

3.5. Zoan Andrea, **Woman and Her Maid,** ca. 1500 (engraving).

NORTHERN EUROPE: DÜRER AND WITCHCRAFT

Renaissance art and ideas spread north of the Alps only slowly and incompletely. Bosch was a contemporary of Botticelli, and while his successors admired and studied Italian classicism, they never let it overwhelm their regional preferences for an unvarnished realism, tending toward graphic caricature and the grotesque, and for presenting social issues in familiar genre scenes rather than the indirect symbolism of myth.

The custom of visiting Italy was made fashionable by Albrecht Dürer of Nuremberg (1471–1528), the premier artist of Germany—called the "Leonardo of the North" for his versatility as draftsman, printmaker, painter, and author. He took two lengthy trips, the first soon after his honeymoon in 1494. Dürer's distant and childless marriage, plus the main extracurricular attraction in Italy—his intimate lifelong friend Willibald Pirckheimer, then studying near Milan—suggest that touring humanists drew the same connections as their hosts did between classical culture and personal desire. The painter, whose vanity about his handsome looks inspired a landmark series of sometimes dandyish self-portraits, traded both creative inspiration and off-color jokes with the lusty dean of German intellectuals. Dürer's letters twit his friend's dual fondness for German girls and Italian soldiers, and Pirckheimer inscribed on Dürer's sketch of him a coarse Greek allusion to their shared proclivities: "With erect penis, into the man's rectum."

Dürer's classically costumed and posed drawing of the *Death of Orpheus* (fig. 3.6), sketched about the time of his first Italian journey, is virtually an illustration of the climactic scene in Poliziano's recent drama. Following the magical singer's ill-fated attempt to lead Eurydice out of hell, sabotaged by her disobedience, Poliziano has Orpheus bitterly renounce the love of women. Launching into a breathless catalog of classical role models, from Hercules to Jupiter, to

3.6. Albrecht Dürer,
Death of Orpheus,
1494 (pen drawing).

justify his turn to "the better sex," he concludes, "I urge all husbands: seek divorce, and flee / Each one away from female company." As in the drawing, the angry women of Thrace then take mortal revenge on the cowering musician for alienating the affections of their menfolk. A scroll in the trees overhead reads, in old German slang, "Orpheus, the first bugger" (sodomite). The subject was probably proposed by Pirckheimer, whose bantering caption lightens the tragic seriousness of his Italian sources.

The audience for such images, whose captions were in the vernacular, not learned Latin, embraced more than a small elite. As in Italy, northern investigations found sodomy distressingly prevalent: complaints surfaced in Holland in 1446 and Cologne in 1484, and we have already seen the burning in Zürich from 1482 (fig. 2.8). Dürer's print of a bathhouse (fig. 3.7), a frequent genre subject, suggests one possible meeting place for this subculture: a physically charged all-male establishment often attached to a brothel. We may imagine that contemporary men spent time as Dürer's lounging nudes do: drinking, playing music, and attracting one another's attention for purposes coyly hinted by the penislike faucet overlapping the scanty G-string of the man at far left, whose springy beard is much like Dürer's own. The erotic physicality of male hair and bathing is further explored in a woodcut of *The Fountain of Youth* by Dürer's younger compatriot Hans Sebald Beham: among a mixed crowd of rejuvenated bathers, one man sweetly holds the head of another while shaving him, and an older and younger man embrace.

Several times yearly, northern towns opened another safety valve for sexual pressures, the kermiss, or carnival; the raucous merrymaking at one village fair in Hoboken in 1559 is detailed in an engraving after the Flemish artist Pieter Brueghel. Taking advantage of the crowds, confusion, and temporary moral license, two men snuggle together on a bench while two women sit arm in arm on a wagon pole. Although the print may have aimed to defend the peasants' rare escape from tedium and deprivation, its caption mocking their need "to dance, caper, and get bestially drunk" condescendingly excuses such behavior as a regrettable necessity among simple folk little removed from animal appetites.

Everyday life in the north included another social phenomenon, witchcraft. A literal firestorm of persecution, fueled by late medieval superstition and intolerance, swept Europe from the fifteenth through the seventeenth centuries. Beginning with publication of a church-approved manual for witch hunters, the *Malleus maleficarum* ("Hammer of Witches," 1486), more than a hundred thousand people were denounced for heretical practices, from casting spells to unnatural lusts, especially sex with the devil. In the pandemic hysteria, even the most trumped-up accusations led almost automatically to drowning or burning. Dürer and his fellow German artists Urs Graf and Hans Baldung Grien specialized in lurid fantasies of witches' sabbaths, such as Grien's *Witches' Orgy* drawings of 1514 (fig. 3.8). The fuming torches, owls,

3.7. Albrecht
Dürer,
Bathhouse,
ca. 1496
(woodcut).

black cats, and flying broomsticks of these supposed rituals became the familiar trappings of modern Halloween.

The overwhelming majority of targets were women, often powerless spinsters or widows; the atrocities attributed to them were largely heterosexual, but lesbian acts were one arrow in the ecclesiastical quiver. The pattern of charges exposes society's anxiety over independent "masculine" women, plus the old habit of blaming that familiar three-headed scapegoat, the treacherously unstable heretic-sodomite-hermaphrodite, for earthly misfortunes whose causes were incomprehensible. In art, too, diabolical heresy was associated almost exclusively with female bacchanales; Grien's drawing omits the popular phallic broomsticks, always suggestive of dildos, but stresses the physical congress of this threesome as they clutch and climb over one another.

Since accused women were given little opportunity to defend themselves, no voices survive to tell us if charges of lascivious abandon were justified or were simply stereotypical assumptions about the general depravity of blasphemers. Whether witches were a figment of the popular imagination or real survivors of the Diana cults preachers ranted against, their persecution continued throughout Europe and even beyond: the infamous Salem witch trials in colonial Massachusetts marked the death throes of the panic as late as 1692.

3.8. Hans Baldung Grien, **Witches' Orgy**, 1514 (drawing).

THE HIGH RENAISSANCE: SELF-EXPRESSION, FLAUNTING, AND CENSORSHIP

During the brief splendor of Italy's High Renaissance, from the late 1490s into the 1530s, the high tide of classical humanism floated a hedonistic and libertine atmosphere that tolerated a lighthearted bisexuality. In Rome, which was fast overtaking Florence as a cultural mecca, the clergy, their bankers, and their lay courtiers and artists all indulged their worldly appetites: on being told of

his election in 1523, the obese gourmand Clement VII enthused, "God has given us the papacy, let us enjoy it." In his colorful autobiography, the sculptor Benvenuto Cellini gossips about a beautiful and talented youth, Luigi Pulci, who made a career in service to Roman bishops, from one of whom he contracted syphilis. Cellini also lets slip his own emotional and physical intimacy with male comrades, including an artists' party where he brought as his date a sixteen-year-old boy model disguised as a girl. Artists like Michelangelo were presumed to have homosexual tastes: the father of one prospective apprentice added as an inducement the boy's services in bed (which the sculptor indignantly refused).

3.9. Michelangelo, **Bacchus**, 1496–97 (marble).

The lavish patronage of Pope Julius II, aimed at restoring to Rome the grandeur of an international capital, spearheaded a classic synthesis in the art and architecture of Leonardo, Michelangelo, and Raphael that set the standard for Western culture down to the nineteenth century. Antiquities unearthed almost daily were snatched up for the collections of wealthy connoisseurs, some with a personal stake in homoerotic history; best known was the bisexual Apollo (fig. 1.17), which Julius proudly installed in his Vatican belvedere as the paragon of monumental beauty. The family of Cardinal della Valle owned a sculpture of Ganymede embracing the eagle, which they displayed on the façade of their Roman palace for the entry parade of Pope Leo X. Normally it presided over their garden alongside an antique Venus, as contrasting symbols of homosexual and heterosexual love.

Sophisticated private patrons lured the young Michelangelo to Rome. For the gentleman banker Jacopo Galli, he carved a marble *Bacchus* (fig. 3.9), which Galli set in his garden among the customary antiques. The bisexual god of wine stands in a precarious contrapposto pose, brandishing the goblet whose contents have made him literally tipsy, while a grinning young satyr nibbles lasciviously at the grapes in his lower hand. His seductive androgyny, recalling the *Apollo Belvedere*, alerted sympathetic viewers to a double meaning behind his Neoplatonic role as "inspirer of divine ecstasy": Jacopo Sadoleto's literary dialogue *Phaedrus*, titled in imitation of Plato's defense of homosexual love, was set in the same garden.

Back in Florence from 1501 to 1504, Michelangelo carved his colossal marble *David*, the most familiar and revered icon of Renaissance aesthetics and modern gay culture. His eighteen-foot nude colossus imagines not Donatello's biblically correct adolescent, but a magnificently muscled young adult, glowering and snorting in anticipation of grappling with Goliath. The statue's official symbolism was both religious and civic—David was the city's mascot—but since Donatello the subject had resonated erotically, and Michelangelo here epitomizes male beauty and

barely restrained physicality. The artist identified psychologically with the plucky hero—whom he transformed to someone nearly his own age at the time—and perhaps sexually as well. Although his private fantasies remain implicit, they must have been widely shared. The potential of the statue's anatomical frankness to stimulate viewers moved the embarrassed city fathers to order the first fig leaf (actually a whole waistband) soon after it was erected in the town square.

In a painting from the same time, Michelangelo visualized both his susceptibility to the classical male body and the lifelong conflict he suffered over it. *The Holy Family with Saint John the Baptist,* known as the *Doni Tondo,* spotlights Mary, Joseph, and baby Jesus against an ambiguous background of nude Greek men lounging in intimate poses; between them, a child John gazes forward adoringly toward his cousin. One appealing interpretation sees in this symbolic sandwich three stages of moral progress, from paganism through John's Judaism to the ultimate Christian revelation. Michelangelo had bought himself a pretext to expose male beauty, but at the price of conceding that such temptations are sinful vestiges of a benighted antiquity and the greatest earthly obstacle to the higher love of God. He began writing poetry at this point, a lifelong avocation that provides the most revealing window on any artist's inner life up to his time, and the first in-depth exploration of homoerotic feelings. His many lamentations over the irresolvable dilemma that "keeps me split in two halves" (poem 168) reveal him as both a passionate pagan and a passionate Christian, caught like John between two worlds: his own deepest desires and the fear of punishment.

Over the next four decades Michelangelo infused his great religious commissions, among them several defining monuments of Christendom, with the same barely suppressed homoeroticism. When called by Pope Julius to fresco the Sistine Chapel ceiling in the Vatican (1508), he surrounded his famous nude Adam and Noah with ornamental figures of powerfully twisting athletes. Later, adding the *Last Judgment* to the Sistine's altar wall, he imagined even Christ and his apostles in brawny Hellenistic bodies, and showed one male couple embracing in the bliss of heavenly reunion. Among a series of large nude figures for Julius's tomb, including the so-called *Dying Slave,* he fused the heroic ideal of David and the languorous passivity of Bacchus into an allegorized exaltation of pagan eros.

Not every homosexual artist was as introspective or agonized as Michelangelo. His contemporary, the Sienese Gianantonio Bazzi (1477–1549), flaunted his eccentricities in public. A fashion plate who kept a menagerie of exotic animals and, though married, an entourage of foppish boys—whom Vasari primly recorded "he loved more than was decent"—Bazzi was soon mockingly labeled "Il Sodoma," the sodomite. When one of his horses won a race, Bazzi defiantly insisted the heralds announce him by his derogatory nickname—arguably the first "coming out" in Western history. For

3.10. Sodoma, **Saint Sebastian**, ca. 1542 (oil).

Agostino Chigi, the papal banker, Sodoma decorated a pleasure retreat, now the Villa Farnesina, in suburban Rome. In the bedroom Chigi shared with his mistress, he frescoed the appropriately flattering subject of the *Marriage of Alexander the Great and Roxana* (color plate 7). The mural illustrates Lucian's Greek *ekphrasis* of a famous painting by Aëtion; faithfully reproducing such written descriptions, all that remains of ancient works, was a favorite test of virtuosity for Renaissance painters. Sodoma accurately shows romping cupids

undressing the princess on her nuptial bed as the conqueror approaches with a bridal crown. To the right is the couple's "best man and helper," none other than Alexander's beloved Hephaestion, "leaning on a very handsome youth," the marriage god Hymen, who recalls the *Apollo Belvedere*. Alexander's bisexual lovelife apparently appealed to the patron as well as the painter: elsewhere in Chigi's palace the scandal-mongering bisexual writer Pietro Aretino reported an antique marble of a satyr assaulting a boy.

Sodoma also carried on the tradition of exploiting the nude beauty of Christ and male saints, whom he wrapped in Leonardo's soft androgyny and smoky mystery. His *Saint Sebastian* (fig. 3.10), again adapted from his favorite *Apollo Belvedere*, depicts the Roman soldier who was martyred when he tried to use his intimacy with the emperor Diocletian on behalf of fellow Christians. Bound to a tree, blood dripping from his arrow wounds, he writhes in an ecstasy of helpless suffering for love open to multiple personal interpretations, from sadomasochistic fantasies to the artist's veiled comment on his own public "martyrdom."

Although we can only surmise Sodoma's reaction to his own image, we know the erotic allure of Sebastian from another version of the popular saint, painted by the monk Fra Bartolommeo as a Christianized Bacchus. When women parishioners admitted in the confessional that the beautiful nude prompted unclean thoughts, the anxious churchmen removed it to their own quarters. Vasari's tale of this incident leaves unspoken (perhaps because it was even more unsettling) what thoughts the image provoked in its priestly male audience—who presumably knew the legend of Diocletian's love for his favorite and were proverbial for homosexual affairs that, in some cases, were tender and long lasting. The canon Luigi Fontino, hauled before a church court in Loreto in the 1570s, justified his sexual dalliance with a choirboy by his hope "to have a disciple who could take care of me in my final years."

Michelangelo, more conflicted and sober than Sodoma, vented his ambivalent affections privately in a series of gifts for Tommaso de' Cavalieri, a handsome and cultivated young Roman nobleman who became the great love of his life in 1532. These drawings, letters, and especially poems—the first large group of vernacular love lyrics addressed by one man to another—pay a multilayered homage to the Neoplatonic ideal he found in this singular youth, confessing a wide range of conflicting feelings in complex and revealing "visual love letters."

Two paired drawings set forth the inextricable joy and pain of love. In the *Rape of Ganymede* (fig. 3.11), the familiar youth's swooning ascent to heaven in the pinions of Jupiter's eagle mirrors the uplifting ecstasy of passion expressed in poem 89: "I fly, though lacking feathers, on your wings." Neoplatonists seized on this image to illustrate their moral emblem books, where it symbolized the soul "rejoicing in God," and Michelangelo's humanist friend Benedetto Varchi lectured publicly on the chaste ideal of "Socratic love" in the

Tommaso poems. But Varchi had a homosexual reputation better documented than Michelangelo's own, and the artist knew the myth's erotic side from Poliziano.

Ganymede's companion piece, the punishment of lecherous Tityos for attempting to rape Apollo's mother, symbolized Michelangelo's tormented fear of retribution for acting on such guilty desires. Calling himself "an armed cavalier's prisoner" (a pun on Tommaso's name), he lamented that "my senses and their own burning have deprived / my heart of peace" (poems 98, 291). That anxiety grew partly from internalized theology and partly from external society, since all Rome gossiped about him, and the unscrupulous Aretino later attempted blackmail. Adding to his suffering, the heterosexual Cavalieri, while deeply touched by this attention, couldn't respond in kind, though he remained a devoted friend down to the artist's deathbed. Though only partly successful as courting gifts, the pictures and poetry remain the romantic as well as artistic high point of early modern homosexual self-expression.

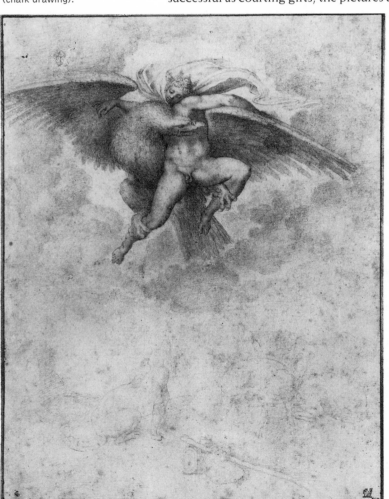

3.11. Michelangelo, **Rape of Ganymede**, 1532–33 (chalk drawing).

Even before meeting Cavalieri, Michelangelo had betrayed his fascination with helpless enslavement. The marble *Victory* for Julius's tomb (ca. 1530) depicts a lithe, muscular warrior kneeling on the back of his crumpled victim, whose sad bearded face seems a metaphorical if not literal self-portrait. The theme of youthful beauty overwhelming a mature man, strikingly similar to Donatello's *David* and Leonardo's lovesick sketching of Salai, foreshadows a Cavalieri poem in which Michelangelo groans that "to be happy, I must be conquered and chained." Officially, what is being subdued and bound in the *Victory* is sin or political foes; but viewed as personal projections, such recurring images of dominance and submission reveal an emotional pattern suggesting that the balance of power in homosexual artists' amours often tipped toward the younger partner.

Michelangelo's private confes-

sions and Sodoma's public one are milestones on the path to a homosexual consciousness, signaling an embryonic conception of individual and even group identity that may be termed "early modern." Sporadically, some men seem to have understood themselves to possess a distinct personality type—or at least they knew that others thought they did. Astrology, then a respected science, offered one natural explanation for different sexual orientations: Michelangelo told his biographer Condivi that he had been born during a heavenly conjunction of Mercury and Venus, a horoscope believed since Ptolemy the Greek to produce men more passionate toward boys than women. Some of these men shared a further consciousness of their common desire, protested being stigmatized for it, and even flaunted their disrespect for cultural norms. Leonardo kept his grievance about his tenuous legal situation to himself, but soon the young Florentine sodomites of the Compagnacci harassed their Savonarolan harassers, and in 1512 a similar group petitioned authorities to release their friends jailed for this offense.

Sodoma was the most outspoken in his contempt for others' contempt of him. Vasari, who considered his morals "beastly," recorded with disgust that the painter's insulting nickname "not only failed to trouble or anger him, but he took pride in it, making stanzas and satirical poems on it which he sang very prettily on his lute." Sodoma's ironic clowning would today be labeled "camp," a humorous counteroffensive from the margins of respectability. But slapping society in the face risked more than a historian's raised eyebrow. When he insisted on being called out as "Sodoma" at the horse race, spectators protested such effrontery; in the ensuing mob uproar, he narrowly escaped being stoned.

As Sodoma and his ilk loomed larger over the cultural battlements, church and state teamed up to fend off their public self-expression. Besides sodomy statutes, which spread to England and Germany, for artists this meant censorship. In 1524 Raphael's assistant Giulio Romano made a series of unabashedly contemporary drawings of various *Modi*, or positions of heterosexual intercourse, which were engraved and published in Rome, each accompanied by a grossly comic sonnet from Pietro Aretino. Their attempt to cash in on a lucrative market did not impress the pope, who burned the prints and imprisoned the engraver. In condemning such erotica as "pornography," Clement VII acknowledged the new mass medium's revolutionary potential to arouse a far broader spectrum of the public than any local altarpiece or palace mural (like the bisexual frescoes in his own Villa Madama), which raised the threat of ungodly stimulation spreading outside a politely Neoplatonic elite. Official suppression of offending images and texts was compounded by artists' own fearful self-censorship and the bowdlerization or evasion of sexual content by later critics, translators, and historians.

Although the *Modi* affair established that unvarnished realism was beyond the visual pale, erotic prints on safely mythological themes found a growing market through the sixteenth century. Countless heterosexual subjects were

joined by the panoply of familiar classical boy lovers, from single scenes of Apollo dandling Hyacinthus or the affectionate shepherds of Virgil's *Eclogues* through whole series of the bisexual loves of the gods, which were engraved after Giulio and his friend Parmigianino by Jacopo Caraglio, Cherubino Alberti, and many northern Europeans.

COURTLY CULTURE: NORTH ITALY AND BEYOND

The tolerant atmosphere of central Italy was magnified in the north, where wealthy noble courts indulged in splendid excess of all kinds. The pleasure-loving rulers of Ferrara, Mantua, and Milan supported artists and writers who treated homosexuality, whether lyrically or comically, as one familiar part of a robust and generally guilt-free bisexuality. Michelangelo's counterpart and rival in High Renaissance Venice, the painter Titian, illustrated a series of erotic myths for the Duke of Ferrara, including a scene of "The Worship of Venus" in which the throng of kissing and embracing cupids that frolic around her statue, following the classical *ekphrasis*, are all boys, and one older male youth chases another under the benevolent gaze of the love goddess.

This Dionysian mood prevailed nowhere more than in Mantua, where Poliziano's *Orfeo* had premiered in 1480, now ruled by the hedonistic, sometimes irreverent Duke Federigo II Gonzaga. When Aretino and Giulio Romano needed a refuge after their pornography scandal, Federigo—who took their Roman disgrace as a letter of reference for an erotic sensibility matching his own—eagerly provided it. As chief court artist for two decades, Giulio designed Federigo's palaces and coordinated the army of collaborators who filled them with bisexual epics frankly intended to stimulate. Aretino reported enthusiastically to Federigo that a nude Venus statue the Duke had commissioned was turning out "so lifelike that it will fill the mind of whoever looks at it with lustful thoughts."

About 1530, the Parmesan artist Correggio contributed a series of *Loves of Jupiter* to the Palazzo del Te, Federigo's hideaway for his mistress, including among numerous female amours Ganymede being swept aloft by the familiar eagle (color plate 8). The first large-scale oil painting of this myth, it delights the viewer with the golden Leonardesque glow of subtly modeled flesh and the rosy drapery that flutters upward in the rush of sudden ascent to reveal his soft legs and buttocks. The eagle's tongue licks Ganymede's luscious wrist while the boy twists his head to look coyly out at the viewer, with parted lips and direct eye contact that suggest both surprise and arousal.

The official justification for these subjects was, as usual, Neoplatonic allegory. But the youth's androgyny makes him almost a twin of the female nymph

paired with him, and suggests another meaning grounded in everyday reality. Wealthy and powerful male adults preferred their sexual partners subordinate in gender, age, or social status, and these indiscriminate pleasure-seekers considered boys interchangeable with women because of the still "feminine" physical characteristics of beardless, high-voiced, smooth-skinned adolescents. Humanists knew all too well that their elevated philosophy could sound like an invitation to sodomy: in his *Book of Love* (1525), the Mantuan Mario Equicola took pains to insist that "not a word of this work is to be understood as the love of boys or sexual acts against nature."

Well he might worry: even Aretino, whose poems for the *Modi* boastfully mock passive homosexuals as unmanly, confessed (not entirely honestly) that a new girlfriend had converted him "from that which he was born, a sodomite." So many nobles had sexual relations with their pages—upper-class youths who served them as an apprenticeship in courtly skills—that the ruler of Urbino ordered the boys to sleep alone. Portraits of noblemen with their pages by Paris Bordone and others attest to emotional and physical intimacy; one anonymous painting shows a page lacing the pantaloons of the bearded Venetian Alessandro Alberti next to his projecting codpiece (a padded sock showing off the penis). Stableboys, craftworkers, and laborers were fair game for gentlemen and each other: Giulio's fresco in the Te's garden grotto shows a company of male harvesters dozing in the noon heat, among them three couples wrapped in positions of lazy affection.

Men's preferred activity with boys, anal intercourse, is hinted at by the exposed backside of Correggio's *Ganymede*, a motif more blatantly repeated in the work of another friend of Giulio and Aretino, Francesco Parmigianino. Many images by this reclusive, eccentric bachelor spotlight the rear view of Ganymede or other adolescents, often copied from the *Apollo Belvedere*. In contrast to Correggio's sunny innocence, *Cupid Carving His Bow* conjures a typically icy, psychologically disturbing mood (stylistic and sexual traits shared with his Florentine contemporaries Jacopo Pontormo and Agnolo Bronzino). In a variation on the hoary theme of youth overwhelming maturity, Parmigianino depicts the curly-haired god coolly shaping the weapon that will inflame men's desire. He treads nonchalantly on two books, flaunting his supremacy over the intellect, and looks over his shoulder to confront the viewer dispassionately. The books remind us that anal sex was stereotypical among the educated classes: the poet Ludovico Ariosto's *Satires* (1525) asserted that "few humanists are without that vice," reporting slyly that "the vulgar laugh when they hear of someone who possesses a vein of poetry, and then they say, 'It is a great peril to turn your back if you sleep next to him.'" The same mocking humor was turned on the notorious clergy: an early sixteenth-century painted ceramic plate (fig. 3.12) depicts a seated monk pointing at the buttocks of a nude boy while brandishing a money bag. The Italian caption reads "I am a monk, I act like a hare," recalling the medieval bestiaries that

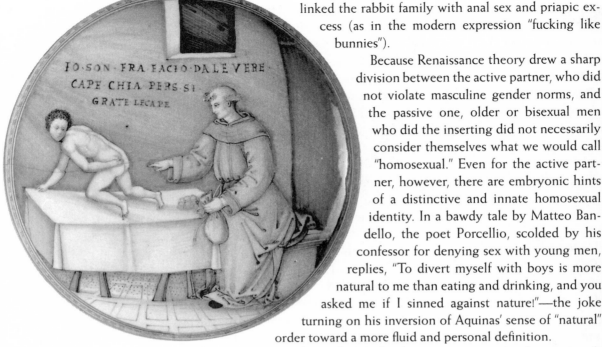

linked the rabbit family with anal sex and priapic excess (as in the modern expression "fucking like bunnies").

Because Renaissance theory drew a sharp division between the active partner, who did not violate masculine gender norms, and the passive one, older or bisexual men who did the inserting did not necessarily consider themselves what we would call "homosexual." Even for the active partner, however, there are embryonic hints of a distinctive and innate homosexual identity. In a bawdy tale by Matteo Bandello, the poet Porcellio, scolded by his confessor for denying sex with young men, replies, "To divert myself with boys is more natural to me than eating and drinking, and you asked me if I sinned against nature!"—the joke turning on his inversion of Aquinas' sense of "natural" order toward a more fluid and personal definition.

3.12. Master C. I. (Italian), **Monk and Boy,** 16th century (majolica plate, detail).

The plethora of terms for the passive partner imply a personality as much as an act, and a rudimentary psychological theory about such men. *Ganymede* and *cinaedus, androgyne* and *hermaphrodite,* all borrowed from antiquity, jumbled effeminacy, youthful androgyny, transvestism, and homosexuality into a constellation of gender transgressions that marked a psychic hybrid amounting to a third gender. In a mocking comedy Aretino wrote for Federigo's court theater, *The Stablemaster,* an actual employee described as "reluctant with women" is pressured into marrying the duke's page, who is disguised as a girl; when the practical joke is uncovered the randy groom declares himself "as happy to find the youth male as he had been sad to believe he was female." Nonplussed by this erotic bedlam, the character of the Pedant grumbles, "Mantua is full of hermaphrodites."

This sexually sophisticated life and androgynous art spread to northern European royalty in the later sixteenth and seventeenth centuries. The bisexual King James I of England and Scotland doted on his younger favorites and fondly called himself the "widow" of his adored Duke of Buckingham. The Flemish artist Anthony van Dyck was a fixture at court, where he painted many "friendship portraits" of paired male aristocrats. James's Lord Chancellor, the philosopher Francis Bacon, wrote a proper platonic essay on this passionate friendship, which he elsewhere called "masculine love"—again implying an innate emotional trait. But Bacon wasn't telling all he knew about such relationships: even his mother knew that he slept with his servants. This circle no doubt took to van Dyck for his exquisite sensitivity to adolescent beauty: he

painted Sebastian and Christ as androgynes caressed by youths and angels, and endowed the unusual scene of the Greek inventor Daedalus fastening wax wings on his ill-fated son, Icarus, with an implicitly pederastic intimacy.

In Prague, the German emperor Rudolf II, a mystical recluse who raised a large family with his mistress but refused to marry, made his Bohemian capital an international center of art, science, and alchemy. An eager patron of erotic art, he commissioned or collected mythological nudes, both male and female, and maneuvered for twenty years to buy Correggio's *Ganymede* and Parmigianino's *Cupid*. Among paintings and sculptures by scores of Mannerist artists working for Rudolf, Hans van Vianen's silver reliefs of gracefully elongated nude male gods seem especially attuned to the bisexual audience at court.

FRANCE AND SPAIN: HERMAPHRODITES AND AMAZONS

Among libertine aristocracies, the royal court of France briefly towered over all others—literally so, when the flamboyantly effeminate King Henri III wore high heels and a dress to official functions. Centered around the country château of Fontainebleau, where Italian artists first exported the Renaissance, the nobility cultivated what long remained a stereotypically French mixture of refined sensuality and nonchalant wit. Henri was a dissolute spendthrift whose liaisons with his male favorites, or *mignons*, were infamous: one courtier, the Sieur de Caylus, was nicknamed "Culus," a pun on the French for rectum. Enemies attacked the greedy mignons in print for draining the public purse, and worse. A satirical fable published after Henri's death, Thomas Artus's *Island of the Hermaphrodites*, illustrated a citizen of this realm dressed in male breeches and a female hairstyle, and imagined its ruler, "King Woman," luring powdered and painted boys into his chamber of sexual mysteries, embellished with tapestries woven on such suggestive themes as Hadrian's love for Antinous.

Complementing extravagant male homosexuality, French culture developed from its Italian sources an exceptional, if narrowly focused, interest in sex between women, which persisted into the eighteenth century. Pretexts for women together included both everyday life and mythology, especially the goddesses Diana and Venus, often depicted in the same print medium that served the market for male-male and heterosexual erotica. A genre scene of women bathing (fig. 3.13), engraved by Jean Mignon in the 1540s, provides a peek inside women's private world similar to Dürer's bathhouse (or a women's bath engraved by Hans Beham), with the same erotic potential. Among the dozen elegant nudes luxuriating in food, drink, and languorous warmth, a seated couple at the right embrace: one fondles the crotch of the other, who reciprocates by slinging her leg over her partner's in a gesture that, as art historian Leo Steinberg observed, signified sexual aggression. Artists and print-

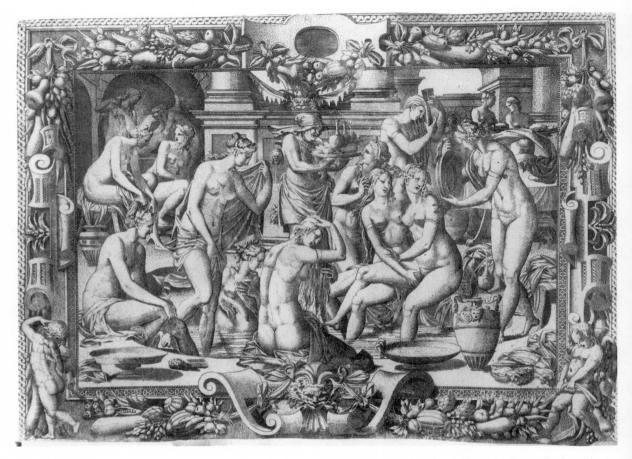

3.13. Jean Mignon (after Luca Penni), **Women Bathing,** 1540s (engraving).

makers were especially fond of illustrating this affection through the adventures of Diana: her Amazon retinue, bathing and cavorting often quite lustily, remained popular from Italian majolica to painting under Rudolf II and in the baroque Low Countries.

All this visual attention did not, however, signal an upswing in lesbian culture. Women artists and patrons still being rare, such images were created by and largely for men: many Dianas were flattering allegories of Diane de Poitiers, mistress of Henri III's father. The male appetite for female intimacy was spurred not by lesbian experience for its own sake, but titillation complicated by anxiety. Nude women offered a stimulating morsel for a man's gaze, spiced by the thrill of spying on the mutual erotic play that, to his ego, could amount to little more than an appetizer for the main course. The most striking evidence that male culture did not take lesbian sensibilities seriously comes from the French scholars who rediscovered Sappho's poetry, first partially published in 1546. Faced with the lone ancient voice of women love, however prestigious, these commentators simply refused to acknowledge the gender of her idols, even reinterpreting them as male.

Not that lesbianism was unknown: Pierre Ronsard and other male writers imagined women speaking of mutual desire, as did the unusually sympathetic English poet John Donne in his "Sappho to Philaenis." The nobleman Pierre de Brantôme, in his cynical memoir *The Lives of Fair and Gallant Ladies*, observed its prevalence around 1580 using a borrowed Italian term, *donna con donna*, or "woman with woman"—precisely the offense, according to the traveling philosopher Michel de Montaigne, for which a cross-dressing Frenchwoman was hanged that same year. Montaigne's influential essay exalting male friendship as the highest form of intimacy reveals how misogyny contributed to the belittling of lesbianism: women lacked the essential tools for social as well as sexual intercourse. With notable exceptions, they could not attain the intellectual and spiritual education that sustained true platonic understanding between men. Paradoxically, since women were improved by modeling themselves on the superior sex, some male observers granted contemporary females' active pursuit of each other a grudging respect: Brantôme wrote, "'Tis much better for a woman to be masculine and a very Amazon and lewd in this fashion, than for a man to be feminine."

Given such conflicting assumptions, it is hard to decipher a unique image from Fontainebleau that depicts Gabrielle d'Estrées pinching her sister's nipple as the aristocratic pair relax together in a bathtub (color plate 9). Does her physical playfulness indicate incestuous sexual arousal, or do the gravely laconic faces suggest a more platonic form of sisterly *amicitia*—or some of both? The court would have framed its interpretation within her primary role as the mistress of King Henri IV and, following Montaigne, would have doubted the depth of comradeship possible between mere women. If d'Estrées is an Amazon, she is their queen Hippolyta, ultimately to be conquered and wed by the Athenian king Theseus.

The most elaborate and lushly sensuous depiction of the Amazon myth was a triad painted by Titian for King Philip II of Spain, part of a series from the 1550s including heterosexual women loved by the gods, called *poesie* because each evoked visually a poetic Ovidian tale. The dour Philip, while a staunch supporter of Catholic orthodoxy, was not above looking at beautiful nudes. But his Dianas entangle such pleasure in ambivalence, both moralizing it through Neoplatonic symbolism and providing fantasies of resolution, good or ill, for men's fears about women alone together.

Diana and Callisto treats one of the nymphs sworn to avoid male company, who consented to Jupiter's advances only when he slyly transformed himself into a transvestite image of Diana. Many artists seized on this pretext for an amusing visual pun, allowing the viewer to enjoy a surface "lesbian" seduction all the while knowing that underneath it's not as deviant as it looks. Such temporary violations of gender norms, including cross-dressing and mistaken identity, were stock comic devices in Renaissance theater, though the final curtain usually restored proper sex roles: as Shakespeare, who often exploited

these effects, put it, "All's well that ends well." Or, as in Titian's canvas, not so well: he illustrates a later episode, when Callisto's pregnancy by Jupiter is exposed to her goddess's avenging outrage—a plot twist comforting to the male assumption that a woman needs a phallus for fulfillment.

Its companion *Diana and Actaeon* (fig. 3.14) illustrates the tragic mortal hunter who stumbled upon the forbidden sight of goddess and nymphs splashing nude in a forest grotto. Here the sumptuous, fleshy women, interrupted while bathing and toweling one another, recoil in shock and anger; the third painting shows the violent retribution of Diana, who turned Actaeon into a stag to be devoured by his own hounds. As a projection screen for male psychology, Actaeon's misadventure intercuts voyeuristic curiosity about female sexuality with a fear of punishment for gratifying that temptation. As for what

3.14. Titian, **Diana and Actaeon**, 1556–59 (oil).

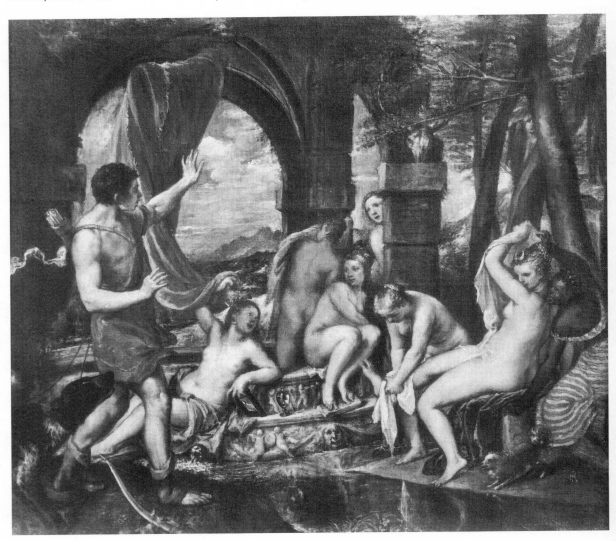

women saw in these potential self-images, although Brantôme tells us a receptive audience existed, as with earlier images like Zoan Andrea's (fig. 3.5) we lack their first-person testimony.

EUROPE MEETS THE WORLD

In the sixteenth century, the wealth and might of Philip's Spain dominated Europe, thanks to its early lead in the feverish scramble for overseas trade and colonies that was ignited by his ancestors' financing of Columbus, and which soon swept every Atlantic nation from Portugal to Denmark. As exploration and conquest penetrated the Americas, Africa, and Asia, new or more frequent encounters with non-Europeans contributed the opening chapters in the long and often shameful saga of cultural confrontation that spawned our modern global society. On every continent, the eyes of soldiers and missionaries fell upon some form of homosexual or lesbian sexuality and an artistic tradition that celebrated it. Rather than viewing these cultures on their own terms, the Westerners refracted foreign ways through the prism of their own values, which distorted and condemned what they beheld.

The Spanish paved the way culturally as they had geographically: occasional erotica for Philip and his family aside, they tended to a zealous puritanism that sought to stamp out erotic excess at home and abroad. And they found much to offend, particularly in the major centers of Mexico and Peru: the chronicler López de Gomara huffed that the natives "are sodomitic like no other generation of men." Before their conquest by Hernán Cortés in the 1520s, the Maya, Aztec, and other peoples in what is now Mexico and Central America had a thousand-year history of densely urban society that, although sometimes prudish about public behavior, worshipped a hermaphroditic love deity through ecstatic homosexual communion with temple prostitutes. In the Maya regions of Yucatán and Veracruz, the Spanish reported transvestite boy prostitutes and private orgies; from Panama to Florida, various societies featured an honored class of cross-gender male berdaches who played a female role like that of the North American Indians.

Franciscan and Jesuit missionaries preached against sodomy to the uncomprehending natives. When persuasion failed, their strategy against immorality was twofold: banning all native rituals and obliterating written and visual evidence of them. The Spaniards' chronicles of their pious vandalism inadvertently preserve almost the only traces of pre-Columbian homoerotic art: in his *Natural History of the Indies* (1535), Gonzalo Fernandez de Oviedo y Valdés boasted of righteously smashing with his own hammer a Colombian gold relief depicting "a man mounted upon another in the diabolic and nefarious act of Sodom." Other lost art included pottery figurines and large wooden temple sculptures depicting male sodomy (in the Yucatán), much goldwork that was

melted into ingots, and murals depicting both heterosexual and male-male intercourse in private homes along Mexico's Pacific coast, where Nuño de Guzmán denounced them in the 1530s. (Maya cave paintings at Naj Tunich showing homosexual lovemaking, unknown to the Spanish, were discovered in 1979.)

A uniquely sympathetic exception is the encyclopedic *Florentine Codex*, compiled by the friar Bernadino de Sahagún to preserve the vanishing remnants of Mexican culture, and illustrated by native artists in a hybrid of local and European styles. Sahagún's lengthy discussion of male and female homosexuality is accompanied by a painting of two men seated together with a flower growing between them. Apparently the pictorial translation of a term for "homosexual" in the Nahuatl language, which associated eros with flowers, this image may descend from similar lost works that imply some knowledgeable toleration (the *Codex* also suggests that practitioners were treated with humor or disdain, though it is hard to disentangle Sahagún's version of earlier days from the already widespread influence of Christianity).

The troops and priests of Cortés's South American counterpart, Francisco Pizarro, were similarly shocked by sodomy in the Inca Empire. Curiously, any known homoerotic pottery produced there was already old upon their arrival: the few ceramics to survive their iconoclastic zeal date back to the prehistoric Mochica and Vicus peoples (see Introduction). Westernized museum staffs later banished such pieces to storage and even destroyed them, out of an acquired national embarrassment, as late as the beginning of this century.

Nor did the conquistadors confine their violence to inanimate objects. On his march to the western shore of Mexico, Nuño captured a man dressed as a woman, purportedly for prostitution, and burned him. An engraving from 1590 (fig. 3.15), illustrating the chronicle of Vasco Núñez de Balboa's 1513 trek across the isthmus of Panama, graphically depicts his troops setting their dogs upon cross-dressing men whom they took to be sodomites, though they were more properly, perhaps, berdaches. The caption tells us that Balboa ordered forty men from the royal retinue of the Cueva people torn apart for their "detestable" acts. By elevating the clothed, erect, and armed soldiers above the cowering, naked, and feminized locals, the composition visualizes the manly heterosexual Spaniards' moral superiority.

This print illustrated one of a lengthy series of travel accounts of *The Great Voyages* to the New World, issued in Germany by the engraver Theodore de Bry and his family from 1590 into the 1630s. As a Protestant émigré from Spanish-occupied Flanders, de Bry never missed a chance to caricature his Catholic oppressors as cruel and bloodthirsty; but here his image, like its source in a Spanish veteran's memoir, seems to justify their actions as righting the inverted gender order. Illustrations to other authors' more objectively anthropological volumes depict the berdaches of a Florida tribe performing women's work, such as carrying food, or spiritual and healing functions.

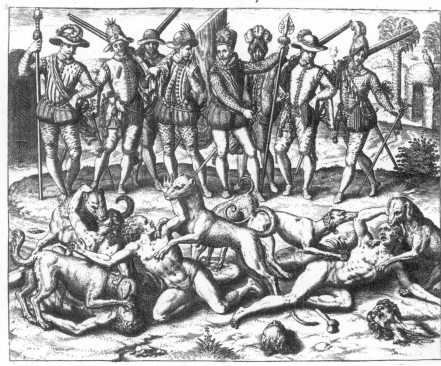

3.15. Theodore de Bry, **Balboa Feeding Indian "Sodomites" to the Dogs**, 1590 (engraved book illustration, **America**).

Pre-Columbian art is treated here, as incompletely as it must be at present, because it all but ceased to exist under this onslaught, even in the historical record. As Europeans fanned out farther across the globe, they encountered other ancient civilizations in the Islamic regions, India, China, and Japan. Stronger militarily and less vulnerable to exotic diseases from another hemisphere, these cultures survived the contact and preserved their own evolving traditions, which are the subject of the following chapter.

REFORM AND REACTION:
MICHELANGELO AND CELLINI

By the time de Bry, a religious expatriate, illustrated a distant massacre from many decades ago, hostility toward sodomites back home was riding the crest of a wave of moral and aesthetic offensives against all deviance. Dragging on for more than a century after Martin Luther nailed ninety-five proposals for reform to the door of a German cathedral in 1517, the doctrinal and civil wars of the Protestant Reformation ultimately split Europe into two antagonistic and fragmented camps. Sexual orthodoxy was one handy weapon in the battle for

public opinion: Protestants denounced Rome as a "cistern full of sodomy," while Catholics returned the dubious compliment to Geneva, stronghold of Luther's rival theologian, John Calvin. Pressure toward sobriety intensified the perennial conflict between pagan and Christian; when the Catholic Church retaliated with an aggressive campaign of moral housecleaning and propaganda known as the Counter-Reformation, the balance of power tipped toward ascetic control.

The Catholic purge was codified by the Council of Trent, whose decrees, issued the year Michelangelo died, in 1564, sought a return to medieval purity and monastic simplicity. Through a series of reforms in everything from liturgy to music and the arts, the Trent cardinals imposed stricter controls on moral and doctrinal laxity, submitting artists to surveillance by their local bishop. They saw not only antiquity as the enemy, but its Renaissance reincarnation: labeling the pagan gods false and lascivious, they denied the uplifting parallels that Neoplatonists had worked so hard to draw between ancient and Christian beliefs. As the church expelled nudity or pagan subjects from religious art, and leaned its moral weight against them even in private settings, mythology gradually declined to a set of conventional fairy tales suitable for minor decoration.

Artists felt the drastic effects of this intolerance both practically and psychologically. Because art could now represent only virtue, even the older pretext for depicting homosexuality as a moral contrast disappeared (in Protestant areas religious painting itself all but disappeared, reviled as an idolatrous "graven image"). Responding to the threat of Protestant subversion via the burgeoning mass media, in 1557 the church formalized print censorship through the Index of Prohibited Books. Such control, as we saw with Giulio's *Modi*, could extend to printed images, and to painted ones: the nudes in Michelangelo's *Last Judgment* were literally whitewashed in 1559. Succumbing inwardly to the ascetic climate, many artists disowned the classical erotica created in their youth and turned toward deeply personalized religious imagery.

The lowered threshold of public tolerance left an artist like Michelangelo vulnerable to the unscrupulous pen of Pietro Aretino, whose exploitation of potentially embarrassing gossip earned him the title "scourge of princes." In 1545, the first year of the Trent sessions, the father of yellow journalism fired off a letter to the master in which, after lambasting the nudity of the Sistine Chapel as "fit for a brothel wall," he attempted to extort some drawings, suggesting that an overdue gift to him "would have silenced all those spiteful tongues, who say that only certain Gherardos and Tommasos can obtain them." Considering that Aretino had once had to flee Venice to escape sodomy charges, his snide insinuation about Tommaso de' Cavalieri and another handsome young man reeks of hypocrisy.

In that same year, a similarly revealing incident befell Michelangelo's Florentine admirer Benvenuto Cellini (1500–71), a swashbuckling bisexual

equally famous for the Mannerist elegance of his sculpture and jewelry, his racy sexual exploits, and his colorful autobiography. In his prodigal youth, which included a sodomy conviction and other scrapes with the law, his erotic work had appealed to Federigo Gonzaga. But his highly selective life story, written while he was under four years' house arrest for sodomizing an apprentice in the late 1550s, indicates the chilling effect of the official crackdown. Although he tattles on the homosexuality of old Roman friends like Luigi Pulci, he denies or downplays his own publicly known homosexual exploits, even as he recounts his female conquests with boastful relish.

Cellini tells how Duke Cosimo I of Florence, a supporter of Trent, received an antique fragment of a male torso as a gift. When the sculptor proposed in front of the assembled court to restore it as a Ganymede, his rival Bandinelli blurted out, "Shut up, you filthy sodomite!" Cellini, who recalls being "choked with fury" at this blunt accusation, retorted, "I wish to God I did know how to engage in such a noble practice; after all, we read that Jove enjoyed it with Ganymede in paradise, and here on earth it is the practice of the greatest emperors and kings." His witty but halfhearted denial managed to defuse an embarrassing situation while dignifying homosexuality by the example of both ancient and modern authority.

3.16. Benvenuto Cellini, **Apollo and Hyacinthus,** 1545–48 (marble).

And in fact the Ganymede was only the first of three marbles on "such noble practices" that Cellini sculpted over the next few years, including a languid lone *Narcissus* and a life-size group of *Apollo and Hyacinthus.* It is tempting to read the last of these (fig. 3.16), carved immediately after the altercation with his nemesis, as a defiant visual retort; certainly the image had deep personal meaning, since Cellini kept it in his studio for the rest of his life. The lithe, sleek Apollo affectionately ruffles the hair of his kneeling beloved, as perhaps Cellini himself stroked the locks of young apprentices.

While the muscular adolescent twists his gaze adoringly upward, Apollo looks absently away, foreshadowing Cellini's own eventual distancing from his youthful passions. After imprisonment, he underwent a conversion to orthodox sobriety, married his mistress, and gave up erotic for religious themes. Yet the artist's appreciation for the male body lingered despite himself: his Escorial crucifix, showing Christ emaciated but totally naked, was sent to Philip II of Spain, who, far more shocked than by Titian's Dianas, draped a handkerchief over its loins.

Philip's impulse to police the arts also motivated the emerging profession of art criticism, whose commentators and theorists were eager to slap any deviation from the norms they laid down for gender and sexu-

ality alongside those for style and content. Ludovico Dolce's treatise *L'Aretino* (1557) favorably contrasted Raphael, who distinguished the appropriate physical qualities of each sex, with Michelangelo, who "does not know or will not observe those differences," since all his figures look like men. And Gian Paolo Lomazzo's *Book of Dreams*, written in the 1560s, imagined an interview between Leonardo da Vinci and the homosexual Greek sculptor Phidias, in which Leonardo nonchalantly concedes the truth of Phidias' query about Salai: "Did you perhaps play with him the game in the behind that the Florentines love so much?" Leonardo defends sodomy on platonic grounds, but the dialogue's cruelly facetious tone suggests that such classicizing struck a more orthodox audience, forty years after Leonardo's death, as ludicrous rhetoric.

The most eloquent and poignant testimony to the effect of these multiple pressures comes from Michelangelo. Although furious when the Vatican ordered loincloths painted over his Sistine nudes, he himself had long since turned his emotional energies away from his sublimated passion for Cavalieri. Having internalized Counter-Reformation austerity, he resolved the unbearable tension between profane desire and sacred ideal by renouncing any hope of earthly satisfaction. His later, equally intimate drawings and poems, all on religious themes, sprang from an autumnal spiritual friendship with Vittoria Colonna, a pious widowed poet he met in his sixties. Ultimately he rejected even this art, and creativity itself, as idolatrous distraction, declaring in one of his last poems (285):

> *Neither painting nor sculpture will be able any longer*
> *to calm my soul, now turned toward that divine love*
> *who opened his arms on the cross to take us in.*

BAROQUE URBAN CULTURE: CARAVAGGIO

In the wake of the Counter-Reformation, only one more major artist painted overtly homoerotic themes with personal meaning. Appearing near the end of the long Renaissance symphony, Michelangelo Merisi da Caravaggio (1571–1610) recapitulated all its themes. In his brief and stormy career, he resembled Cellini: a hot-tempered, swaggering bisexual often in trouble with the law, whose pictures, snidely characterized by a pious cardinal as somewhere "between devout and profane," depicted his own models and lovers. Caravaggio laid the foundations of the seventeenth-century baroque style, replacing Cellini's cool Mannerism with a direct appeal to the emotions and a promise of religious passion all but indistinguishable from its physical counterpart. The Catholic Church hoped to lure the masses back to belief by portraying remote sacred events as if they were happening in an ecstatic here and now to ordinary, even coarse commoners, whom Caravaggio depicted with the unvar-

nished realism called naturalism and dramatized by sensual poses and theatrical spotlighting, or chiaroscuro. He also exploited homoerotic mythology and genre, contributing to all these subjects another link in the chain of homosexual self-portraiture and personal confession.

Unfortunately, he left no letters or poems to help decode his private obsessions. But Caravaggio's tendency to project his own sensibilities into his work was far too blatant for the Roman church authorities who commissioned *Saint Matthew Inspired by an Angel* in 1602. His first version, showing a sweet, bearded peasant all but smothered by an androgynous angel who tangles himself into the saint's arms (to guide his hand writing the gospel), was rejected by the monks. The approved revision uncoupled the pair's erotic interlace and restricted the winged youth's stimulation to glancing and gesturing from a safe distance in midair.

As opportunities for public homoerotic imagery shrank, a compensating arena for private expression was opening. Caravaggio was fond of picking up Roman street urchins, who often modeled for his seductive pictures. Thinly disguised as Bacchus or Cupid (color plate 10), they stretch classical justification to its breaking point, while his sultry androgynous musicians all but dispense with mythic allusion. His unprecedented frankness results from a landmark in patronage: such pictures circulated among wealthy churchmen and nobles with pederastic tastes, the first subcultural network where we can identify not only the major clients and artists but their social contacts and viewing habits.

Many were commissioned by the cultivated and pleasure-loving Cardinal Francesco del Monte, the earliest known patron with homosexual interests who hired an artist to represent scenes with a common emotional appeal for both parties. A few were religious, but their potential for double meanings confused contemporaries: *Saint John the Baptist* was so sensually encoiled with a ram that when the picture was later sold it was assumed to portray Corydon, the lovestruck shepherd in Virgil's *Eclogues*. The more numerous mythological pictures depict scantily draped ephebes offering the viewer wine or fruit and, implicitly, themselves. Some are probably portraits of the precocious artist himself, then in his midtwenties, others of his clients' young entertainers and banquetmates from the streets and taverns, all identifiable to one another as members of a semiclandestine fraternity.

At times these pictures approach unadorned genre: the *Luteplayers* or *Musicians* (fig. 3.17) shows four half-clad boys (the right rear one perhaps another self-portrait) dreamily lost in tuning up before the very kind of performance often sponsored at del Monte's palazzo. This variation on the pastoral theme of music as the handmaiden of passion de-idealizes its classical roots: obviously far from fauns or shepherds, these are denizens of the contemporary demimonde that sold services to the elite, from music to sex. Numerous contemporary copies of all these pictures (and variations by Giovanni Lanfranco)

suggest there was a sizable demand for such subjects among like-minded Romans, creating a "homosexual market," the economic crucible of an emerging subculture.

For the nobleman Vincenzo Giustiniani, Caravaggio made more than a dozen paintings, including *Victorious Amor,* or *Cupid* (color plate 10), the culmination and swan song of openly homosexual expression in this period. Like Donatello and Michelangelo, Caravaggio imagines a youngster triumphing over symbols of mature judgment and responsibility, from the books and music of cultural life to the crown and armor of politics. In his blatant realism, this chubby preadolescent, as insolently warning as Parmigianino's *Cupid* but more gleefully tempting, is no ideal god but an exhibitionist ragamuffin, his leg caressed by a feather plucked from a marketplace chicken. The model may be the Giovanni Battista named in a libel suit brought by a rival painter in 1603 as his "bardassa," or catamite—a word borrowed from Persia, a civilization then proverbial to Europeans for boy love. Giustiniani hung *Amor* behind a green

3.17. Caravaggio,
Musicians, ca. 1595 (oil).

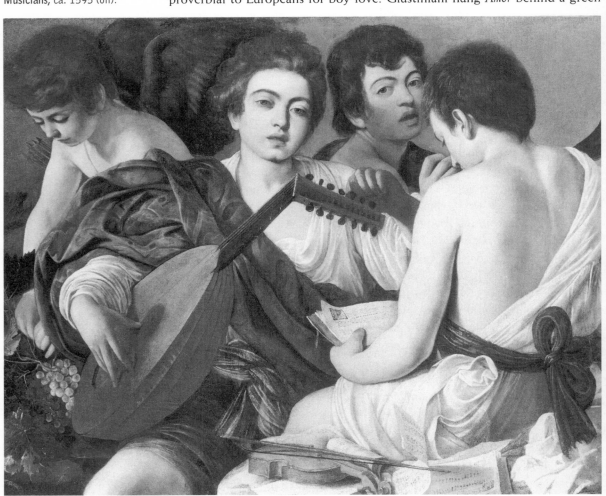

silk curtain that could be closed for artistic reasons or perhaps, discretion being necessary in such prickly times, when visitors less sympathetic than del Monte came to call. (He also snapped up Caravaggio's heavy-breathing version of Saint Matthew.)

Caravaggio was the first to borrow homoerotic motifs from an earlier artist who, he must have heard, shared similar tastes. Among many quotations from Michelangelo, *Amor*'s triumphant pose echoes the *Victory* of 1530, picking up the slender thread of a rudimentary "homosexual tradition" passed down from Poliziano more than a century earlier. Caravaggio's illustrious predecessor and namesake loomed over his shoulder as both role model and oedipal rival: invoking themes and symbols sanctified by Michelangelo, he simultaneously paid homage to these erotic precedents and mockingly reversed their genteel philosophy. He followed both Donatello and Michelangelo in painting the personally resonant theme of David, who wistfully contemplates the decapitated head of Goliath held in his outstretched arm. The gruesome, shaggy face, still gaping in mute horror, is a self-portrait, and David is another young beloved. Like the reverse of the psychic coin represented by *Amor, David* once again reveals the older partner's dread of "losing his head" in masochistic submission.

Caravaggio straddled the intersection of a declining Renaissance and a rising modernity. On one hand, his art represents the autumnal flowering of the classical synthesis, at least for overtly erotic images created by or for identifiable homosexuals—though the aging platonic tree produced sporadic later blooms with an aroma of sensuality: Caravaggio's contemporaries van Dyck and Guido Reni, a possible homosexual who delighted in painting the usual suspects from Apollo to Sebastian, and the Spanish baroque obsession with the sadomasochistic suffering of male saints and their ecstatic visions of Christ. But Caravaggio's life, on the other hand, reveals the foundations of a new social, sexual, and artistic order. As cities grew, the urban homosexual subculture that coalesced in the entourage of a few wealthy Roman aristocrats expanded beyond a learned elite to become increasingly visible and intermingled with the middle and working classes.

Considering that our knowledge of these networks comes from records of attacks on them, they were remarkably widespread and energetically creative. Several pairs of Portuguese men were "married" in a Roman church in 1578, apparently a survival of the same-sex unions of medieval times; the couples lived together for some time before police arrested and burned them. Late sixteenth-century Naples, the burgeoning metropolis of Spanish southern Italy, reported prostitution and cross-dressing, and the passionate homoeroticism of Spanish religious art, paralleled in the mystical poems of St. John of the Cross, would have been appreciated by the homosexual communities that the Inquisition turned up in Seville, Valencia, and around the royal court. Similar patterns were exported to the new world: Rio de Janeiro, capital of Portuguese

Brazil, boasted a subculture mixing native, European, and African customs, as obnoxious to the Inquisition as the one back home in Lisbon.

Thanks to the English literary Renaissance, London is the most richly documented community. To judge from ribald popular songs of the 1570s, common folk were titillated by the "Sodome and Gomorra" in their midst, and the poets Donne and Marston railed against tavern-brothels in the 1590s. Shakespeare wrote some of his plays for the court of the bisexual King James I, others for the new public theaters, a racy demimonde where transvestite boy actors provided more than thespian pleasures for bisexual spectators; the playwright's sonnets to a beloved woman and young man suggest that he knew whereof he wrote. Male passion was evoked most eloquently by his contemporary Christopher Marlowe, an underworld habitué whose dramas deal frankly with historical homosexuals, from England's medieval Edward II to the recently assassinated Henri III of France, and who reportedly declared that "all they that love not tobacco and boys were fools." Like the uppity Sienese who had scandalized Saint Bernardino, Marlowe dignified his predilections by appeal to biblical example, claiming that Christ and Saint John were physical lovers. Groupings of like-minded men in many cities increasingly solidified into the modern sexual subcultures that emerged fully by 1700.

As yet, women with women played little part in this subculture or its art. Since ladies above the laboring classes were generally sequestered at home, they had few opportunities for sexual contacts except in the notorious convents, and little wherewithal to be patrons. A provocative exception was the freewheeling Queen Christina of Sweden, who dressed in men's clothes, had at least one lesbian affair, and abdicated to avoid marriage. Christina devoted her later years to extensive art collecting; the preferences of such princely buyers, still largely unexplored, suggest that some of them sought to amass art-historical validations for their own erotic delights. Unlike her wealthy male contemporaries, unfortunately, Christina could have found little for sale representing a lesbian historical tradition; perhaps her purchase of a Roman male couple, the *Ildefonso Group*, was a kind of cross-gender substitute.

At the opposite end of the social spectrum, Moll Cutpurse, the "Roaring Girl" of early 1600s London, was only the most infamous of the "passing women," female transvestites whose escapades may have included lesbianism (though perhaps some of Moll's partners were fooled by her disguise). Unlike the privileged ex-queen, for such poor and marginal women cross-dressing was a risky strategy for economic and social independence in the male public world. In contrast to Brantôme, who thought masculine women relatively acceptable, courts considered lesbianism more grave the more it laid claim to male prerogatives: Spanish authorities sentenced two women to a whipping for sex "without an instrument," but penetration with a dildo earned two nuns the stake. Such creatures were rare in life and even rarer in art—too bizarre or terrifying to illustrate.

HETEROSEXUALIZATION

Throughout the seventeenth century, economics, politics, and religion all conspired to draw a permanent social version of Giustiniani's green curtain over both aristocratic libertinism and mass urban subculture. Not content to discourage positive self-expression, official culture tried several tactics to tar homosexuality in the public eye: issuing its own propagandistic images, trivializing or de-idealizing classical role models, and bowdlerizing the existing tradition. Art and literature were sanitized to fit an exclusively heterosexual, family-centered morality preached by both puritans and Catholic reformers, especially the prospering urban middle class, who increasingly empowered the state to police as crimes what had once been private sins.

Satirists and moralists quickly exploited mass printing to attack homosexuality: beneath the illustration of Henri III's androgynous courtier in his *Island of the Hermaphrodites*, Artus labeled him "neither male nor female," monstrous and depraved. By the late sixteenth century, printed news reports of punishment fed the public appetite for moral scandal, complete with gory details. The Flemish engraver Nicholas Hogenberg recorded a group sodomy execution in Bruges, showing two men whipped at the stake while three others in monk's robes prepare to be burned, all before a crowd in the town square. When the Irish Anglican bishop John Atherton was hanged in 1640 for the libertine combination of adultery, incest, and sodomy, an anonymous popular pamphlet described his trial and execution in tones of sanctimonious shock. The pointedly captioned "ende" illustration (fig. 3.18) shows Atherton and his lover, John Childe, swinging from their separate gallows—both wearing full beards, a rare visual testimony that Greek pederasty was not the only pattern for love between men.

The new moral climate in England was set in part by the sober King Charles I, notably in the court masque, or allegorical pageant, staged in his palace in 1634. *Coelum britannicum*, or "The British Heavens," represented Charles onstage as a

3.18. **The Life and Death of John Atherton,** frontispiece, anonymous pamphlet, London, 1641.

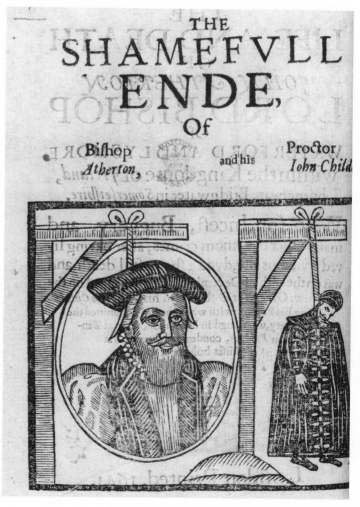

"new Jupiter" who rejected the frivolous excess of his father, James I, and vowed to cleanse its "loathsome stains" from the local skies. On the towering painted backdrop, the muscular giant Atlas knelt under the weight of a twinkling celestial globe, whose mythic constellations, each symbolizing a sin, were extinguished as the narrator read the relevant decree. Referring to the problem of beardless pages and grooms, he declared, "Ganymede is forbidden the bedchamber." Sodomy had become too scandalous to overlook; it had to be named (however indirectly) and its image ignominiously expelled from the public realm.

Similar pressures deflected art and society worldwide. When Michelangelo's nephew published his uncle's poems in 1623, he allegorized their evident male love as chastely divine or silently changed the sex of their original addressees. The same emasculation was performed on Shakespeare's sonnets when they were first printed in 1640, and through deliberate mistranslation of classical literature, particularly Sappho. When Claudio Monteverdi, the virtual inventor of Italian opera, composed his musical version of *L'Orfeo* (1607), he cut Poliziano's final episodes, which recounted Orpheus' turn to homosexuality, and tacked on a happy ending.

In a rare convent crackdown, the Italian nun Benedetta Carlini was sentenced to life imprisonment in 1623 for claiming to have seen visions of an angel who demanded that her cellmate masturbate her; the church condemned her not for lesbianism as such, but for blasphemy, invoking the old link between female sexual excess and heresy still alive in colonial Massachusetts at the close of the century. As exploration expanded, efforts to stamp out deviance were exported not only to British Salem but also to Spanish Mexico, where sodomites were burned in the capital about 1660 before a large crowd, and to China.

Art critics and historians, avid since Dolce to keep art in line with orthodoxy, matched the pace. The seventeenth-century commentators Boschini and Ridolfi, struggling to interpret Titian's painting now called *Il Bravo*, decided that its cryptic nocturnal encounter between a well-dressed young aristocrat and an armored tough who accosts him with drawn dagger must represent the virtuous Roman soldier Trebonius, who was pardoned after killing his superior officer to stave off an unwelcome sexual advance. Since no one before these critics mentioned this obscure historical episode, and no one else ever illustrated it, their vision of moral outrage probably tells more about baroque homophobia than the painter's Renaissance intent.

Titian was also subjected to the interpretive zeal of Peter Paul Rubens, the premier baroque artist in Flanders, a twice-married and devoted family man best known for the voluptuous ideal of buxom nude womanhood still called "Rubenesque," which he enjoyed doubly in a version of *Diana and Callisto*. His reverence for the Renaissance Venetians was only stylistic: copying Titian's *Worship of Venus*, he altered the master's embracing male putti and amorous ado-

lescents to boy-girl couples. His *Ganymede and Hebe,* painted in 1611, similarly stood classical sources on their head, by imagining Ganymede ceremonially receiving the cup of office from his predecessor as cupbearer, Juno's daughter Hebe. Most illustrations of this myth, by Parmigianino among others, "correctly" emphasized the sexual rivalry and violent animosity with which Jupiter ousted Hebe to replace her with his male favorite. Since antiquity, Ganymede's rancorous triumph had offered a misogynistic parable for the superiority of male over female lovers, most recently invoked by Marlowe's dialogue between Jupiter and the newly ensconced boy, whom he dandles on his knee while laughing at Juno's disgruntled rebellion. But Rubens, who may have intended Ganymede as the soul of his recently deceased brother being welcomed to heaven, neutralized the original myth's tension between homo- and heterosexuality, and the resultant potential for conflict between husband and wife, so foreign to his own family and morality.

Such threats could also be neutralized more directly: Rubens's Flemish compatriot, the sculptor Jérôme Duquesnoy, was strangled in 1654 for committing sodomy with two boys in the church in Ghent where he was working. The Flemish ruler Archduke Leopold Wilhelm, whom Duquesnoy had served as court sculptor, refused to protect him and, in the censorious phrases of the German biographer Joachim Sandrart, "He died as he had lived: an example and lesson to one and all." Shortly afterward, the transformation of sodomy into the "unspeakable" crime found a new twist: an inventory of Leopold Wilhelm's art collection described each of Duquesnoy's works fully but pointedly omitted the name of the artist, who had become a public embarrassment to his employer.

Protestants in the neighboring Netherlands, a prosperous bourgeois republic then enjoying its Golden Age, also had little use for homoerotic myths except as quaint fables to moralize, amuse, or uplift: a painting within a painting might comment symbolically on the lascivious goings-on in brothels and homes. Although a version of Ganymede's abduction painted in 1635 by the representative artist of the age, Rembrandt, retains some Neoplatonic symbols, his commitment to realism downgrades the exquisite ephebe of classical tradition to a pudgy baby in a modern nightshirt who squalls in protest at his kidnapping and lets loose a stream of airborne urine. Rembrandt's pupil Nicolas Maes completed the neutering of myth to suit Calvinist families: he painted their deceased children as Ganymede or Diana, consoling memorials of innocent souls for whom these subjects' erotic adventures were simply irrelevant.

RESTORATION TO REVOLUTION

Despite the moralists' best efforts, libertine homosexuality persisted through the seventeenth and well into the eighteenth century, but its ebbing visual

legacy signaled the receding tide of the Old Regime. As the aristocracy lost its grip on the rudders of both political power and artistic patronage, the dwindling ripples of Renaissance tradition were swamped by a rising wave of social change. The culture that would supplant lingering feudalism was more urban, capitalist, scientific, and sexually rigid. Ironically, in its urge to narrow the bisexual gender roles tolerated by the elite, emerging modern society segregated men with homosexual tastes into a subculture soon large enough to offer its members an alternative community and to spawn a conscious search for historical precedents and self-understanding.

In England, the splendid excess of this period is named for the Restoration of King Charles II, who ousted Oliver Cromwell's repressive Commonwealth in 1660, initiating an astounding tolerance for foppish display and bawdy licentiousness. The Earl of Rochester, a scandalous rake in both life and art, wrote an obscene play titled *Sodom, or the Quintessence of Debauchery* (1684) that burlesques the court's gross pansexuality; of himself he wrote crassly that, "missing my whore, I bugger my page." King William III did the same with his wife, Queen Mary II, and his male servants and favorites. But this noble circle (like the last Medici rulers of Florence, also homosexual) commissioned little visual art on homoerotic themes, perhaps a prudent concession to the Puritan attitudes that had expelled them once and still surrounded them in such satires as a 1660 translation of Juvenal's *Manners of Men*, with an illustration mocking an effeminate Roman who paints his face with cosmetics.

While libertinism was international, France set forth its philosophy, beginning with the poets of the "generation of 1620" led by Théophile de Viau, whose praises of his male loves and skepticism toward traditional religious beliefs earned him a lengthy court action for debauchery and atheism. Derived from "liberty," libertinism joined free thought and free love, doctrinal as well as sexual deviance, in its clarion call to "follow nature's law," even when one's "natural" inclinations might lead toward forbidden fruits. This Epicurean appeal to nature, in a very anti-Aquinas sense, held a potent allure for the century of Newton and Descartes, when mathematicians, philosophers, and scientists discovered that the cosmos was governed by universal forces operating on invariable laws that owed nothing to Christian revelation, and indeed—most famously, Copernicus's calculation that the earth moved around the sun—often conflicted with biblical history and beliefs.

Reacting vigorously, in 1600 the Inquisition executed as a heretic Giordano Bruno, who had written jokingly like Bandello of a "natural inclination to the filthy love of boys," and it later prosecuted the astronomer Galileo. But religion was clearly on the defensive: only in a period when its credibility was eroding could the English poet Richard Barnfield assert blithely as early as the 1590s, "If it be sin to love a lovely lad, Oh then sin I." Perhaps the church's ancient linkage of sodomy with heresy intuited a subtle psychological reality: some of those who are stigmatized as deviant will, to retain a measure of self-

respect, become "conceptual traitors," ready to flout or abandon traditional categories that deny their worth and pleasures.

Although far from open rebellion, Philippe of Orléans (1640–1701), the bisexual brother of King Louis XIV, presided over a court-within-a-court of male favorites and sexual servants attracted by the foppishly charming, artistic, and appetitive "Monsieur," the second-richest man in France. Much of his biography is gleaned from letters of his wife, who deeply resented her husband's neglect and interpreted his extramarital relations and cross-dressing as a frivolous disgrace; one courtier reportedly "sold boys like horses and would go shopping in the pit of the Opera." Shut out of public affairs by his suspicious brother, Philippe turned to patronage on a lavish and finally obsessive scale: building country and city estates, surrounded by gardens and fountains, and stuffing them with art, antiques, and jewels. (His Palais Royal in Paris was painted by Pierre Mignard, whose *Ganymede* perhaps caught the patron's eye.)

Philippe's contribution to homosexual culture was to open up creative patronage as a compensatory outlet, a safety valve for the frustrated energies and ambitions of men who are denied more serious responsibilities. "Patronage" can refer to politics as well as the arts: both are sources of power, and art too was a battleground, where the victor might carry off prestige, popularity, and the influence of a tastemaker. The cultural arena was smaller than the political, and considered less "masculine" than "feminine," but within its barricades he could rule unopposed—just as in modern times gay men, excluded from other occupations, have stereotypically dominated the arts, decoration, and entertainment. Philippe's marginalization was more the fault of his dynastic than his sexual status, but the two were not easily separated: the prudishly heterosexual Louis once sniffed to a courtier, "One finds one's fortune with my brother by certain means which, when practiced, lose favor with me."

Philippe's younger contemporary and sexual fraternity brother Prince Eugene of Savoy, an international general who never married, was nicknamed "Mars without Venus." He too was a lavish patron, whose tastes suggest that he approached the arts with some early sense of homosexual cultural tradition. He collected provocative antiquities like the Hellenistic bronze of a *Praying Youth*, a nude ephebe with hands and eyes raised to heaven, then thought to represent Antinous—perhaps as a historical model for the worship of male beauty. Ditto for more recent artistic precedents: he bought Guido Reni's *David and Goliath*, and in Balthasar Permoser's elaborate marble *Apotheosis of Prince Eugene*, sculpted for his Viennese palace in 1721, the upright officer treads on a crouching Turkish prisoner in the same attitude of eroticized victory modeled by Michelangelo and borrowed by Caravaggio.

As aristocratic bisexuality succumbed to the urban middle class and its family-centered heterosexual morality, men who desired men found it increasingly difficult to straddle the rising wall between personal fulfillment and social demands. Male clothing grew more sober in color and decoration to suit

the role of bourgeois paterfamilias, starkly visualizing the alternatives for the homosexually inclined: to live an unhappy lie in marriage, or escape altogether into the mushrooming demimonde where men like themselves, often marked by effeminate dress and behavior, found congenial company. As early as 1707, popular prints recorded London's "molly houses," or homosexual tavern-brothels, by then a familiar feature of the social landscape. Women had no parallel subculture for more than another century, though the first lesbian voice in modern literature appeared about 1660: Katherine Philips, known as "The English Sappho" for her poems on romantic friendship between women.

The Renaissance may be visualized as the first shock of an earthquake that ruptured the solid ground of ancient verities, opening gaping fissures out of which the modern world could erupt. By the eighteenth century, when its aftershocks died away with the rococo era, not only had antiquity been blasted away from the center of cultural history, but the Catholic religion had been de-centered in Europe, Europe had been decentered on the globe, and the globe had been decentered in the universe. Alternatively, we can view the lyrical, poetic, and classizing culture of the Renaissance as a more benign and less revolutionary spring morning of late feudal times, when the still slowly melting snows of the past exposed merely scattered, tender green shoots that would take centuries to ripen into the world we know today. Whether we emphasize the gulf that separated the Renaissance from all pre-modern societies, or the distance we ourselves have traveled away from it since, the struggling emergence of homosexual expression fills an integral and beautiful page of that storybook period.

ASIA AND ISLAM: ANCIENT CULTURES, MODERN CONFLICTS

A t about the time the French dandy Philippe of Orléans wore his first dress to a palace party, a seventeenth-century Persian miniaturist illustrated a translation of an Indian sex manual, the *Koka Shastra*, made for India's Islamic conquerors, the Mughals, or Moguls (fig. 4.1). Among the volume's grab bag of suggested coital positions and actions, otherwise heterosexual, this scene dramatizes how two women might incite mutual passion. The alarming bow that one lover aims at the other's genitals is not to be taken too literally: the arrow, with a dildo for a tip, is a visual metaphor for less dangerous methods of vaginal stimulation.

This playful image, quoted almost exactly in multiple copies of the popular handbook, was already a late flower in an Indian tradition dating back to the renowned *Kamasutra*. That "Treatise on the Arts of Love" is one of a handful of classics familiar to Western eyes out of a profusion of erotic art bred by the sophisticated ancient cultures across the vast reaches of Asia and Islam. Though richly diverse and often at war, these societies borrowed or imposed ideas on one another for millennia. Buddhism leapfrogged from its Indian homeland to China and Japan; Islam swept eastward across Persia and India to Indonesia, west into Africa and Spain, and north under the banner of the Turks who overran Byzantium. While Koka Pandita's original *Koka Shastra* dates from the 1200s, most of what survives from these erotic traditions is the fruit of later centuries, contemporary with Europe's Renaissance and Baroque era. Like "Versailles," "Mogul" has passed into English as shorthand for splendor and sensuality in the service of wealth and power.

Koka's book testifies to the fundamentally positive attitude toward sex and its imagery that long dominated this cultural region. In striking contrast to Western theology, Hindu, Islamic, and Taoist philosophers treasured human eros as a natural feature of earthly life, a universal source of not only pleasure but physical and even spiritual energy. Having no concept of original sin—the primeval coupling of desire and evil that distinguishes the Judeo-Christian worldview—their traditions felt no guilt about sexuality as such, no need to denigrate or repress it. Quite the contrary: like other everyday activities from

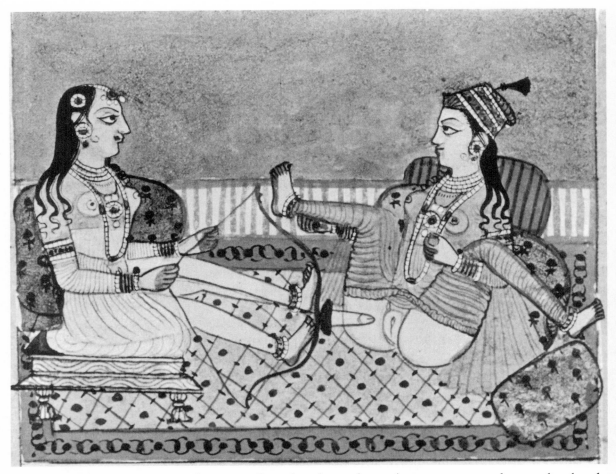

4.1. Mughal India, **Lesbian Allegory,** 17th century (manuscript illustration, Koka Shastra).

cooking to calligraphy, they cultivated eros as an art, whose stylized techniques anyone could study and practice—including, usually, those who sought enjoyment with members of the same sex.

Myth, ritual, and art cooperated in spreading these attitudes. In the legends of India, China, and Japan the gods themselves are sexual beings, and their creation of the world is imagined as a cosmic copulation, the ideal primal unity of body and soul, matter and spirit. Shintoists and Hindus worship these sacred powers in the form of womblike or phallic sculptures, recalling the ancient Greek herms and Roman Priapus statues. Worldly desire is no mere animal instinct, but an urge to imitate divinity, which can blaze a path to enlightenment: an exalted sexual mysticism animates the Tantric tradition within Hinduism and Buddhism and the Islamic sufis, or dervishes. On a more practical but no less poetic plane, Indian, Chinese, and Japanese patrons commissioned a steady stream of how-to books featuring both words and pictures, like the one illustrated in figure 4.1.

Such an awesome force had to be channeled into socially acceptable out-

lets, but taboos worried about the participants' class and age more than their gender. An overriding emphasis on familial duties—marriage, continuing a dynasty, and ancestor worship—meant that, apart from Buddhist monks and nuns, who limit sex to concentrate on metaphysical pursuits, there was little escape from heterosexuality. So, as in the West up to that time, for anyone with homosexual desires the realistic expedient was bisexuality—more available to men than women.

Because homosexuality, though important in private life, was peripheral to the public concerns of family, state, and religion, it appears only rarely in the monumental arts of temples, palaces, and official chronicles. It abounds instead in private, secular, and intimate art forms, especially love manuals, poetry and fiction, and miniature painting or prints, often combined in luxury books. From the classical Arabic period of Abu Nuwas onward, Islamic poetry celebrated male love, especially for boys—a tradition continued in Persian by figures as exalted as Babur, founder of the Mughal dynasty, and depicted by Persian illuminators between rulers and pages and other loving couples. Chinese and Japanese literature pioneered prose fiction, realistic stories and novels of male lovers, actors, and bordellos, whose illustrated versions were, thanks to the local invention of printing, widely popular.

Beginning when Portuguese sailors reached Goa in India shortly after 1500, all of these traditions were drastically altered by rapidly increasing contact with the West. Renaissance merchants, missionaries, and colonists were roaming the globe in sufficient numbers to observe the homosexual customs of formerly remote civilizations. And observe they did, from Moorish north Africa to sixteenth-century Burma, their outrage inseparable from their titillation. In his revealingly titled *Monsters and Marvels* of 1573, the French surgeon Ambroise Paré disapprovingly repeated reports that African women openly had sex together, blaming such excess on demonic possession. Echoes of black women's proverbial lasciviousness may have reinforced the sapphic undertones of Titian's nearly contemporary Diana (fig. 3.14), who is being intimately toweled by an African attendant.

As Europe's political and economic dominion mushroomed from the seventeenth century into the nineteenth, Eastern societies felt tremendous pressure to conceal or deny their long-standing homosexual traditions. Even today many Asian nations are reluctant to acknowledge past or present sexual differences, for fear of seeming backward or scandalous to outsiders. Beyond the oriental concern for losing face, they may also have feared losing their heads: priests railed with equal fervor against sodomy among the Indian natives of Goa and the Jesuits' own countrymen in the European colony there, several of whom were hanged in 1559.

A unique testament of cross-cultural visual propaganda from this era is an image designed by Matteo Ricci, an Italian Jesuit missionary who introduced Western homophobia to India and China in the quarter century before his

death in 1610. When the publisher Cheng Dayue asked Ricci to contribute to a luxurious printed arts anthology to be called *The Ink Garden of Mr. Cheng*, Ricci provided several biblical engravings as models for illustrations to his moral commentaries in Mandarin Chinese. *The Destruction of Sodom* (fig. 4.2), which accompanied his preachings against "Depraved Sensuality," depicts the angels who lodged in Lot's house casting down and blinding the men of Sodom who demanded to "know" them. This hybrid print was produced by a native artist, who took his imported prototype to heart, endowing the biblical Hebrews and angels with Chinese faces. The implicit message: this sacred story is our history too, and Sodom could happen to people like us.

From that moment forward, all the cultures of the world have grown inexorably interconnected, until recently on terms set by the West. Direct missionary work made only limited converts, but European values triumphed in the "Victorian" sexual mores of Raj and post-Raj India, Communist China, and the Islamic world. All the same, to blame this astounding turnabout entirely on foreign intruders would ignore the role of indigenous movements for sexual austerity, which surfaced periodically among puritanical Indian Brahmins and neo-Confucians in the Far East. In India and Qing China the outsiders reinforced such agitators when they found them; in Japan, which shut out Western influences until the mid-nineteenth century, a strict reforming regime came to power just before the country reopened.

So for reasons both foreign and domestic, while much art illustrating male and female homosexuality existed, and much probably survives, until recently it remained suppressed or ignored within its native countries and beyond. Local scholars have done scant research on their arts, and much of the literary and visual material remains inaccessible to nonspecialist Westerners. Matteo Ricci was shocked at the pervasive homosexuality in China—especially male prostitution in Beijing—and tried to

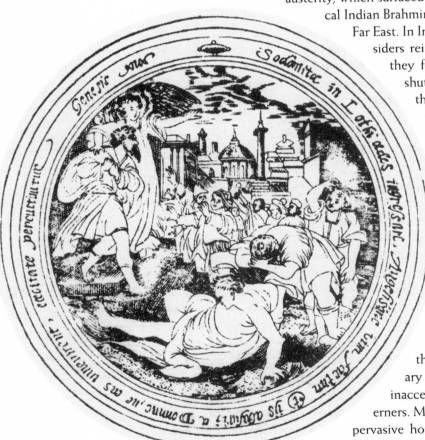

4.2. The Destruction of Sodom, 1609 (woodcut book illustration, **The Ink Garden of Mr. Cheng).**

stamp out its widespread toleration through his prints and sermons. Ironically, his viewpoint ultimately grew so pervasive that in the twentieth century, the Chinese Communists could denounce homosexuality as a contagious import from the decadent bourgeois West, alien to their own bowdlerized history of Chinese culture.

INDIA: EROS AND SPIRIT UNDIVIDED

India holds pride of place in any history of sexuality as the fountain from which the spiritual acceptance of eros first flowed. The village and court life of the subcontinent revolved around a succession of religious traditions, Hindu and then Buddhist, later overlaid by the Islamic invasion.

Hinduism—among the world's oldest living religions, dating back some four thousand years—is a widely branching tree with numerous local offshoots of custom or belief. Although they share neither a single theology nor centralized priesthood, all Hindus revere the same early scriptures (*Veda*) and believe in reincarnation, the soul's status in the next life depending on the accumulation of moral *karma* in this one. Their vast pantheon of gods—all manifestations of a single universal spirit—are enthusiastically amorous, especially the handsome and voraciously sexy Krishna. And their early society seems to have found room for sexual diversity: the classic religious texts and epics say next to nothing about homosexuality, and the law code of Manu (begun about 200 B.C.E.) only prohibits male and female homosexuality when partners violate caste boundaries—the hereditary categories of occupation and class that still stratify Indian society.

The Hindu gods, like the world they created from the primordial union of the twin deity Shiva and his wife/alter-ego, Parvati, are not only erotic but androgynous—perhaps an echo of ancient matriarchy—and their procreative powers are worshipped as the lingam and yoni, carved stones representing male and female sex organs. Myth and epic abound with hermaphroditic demigods, miraculous sex-changes, and transvestism. Bronze and stone cult statues visualize some of these divinities, especially Shiva-Parvati, as half man, half woman, an omnipotent godhead that transcends the earthly illusion of two fixed and opposite genders.

To judge from other religious images, this worshipful pansexuality could also be directed at ordinary mortals. The crowning glory of Hindu art was architectural sculpture: rulers and affluent commoners vied to endow vast temples encrusted with thousands of elaborate and graceful high-relief figures of gods, humans, and spiritual symbols. These *maithuna*, or sacred couples, cavort in an inexhaustible variety of sexual postures, recalling those in the *Kamasutra*. The purpose of these carvings remains in dispute: to instruct in Tantric technique, to depict actual ritualistic orgies, or to offer the pilgrim a temptation to

overcome. At the least, they represent sexuality as a universal desire; most probably, like European Neoplatonism, they entice the faithful with a tender ideal of intense communion prefiguring heavenly bliss.

Most maithuna are heterosexual; often one man enjoys up to three women, who may be either an *apsara*, an angel in paradise, or her earthly counterpart, the *devadasi*, or sacred temple prostitute. But a small percentage of these sculptures, only now being archived by the scholar-photographer Giti Thadani of New Delhi, depict male couples or goddesses in lesbian couplings whose symbolism seems interchangeable with all the others. A few hundred of these are scattered among the heterosexual groups, suggesting that they too represent sexual practices, or at least fantasies, of the time. In several male-male scenes, for example, one man is a monk, perhaps reflecting the role of homosexuality in some sects' secret initiation rites.

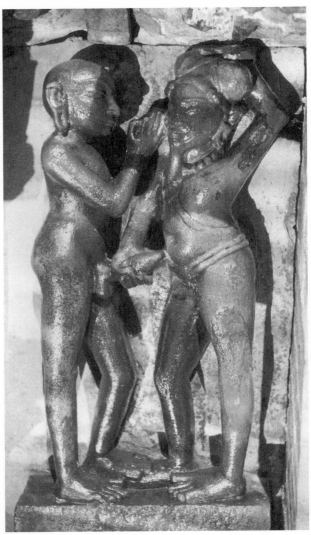

4.3. India, **Monk and Layman,** 10th century, Khajuraho, Vishvanatha Temple (stone sculpture). Photo Raymond Burnier/ Archives J. Cloarec.

One of the largest and best-known complexes is Khajuraho in northern Bundelkhand, erected by the Chandella rulers between 950 and 1050. In one of the horde of maithuna sculptures (fig. 4.3), a standing male layman piously raises his hands to greet a monk, identifiable by his hanging beard and headdress, who returns the greeting by grasping the layman's penis invitingly. The later stages of such encounters are graphically depicted in temple reliefs of the twelfth century: at Chapri (central India), a monk pleasures a reclining princely visitor with oral sex, and at Barmer (Rajputana), two men interlock in an erotic somersault.

The Hindu metaphor of worship as erotic union affirmed and even celebrated this fluidity of gender. All souls, regardless of the body that housed them, were considered fundamentally feminine in their ecstatic surrender to the godhead; since that deity is pansexual, then the various combinations of gender between worshipper and god were spiritually irrelevant. In practice, however, asking earthly men to imagine themselves as the submissive consort of a celestial being of either sex conflicted with the enduring social pattern of male dominance. Some devotees resolved this contradiction by ritual transvestism linked to homosexuality: in northern India, an annual festival still persists in which male prostitutes impersonate the female shepherdesses beloved by Krishna.

If the divine is sexual, then the sexual is divine, and earthly copulation was treasured as a creative source of pleasure, offspring, and cosmic energy. It is difficult to generalize about erotic practices across such a varied social landscape, and as usual we know more about the elites, who could probably afford to indulge their appetites more than common folk. The images of homosexuality we do have derive from two traditions: secular love manuals and the more spiritual and ascetic discipline of the Tantra.

Secular art and literature date back to the Hindu sage Vatsyayana, whose *Kamasutra*, written before the fourth century C.E., is the ancestor of all later sex manuals. (Kama, like the Greek Eros, was the name for both physical passion and the lesser god who ruled over it.) Vatsyayana treats courtship and mating, detailing the gamut of erotic techniques and positions, among them one chapter on such male homosexual habits as fellatio among eunuchs. Though he recommended the study of his "64 arts" to princesses, courtesans, and married women, like most such authors he was writing primarily about heterosexuality from and for a male viewpoint. Indian women were consigned to an inferior position: the demand for chastity led to seclusion and arranged marriages, while men could enjoy as many wives and concubines as they could afford. Male privilege had its burdens, however: sexual pointers from the *Kamasutra* were indispensable to a polygamous husband who needed to keep up an exhausting performance schedule.

Not that the literature neglected women altogether. Vatsyayana noted sympathetically that multiple wives and mistresses were often left alone together for extended periods, and "since the women of the harem are not allowed to other men, and have only one husband common to all of them, they are physically dissatisfied and therefore give pleasure to each other." Just such mutual comfort is shown in the *Koka Shastra* illustration (fig. 4.1) and a similar miniature of two women embracing on a luxurious bed (Paris, Musée Guimet). Koka's dildo-tipped bow and arrow is an extravagant variation on Vatsyayana's frequent metaphor of lovemaking as a playful form of war, in which "attacks" with stimulating "weapons" might lead both combatants to the pleasurable "victory" of orgasm.

Tantric sects, important in both Hindu and Buddhist mysticism, preached a system of rituals aimed at harnessing erotic energy for spiritual transcendence. Men and animals were believed to flow, as plants do, with a universal sap or juice embodying the vital force of generation, which could be heightened and channeled. Tantra was no mere cult of sexual indulgence, since orgasm was to be postponed so that semen would course throughout the body to produce continuous ecstasy: the transfusion of supernatural power opened a vision of beatific oneness. Thanks to this spiritual physiology, anal intercourse, believed to stimulate an important *chakra*, or energy center, was eagerly recommended (though not, it seems, illustrated).

Buddhism, which grew out of Hinduism, took shape about 500 B.C.E. in

the teachings of Siddhartha Gautama, a prophet honored as Buddha, or the enlightened one; he too preached the need to overcome earthly dualism, symbolizing the inextricability of complementary principles by the circular "yin-yang" emblem. Like Hinduism, Buddhism later branched into contrasting traditions varying between asceticism and compassionate worldliness; the faith swept across China and into Japan and, though it later died out in its homeland, still holds sway in the Himalayas, Tibet (until recent Chinese repression), and Indochina. Buddha said little about sexuality, and his love for his disciple Ananda is touchingly homoerotic, as are a few of the legends about his bodhisattvas, guardian angels of fluid sex. For most lay Buddhists, sexual orientation was less of a moral issue than the obligation to improve one's karma by behaving ethically within whatever life one is allotted—a tacit tolerance for most consensual sexuality that still characterizes modern Thailand, an erotic mecca for both gay and straight tourists.

A more stringent code, however, applied to monks and nuns, who dedicated their current lifespan to reaching nirvana, the state of enlightened immortality granted only to those souls who successfully freed themselves from the shackles of earthly illusion. Buddha taught that suffering and immorality are the fruits of excessive desire, and the only escape from the ceaseless cycle of rebirth and pain is to eliminate it. Not all desire, it is important to point out, but only an enervating addiction to it—a subtlety that provided some escape valves from celibate theory. Monks were sworn not to emit their semen anywhere, but all that was not forbidden was enjoyed, especially by young novices still exempt from final vows.

Sexuality plays little role in Buddhist art outside Tantrism, though a few late homoerotic images, probably based on lost prototypes, lurk among the brightly painted sculptures adorning temples in Nepal, where Hindu and Buddhist traditions overlap. A shrine to the proverbially randy monkey-god Hanuman in Katmandu features a sixteenth-century carving of one man mounting another, while the multiple inventive scenes of sexuality carved into the roof struts of the nearby nineteenth-century shrine to Shiva include a female couple, one of whom manually stimulates the vagina of her standing and smiling companion.

By the time this image was installed, the Hindu Brahmins, the priestly caste expected to uphold uniquely high standards of sexual austerity, had been gaining in power for a century. In exchange for Brahmin support, the English colonists, who found the Brahmin code of disciplined sobriety most congenial to their own values, imposed their puritan ethic on all Indians. Queen Victoria's government closed the erotic temples, and some were later defaced as obscene. This tragic reversal, still enshrined in Indian law and attitudes, is now denounced by the country's fledgling Westernized gay community as a vestige of imperial interference, forcing on everyone a morality that for millennia had applied merely to a respected but distinct minority.

CHINA: PLEASURE AND DUTY

In his 1849 novel *Precious Mirror of Ranking Flowers*, the late Qing-period author Chen Sen extolled the illustrious custom of Chinese men's love for male "flowers"—actor-prostitutes or other young men or boys: "Across tens of thousands of miles of territory, through five thousand years of history, nothing and nobody is better than a favorite." Though this age-old tradition was by then fading away under Confucian moralizing, Chen's passionate plea invokes the whole of a vast and immemorial culture in its defense. The oldest continuous civilization on earth, China, by Roman times, had parlayed its cultural head start, plus its sprawling territory and enormous population, into a commanding position as the self-styled "Middle Kingdom," the center from which a succession of imperial dynasties radiated their prestigious influence over Korea, Japan, and Southeast Asia.

Though fragmentary and sometimes obscure, evidence of male homosexuality dating back to the Bronze Age in the second millennium B.C.E. indicates that it was acceptable, even common, among many classes and occupations. Literature and art representing same-sex passion emerged only a few centuries later, though no visual images survive before the sixteenth century C.E., when improvements in the Chinese invention of printing sparked a boom in illustrated books ushering in the golden age of Ming dynasty erotica. While these anthologies, most produced in the southern art-center of Nanjing, were mainly heterosexual, some 2 percent portray lesbian love, and a handful show two men. Prints were fragile, as were watercolors on silk, and we often have to reconstruct the classics from better-preserved late versions like color plate 11. This painting, one of a dozen all-male scenes on a Qing scroll, peeks at a man and youth, probably costumed actors of Chen Sen's day, hard at play on a flowery garden terrace.

China's three spiritual traditions—the teachings of Lao-tzu (Taoism) and Confucius, and the Buddhism imported from India—embraced sex as an essential part of life. But Confucianism, the official state religion after the second century B.C.E., preached moderation and held obligations to family, state, and gods paramount. The importance of continuing one's family line made marriage all but compulsory—except, as in India, within a Buddhist monastery or convent. Also like India, a sex-positive attitude remained in tension with a sterner ideal that framed eros in terms of duty rather than pleasure, and periodically flared into moralizing campaigns. For most of Chinese history, male homosexuality was tolerated provided it was neither exclusive nor permanent, and as long as active and passive sexual roles mirrored the social hierarchies of gender, class, and age.

Men's passive male partners were not only younger but often of lower status: entertainers, servants, prostitutes, or students. A 1610 album of verses accompanied by erotic woodblock prints, the *Hua Ying Chin Chen* or "Various

Positions of the Flowery Battle," includes one poem titled "The Way of the Academicians," referring to the imperial Han Lin academy, training ground for literati officials—a profession notorious for pederasty. An older scholar implores a youth to let him try "the flower of the rear garden"—a typically poetic euphemism for the anal intercourse displayed in color plate 11. In the album, the text is ambiguous about the younger partner's gender, but the academic setting is a giveaway, along with the fanciful signature, "A Candidate from the South," the region proverbial for homosexuality. The illustration shows the youth giving in, but the ground rules demand discretion: he whispers, "Hurry up, and don't ever tell other people!"

Female passion was also attested from earliest times, but as in other cultures both West and East, the historical voices and artists are all men. As in India, men were permitted plural wives and concubines, creating a demand for illustrated love manuals, read for both instruction and arousal, that described various positions for married men with one or more women. The innumerable combinations often include lesbian affection as part of a ménage à trois, though women are also portrayed alone. A typical woodcut (fig. 4.4) depicts two elegantly coiffed women with a man in a sumptuously furnished interior; the female couple embrace gently while the erect husband prepares to penetrate the reclining partner. The spice of lesbianism would excite the man, whose desire is clearly dominant, with the added benefit of enabling him to accommodate several of his household in one evening. Women's inferiority was epitomized by the practice of foot binding, stunting the growth of young girls' feet by tight wrapping to produce the tiny club feet visible here, which were considered the quintessential attribute of beauty but confined gentlewomen to helpless hobbling within the home.

The cultural compost that nourished these images began to accumulate in the earliest periods of Chinese history, whose court records tell us only about the male elite of rulers, scholar-officials, and gentleman artists. Many emperors of the early Zhou dynasty (ca. 1100 B.C.E.) had male favorites, whose names and deeds provided a vocabulary of poetic role models. Homosexuality was long known as "the passion of Longyang" (after the favorite of a Wei prince) or "the love of the half-eaten peach," recalling the self-denial of the emperor Mizi Xia, who offered his beloved the remainder of an especially delicious fruit.

The Han dynasty, which unified all of China about 200 B.C.E., originated another lyrical byword, "the passion of the cut sleeve." Emperor Ai (6 B.C.E.–1 C.E.) was napping with a favorite one lazy afternoon when suddenly called to court. Reluctant to disturb his beloved Dong Xian, whose head had nodded off across one arm of the emperor's robe, Ai gently snipped off his sleeve before rising. The assembled aristocrats were so touched by his explanation for the slashed garment that they followed suit, starting a new trend and an expression proverbial ever since. Here, just as in Petronius' Rome or Philippe d'Orléans's

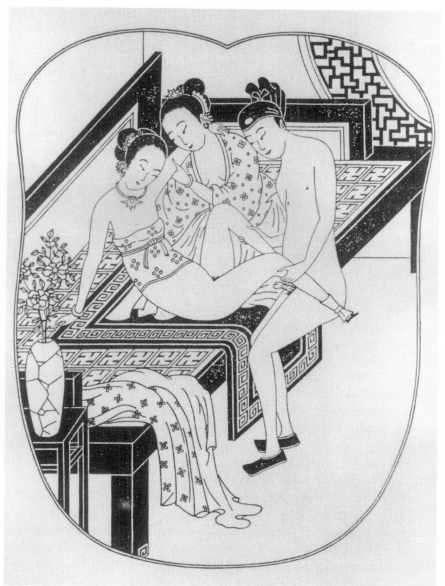

4.4. China, **Ménage à Trois,** ca. 1640 (woodblock illustration to erotic album, **Chiang Nan Hsiao Hsia**).

France, male fashion was so closely interwoven with homosexuality as to make it, if not quite a "fine art," certainly a prominent medium for visual expression. Clothing not only reflected passion, but inspired it: Chinese courtiers seeking to catch the eye of other men competed through extravagant costume. Because men who wish to advertise their availability everywhere dress the part, sartorial flamboyance and luxury are commonly associated with homosexuality, effeminacy, and transvestism. But these connections owe less to orientation than to gender: human males seem to be aroused by visual stimuli more than women, so when both parties to a courtship are men, the tendency to erotic

display is squared. In other words, you don't have to be homosexual to play the foppish peacock, but it does add another motive, one frequently singled out by Western critics from medieval times to Saint Bernardino and beyond.

Despite its popularity at court, homosexuality hardly appeared in official public art, whose Confucian subjects are ceremonial or religious—though early texts preserve tantalizing descriptions of a few images created for private patronage. Xi Kang, an exceptionally handsome third-century C.E. poet, and his companion Ruan Ji, a scholar who penned a tribute to male lovers of earlier times, had themselves portrayed on incised stone reliefs seated intimately beside each other; and a Tang dynasty crown prince, Li Chengqian (ca. 650), memorialized his murdered beloved by erecting a statue of the boy actor in his palace and offering sacrifices to it.

By medieval times, the aristocracy's cultural monopoly was broken by a competing arena: the prosperous mercantile society of the mushrooming cities. Similar to the contemporaneous upsurge of town life in Europe, Chinese urbanization increased opportunity for sexual contacts, or at least left behind accounts from a variety of classes, including merchants and workers: the capital of the Song dynasty (960–1279) reportedly supported ten thousand male prostitutes, mostly adolescents, in its teeming brothels.

As in the West, however, increasing visibility prompted a backlash. While homosexual desire raised no theological hackles, until quite late the Chinese imagined it more like Rome than Greece, as a private pleasure that served no pederastic or public ends. So it remained vulnerable to the Confucian disapproval of mere frivolity and to the corollary prejudice against representing it in texts or images that might tempt viewers away from the sober fulfillment of their marital responsibilities. The Song period witnessed the first of several waves of moral renewal and censorship, though the punishments and fines decreed for prostitution proved largely unenforceable.

Under the wealthy and cosmopolitan Ming dynasty (1368–1644)—the high point of classic Chinese culture, contemporary with Renaissance and baroque Europe—sexual, literary, and artistic expression flourished together in all walks of life. Inside the imperial palace male lovers continued in favor, while outside its gates certain streets in the new capital city, Beijing, quickly grew notorious for homosexual prostitution. In the southern province of Fujian, men of all classes ceremonially swore to live together as "older" and "younger brother"; though these passionate pairings could last up to twenty years, they were still conceived as temporary, since the junior partner would eventually obey his duty to take a wife.

This widespread custom was dignified by a deity of homosexual love personified as a rabbit, whose cult may have given birth to explicitly homoerotic sculpture and even architecture. This demigod was probably venerated in actual carved images, though none survives, and the fictional tale of "The Rabbit Spirit" imagines a full-scale building inspired by his powers. After a govern-

ment official orders the execution of a lovestruck young soldier who has been peeping at him, the dead man returns in a dream and demands that local men erect a temple for his worship; they gladly comply, but keep their shrine secret, perhaps a literary echo of subcultural patronage, solidarity, and forced discretion.

This story was only one spark of an explosion in writings on male love. One anonymous Ming scholar turned erotic curiosity to creative research: his seventeenth-century *Records of the Cut Sleeve* compiled more than fifty surviving tidbits from two thousand years of history. As the earliest systematic chronicle of Chinese homosexuality and arguably the first known example of a self-conscious "gay history," this anthology is still the starting point for modern scholars. Improvements in printing and literacy fostered a flowering of prose fiction, including novels and short stories dealing with both lesbian and male

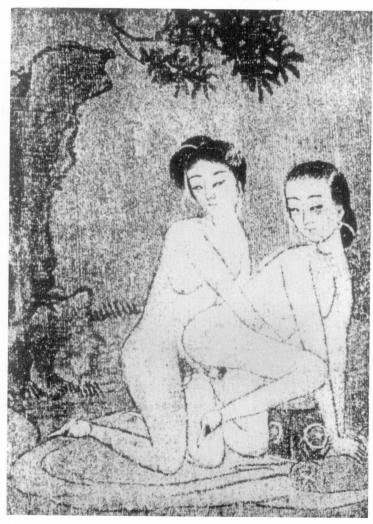

4.5. China, **Two Women Making Love,** ca. 1640 (painting on silk).

love, which introduced a new romantic ideal of devotion even unto death. As the Ming gave way to China's final dynasty, the Qing, drama and the new Beijing Opera were dominated by popular boy performers, some of them transvestites, who eked out their salary as prostitutes and were excused from the Confucian command to marry; authors and gentlemen could find both literary inspiration and more physical satisfactions in the world of the theater, as did its denizens among themselves (color plate 11).

In the visual arts, the late Ming period (1550–1650) was the high-water mark of erotica. Prints in multiple colors—either independent sheets or book illustrations—and watercolor paintings on silk, gathered in albums or scrolls to provide erotic handbooks, proliferated. Delicate in design and drawing, with stylized contours, they crowned a long tradition whose earlier prototypes were all destroyed by the Qing invaders.

Besides male scenes and marital threesomes, some of these pictures depict lesbianism alone. Intimate relations like those in a seventeenth-century album painting on silk (fig. 4.5) are

recorded among the thousands of women secluded in palace harems, who had to find solace among themselves and might even pair off into long-term couples, as did some Buddhist nuns. Here, one inserts a double-headed ivory dildo to stimulate herself and a kneeling female partner; others used their tiny bound feet. This sweetly smiling couple's gentle, almost naive tenderness is characteristic of much Chinese erotic art. While their poses are inventively acrobatic, the characters betray little stress or exertion, and none of the sweaty abandon of real passion. Figures are sketched in softly calligraphic curves that barely differentiate between male and female anatomy, avoiding body hair except at the genitals.

The picture's lyrical dignity is enhanced by its garden setting. Narrative illustration of any human activity was always far less esteemed in China than landscape, the art form invested with the highest spiritual content for its meditative evocation of the pantheistic life force throbbing within the physical world. As in color plate 11, the Chinese often set sexual scenes in gardens or outdoor pavilions, where a view of nature itself (or landscape art on the walls) underscores the cosmic symbolism of intercourse.

Men are not shown together in the love manuals, most of which were for polygamous families, where male-male passion was irrelevant. But masturbation is also rare, and fellatio nonexistent, which suggests another reason for such reticence rooted in medical-scientific beliefs. Taoist philosophy hailed intercourse as an opportunity to achieve psychic wholeness by exchanging active male yang and passive female yin energies. Yang, unlike yin, was held to be in short supply, so men were exhorted to avoid ejaculating to conserve their semen, even while absorbing yin from women—goals that rendered homoeroticism, autoeroticism, and oral sex alike superfluous or wasteful. (Two women together, by contrast, raised no great concern, since they had no yang to spill.)

Where male homosexuality does appear is in popular fiction, most memorably in two collections of novellas by an author known only as Master Moon-Heart, who explored the many modes of same-sex desire between 1620 and 1650. In the didactic *Cap and Hairpins,* Moon-Heart sings the praises of a series of boyish lovers whose passive surrender epitomizes his romantic ideal by melding masculinity (symbolized by a man's hat) and femininity (hairpins); the more ambiguous *Fragrant Stuff from the Court of Spring* recounts the degrading consequences of losing control of one's passion. Unfortunately, by the time the known editions of these books were printed, their dozens of woodcut blocks illustrating various male couples embracing, preparing for intercourse, or sleeping together in pavilions or bedrooms, alone or with attendants, had worn down to near illegibility.

Once the Qing conquered China in 1644, sexual art declined under the dual pressures of Western homophobia and a homegrown upswing in Confucian asceticism. Contacts with the world beyond Asia had begun to accelerate

with the thirteenth-century Italian visitor Marco Polo and reached high gear when giant Ming trading ships swept the seas from Africa to the Pacific islands, leaving in their wake the Chinatowns of a world diaspora. Conflict became inescapable late in the sixteenth century, when the Spanish viceroys of the Philippines arrested men in the Chinese quarter of Manila and burned or flogged them for sodomy; by 1610, Matteo Ricci was publishing his engraved sermon against local depravity in Beijing itself.

The Qing rulers gradually outlawed all homosexual sex, though as always enforcement was uneven and the elite managed to pursue their discreet pleasures with impunity. Poetic and pictorial renderings of male love decreased steeply after the eighteenth century, though the standard gamut of trios and lesbian couples was repeated in late love manuals, alongside rare episodes of male anal intercourse or mutual masturbation. A British envoy to the imperial palace around 1800 could still witness a marble sculpture of two male youths indulging what he called "the vice of the Greeks," but by 1849, when Chen Sen published his *Precious Mirror of Ranking Flowers*, the forced break with traditional sexuality had succeeded well enough to provoke nostalgia for a bygone paradise. In a rearguard attempt to turn back the cultural clock, Chen set his romance between scholars and actors some two centuries earlier. But his plea was the death rattle of China's continuity with its past, further undermined by invasions and a succession of revolutions: one deposed the last emperor in 1911, only to be toppled in turn by the present Communist rulers in 1949.

In all this upheaval, much more has been destroyed than physical artworks. Communism, although a Western import, resonated with the Confucian ideal of submission to collective duties, and Mao Zedong harshly stepped up controls on homosexuality and the arts. Until the past decade, when Mao's successors pragmatically began to overlook culture in favor of economics, the Chinese themselves obstructed any increased awareness of their own sexual history.

JAPAN: MONKS, WARRIORS, AND MERCHANTS

According to legend, male homosexuality was imported to Japan by the monk Kobo Daishi upon his return from studying Buddhism in China about 800 C.E. Since Kobo also gets credit for an impossibly wide catalog of cultural innovations, whoever created this tale was no doubt borrowing Kobo's historical luster to dignify a custom that already existed. Though fictional, the anecdote puts its finger on several defining traits of Japanese culture and eros. Many social and artistic patterns, including religion, writing, and painting, were adapted from Chinese sources—though openness to foreign influences changed course dramatically over the centuries—and the earliest records of homosexuality do come from Buddhist monasteries.

In the creation myth of Shinto, the native animist religion, the world was born from the sexual union of male and female divinities; so, as in China and India, the pleasures of the body are natural and potent. Surviving prehistoric art often concerns fertility, including mother goddess figures, sexual amulets and carvings, and cemetery figures with outsize genitals who use them on one another. But sex, even cosmic sex among the spirits of the Shinto pantheon, was not all uplifting or benevolent: the scruffy, pot-bellied god of healing once took revenge on the devilish thundergod by forcibly buggering him from behind. This legend, illustrated in the later Edo period, set the tone for a continuous current of bawdy, even grotesque, humor; apparently, religious awe and respect did not rule out amusement at divinities who could act as randy and foolish as their earthly subjects.

Men's duty to marry, sometimes polygamously, took precedence over personal desires; outside the Buddhist monasteries, bisexuality was the familiar norm. Until the Edo period male passions were temporary and reflected hierarchies of age and status: in anal sex, the favorite practice, the older partner did the penetrating. *Shunga,* or "pillow books," illustrated erotic manuals for all orientations (which doctors were required to study), were produced from the seventh century onward. Their highly explicit paintings on silk, bound in albums or continuous scrolls, were also highly fragile, and all but the later examples disintegrated from overuse. One surviving series, a ten-panel scroll published by Tsuneo Watanabe, shows prostitutes, samurai, and other men in a variety of erotic tangles, including voyeurism and a bisexual ménage à trois. Japanese artists outdid their Chinese models in dramatic portrayal of erotic abandon and an inventive fondness for comical exaggeration.

Little evidence of lesbianism surfaced before the seventeenth century, when occasional female episodes appeared in erotic fiction written by men. This long silence is surprising, because Japanese vernacular literature was pioneered by women, compensating for being denied an education in the Chinese classics revered at the imperial court of the Heian era. Most esteemed among these high-ranking women was Lady Murasaki Shikibu, whose eleventh-century masterpiece *The Tale of Genji* includes among its endless court intrigues several episodes of deep male affection, but none between women.

Premodern Japanese history falls into three distinctive though overlapping phases. In the first period, dominated by the court and the Buddhist monastery, male love was associated with the clergy; in the medieval period their passion was also taken up by feudal knights, or samurai; and by the time of figure 4.6, from the Edo period, a rising urban middle class was creating an early modern commercial culture of bordellos and popular entertainment. All three cultures intersect in this woodcut illustration for a printed book of stories about the loves of *yaro* actors. Here a monk and a samurai, members of the two established elites, visit a teahouse-cum-whorehouse connected to the theater; the warrior at far left with his twin swords and the bald Buddhist beside him

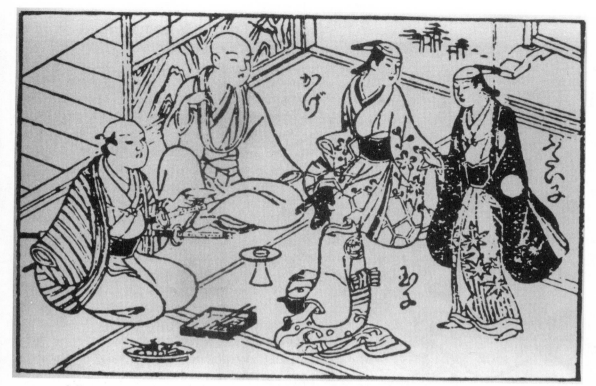

4.6. Japan, **Monk and Samurai Visiting Actor-Prostitutes**, ca. 1700 (woodcut illustration, **Yaro Kinuburi**).

are gracefully entertained by the three grades of male actor-courtesans, at lower center and right, each identified by a caption in calligraphy.

Early Japan lapped up the first wave of foreign fashion: the court elite read Chinese literature, and Buddhism (especially the well-known Zen branch) reached Japan two centuries before Kobo Daishi. In the Heian and Kamakura periods (ninth to fourteenth centuries), religious art was dominated by monumental temples whose colossal bronze Buddhas left little room for eros—though secular art reveals that plenty of male sex took place unofficially within temple walls. Monks were forbidden to consort with women, but their vows were more ambiguous about men, and many clerics loved their young assistants, or acolytes (*chigo*, ages eleven to sixteen), with whom they often swore a solemn bond of brotherhood. From early poems grew the fourteenth- and fifteenth-century genre of "acolyte tales," in which the authors, probably priests themselves, typically exalted both the passionate love for a youthful apprentice and the spiritual enlightenment that might follow a tragic loss of the beloved.

While some of these tales emphasize the spirit more than the flesh, the story illustrated in figure 4.7, which details the lengths to which an exemplary chigo would go to satisfy his aged master, brings a sweet humor to the frank depiction of sexual mechanics. The *Acolyte Scroll* (*Chigo no soshi*), whose five scenes were painted and inscribed on paper in 1321, is Japan's earliest surviv-

ing erotic scroll. In the episode shown here, a servant warms the boy's buttocks over a charcoal brazier; in another panel he lubricates them with clove oil, all to help the monk penetrate with less difficulty. This time-consuming consideration for an older partner's declining potency leads to the text's moral, "Such a sincerely devoted acolyte is without parallel; one must regard him as priceless." But devotion need not be exclusive: in another panel, the frustrated servant, his penis swollen to outsize proportions by these sensuous ministrations, complains to the chigo that he'll have to masturbate after the boy leaves unless, he implores, "Before you go to the honorable priest, I wonder if you'd let me stick *my* penis in"—which the youth obligingly permits.

In its second, or medieval, phase—the Kamakura and Muromachi periods, from about 1200 into the late 1500s—Japanese society shared much in common with its feudal European contemporaries. Centralized imperial authority weakened, giving way to a prolonged period of bloody conflicts between provincial warlords or *daimyo*. The samurai dominated the fray from their rural fortresses, where they fostered a martial culture with a code of male honor corresponding to Western chivalry. The samurai "way" considered love between an adult warrior and a youth in his late teens, or *wakashu*, a noble attachment similar to ancient Greek pederasty. The junior partner was no longer the passive chigo; rather, like a Western squire, he was old enough to learn courage and feats of arms. The mature lover offered an ideal model of masculinity as well as practical and emotional support; in return, the wakashu was expected to submit to his mentor's desires. Once his apprenticeship ended, the wakashu would graduate in his early twenties to taking a young male beloved of his own before finally marrying a woman.

Although chronic warfare produced ruinous instability, the arts flourished under knightly patronage, which created such characteristically refined and austere Japanese arts as the tea ceremony and the No drama—whose traveling companies featuring beautiful boy actors spread homosexual ideals (and prostitution) across the provinces. Male love also inspired a rich literature, including advice manuals for wakashu and fictional paeans to affectionate bonding. Many later stories, with titles like Ihara

4.7. Japan, **Servant Chuta Warms the Chigo's Buttocks,** 1321 (watercolor painting, Acolyte Scroll).

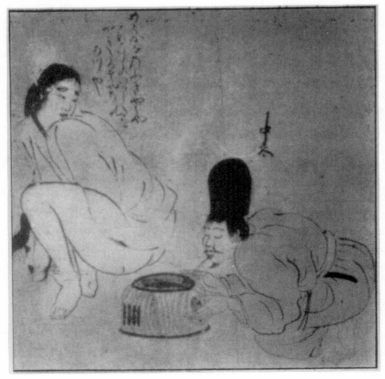

Saikaku's popular "Comrade Loves of the Samurai," were illustrated with woodcuts showing the whole range of courtship, from a samurai and his wakashu tenderly holding hands to scenes of men and boys drinking and feasting to couples in flagrante. At its highest, martial devotion could prompt heroic self-sacrifice; the tales often end in noble tragedy since, as in Greece, steadfast loyalty unto death was the ultimate ideal of the warrior's love pact. Writing in 1482, the social commentator Ijiri Chusuke paid tribute to the long and noble history of male love, from early Buddhists through latter-day knights who "swore perfect and eternal love whether their partners were noble or common, rich or poor," and added his fervent plea that "this way must be truly respected and never be permitted to disappear."

His wish was not to be granted, due to the landing of the first Westerners and the violent local reaction against them. The Portuguese Jesuit missionary Saint Francis Xavier, who advanced on Japan from India in 1549, railed against the casual prevalence of homosexuality in both monastery and castle, even insulting a daimyo to his face for keeping a young male beloved. Though priests and nobles indignantly threw him out of court, within a few decades Catholicism made hundreds of thousands of converts. The strife-torn nation was at last reunited by a powerful shogun, or constable, whose Tokugawa dynasty consolidated control after 1600. The shoguns established the emperor as a unifying figurehead in Edo (modern Tokyo), which gave its name to the third phase of Japanese history, a long stretch of peace and prosperity that lasted until the mid-nineteenth century. Deprived of their function in a pacified country, the samurai faded into irrelevance and often poverty. In revulsion against foreign interference, the shoguns virtually cut off the islands from the outside world; those who clung to outlawed Christianity were massacred in 1637.

The energy turned inward touched off dramatic urban growth, and the economic and cultural mantle gradually passed to the metropolitan middle class of merchants and artisans. Urbanization, occurring only a few centuries after it began in Europe and China, produced a parallel evolution in sexual customs: as society shifted from rural feudalism to a dense and anonymous market economy, love between men shifted from an idealized and personal bond to a cash transaction, albeit one of characteristically Japanese refinement. As illustrated in figure 4.6, citified samurai along with monks and commoners all rubbed elbows (and more intimate parts) in a burgeoning commercial sex culture whose hedonistic epicenters were Yoshiwara, the bustling entertainment and red-light district of the capital, and its raunchy port, Yokohoma.

That culture is familiar to modern eyes from its rich legacy of popular literature and art, whose best-known forms were haiku poetry, kabuki theater, and woodblock prints. Focusing on theaters and teahouses and the pleasures and pastimes of all classes and orientations, Edo art vibrated with the realistic genre details of everyday life. Homosexual love affairs were featured in some of the melodramatic kabuki plots and in prose fiction and illustration, which

were amplified by mass-production technology and even specific woodblock images imported from China. The perennially reprinted author Ihara Saikaku was best known for dedicating an entire volume to *The Great Mirror of Male Love* (1687). His sometimes humorous, sometimes tender short stories were issued, like many others, with illustrations, similar to that of figure 4.6, that offer a cross section of homosexuality in theaters, temples, and brothels, and also among women.

We met Saikaku earlier as an author of samurai tales, and it is one of the ironies of cultural conservatism that most images of the knightly class were produced after that world had slipped into decline. The rising mass audience may have been urban and bourgeois, but these insecure parvenus looked nostalgically to the waning elites for models of decorum and prestige—including pederasty. Significantly, though, the townspeople renamed it *nanshoku*, simply "male love," erasing the overtones of emotional and educational uplift in the older term for the samurai "way." The priesthood offered similarly popular role models: monastic manuscripts like the *Acolyte Scroll* were printed, with woodcut illustrations.

Edo art mirrors its European counterpart, the rococo style, in its aesthetic hedonism, a lighthearted yet wistful celebration of living for the intense but evanescent joys of physical beauty, best captured by the era's world-famous prints on rice paper. Beginning with black-and-white book illustration, the graphic arts expanded into large independent sheets whose calligraphically abstracted lines were enriched by sophisticated multiple printing in pure colors; the delicately allusive name given to these prints, *ukiyo-e*, or "pictures of the floating world," sums up their ambivalent aspirations. "Floating" meant shifting or transitory, a moral metaphor that cut both ways: Buddhists held all such fugitive earthly pleasures in contempt, but ukiyo-e celebrated floating as oceanic bliss, an undulating wave of sensuous delights. Edo sexuality was also fugitive in the legal sense: among several parallels to urban sexual subcultures worldwide, the growing visibility of this quasi-underworld set off periodic though halfhearted outbursts of Confucian hostility and censorship.

Kabuki, which took hold in the seventeenth century as a more accessible alternative to the highbrow No drama, took its plots from contemporary life rather than remote legend. The theater soon became an all-male preserve in which the boy actors doubled as prostitutes, attracting "fans" with the magnetism of modern soap-opera stars. Audiences and their artists were alert to the subtle visual codes of this eroticized demimonde: woodcuts of theatrical groups, like figure 4.6, carefully distinguished the multiple cast of characters by age, costume, and props. Ambiguous young players of female roles, identifiable by the customary long forelocks on the boy in the center foreground, provoked such scandal that the shogun, to defuse their erotic appeal, ordered them to shave their foreheads in the manner of adult men, like the samurai at the left. Actors, being both resourceful and hungry, preserved the illusion of

youth by covering their bare brows with a tight "yaro cap," worn by the two older performers at upper right.

The crowds worshipped these yaro idols in individual portrait prints, an early combination of Hollywood's "pinup" and "publicity still." Still later ukiyo-e celebrate a newly emerging type of actor-courtesans, who lived as women both onstage and off; these *oyama* (or *onnagata*) assumed a fixed identity based on gender, not age, and a permanent social role to match. While recalling such ancient patterns of lifetime cross-dressing as the Amerindian berdache, they also bear a striking resemblance to the exclusively effeminate "mollies" just then becoming visible in similarly urbanizing eighteenth-century London.

Ukiyo-e prints also illustrated more expressly erotic scenes, some of them bisexual or exclusively same-sex. Kitagawa Utamaro, a late star in the Edo firmament, spent so much time in the Yoshiwara quarter that his contemporaries honored him as its all-but-official painter; like his slightly later Western counterpart Toulouse-Lautrec in the Parisian brothels, he knew whereof he drew. Whether they follow an existing text or invent a scenario, his prints often include lengthy calligraphic captions to untangle their exotic combinations, such as an old monk sodomizing a young man who has been simultaneously trying (not too successfully) to satisfy a female courtesan.

Although Utamaro and his fellow artists Ando Hiroshige and Katsushika Hokusai often lavish attention on magnified male and female genitals and the details of penetration, total nudity is rare: the sensuous charge of bare flesh is transferred to the rustle of swaying or rumpled fabric, evoked through rhythmic line and saturated color. When confronted with the physical body, Japanese art sees less the Renaissance microcosm of divine beauty and more the tragicomic whimsy of Utamaro's *Frustration* (Boston, Museum of Fine Arts), in which a stymied older partner gnaws at his fingers in dismay over the mismatch between his impossibly swollen penis and his waiting male paramour's exposed but dainty derrière. Here, as so often in Chinese and Japanese erotica, a third party peeps in—a courtesan outside the curtain.

Beginning with Moronobu, a founder of ukiyo-e, some prints depicted women together. Such images reflect a female subculture parallel to men's: women could buy sexual favors from either sex as well as sell, and lesbians had their own section of the Yoshiwara district. But these pictures generally view female sexuality through a phallic lens, and were probably aiming to titillate a male audience. Typical of their unromanticized emphasis on mechanics is Utamaro's 1788 color print of two lesbians with inflated vaginas preparing to use a strapped-on dildo thicker than their arms. A more fanciful example in Boston illustrates a lesbian joust from the book *Kaisei suikoden* ("The Epic of Sex"). Much like the Mughal painting of figure 4.1, this color woodblock, attributed to the printmaker Eisen, imagines female sexuality in terms of penetrating weapons: long lances tipped with tampons. But abandoning Indian or Chinese decorum, he revels in detailing the result for one combatant: a toe-curling,

neck-arching ecstasy signaled by a geyser of bodily juices that mimics male orgasm and excites the referee looking on (a stand-in for the viewer) to poke his hand under his robe, perhaps to masturbate.

After American Commodore Matthew Perry's gunboats forced their way into Yokohama in 1854, the Japanese—thrust against their will onto the international stage—coped with the shock of exposure by enthusiastically taking up Western ideas and techniques. Emperor Meiji overthrew the last shogun and restored an effective central government committed to making Japan competitive among world powers on the terms set during its isolation. Modernization required two rapidly telescoped revolutions, industrial and moral. Since Francis Xavier, the Japanese had known all too well what Westerners thought of homosexuality, and Meiji's concern for foreign opinion piggybacked on the homegrown asceticism that had cropped up most recently in the Tempo reforms of the 1840s. New laws banned shunga painting and all nudity in art, and abolished male prostitution in the theater, effectively driving most forms of sexual expression underground. As if in revenge, ukiyo-e prints caused a sensation in nineteenth-century Europe and America, though more for their abstract graphic style than for their very un-Victorian celebration of the flesh. Ironically, just as its tradition was cut off at home under the heavy hand of Westernization, ukiyo-e became Japan's best-known cultural export, profoundly altering the course of modern art.

THE ISLAMIC WORLD: DIVERSITY AND DISCRETION

The youngest of the great Asian cultures was Islam, which made up for a late start by its lightning conquests across three continents. The Muslim religion, founded in Arabia by the prophet Muhammad early in the seventh century, spread by sword and sermon to the west, across Africa and into Spain; eastward into Persia, and from that splendid empire into India and southeast Asia; and north to the Turkish Mongols who captured Constantinople, renamed it Istanbul, and nipped at Christendom's Balkan flanks until the early twentieth century. Unlike the Far East, Islamic civilization is not the product of a single geographic area or people, but an eclectic international hybrid that grafted onto a trunk of Koranic beliefs the flowered branches of assimilated peoples.

Islam's cosmopolitan culture as well as its laissez-faire attitude toward homosexuality reached their peak in an illuminated 1627 portrait of Shah Abbas I tenderly embracing his page (fig. 4.8). This delicately tinted and gilded love scene depicts a Persian ruler, whose countrymen ruled India, wearing a Mongol-inspired hat atop his shaved head and drooping mustache, and bears a caption written in Arabic letters. The poem prays, "May life provide all that you desire from three lips: those of your lover, the river, and the cup." The sugges-

tively shaped wine flagon held erect on the boy's bared knee and the watery garden setting, recalling the Koran's image of paradise, underscore how eloquently, despite official reservations, male love was treasured as an intoxicating and even spiritual bliss.

Like its Asian neighbors, Islam was sex-positive at heart: in the Koran, his principal scripture, Muhammad held sex a normal and pleasurable source of vitality and health, and in its earliest centuries Islamic art featured erotic frescoes in bathhouses, all now lost to decay and later puritanism. But as the last of the three Mosaic faiths tracing their origins back to Abraham, Islam inherited the Old Testament hostility to sex between men: the Koran specifically condemns male homosexuality by citing the fate of Lot and the Sodomites. At the same time, Muhammad left loopholes, raising roadblocks to prosecution and assigning no specific penalty. Figure 4.8 reveals that, like the Muslim taboo on wine, visibly flouted by Shah Abbas's splendid drinking vessels, the ban against male intimacy was more honored in the breach than in the observance.

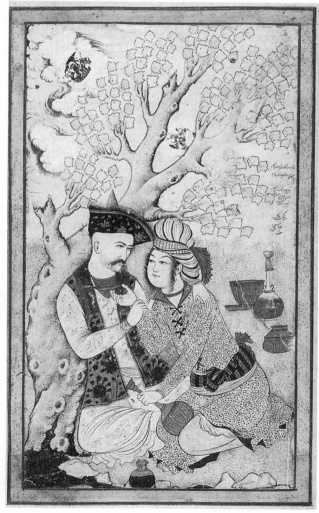

4.8. Muhammad Qasim, **Shah Abbas I with a Page,** 1627 (miniature painting).

Long before Abbas, Islam recorded the love of boys in history and celebrated it in literature and philosophy. Europe's medieval crusaders reported on the ubiquity of "infidel" male sexuality in the Middle Eastern capitals of Baghdad and Damascus, and pilgrims met it in Muslim Spain, center of the golden age of homoerotic poetry. The tradition of extolling the beauty of youths, established in the classical Arabic period by the poet Abu Nuwas, continued in such literary favorites as *The Perfumed Garden,* the "Islamic Kamasutra," which devotes one chapter to male homosexuality—apparently following the matter-of-fact advice from an eleventh-century *Book of Counsel,* "In summer devote thyself to boys, in winter to women." Episodes of male love feature prominently in the *Thousand and One Nights* (Arabian Nights), and in the *Rubaiyat* of Omar Khayyám (d. 1132), whose proverbial verses singing the joys of "a loaf of bread, a jug of wine, and thou" were written to an idealized boy.

All the same, such romantic passions had to negotiate a discreet truce with Islamic law (Shariah) and the "Mediterranean" sexual pattern that prevailed across much of Islamic territory, even away from the sea that gave it its name. In

this patriarchal system, the sexes were rigidly segregated; a man could have four wives and divorce them at will; and adult males dominated passive women, youths, and slaves. Though strict, the moral code never sought to repress sex itself, only to channel it toward overarching social goals: male prestige, gender hierarchy, and community cohesion. In contrast to medieval Christianity, so concerned to stamp out heresy even of thought, Islam could turn a blind eye to legally deviant ideas and acts as long as they were kept out of public view. Muhammad's stipulation of four witnesses to convict a man of sodomy sent the message that it was tolerable up to the point where it openly challenged social uniformity.

So, while much was going on in private, Islam's demand for decorum—not flaunting one's indiscretions—erected an obstacle to the visual representation of homosexual love that, outside its Persian heyday in Abbas's time, proved insurmountable. The dearth of surviving homoerotic images cannot simply be blamed on Muhammad's ban on figurative art, which never extended beyond sculpture and the mosque; illustrated poems, aristocratic romances, epic histories, and sex manuals offer a trove of erotic art, overwhelmingly heterosexual. Sophisticated schools of book illumination and miniature painting flourished in Persia, India, and Turkey; like figures 4.1 and 4.8, all share Arabic script, calligraphic line, and flattened space enlivened with the stylized floral ornament still called "arabesque."

Not surprisingly for such a misogynistic culture, lesbian love was largely ignored. "Harem" is an Arabic word, and Islamic women, cloistered under male control and heavily veiled during rare public appearances, were culturally silenced. Ironically, while sex between women was frowned upon as adultery, sequestering a wealthy household's numerous wives, concubines, female relatives and servants in close quarters fostered precisely such intimacy. Western visitors to Africa and Persia often remarked on the ubiquity of sapphism, and one eighteenth-century European engraver inserted embracing females in his imagined peek at the imperial seraglio of Istanbul's Topkapi Palace (fig. 5.5). Though technically illicit, such hanky-panky aroused little indignation since, again, it took place behind closed doors. Men wrote about it occasionally, as in the Arabian Nights, though with mocking humor; and polygamous Mughal households found it useful to translate the native Indian *Koka Shastra* with its illustrated techniques for women's mutual satisfaction.

The most glorious art center was Persia (modern central Asia). Arab armies converted the Persians by 637, only fifteen years after Muhammad's flight from Mecca, overriding the Zoroastrian tradition whose distaste for homosexuality we saw in the Introduction. Under the Safavid dynasty in the sixteenth and seventeenth centuries, their capital at Isfahan was the fountainhead of Islamic art, whose waters also irrigated the contemporary culture of Mughal India, established by the conqueror Babur (1483–1540). Islamic illustrators laid over the traditional public iconography of battle scenes and court cere-

monial a new vogue for individual portraits and amusing genre scenes, including the portrait of Abbas and his page (fig. 4.8). These exquisitely drawn miniatures of beloved women, boys, and dervishes—whether calligraphically inked or richly colored—offered a more private artistic sphere, conducive to Muslim art's one significant cluster of homoerotic images.

The father of this short-lived brood was Isfahan's reigning master, Riza-i Abbasi, who specialized in vignettes of young men responding to the polite advances or crudely graphic come-ons of older men or, on occasion, to each other. It is sometimes hard to tell the gender of his androgynous adolescents locked in sinuous embrace, but that ambuguity is part of the message: both beardless boys and smooth-cheeked females would have delighted male viewers without violating the taboo against mature men taking the passive role. Color plate 12, in which a lavishly dressed couple nuzzle affectionately, typifies Persian art's lyrical sweetness, gentle mysticism, and emotional subtlety— all rendered more appealing by the lush yet delicate colors, glimmering gold background, and poetic calligraphy.

This brief artistic flowering twined around the ancient vine of Persia's literary tradition, whose roots stretch back to Omar Khayyám; in the thirteenth and fourteenth centuries, his successors Sadi and Hafiz invented the *ghazal*, a love poem to a young boy that became as familiar as the Western sonnet. With their compatriot Rumi, who founded the spiritual order of whirling dervishes, all three poets were adherents of Sufi mysticism, which, like Neoplatonism, preached that the physical rapture of gazing on the roguish eyes or luxuriant curls of a beloved (whether slave, page, or prostitute, of either sex) could uplift the spirit toward the divine beauty of his unseen creator, Allah. The masterpiece of this tradition is the poetic anthology called *Haft awrang*, or "Seven Thrones," by Abdul-Raman Jami; the lavish version now in Washington's Freer Gallery, which took a team of Safavid collaborators from 1556 to 1565 to complete, illustrates a dervish's unrequited love for a boy and a father advising his son how to choose among his throng of male admirers.

On his less exalted days, Hafiz was not above frequenting places of mere earthly delights, bawdy taverns and bazaars where boys entertained both onstage and in bed (the term *bardassa*, from which Europeans borrowed *berdache* for gender-crossing New World homosexuals, came through Arabic from a Persian world for sexual slave or boy prostitute). Pictures like figure 4.8 and color plate 12 share with Persian verse not only characters and situations but even specific props: the bowl of fruit and the carafes containing what the poet Eraghi called "the wine of lovers." These handmaidens of seduction stand for plucking the delights of beauty and luxuriating in Dionysian passion.

The Mughals brought Persian traditions to India, where aristocratic pederasty was recorded in poetry, diaries, and autobiographies, from Babur's own confession of infatuation with a seventeen-year-old boy to courtiers in the capital at Delhi. The hedonistic newcomers in turn picked up some local cul-

ture, like the lesbian love techniques copied by a Mughal artist in figure 4.1. The *Koka Shastra* manuscript was translated from Indian to Persian about the reign of Shah Jehan, legendary for memorializing his young wife in that ultimate valentine to marital love, the lacy marble mausoleum of the Taj Mahal. But visual tributes to homosexual or lesbian love were never to be so monumental, and after the seventeenth century we know only a few scattered miniatures. Silk fabrics sometimes showed a prince and his page riding the same horse arm in arm—an intimacy whose erotic possibilities were no doubt obvious to sophisticated onlookers, but remained safely offstage. Perhaps this later discretion indicates self-censorship, a bargain that bought men sexual freedom in private, at the cost of foreclosing an openly homoerotic voice in the Muslim world until today.

The same reticence affected the Ottoman Empire, ruled by Turkish Muslims until World War I. Although we have reports of homosexuality there as early as Mehmed the Conqueror, who wrested Constantinople from its Greek holdouts in 1453 and carried off the handsomest sons of Byzantine nobility for his own harem, there were limits to how much visibility the public would stomach. The poet Mehmet Ghazali (d. 1535), who wrote praises of male love, built a personal pleasure palace in Istanbul, but neighbors outraged by the constant comings and goings prevailed on capital officials to raze it to the ground; Ghazali replaced it with an identical compound in Mecca, making him a unique early patron of homosexual architecture.

The only known Turkish homoerotic images grace a nineteenth-century manuscript of the *Khamsa* (or Hamses, "Five Poems") by Nevi Zade Atai (color plate 13). On this page—one of several depicting frank homosexual intercourse—a turbaned man is about to penetrate the youth spread-eagled below him while three adult male spectators masturbate excitedly; on another, a youth untypically buggers a bearded adult while an ogling male orchestra serenades their idyll. No other illustrations like these have come to light; whether a richer visual tradition succumbed to later Islamic prudery (as in modern Iran), we cannot yet say.

A brief survey of the Old World outside Europe can only sketch the broad outlines of sexual culture in these ancient societies, which together embrace over half the population of the earth. Though their visual evidence is often fragmentary, the rich literary and historical record suggests that the surviving images of homosexuality are but the chance flotsam thrown ashore by waves of time and cultural conflict from an ocean of sexual affirmation now dammed and dried. No doubt more fossils remain to be excavated from that art-historical seabed. Though it may not please many a present-day custodian of such pictures, their example of guilt-free and dignified passion might offer one of the Asian world's constructive legacies to our increasingly amalgamated global civilization.

FROM WINCKEL-MANN TO WILDE: THE BIRTH OF MODERNITY, 1700–1900

As the poet Tennyson marveled in the mid-nineteenth century, "All ages are ages of transition; but this is an awful moment of transition." He might have added that it was an awfully long one. The wrenching changes unleashed in Western culture after 1700—intellectual, scientific, political, and economic—took nearly two centuries to drastically reshape society and art in Europe, then around the colonized globe. This cataclysmic upheaval, the labor pains of modernity, brought forth from the dying feudal and absolutist Renaissance a new world of bourgeois capitalism, urban industry, mass culture, and contentious pluralism. Art too split into factions; the dizzying parade of stylistic movements that overlapped, battled, and intermingled fell into three broad groups, depending on artists' and patrons' reactions to a shifting world. Neoclassicism tried to carry on the Apollonian language and values of the Renaissance elite; realism rejected that past to preach unflinching study of the present; and romanticism turned its back on both traditional authority and contemporary turmoil to seek out the exotic, the Dionysian, and the inner world of individual emotion.

For gay culture, the period between Johann Winckelmann and Oscar Wilde was a fertile pregnancy, giving birth to a new homosexual identity. Though men had a head start over lesbians, each group grew steadily more visible, and vocal, in social life and the arts. Both the woodcut of figure 5.1 and the fresco of figure 5.3, depicting an intimate embrace between males, were created in eighteenth-century Europe, and sprang from the enormous potential then being unlocked for homosexual self-expression; but their many differences dramatize the competing cross-currents in cultural life. The fresco, an imitation of Roman classicism, was painted in aristocratic Italian circles where its arcane references appealed to scholarly neoclassicists like its recipient, the archaeologist Winckelmann. And the kiss that Jupiter bestows on his beloved nude Ganymede unfolds on the safe stage of myth, speaking a retrospective language of idealized pederasty that would have been comprehensible to Phidias or Michelangelo.

The woodcut, in contrast, presents three crudely realistic genre scenes to

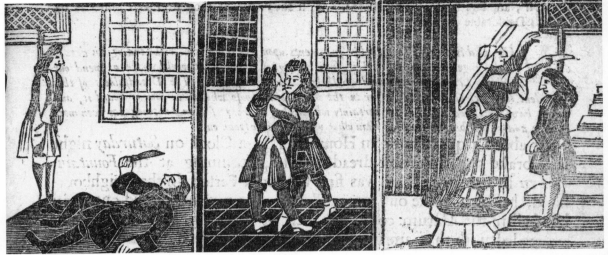

5.1. The Women-Hater's Lamentation, London, 1707 (woodcut illustration).

ornament a tract titled *The Women-Hater's Lamentation,* published in 1707. The two central adults—not a classical man and boy—sport the fashionable wigs and frock coats of their own day, and sneak their kiss in contemporary London; flanking them are single men who committed suicide when exposed. Such pamphlets, as well as single broadsheets or satirical printed flyers, were hawked in the streets to comment on current events. While voicing neighborhood hostility, this illustration nonetheless shows that men who loved men had become a familiar urban type; it is our first visual witness to the homosexual subculture that had begun to take shape in Caravaggio's time, but now burst into public view in the mushrooming cities.

But urban expansion, which upped the chances for anonymity and sexual contacts, was only one beam in the elaborate framework of modern homosexuality. Three overarching revolutions—intellectual, industrial, and political—transformed the eighteenth century; interwoven and mutually reinforcing, they still propel the world today.

The intellectual revolution called the Enlightenment aimed to sweep away the outmoded authority of church and state by applying a new standard of empirical objectivity to sex, politics, and religion. Inspired by the triumphs of science, the French philosophers Denis Diderot and François de Voltaire substituted for divine Providence and the divine right of kings a new first principle: that human reason is the most powerful and potentially good force in the world, whose light should beam over all laws and customs. Applied science gave birth to the Industrial Revolution; as machine power replaced human and animal limbs, factories required massive concentrations of both capital and people, who migrated from farming village to metropolis. England led the way: between 1750 and 1800 London—already large enough in 1707 to support the homosexual subculture depicted in figure 5.1—doubled its population to more than a million. The third revolution was political: growing resentment

between the middle classes, prospering in the new capitalist marketplace, and the increasingly ineffectual elite broke out in the American rebellion of 1776 and the equally epochal French civil war of 1789. For the first time, but far from the last, democratic republics toppled hereditary monarchs.

The shift from religion to science, to a new faith in the individual and in humanity's collective ability to shape its own destiny, inspired a poignant optimism. Secular progress would march inevitably toward utopian heights of material prosperity and the social and psychological paradise proclaimed in the French Revolution's noble slogan, "Liberty, Equality, and Fraternity." But the age of progress was also an age of anxiety, triggered by the loss of eternal certainties, the instability that came with rapid change, and a nagging sense of the spiritual void left by rejecting traditional Christianity.

As the age-old linkage of Sodom's sin with heavenly plague succumbed to bacteriology and psychology, the focus of authority shifted from above to below, from outside to inside, from blind obedience to individual conscience—with profound implications for sexuality and gender. Antimonarchists welcomed the theory, eloquently expressed in America's Declaration of Independence, that every political and moral order was, in Jean-Jacques Rousseau's famous title, a "social contract"—an arbitrary agreement that could be revised whenever necessary to ensure the sovereign truth that all men are created equal, and endowed with certain inalienable rights. Among these rights Thomas Jefferson added "the pursuit of happiness," subtly elevating subjective passions to a political issue. The sober Enlightenment philosophers did not approve of homosexuality, but their credo of privacy and individual freedom ruled out state interference; Voltaire wrote flatly, "When not accompanied by violence, sodomy should not fall under the sway of criminal law, for it does not violate the right of any man." And by the 1790s, women began to question why rights for "all men" so often excluded the second sex from the promise of equality.

Throughout much of the eighteenth century the nobles and clerics who came to be vilified as the Old Regime, insulated by inherited wealth and privilege, were slow to acknowledge or adapt to these radical changes brewing under their noses and their heels. Princes like Eugene of Savoy, whose homoerotic patronage we saw in chapter 3, carried the libertine bisexuality of the baroque courts well into the new century. The mood of the aristocracy in its twilight decades was defined by the rococo style, a final flower of the Renaissance tradition, which bloomed from the early 1700s almost to the eve of the French Revolution. In life and art, erotic flirtation and nervous frivolity distracted a teetering nobility whose oblivious refusal to cut back their customary pleasures is epitomized by the quip of King Louis XV: "After me, the flood."

The public attacked homosexuality as a vice of this indolent and corrupt upper class, though in fact the extensive network that turned up on the Paris police blotter embraced all social levels. They embraced each other in public

parks, notorious dens of erotic iniquity, where sculptures of Ganymede were a popular ornament. The portraitist Rosalba Carriera, stung by the insufficient enthusiasm of a male art critic for the work of women like herself, wrote to a French patron about 1740, "but what could you have expected from a Ganymede?"—betraying the spreading assumption that homosexuals were a breed apart, both effeminate and misogynist. So perhaps the men who cavorted in these Paris gardens grasped the contemporary relevance of Ganymede's well-worn tale, if they bothered to look up from their nocturnal attempts to grasp real youths.

But Carriera's casual shift in meaning, making the adolescent Ganymede stand for an adult, also exposes the classical tradition's terminal exhaustion. The pastel wit of rococo art leached all intensity from mythic passions and stripped them of purpose beyond superficial titillation: François Boucher's playful quasi-lesbian illustration of Jupiter disguised as Diana tickling a sleeping Callisto (1745, San Francisco), could be commissioned for the château of Madame de Pompadour, mistress of Louis XV. Diana and her band bathing al fresco were also painted by Boucher's follower Jean-Honoré Fragonard and by the Italian Giovanni Battista Tiepolo, while outside the gardens images of male love-myths continued to decline.

As court and street increasingly intersected, homosexuals and their sympathizers staked their claim to a recognized role on that public stage by occupying all the spaces of social and cultural life, from the home to the park to the capitol. The regiment of homosexual artists, mustered since Donatello, was augmented by specialized troops sent into new cultural trenches. While writers and painters produced erotic stories and pictures for the boudoir, scholars and connoisseurs wrote books for the study, and patrons and collectors sponsored old and new works for the parlor and the museum. The ascending curve of this subculture will take us from its earliest images, produced by the enemy (figs. 5.1, 5.2), to a full-fledged community with its own organizations and meeting places. And its own mass media: magazines and journals, that ephemeral but influential space of the printed page where art historians and critics could preach their crusade to a wide public forum.

But these two centuries, while crucial to the formation of today's gay world, were not a smooth triumphal march toward homosexual self-realization. To secularize sodomy was not necessarily to accept it: medical science replaced sin with the equally derogatory categories of deviance and disease, and the bourgeoisie strenuously tried to impose their moral order—family-centered, patriarchal, and self-denying—on licentious peer and unruly worker. Tolerance for homosexual expression varied widely over time, space, class, and sex; and tactics shifted accordingly, from storming the citadel to strategic retreat to the sly espionage of camp. So the graph of homosexual art rose in fits and starts—or, to use a modern metaphor, in a series of quantum leaps. Like the particles in an atom, each time the forces building toward gay

culture reached a critical mass, their accumulated energy triggered a sudden expansion to a new level of creative activism, which would then build up steam for a further jump while heating up its opponents' rage.

EARLY EIGHTEENTH CENTURY: THE URBAN HOMOSEXUAL

The composer George Frideric Handel (1685–1759) straddled the intersection between a declining Old Regime and the subculture drawing strength from the era's first quantum leap, exponential urban growth. This peripatetic German, probably homosexual, was welcomed by *simpatico* nobles at Italian courts and English estates but found commercial success in London's gender-bending world of music, theater, and opera. In this racy milieu, transvestism and sexual drama both onstage and off spotlighted the androgynous castrati, boys castrated before puberty to preserve their high voices; idols like Farinelli received tributes from male admirers and publicity from portraits. The homosexual side of the entertainment industry—which also featured public pleasure gardens, brothels, and bars—had first become audible in late-sixteenth-century tavern songs. Now it also became visible, both looming larger in the physical townscape and being represented in graphic form. As early as 1707, prints like figure 5.1 documented the sodomites and their haunts; castrati made their entrance around 1730 as characters in satirical images of amusement parks. Handel also straddled a yawning geographic divide: citified new mating habits took hold mainly in industrialized northern and western Europe, while the Mediterranean and Islamic pattern, where boys were available to adult men, persisted in the south and east, making these regions a mecca for wealthy northerners' sexual tourism.

Men of lesser means had only to travel to the margins of their own city to satisfy their shared desires. While many "dropped in" to this clandestine underbelly on temporary leave from marital duties at home, others began to live outside the traditional family as permanent lovers of men. New social rituals evolved in meeting places like the tavern-brothels whose name, "molly houses," was apparently derived from the first known private sodomites' association, the Mollies Club, reported by the gossipy journalist Edward "Ned" Ward in 1709. The club was punished and disbanded, but bequeathed its title to a type of building and to the men found around it. Outside these relatively protected shelters London mollies, like Parisian Ganymedes, followed in the footsteps of their erotic ancestors beneath the arcades of Renaissance Florence, appropriating public spaces in parks, toilets, and the open plaza around Covent Garden market.

As this coalescing community reshaped the practice of sodomy, a parallel evolution reformulated the theory of sex. In contrast to the Mediterranean tol-

erance for adult men's dominance of women and boys, grown men now sought each other: sexual couplings shifted from the age hierarchy of pederasty to equal pairs of adult comrades like the two in figure 5.1. What Renaissance writers had often suggested—that some people feel an innate and exclusive desire for their own sex, linked to a distinctive personality—now became an article of faith. Fluid bisexuality gave way to a rigid psychological classification of four genders: male and female heterosexuals, sodomites, and lesbians (or *tribades*). "Sodomite" expanded from a legal category to a core identity—the men in figure 5.1 are defined by the very title of their book as congenital "women-haters"—characterized by cross-dressing and the subversive frivolity now known as camp. In London and Paris, mollies took up women's names, slang, and clothing, and thumbed their noses at heterosexual proprieties by calling sexual couplings "marriage." Though these roles were not yet the same as today's gay (or lesbian) identity, they are recognizable as the embryos of modern gay culture.

Even for those who promulgated it, this new psychology produced new anxiety. Ned Ward complained that the mollies "adopt all the small vanities natural to the feminine sex" and "behave as women do"—invoking the "natural" to condemn not, as Thomas Aquinas had, a sexual sin, but a transgression of tightening gender boundaries. Ward mocked them for having "so far degenerated from all masculine deportment or manly exercises," introducing a medical language of decay to brand them as less than fully "men"; the homosexual type even became associated with occupations such as tailors of women's clothes. The "normal" male now had to guard against any behavior that might suggest effeminacy, and bourgeois men's fashions grew pointedly more sober in color and decoration.

Figure 5.1 is prophetic for its medium as well as its message. Inexpensive broadsheets and prints, the ancestors of today's tabloid press, served a growing mass audience of literate and leisured urbanites more in the market for contemporary news and scandal than for the remote myths of high culture. Whether simply reporting current events, or venturing into caricature and lampoon, the new popular culture "policed" social norms in the name of bourgeois morality, pouncing on all deviations with relish. The rather sweet embrace in figure 5.1 was just the sort of display to incite this righteous outburst from the author of the pamphlet *Satan's Harvest Home* (1749): "Nor can anything be more shocking, than to see a couple of creatures, who wear the shapes of men, kiss and slaver each other . . . even in our most publick places." Ironically, the very act of attacking such goings-on in print served to advertise them further.

As in China and Japan, visibility created backlash: intermittent campaigns not just in the press but in court, fomented in London by private watchdogs like the Society for Reformation of Manners. Figure 5.1 depicts the gruesome suicides of mollies caught in the wave of prosecutions the tract reports. Paris police also kept their Ganymedes under surveillance. The history painter Jean-

Baptiste Nattier was imprisoned in a 1726 scandal over boys abducted for sale to nobles; the barons were immune from the law, but the humble artist cut his throat rather than risk burning at the stake.

A wave of exceptionally zealous persecutions swept the Netherlands in 1730, pointedly propagandized by prints like figure 5.2, whose six panels depict in comic-strip fashion the misadventures of two hapless victims. The series, published on a single sheet with the moralizing caption "Temporal Punishments Depicted as a Warning to Godless and Damnable Sinners," documents in miniature both the genre details of local mollies' everyday life and the fate that always hung over their heads. One group arrested in Utrecht implicated others, setting off a hysteria that led to at least fifty-nine executions from The Hague to remote villages. The decree ordering this roundup specified that anyone who fled his hometown was suspect—just as the two nameless men try to do in panels 1 and 2, sneaking out of a tavern and leaving their families. In the remaining panels they are arrested in the street, languish in prison, and are burned alive, their ashes scattered to obliterate their stain on the body politic. Other broadsheets illustrated individual hangings: the printer Cornelis van Zanten, apparently hard-pressed to keep up with the nationwide witch-hunt, met the incessant demand by reusing for Delft in July and Amsterdam in September the same generic woodcut of an executioner cutting down a victim.

5.2. Temporal Punishments Depicted as a Warning to Godless and Damnable Sinners, 1730 (engraved broadsheet).

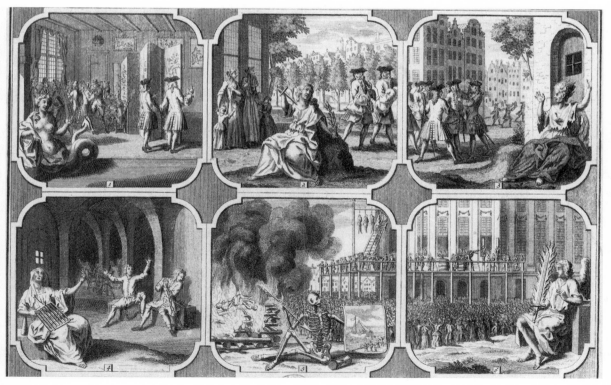

These victims' stain was so visible because Dutch mollies washed their dirty linen in public. Promenading men claimed the arcade of Amsterdam Town Hall, signaling their availability by holding one arm akimbo like Donatello's *David*—a gesture adopted from female prostitutes, though intriguingly common in male portraits of the Dutch Golden Age. Civic authorities, outraged by such brazenness at the very building where sodomites were tried and burned, increased the lighting under the arches; as with similar modern crackdowns, the resourceful hunters simply moved on to another nearby public space, the New Church. Further persecutions and pictures testified to this ongoing threat from the urban underworld and to society's determination to enforce the new gender code. An English broadsheet of 1762 depicted a molly exposed in the public pillory amidst a jeering crowd who brandish flails and rotten fruit, with speech balloons over their heads letting us hear the taunts from their leering faces: "Flogg him" and "Cut it off."

NEOCLASSIC AND ROMANTIC: GRAND TOUR AND GRAND PASSION

Meanwhile, far from the stew pots and shadows of gritty London, in sunny Italian villas and misty English manors, a more rarified pattern of homosexuality was taking shape. When the notorious libertine Giovanni Giacomo Casanova—whose noble Venetian surname, like the Spanish version of his first name ("Don Juan"), still stands for an irresistibly rakish adventurer—stumbled upon Johann Winckelmann in his Roman study one day in 1761, he caught the learned archaeologist pulling back quickly from a young male companion. Without realizing it, Casanova was also witnessing the next quantum leap in the formation of homosexual culture: a community of intellectuals and artists marshaling history and aesthetics as a means to self-understanding and justification. Homosexual painters, poets, and theorists—with key support from freethinkers and feminists—played prominent roles in creating both neoclassicism and romanticism, the twin artistic movements that would dominate the century between 1750 and 1850.

Hoping to bolster the authority of the ancient world—to rejuvenate its effete rococo seedling with a dose of the sober moral uplift and harmonious simplicity of Athens or Republican Rome—neoclassicism put knowledge of the past on a scientific and intellectual footing: excavations at the Roman city of Pompeii, preserved by the lava from Mount Vesuvius, began in 1748, followed by field trips to Ottoman Greece. Romanticism was conceived in passionate crusade against just this Enlightenment rationality, against the dragon of a secularized materialism whose flaming breath ignited the physical slums and spiritual turmoil of the new cities; but it too opened new arenas for the play of a homosexual imagination.

Johann Joachim Winckelmann (1717–68), a German scholar who migrated to papal Italy, cast the longest shadow over neoclassicism. His enthusiasm and encyclopedic knowledge earned him a post as librarian to Cardinal Alessandro Albani; his writings, which reigned as standard reference works for a century, earned him a double title as founding father of art history and archaeology. The German poet Johann von Goethe, whose own passions mirrored Winckelmann's, later wrote of him, "Everything that he produces is great and remarkable because it reveals his character"—including, though Goethe didn't quite, his idealized attraction to androgynous younger men. The guiding force behind Winckelmann's intellectual pursuits was a yearning to dignify his own predilections by appeal to the prestige of the ancients—for whom, as he wrote to his most passionate infatuation, Friedrich von Berg, "the supreme beauty is male rather than female."

At Albani's Roman villa, Winckelmann delighted in both the distinguished collection of antique sculpture and the homosocial atmosphere tolerant of discreet bisexuality. In his published catalog of the collection he declared one relief, showing Antinous as the mythical Vertumnus, to be a paragon of male beauty. Antoine Maron's portrait of Winckelmann shows him writing while an engraving of that favorite work lies across his notebook; from then on Antinous all but replaced Ganymede as the premiere archetype of male desire in art. But the fading cupbearer's last star appearance was also inspired by Winckelmann: Figure 5.3, a mock-Roman fresco created in 1760, was an elaborate hoax perpetrated by artist friends on the lovestruck classicist. Knowing his frustration at not finding more evidence of antique pederasty, Anton Mengs or Giovanni Battista Casanova (not the lothario) forged this plaster pastiche of ancient and Renaissance motifs and "brought" it excitedly to Rome as a new-found excavation. Enchanted, Winckelmann published it as authentic; only much later, after he had praised the nude Ganymede as "pining for sensual pleasure," did he discover to his chagrin that his friends had been duping him.

In his classic *History of the Art of Antiquity* (1764), Winckelmann nostalgically exalted the long-lost harmonious unity of Greek art's "noble simplicity and calm grandeur." For history as chronicle—a mere accumulation of facts and dates—he substituted history as narrative: a systematic theory of how art evolves in response to changing social conditions. His thesis was a moral one: the Greeks' aesthetic perfection reflected the ethical utopia of the city-states, their fostering of individual freedom within a perfect bisexual manhood. Prime totem of that Platonic paradise was the male nude, sculptures of which he described in almost fetishistic rhapsody: "A beautiful, youthful, godly physique awakens tenderness and love that can transport the soul into a sweet dream of ecstasy"—a spiritual vision through which modern society might transcend its sexual fragmentation.

His famous passages on the Hellenistic *Apollo Belvedere* (figure 1.17), whose youthful godly beauty he crowned "the highest ideal of art," bodied forth a

novel approach to sexuality and art. Contemporary philosophers like Edmund Burke split aesthetic experience into two sharply contrasted and gendered poles: the "sublime," associated with the awesome and muscular potency of active masculinity, versus the "beautiful," assigned to the gracefully seductive and passive female object of this power. By praising the androgynous male as beautiful, Winckelmann stood these categories on their heads: men could now play both the desiring spectator and the vulnerable recipient of that desiring look. The fresco foisted on him could only have been invented by someone who knew his longings intimately, for it visualizes just that fantasied exchange of gazes: the mature bearded Jupiter, stand-in for the scholar, dotes on the ado-

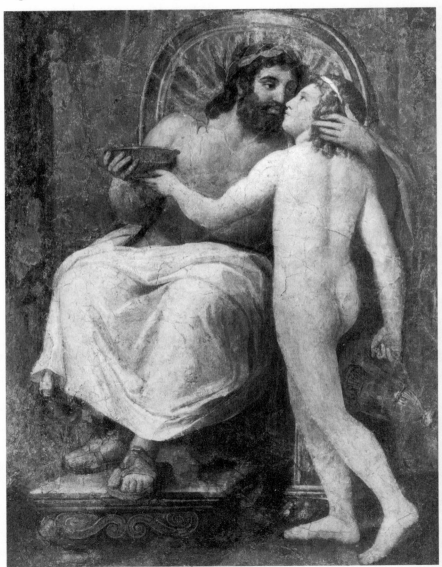

5.3. Anton Mengs or
Giovanni Battista Casanova,
Jupiter and Ganymede, 1760
(forged antique fresco).

lescent ephebe whose pose reproduces the *Apollo Belvedere* seen from behind.

Winckelmann was acutely aware that his exploration of an alternative sexual vision was leading him into hostile territory, and his writings slyly betray their unwilling discretion to any reader learned enough to crack the code. In the preface to *Art of Antiquity* he hints that "I would have been able to say more if I had written for the Greeks, and not in the modern tongue, which imposes upon me certain restrictions," then confesses that he "reluctantly" left out a dialogue on beauty modeled on Plato's *Phaedrus*—a founding text of pederasty. By calling attention to the crevasse that separated his sensibility from the norm, he mapped two camps facing each other across a disputed border—and then rallied his own forces around a claim to intellectual and moral superiority. As he scornfully wrote to von Berg, "those who are observant of beauty only in women . . . seldom have an inborn instinct for beauty in art." Vulnerability to beauty was, in other words, closely tied to vulnerability to male desire, and both of these capacities, which effeminate homosexuals stereotypically displayed to excess, were paradoxically elevated from faults to strengths, the wellsprings of creative genius.

Unfortunately for Winckelmann, his remarkable theory, though it made a vital leap toward positive homosexual identity, wasn't true of all individual homosexuals. Passing through Trieste in 1768, he invited to his hotel room just such a seemingly sensitive young stranger, ostensibly to show him some antique coins. Whether the offer was purely educational or a variation on the modern line "Come up and see my etchings," the sometime thief stabbed him but ran off without the coins. His interest in Winckelmann's treasures may have been mercenary, but countless other men were inspired by Winckelmann's work, which offered them a sense of their own pedigree and the legitimacy of their feelings. For forging the link between homosexual desire and aesthetic sensibility, later generations, from Goethe to Walter Pater, invoked him as the godfather of the gay imagination.

Winckelmann's sordid end did nothing to slow the swarm of northern Europeans who descended on Italy for the Grand Tour, a strenuous odyssey sometimes lasting several years that laid the indispensable keystone of a young gentleman's education. As it had been for Albrecht Dürer in the Renaissance, a carriage ride over the Alps was a "hot ticket," in all senses of the term: admission to opportunities for drinking from the classical heritage at its source, studying the modern marvels of art, and sexual initiation. The pastoral landscape where the ancients themselves had frolicked, where James Boswell declared "my blood was inflamed by the burning climate" that northerners associated with languorous indulgence, offered a fertile field for young swells to sow the same wild oats in modern dress. The magnets for wandering "milordi" were Venice, Florence, and Rome, where they could hobnob with learned guides like Winckelmann himself and with wenches or cute boys more readily available than at home.

5.4. Pompeo Batoni,
Portrait of a Young Man,
ca. 1760–65 (oil).

What these gentlemen picked up on their travels can be seen in their
many portraits: in Pompeo Batoni's picture of a typical young noble, perhaps
French, from about 1765 (fig. 5.4), the bewigged and bookish young dandy
shows off a copy of the Antinous relief then in Cardinal Albani's villa. Not con-
tent with painted mementoes of such prestigious symbols, wealthy tourists
outbid one another for artistic souvenirs—marbles, prints, and oils—to adorn
their great country estates. Back home, connoisseurs formed clubs like the So-

ciety of the Dilettanti, whose name still perpetuates the link between homosexuality and amateur art collecting and appreciation.

Florence was the most popular British stopover, thanks to Ambassador Horace Mann, whom the gossipy Mrs. Thrale called a sodomite. Mann hosted many compatriots with similar leanings, like the writers Thomas Gray and Horace Walpole, who traveled together in the 1730s amassing Antinous figures and other classical trophies. The artist Thomas Patch, who accepted Mann's hospitality after being banished from papal Rome in 1755 for some homosexual indiscretion, painted popular caricatures of his visiting countrymen. Patch was satirized in turn by his contemporary Johann Zoffany's *The Tribuna of the Uffizi* (1779), where a mob of prominent cognoscenti admire the Medici museum's wall-to-wall treasures. Patch stands with Mann before a Titian *Venus*, but points over his shoulder toward a Greek marble of two male wrestlers—perhaps a wry snicker at the pair's Winckelmannian preferences.

Similar circles sprang up outside Italy, most notably at the court of King Frederick II of Prussia, known as The Great (1712–86), one of Europe's most enlightened monarchs, whose glittering Berlin hosted such cultural superstars as the French philosopher Voltaire. As a sensitive prince bullied by his martial father, Frederick tried to run away from home with an older army officer; the king nipped the plot in the bud and forced his boy to witness the handsome guardsman's beheading—whereupon Frederick fainted. As king, the constraints of his public role left little opportunity for fulfillment in love (forced to marry, he later banished his wife); like so many contemporaries, including Sweden's homosexual ruler Gustav III, Frederick sublimated his longings into male companionship and cultural patronage.

Something of a sketcher himself, Frederick took an active hand in designing his palace of Sans Souci, a rococo retreat set in a vast suburban garden to imitate Hadrian's villa outside Rome. He purchased antiquities on homosexual themes then being excavated at the original Tivoli, including Hadrian's memorial images of his beloved Antinous, and bought a nude antique bronze, *Praying Boy*, that had previously belonged to Eugene of Savoy. He installed the graceful youth (then fashionably labeled another Antinous) outside the window of his study, where he would gaze at him longingly to rest his eyes from state papers. Courtiers, who knew his sexual leanings, no doubt understood the idol's function: a consoling reminder in art of ideals that, for a king, had to remain just beyond his grasp in life.

The passionate fulfillment that Frederick denied himself was, however, achieved by at least one German contemporary. A huge canvas of *The Death of Hyacinthus*, painted about 1752 by Venice's last rococo master, Giovanni Battista Tiepolo (color plate 14), seems to be a testimonial to one of the transalpine love affairs that sprang up on the warm soil of Italy. The patron was a twenty-eight-year-old German baron, Wilhelm Friedrich Schaumburg-Lippe Bückeberg, who lived blissfully in Venice with a Spanish musician until the

youth died in 1751. Since Wilhelm's father wrote to him about "your friend Apollo," the bereaved younger noble probably commissioned this memorial as a tribute to his lost godlike beloved. While Apollo/Wilhelm's gesture of shock and anguish is no doubt heartfelt, it verges on histrionic, and the picture's incongruous updating adds an unintented humor typical of mythology's decline: the massive classical discus that Ovid blames for the boy's death is here replaced by a tennis racket, then a fashionable game but played with balls, like the tiny ones in the foreground, unlikely to produce such dire effects.

Neoclassicism succeeded in Winckelmann's goal of keeping alive the tenets of antique art, until it faded away into the vestigial nineteenth-century mythological "salon pictures" that modern artists are taught to laugh at. Along the way, its many themes provided the generations from Jacques-Louis David to Frederic Leighton with pretexts for rich homoerotic works; but it was not alone.

ROMANTICISM: RECLUSES, TRAVELERS, AND PORNOGRAPHERS

If classicism was the obedient offspring of the Enlightenment, its twin, romanticism, proved a rebellious child. Romantics were appalled at the physical and social environment produced by the scientific Enlightenment, a mix of ugly industrial materialism and bourgeois philistinism that stifled the life of the spirit. Rejecting reason as a panacea for contemporary problems, they replaced it by a cult of emotion, a melancholy nostalgia for anywhere but the here and now. They exalted turbulent individual desires, not calm, collective order—in Burke's terms, the sublime inner darkness over beautiful daylight clarity, body over mind, feeling over thinking. Seeking antidotes to the meaninglessness of everyday life in the imaginative realms of mysticism, sensuality, and "art for art's sake," they claimed for the sensitive soul a passionate license outside all social conventions.

Sex was one private desire to be released: echoing Jean-Jacques Rousseau's famous cry, "Men are born free, and everywhere they are in chains," his acolytes preached a liberation of the erotic body as much as the body politic. His book of intimate personal *Confessions* opened up self-knowledge of each individual's unique personal essence as the door to an ideal of self-fulfillment epitomized in Jefferson's "pursuit of happiness." Though Rousseau himself confessed shock at the prevailing nonchalance about homosexuality, his credo was a time bomb lobbed by homosexual activists a century later.

Explicit male sexuality is rare among the romantics, partly from forced discretion. Although the era's effusive declarations of passionate friendship were long discounted as overheated formulas for merely platonic affection, the reverse is more likely: in a time of harsh public scrutiny, more went on physically

than all but a few writers dared commit to paper. Goethe's *Wilhelm Meister*, a novel of two men whose "passionate kisses swore eternal friendship," echoed Winckelmann's fevered descriptions of nude male beauty, but for many leaders of the movement, homosexuality remained a subtext shadowing their life and art. Either way, it was a passion all the more conducive to poignant romantic suffering for being forbidden, a tragic yearning that must be locked up in secret struggle.

Among the early romantic tastemakers were a series of English bachelors (of both sexes), as intent as Winckelmann on creating a private space for their publicly suspect passions. In his *Castle of Otranto* (1765), the wealthy aesthete Horace Walpole (1717–97), whom we met in Florence with Thomas Gray, invented the "Gothick" novel, a luridly supernatural horror story unfolding in gloomy dungeons replete with shrieking skeletons. Though Otranto's unbridled passions are heterosexual, the dark secrets hidden in its ancient bastions served Walpole as a metaphor for the dark secret of homosexual desire, mostly repressed to stave off the snide attacks on his male loves. At his country home, Strawberry Hill, Walpole created his own version of fairy-tale Otranto: pioneering the new Gothic Revival architectural style, he trimmed the existing building with medieval gingerbread to create a romantic setting for melancholy thoughts of past and unfulfilled love. Among the houseguests were his heir, the sculptor Anne Damer, and her lover Mary Berry.

Thomas Gray, the most popular poet of the century, was a bookish introvert who sublimated his homosexual longings into requiems for dear departed men. Best known is his "Elegy Written in a Country Churchyard," begun after the death of his school-days companion Richard West; painting a word-picture of the funeral for a man once "crossed in hopeless love," Gray could as easily be referring to himself as to the deceased in the heartbroken lines, "He gave to Misery all he had, a tear, / He gained from Heaven ('twas all he wished) a friend." Walpole published Gray's major poems in a 1753 edition illustrated by Richard Bentley, a collaborative landmark in English book design whose homoerotic foundations were politely camouflaged as a tribute to chaste classical amicitia.

William Beckford (1760–1844), the richest man in England, exulted in his Winckelmannian sensibility, rhapsodizing about his grand tour of the Uffizi Tribuna, "I fell into a delightful delirium which none but souls like us experience." Hounded out of Britain in 1784 after being caught in the bedroom of an earl's sixteen-year-old son, and socially ostracized after his return, the embittered Gothic novelist spent his later years building another faux-medieval rural retreat. At Fonthill Abbey, in endless chambers crammed with commissioned artworks beneath a spire intended to overtop Saint Peter's in Rome, he staged extravagant entertainments, complete with his beloved castrati, for those who would still visit him. Even more than his titled role models Walpole and Philippe d'Orléans, Beckford exemplified patronage as an outlet for the pow-

erless. For homosexual men of money and taste, art could provide both refuge and revenge: banished from the social stage, they created an offstage platform of aesthetic achievement where they could flaunt their cultural superiority.

Romantic obsession with the faraway and long ago was reinforced by improvements in transportation, printing, and journalism and the upsurge of exploration and colonization, which exposed Europeans to the exotic sexual cultures of Africa and Asia. Figure 5.5, an engraved cutaway view into the multistoried harem in Istanbul's Topkapi Palace, was imagined in the early 1800s by the visiting artist Anton Ignatz Melling, who included among the daily routine two female inmates embracing in a doorway at the lower center. Although Melling was barred from entering, he had no shortage of sources for the close relationships fostered in this cloistered seclusion, which was depicted in Turkish miniatures and described by travelers to Ottoman lands like the poet Lord Byron and diplomat Richard Burton. Verbal and visual reports set off a wave of what we would now call multicultural eclecticism, overlapping artistic crazes for Turkish, Indian, and oriental motifs. Frederick the Great built a Chinese teahouse at Sans Souci; whether or not he knew that gazebos like his were a common setting for Eastern homosexual erotica, such borrowings betray how Westerners, confronted with a staggering variety of other ancient cultures, grew less certain that they alone represented "normal," much less "ideal" civilization.

Reporting about sex in the respectable guise of travelogue or anthropology shaded into the burgeoning genre of pornography, which took the liberation of desire to prurient extremes of both text and illustration. France's Marquis de Sade is only the best known of many who penned salacious literature for the expanding print market, from Casanova's memoirs to John Cleland's 1749 novel *Fanny Hill*—whose plot is revealed in its subtitle, "Memoirs of a Woman of Pleasure." Winckelmann appreciated that Fanny's description of a male body dared to give erotic voice not only to women but also to the feminine mollies who heard her ventriloquizing their own passionate gaze; less sympathetic readers ignited the critical firestorm that still swirls around printed obscenity and "smut."

Some artists sought biblical or classical pretexts for homosexual erotica, aiming for a marketable mix of lascivious titillation and mock disapproval (today called "redeeming social value"). In François Rolluin's engraved illustration to a 1781 retelling of the story of Lot, the Sodomites embrace and copulate in full view of God, who slaps his forehead in shock. Two erotic volumes were issued by the French Baron Hugues d'Hancarville in the 1780s, one purporting to depict "The Private Life of the Twelve Caesars" in a series of prints, imitating antique cameos, of bawdy homosexual encounters loosely drawn from the similarly titled book by the moralistic Roman historian Suetonius.

The writings of Sade smack their lips over both male and female sodomy among a stunning variety of deliberately shocking and inventive scenarios,

5.5. (opposite) Anton Ignatz Melling, **Interior of the Royal Harem, Topkapi Palace** (detail), Paris, 1819 (engraved illustration to **Voyage pittoresque**).

whose pansexual perversions often feature the bondage and flagellation now labeled, in his honor, sadism. He claimed an enlightened pedigree and liberal goal for his works, arguing in *Philosophy in the Boudoir* that no criminal penalty should be attached to same-sex love, which he termed a mere "abnormality of taste." But his actions went beyond his words, leading to decades in prison for sodomy and debauchery. And his words were inflammatory enough, fantasizing such bizarre extremes as hermaphrodites and a full circle of Polish men each penetrating the one in front of him. Engravings for the first edition of *La Nouvelle Justine* (1797) illustrated the novel's frequent orgies where chains of men sodomize one another (sometimes alongside heterosexual copulation) or engage in fellatio and mutual masturbation.

Sade's call for flagrantly indiscriminate pleasure-seeking embraced the lesbianism of *Justine*'s heroine. Juliette, pronouncing herself "exempt from all religious dreads," dares the world, "What is the power, human or divine, that could impose a check upon my desires?" The specter of this female outlaw, the insatiable voluptuary, haunted a wide public: revolutionary attacks on France's self-indulgent queen Marie-Antoinette often caricatured her as a lesbian nymphomaniac, illustrated "convent novels" treated nuns like witches, and d'Hancarville's second volume laid bare "The Secret Cult of Roman Women." Amid all these images from men, *Mary: A Fiction* (1788), by the outspoken feminist Mary Wollstonecraft, was the first book by a woman to treat love among her own sex.

At the same time that lesbian eros was surfacing in the arts as shocking and libertine, embryonic possibilities opened for real women—at least the wealthy and discreet—to share their lives without social reproach. Sarah Ponsonby and Eleanor Butler, learned and creative girls from noble Irish families, eloped together in 1778 to spend the rest of their days in the same bed in a charming cottage in Wales. Just what they did in that bed is unknown, but the "Ladies of Llangollen" got away with their mutual passion by exploiting the uncharted turf between the rigidly dichotomized female roles of virgin and whore, temptress and moral beacon. Like male amicitia, romantic friendship between women was publicly admired as long as it maintained a façade of chastity, a spiritual affection that transcended the flesh. It also avoided mundane marital duties, which made it appealing to early feminists; but the Ladies were no feminists. Conservative in all but their independent "marriage," they entertained leading writers and statesmen and even attracted tourists. Early celebrity-seekers would have seen Mary Parker's oil portrait of the pair in their book-lined studio, sporting mannish clothes and haircuts that give them the safely neutered look of two old bachelors. Later this realistic genre scene was reproduced in engravings for a mass audience, marking the first female equivalent to the molly prints that began a century before.

LATER CLASSICS AND ROMANTICS:
DAVID AND BYRON

From the late eighteenth century well into the nineteenth, classicism and romanticism evolved new fruits to suit a shifting political climate. The standard homoerotic myths were illustrated by British neoclassicists Gavin Hamilton and Benjamin West in the 1760s and '70s, followed by the German Asmus Carstens, the Danish Bertel Thorvaldsen, and the Italian Antonio Canova. But France occupied center stage in Europe's cultural drama, especially after Napoleon Bonaparte crowned himself emperor and aggressively spread the Revolution's gospel as far as Russia and American Louisiana. The adaptable dean of later neoclassicists, Jacques-Louis David, purveyed antique subjects to his rapidly rotating patrons under royalty, republic, and empire. His *Death of Socrates* (1787) typically cloaked the call for freedom and public-spirited individualism, associated with Greek society, in the ideal Winckelmannian body, a seductive fusion of virtue and beauty.

Nor was Socrates the only poster boy in what became a systematic cultural campaign. French neoclassicism was officially promoted by the annual Salon, or state-sponsored painting exhibit. The arts bureaucracy that set topics for the Prix de Rome competition—a ticket to foreign study and academic success—ransacked ancient history and myth for scenes of moral uplift and, often, beefcake. Between 1780 and 1820, Salon entries by David and his circle illustrated Daedalus and Icarus, various ill-fated male loves of Apollo, and Trojan War episodes featuring Achilles and Patroclus. David debuted with a grandiose *Funeral of Patroclus* (1779), centered on Achilles weeping over the pyre of his slain beloved. In 1801 his student Jean-Auguste-Dominique Ingres won the Prix de Rome with a rendering of the same pair, still alive, receiving the ambassadors of their estranged ally Agamemnon. Ingres knew his antique sources, basing Patroclus on a Ganymede sculpture in the Vatican; and he knew his Winckelmann, precisely defining, in the contrast between the stiffly upright bodies of the bearded messengers and the younger couple's sinuous feminine curves, the alternative visions of sublime masculinity and beautiful androgyny.

The sexual tolerance of antiquity pervaded politics as well as art. In its sweeping 1791 overhaul of royal legislation, the national assembly that guillotined Marie-Antoinette and Louis XVI also chopped down all legal prohibitions on consensual sodomy, relegating it to the archaic category of witchcraft and blasphemy. A similar laissez-faire animated the Code Napoléon of 1804, a systematic revision of French law carried out at the new emperor's behest by his chancellor Jean-Jacques Cambacérès, whose discreet but hardly secret homosexuality exasperated both his boss and the public: when popular broadsheets caricatured the minister's foppish effeminacy, his government tried to censor them. The Code was extended to many of the nations Napoleon con-

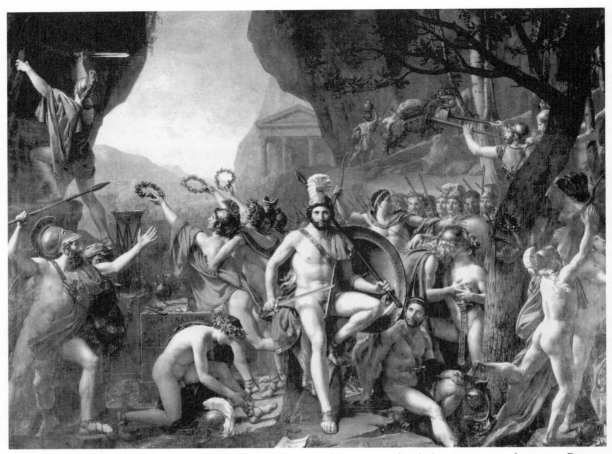

5.6. Jacques-Louis David, **Leonidas at Thermopylae**, 1800–14 (oil).

quered, legally reinforcing the existing divide between an unforgiving Protestant north and a more easygoing south. Though police could still harass the sexual underworld for lesser offenses, France's pioneering decriminalization turned Paris, "the capital of the nineteenth century," into a mecca for generations of sexual expatriates.

David's last great classical history painting, *Leonidas at Thermopylae* (fig. 5.6), visualizes this newly liberal society. The Spartan general, whose troops were renowned for their mutual devotion, is caught in a moment of fateful meditation as his men frantically prepare to meet certain death at the hands of the invading Persians. Leonidas is a full frontal nude in the flower of manhood, his genitals not quite concealed by a phallic upright sheath. To the right, a young eromenos, naked but for a rose garland in his hair, kisses his bearded erastes an emotional farewell; in the left background a youthful quartet clasp shoulders while offering wreaths to the warrior-hero Hercules. David began his picture in 1800, when its theme of self-sacrifice for the common good enjoyed a desperate popularity in a revolutionary France beleaguered by foreign forces. By the time he and his students finished the giant canvas in 1814, Napoleon's im-

pending defeat at Waterloo lent a new relevance to the pathos of men passionately bonded under a charismatic and doomed leader.

David was no sodomite, but the emotionally charged male bonds of armies old and new mirror the homosocial atmosphere in his workshop, where pupils vied for attention and approval. Anne-Louis Girodet de Roucy Trioson and Jean-Germain Drouais looked up to their beloved master just as the splendid lieutenant seated at Leonidas' feet looks up to him in somber devotion; for his part, David said of Drouais, "I could no longer do without him." These followers pushed the Davidian ideal of feminized male eroticism, but softened his crisp linear style into an eerily backlit dreamworld. In 1801 Jean Broc, member of a nonconformist brotherhood who called themselves the Barbus, or "bearded ones," after their bohemian style of dress, exhibited his *Death of Hyacinthus*, which melted the *Apollo Belvedere* into a pair of morbidly limp androgynes, their eyes shut in the pathos of final embrace. In Girodet's *Sleep of Endymion* (1791–93), yet another adolescent nude, sentenced to eternal sleep by the lovestruck but conflicted Diana, sprawls in a lush forest clearing like a fitful Borghese Hermaphrodite as the invisible virgin's gaze plays over him in a shaft of moonlight; though the story is heterosexual, the boyish Cupid whose ogling grin stands in for the absent goddess allows free rein for an all-male reading. In these mystical, almost saccharine fantasies of swooning ephebes, the classical stream began to evaporate into the tragic mists of romanticism.

Girodet illustrated a translation of *The Odes of Anacreon*, who was crowned poet laureate of Athens for his lyrical hymns to love and delight. The many

5.7. Anne-Louis Girodet de Roucy Trioson, **Bathyllus Drawing a Portrait for Anacreon,** ca. 1817 (engraved illustration to **The Odes of Anacreon**).

scenes of garlanded nude ephebes, putti, and satyrs carousing around a wine vat include a sweet rendering of Anacreon's plea to an artist friend to "draw for me my companion Bathyllus, as I instruct you" (fig. 5.7). In what sounds like a recipe for Endymion, Anacreon instructs the artist to capture the boy's androgynous appeal by combining features of Mars and Venus, and to "make his ringlets shining and as dark as midnight." The image captures all sides of the neoclassic studio's triangle of ancient history, modern art, and male friendship: we may read the

older Anacreon as David, intimately involved with the seated younger artist through their shared contemplation of the beautiful model, whose languidly feminine pose Girodet copied directly from his *Endymion*.

While Broc and Girodet treated classical subjects with romantic touches, the pure romanticism that culminated in William Blake and Francisco de Goya exhibited scant interest in male homoeroticism (one exception is Richard Bonington's *Henry III and the English Ambassador* of 1827, in which the hearty Falstaffian envoy's dismay at the indolent, bejeweled Renaissance king takes a nationalistic slap at French effeminacy). The triumvirate of English poets John Keats, Percy Shelley, and Byron did far more for unconventional desires with their literary paeans to erotic, artistic, and political freedom. Keats's epiphany on a Grecian urn that "beauty is truth" begat the aesthetic attitude that captivated generations of disciples, many of them homosexual. His boon companion Shelley, though married to Mary Wollstonecraft Godwin (daughter of the feminist), was a militant atheist who penned one of the earliest essays defending same-sex desire. His sometimes ambivalent "Discourse on the Manners of the Ancient Greeks Relative to the Subject of Love" (1818) invoked Plato's *Phaedrus* to plead that men "ought not to be excluded by this [modern] prudery" from enjoying the form of beauty embodied in classical sculptures of Apollo and Ganymede.

George Gordon, Lord Byron led a swashbuckling life of scandalous bisexuality, alternating his infidelities and even incest with political freedom-fighting in the Greek war for independence from Turkey, where he saw action

5.8. Henry Fuseli,
Bedroom Scene, ca. 1820
(wash drawing).

as often sexual as military. In his throbbing poems as in life, Byron toyed with gender ambiguity: one female lover dressed up as a male page, partly to sneak into their adulterous assignations, but also to compete with the poet's equal attraction to his real page, Robert Rushton. Rushton stands adoringly behind his master in a portrait by George Sanders, *Byron Landing from a Boat*, prophetic of a journey the pair undertook in 1809. Through Greece and Turkey they crossed paths with the Greek Revival architect Charles Cockerell, who serenaded Byron from another boat and, following the tradition set by Alexander the Great, ran naked around the tomb of Patroclus.

The wild sexual abandon of women together continued to appeal to voyeuristic male artists like the Swiss painter Henry Fuseli, who drew both menacing witches and everyday lesbians cavorting in the heavily draped privacy of a contemporary boudoir. In his *Bedroom Scene* from about 1820 (fig. 5.8), the prostrate male bacchanalian is nearly smothered beneath the eagerly grappling female trio, whose nudity is accented by their elaborately braided Regency hairdos. Like Sade's monstrous Juliette, the romantic fascination with the illicit and the Dionysian pictured women as voracious maenads—an association that would flower more fully in the late romantic school of the decadents.

1848: REALISM AND SOCIAL REFORM

In his short story *Sarrasine* (1830), the French writer Honoré de Balzac commented that the androgynous beauty of a young castrato, given the feminine stage name "La Zambinella," could have been the model for Girodet's *Endymion*. By breaking down the barrier between art and life—pointing unflinchingly to the latter-day incarnations of a remote Salon myth—Balzac instigated the realist movement. Realism tackled the central question of the century: in Robert Hughes's term, "the shock of the new." By 1847, when the French poet Charles Baudelaire wrote his essay "The Painter of Modern Life," it was clear that this way of life, whatever its distressing differences from the Old Regime, was here to stay—and, despite its problems and conflicts, held genuine attractions for the boulevard strollers of Paris or London, from cafés to theater to brothels. And anyway, it was all they had: the group's founding painter Gustave Courbet scoffed, "I cannot paint an angel, for I have never seen one."

Realism sought to turn the public eye from gauzy nostalgia for an imaginary past to empirical study of ordinary experience among contemporary peasants and city dwellers. "We associated ourselves with the passions of the humble," wrote painter Jules Breton, "and art was to do them the honor formerly reserved for the gods and the mighty." This liberal current of social reform gained strength from the wave of democratic revolutions in 1848, which

5.9. Jean-Auguste-Dominique Ingres, **The Turkish Bath**, 1859–62 (oil).

inspired the German Karl Marx to develop his socialist analysis supporting the workers' class struggle against economic and political elites. Realism added a third stream to the stylistic maelstrom, often flowing counter to the classicism preferred by the lingering upper crust, sometimes reinforcing the erotic eddies of the romantics.

Realism's coverage of homosexuality was schizophrenic: thanks to the weightier taboo on male deviance, sodomites were scarcely noted, but tribades were irresistibly popular. The lesbian underworld was as seamy as most realist artists dared to venture in their fieldwork among the humble; and besides, they, like their male audience, were aroused by peeking at women's sexual play. Voyeurism also soothed some of the anxiety felt by male outsiders as women began to clamor for attention on their own terms. The second "revolution" of 1848 is symbolized in the newspaper of that name published by the suffragist Susan B. Anthony, whose lifelong partner, Elizabeth Cady Stanton, staged America's first women's rights convention in that year. In the wake of this accelerating movement, more women began to find their own artistic voice.

Two paintings for the same patron demonstrate the overlap of new and old styles. The Turkish ambassador to Paris, Khalil Bey, commissioned *Sleep* of 1866 (color plate 15) from Courbet. He portrayed two fleshy nudes nestling in the exhausted aftermath of a passionate abandon hinted at by the cast-off hairpin and broken strand of pearls scattered across the rumpled sheets; otherwise, their identity is vague, and their possible models are legion. Following Balzac and Baudelaire in their enthusiasm to capture the gritty panorama of urban society, realistic and romantic authors from Guy de Maupassant to Algernon Swinburne described the erotic constellation of prostitutes, courtesans, and noblewomen that led Arsène Houssaye to remark, "Sappho was reborn in Paris."

Beginning about 1830, illustrated editions of these stories and independent prints by the same artists, among them Achille Devéria (*The Girl Friends Discovered*) and Octave Tessaert, observed this scene from diverse standpoints. Some reported with clinical objectivity, others with gentle humor, while

Théophile Gautier exalted lesbians as avant-garde heroines of his assault on repressive bourgeois morality. Still others, like Baudelaire, viewed the love between two "femmes damnées" as anguished and ultimately sterile, one of the manifold "Flowers of Evil" in his verses under that title. Though Courbet's skimpy details leave all such possibilities open, clearly his unidealized sweaty couple are no longer Boucher's goddesses, but real women, who perhaps reminded the Turkish Bey of a hometown harem.

Khalil Bey also bought for his extensive collection of erotica a late neoclassical picture from Ingres. *The Turkish Bath* (fig. 5.9), reworked after its original patron returned it as too risqué, is overstuffed with nude odalisques in classicizing poses whose rubbery inflated flesh and overlapping gestures are curiously inert, yet rife with hints of how seraglio women amused themselves away from their distant master. Having read Lady Montagu's 1718 report from an Ottoman bathhouse, the first by a Western woman, Ingres could focus Melling's panoramic harem spectacle (fig. 5.5) more explicitly, zooming in on alluring details like the two women at the right who embrace tightly, one hand fondling a bare breast. To a sybaritic visitor like Khalil Bey, the local aesthetic squabbles dividing his European hosts mattered far less than their shared subject matter, whose male appeal transcended geographic as well as stylistic borders.

The French animal painter Rosa Bonheur (1822–99) was the first to picture lesbian life from an insider's perspective, though this most successful of nineteenth-century women artists had to walk a familiar tightrope between her private inclinations and her conservative public. Committed to direct observation but barred from slaughterhouses and livestock markets, she sneaked into these raunchy all-male enclaves

5.10. Rosa Bonheur, **The Horse Fair** (detail), 1853 (oil).

by cropping her hair and donning trousers and fedora. Though she insisted defensively that her mannish costume was necessitated by work, she in fact wore it on all but the most formal occasions—a predilection that, like her forty-year "wife," Nathalie Micas, fueled curiosity about the outspoken feminist who wrote, "In the way of males, I like only the bulls I paint." Drag was a weapon in her battle to claim masculine prerogatives and create an androgynous, proto-lesbian visual identity.

Bonheur typically depicted animals alone in natural settings, but in a few scenes where human figures join animals for hunting or commerce, she included discreet self-portraits that celebrate her own nonconformity. Her masterpiece is *The Horse Fair* of 1853 (fig. 5.10), a mural-size genre scene of the Paris animal market where brawny male handlers prance their barely tamed charges around a show ring in sun-dappled baroque swirls. The central horse-tamer, whose head is just right of the rearing white horse, is a self-portrait of Bonheur's own beardless and short-bobbed head, confronting the viewer inside the cap and male smock she wore as camouflage. If her visual challenge to feminine norms is subtle—caught at the time, perhaps, only by a few friends in on the joke—we must remember that transvestism was illegal. For her drag outings Bonheur had to obtain a police permit, one way the state could still regulate, if not lesbianism itself, the outward and visible signs through which such women might identify one another. The popular press also policed these tense social boundaries: like Cambacérès, Bonheur was caricatured in magazines and newspapers, which subjected her puzzling persona to scrutiny and attempted to defuse its radical implications through humor.

Peopled or not, all her work is a three-tiered protest against the halters that culture imposed on nature. She affectionately identified with animals as icons of untrammeled freedom in their own right, as surrogates for women's desire for a parallel freedom from male domination, and as symbols of the longing by gender-deviant women (and men) to escape from arbitrary codes of masculinity and femininity. She was alternately amused and annoyed by the public fuss over her attempts to break the Rousseauian chains of social convention; in letters, she compared herself to horses "tethered" by human control and mocked a fancy dress required for a formal wedding as her "gala harness."

One place where Bonheur could get out of harness was at home—a country estate near Fontainebleau where she kept a menagerie of exotic pets and tramped the woods in her fedora. There she experimented with the revolutionary new medium of photography, invented by the Frenchman Daguerre in the 1830s, to create what may be the earliest lesbian genre scenes: domestic snapshots of herself in drag, leading her horse or smoking a masculine cigarette, and of the American painter Anna Klumpke, her companion after Micas's death, working on a portrait of Bonheur *en travesti*. The cheap and simple technique empowered even amateurs to create images of alternative identities outside traditional public structures of patronage, audience, and criticism; but

these touching mutual homages, in which two "masculine" career women gaze at each other with loving creativity, were shown only in the parlor album, not the Salon. If Bonheur's life and art were the baby steps of lesbian self-expression, they still had to tread a narrow path.

FURTHER CLASSICISM: HAVEN FOR DEVIANCE

Bonheur's notorious example was part inspiration and part curse to aspiring women artists, whose numbers swelled as public careers gradually opened to women. Like her, they often renounced male companionship, in order to concentrate on their work or their lesbian love (or both); and like her, they were mocked for violating the stereotypical female role. The ground was broken by a group of American women sculptors who took up residence in Rome, reveling in the availability of classical masterpieces and of the training still closed off to their sex at home; Italy also offered them, like their male counterparts, a safe getaway for romantic friendships and same-sex marriages. Later classicism also attracted homosexual men, but the two circles were skittish about acknowledging their emotional intersection, which risked exposing both to similar hostility.

Hub of the bustling expatriate women's colony in Rome was Massachusetts's Harriet Hosmer (1820–1908), the most famous female sculptor of the century, who briefly called fellow émigré Emma Stebbins her "wife" before Stebbins (1815–82) became the lifelong companion of the tomboy stage star Charlotte Cushman. Stebbins's bust of Cushman probably wins the palm for the earliest portrait of one sapphist by another; the actress in turn used her social connections to land Stebbins the commission for the bronze Bethesda Fountain in New York's Central Park, *Angel of the Waters* (1862)—whose winged female was doubtless read, by the sculptor at least, as an image of the guardian angel that Charlotte played in her life.

These women filled the myriad commissions for American public monuments in the neoclassical style, still the standard for glorifying the expanding democracy's Greek ideals of citizenship. Apart from portraits of contemporary statesmen, they often chose female subjects, historical or allegorical, with a feminist message. Hosmer knew Susan B. Anthony well and spoke out herself for suffrage; works like her wildly popular *Zenobia in Chains* (1859), celebrating the defeated Near Eastern queen's stoic fortitude in captivity, offered an ancient mirror for modern women's aspiration to break the bonds of patriarchy. Some of these projects were funded by women who were setting up novel female arts organizations; taking her cue from the "old-boy networks" in place since Cardinal del Monte and Caravaggio, Hosmer turned the wealthy Louisa, Lady Ashburton from a romantic infatuation into a patron.

Women painters were nothing new, of course, and genteel girls had long

been expected to sketch with amateur skill; but the nasty criticisms of these "sculptresses'" efforts to integrate themselves into the commercial art world laid bare how feminism and lesbianism were twins in the Victorian womb. By daring to put their work on a pedestal instead of themselves, these women raised the specter of deviance that haunted both women-identified women and sculpture itself. The medium's gritty physical labor offended the bourgeois expectation that girls, whose frailness proved their moral superiority, would stay at home and cultivate a refuge for men from the hurly-burly of the marketplace. Swipes at Hosmer's "mannishness" scolded both her challenge to a male profession and her colorful love life.

The author Henry James, another expatriate American who met Hosmer and company in the 1870s, dubbed them the "white marmorean flock," ridiculing both their bleached marble works and their suspicious herding into a circle that excluded men. That James, himself a repressed homosexual, was threatened by women's independent solidarity demonstrates how seldom such men could see past their own misogyny, or their panic at any flagrancy that might trigger a backlash, to a sympathy for their shared plight; as we shall see, he broke out in a similar rash of literary hostility over outspoken gay male contemporaries. In his novel *The Marble Faun* (1859) Nathaniel Hawthorne—like James, a visiting Yankee writer who barely acknowledged his own same-sex leanings—took imaginative revenge on these upstart women, making his Hosmeresque sculptors mediocre or ill-fated; one target, Anne Whitney, who had a Boston marriage with a painter, shot back that the book was "detestable."

Hosmer was close to the English painter Frederic, Lord Leighton (1830–96), who carried the flickering torch of academic classicism to the end of the century in his prestigious position as president of the Royal Academy of Arts. Leighton's worship of the antique past and its Renaissance revival extended beyond style to his pederastic attraction to young men. Though in letters he relaxed enough to permit the feminine nickname "Fay," outwardly he conformed to the role of dapper artistic bachelor. In the wake of William Beckford's social shipwreck, any homosexual with aspirations to a public career dared not rock the boat; Leighton's discretion was rewarded with a peerage. But he did scour myth and the Bible for legitimizing if indirect excuses to display male beauty and intimacy, from Daedalus and Icarus to the bearded Hebrew prophet Elisha reviving a Shunamite boy with his tender embrace.

Jonathan's Token to David of 1868 (fig. 5.11) seizes an unusual moment in the poignant affair between the biblical heroes—while David is hiding from the wrath of Jonathan's father, King Saul—to celebrate not only statuesque male beauty but hopeless love. Jonathan, accompanied by a page, is pulling an arrow that he will shoot to signal David that it is unsafe to return, a prelude to the impending death of Saul's son, over whom David famously lamented, "Thy love to me was wonderful, passing the love of women." Pietistic Christian literature of Victorian times idolized the pair as a symbol of uplifting brotherly

love, any physical fulfillment conveniently sidetracked by tragic fate; but the picture's sentiment is probably closer to the yearning Neoplatonic elegy *In Memoriam*, penned by England's poet laureate Tennyson on the death of a beloved young soulmate: "Dear friend, far off, my lost desire." Adding to Jonathan's homoerotic appeal and historical pedigree, Leighton based the youth's rippling body on Michelangelo's *David*.

Leighton forged even closer links to all that the sunny south represented for a chilled northerner. Like fellow artists Simeon Solomon and Edward Burne-Jones, he drew his boy models from London's Italian colony—a commercial and eroticized crossing of classes reminiscent of Caravaggio's Rome. Not content with imports, this inveterate traveler returned often to Rome, North Africa, and the Near East; no doubt he was told what to expect besides scenery by his boon companion and portrait sitter Sir Richard Burton, the in-

5.11. Frederic, Lord Leighton, **Jonathan's Token to David,** 1868 (oil).

trepid British explorer, scholar, and consul to Damascus who published firsthand reports on pederasty in the torrid zones and translated Arab erotica. Whatever Leighton did with the locals beyond sketching was kept private, and Henry James, who based Lord Mellifont in "The Private Life" on him, saw the safe façade of an aesthete who set aside sexual passion. We may never know what shared sympathies he exchanged with Hosmer over tea in his parlor lined with Islamic tiles, but her vision of intimacy saturates his painting *Summer Moon,* which depicts two classically draped women collapsed together in a lassitude recalling Courbet's sleepers, their bodies falling into rhyming poses taken from Michelangelo's Vatican Christ.

Leighton's far more outrageous friend Simeon Solomon (1840–1905), who floored one bohemian soirée with his skimpy Cupid costume, offered a pathetic object lesson in what could happen to London bachelors who were not discreet enough. He stretched the limits of traditional subject matter into softly mystical allegories peopled with dreamy androgynes whose hothouse

sensuality exhaled, in the words of appreciative critic John Addington Symonds, "the indescribable perfume of orientalism." His pouty-lipped male youths ran the gamut from a semidraped classical Bacchus to lushly ambiguous reworkings of religious texts (the Song of Songs, David before Saul) to such swarthy contemporary "easterners" as Greek Orthodox acolytes and Jews (drawn from his own background).

His flattened and stylized pen drawings exposed even more of both body and soul, like one dream vision of Eros in a costume uncomfortably close to Solomon's Chelsea party outfit. A sketch of Socrates with a disciple conjures up Solomon's sometime friend, poet Algernon Swinburne, who called him a "translator of Platonic theory into Socratic practice." In *Bridegroom and Sad Love* (fig. 5.12), Solomon illustrated a painful dilemma familiar since the Roman poet Catullus described a groom forced to bid his male lover farewell en route to the altar. As Solomon's reluctant husband embraces his wife-to-be, he stealthily fondles the disconsolate nude Cupid—Solomon's favorite image for the modern homosexual, pushed into the social background by conformity and reaching back for solace to the classical past evoked in Sodoma's *Marriage of Alexander and Roxana* (color plate 7), where the emperor's beloved Hephaestion also watches from the sidelines.

Swinburne and Solomon, with their friend Burne-Jones, brought to England the fluid gender of the aesthetic movement inspired by Baudelaire. Though the French critic championed realist painters, the dandyish hedonism he popularized was romantic in its fascination for transgression and voluptuous androgyny. Solomon and Swinburne shared a bond of outlaw sexual tastes (the poet preferred whipping), and together they explored the gamut of sexual identities: Swinburne first used the word "lesbian" in English, his translations of Sappho complementing Solomon's 1864 painting of the poet with her love Erinna. The female image provided deviant men a double-sided screen: they could project themselves on it, into what literary critic Thaïs Morgan has called "the male lesbian body," and hide behind it, flirting with same-sex love without "going all the way" to personal confession.

Unwisely, Solomon ventured into the London streets looking to procure more than just models. Arrested while cruising a London urinal in 1873 and briefly imprisoned, he was swiftly ostracized by the terrified hypocrite Swinburne, took refuge in alcohol and drugs, and was reduced to selling the occasional pastel to his remaining supporters, including Walter Pater and Oscar Wilde. Small wonder that Solomon's German counterpart Hans von Marées, who painted classicizing nudes—from virile oarsmen to bathers and the rape of Ganymede—in a similar richly colored yet somberly suggestive style, sometimes collaborating with his intimate friend Adolf von Hildebrand, was little appreciated in his day.

5.12. (opposite) Simeon Solomon, **Bridegroom and Sad Love**, 1865 (drawing).

NEW NAMES, NEW THEORIES: ACTIVISM AND AESTHETICISM

The next quantum leap for gay culture took place in the 1860s and '70s, when the infant, now fully emerged, was baptized and began to cry. As the urban male subculture and the marmorean female flock erupted into public view, what to make of them grew into a legal, medical, and cultural controversy. One sympathetic Hungarian observer, Károly Mária Kertbeny—who coined the term "homosexuality" in an open letter of 1869 urging law reform—estimated that Berlin alone was home to ten thousand such men (1 to 2 percent of inhabitants), who were suffering arrests, like Simeon Solomon in London, for sex in the parks there and in smaller cities. Once awakened to their own numbers and given a name suggesting their core personality, men "like that" realized that they had in common both their psychological identity and their sociological plight as an oppressed minority—and began to coalesce into a vocal community. Predictably, those who didn't like to hear the new fledgling squawk proposed to smother it.

The German Karl Heinrich Ulrichs (1825–95) is deservedly honored as the grandfather of gay liberation. In a landmark speech to an 1867 jurists' conference urging repeal of sodomy laws, he became the first self-avowed homosexual to plead for equal rights. Though he was shouted down, this tireless theorist, activist, and journalist issued a flood of pamphlets and the short-lived magazine *Prometheus* urging homosexuals to unite politically. Ulrichs founded his campaign for solidarity and tolerance on a novel theory: "man-manly" men, whom he called Urnings (after Plato's connection of male love to the muse Urania), were a psychic androgyne or third sex, "the soul of a woman enclosed in the body of a man," while lesbians were the obverse. This "inversion," being inborn, could be neither unnatural nor criminal. Kertbeny's nonjudgmental term, meaning simply "same sex," had the same goal: to define "homosexuals" as acting in harmony with their own distinctive inner "nature."

Such ideas were hardly new: the urge to categorize and label sexual behavior had begun in reaction to the molly subculture, and the term "third sex" dates back to the early eighteenth century. In fact, one tack Ulrichs took to prove that same-sex love was natural was to show that it had existed throughout history, even despite severe persecution—and one indisputable form of evidence was visual art. In an 1865 pamphlet he praised the already clichéd precedent of Antinous and, though a mere amateur, he was inspired by an ancient coin to carve an alabaster sculpture of Hadrian's divine beloved.

Ulrichs got little to show for his agitation; in 1871 a newly unified empire imposed the Prussian penal code, whose paragraph 175 outlawed sodomy, on all the German states. To the threat of jail, medical authorities added the asylum: unfriendly psychologists like Richard von Krafft-Ebing, while conceding that same-sex desire was an inversion of gender norms, were eager to label

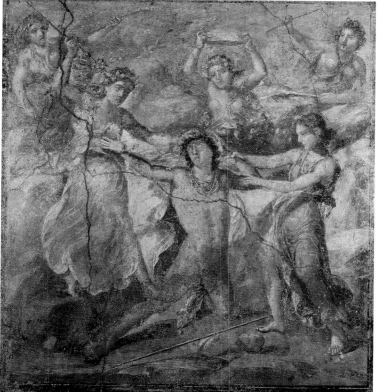

Plate 1. Etruscan, **Tomb of the Bulls,** ca. 530 B.C.E., Tarquinia (fresco).

Plate 2. **Death of Orpheus,** 1st century C.E., Pompeii, House of the Vettii (fresco).

Plate 3. **Scene from the Theater,** 1st century c.e., Pompeii, House of Pinarius Cerealis (fresco).

Plate 4. **The Destruction of Sodom,** ca. 1170–90, Monreale Cathedral, Sicily (mosaic).

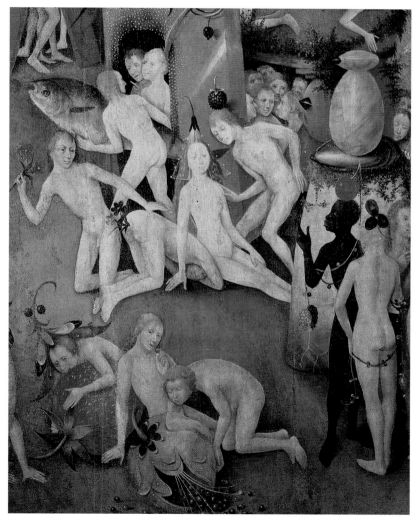

Plate 5. **Union of Emperor Basil I and John,** ca. 1150–75, Byzantine south Italy (manuscript illustration. **The Chronicle of John Skylitzes**).

Plate 6. Hieronymus Bosch, **The Garden of Earthly Delights** (detail of center panel), ca. 1500 (tempera).

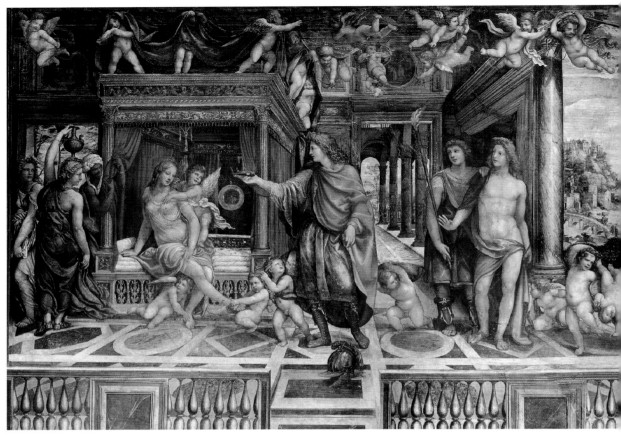

Plate 7. Sodoma, **Marriage of Alexander the Great and Roxana,** ca. 1517, Rome, Villa Farnesina (fresco).

Plate 9. School of Fontainebleau, **Gabrielle d'Estrées and Her Sister in the Bath,** ca. 1594 (oil).

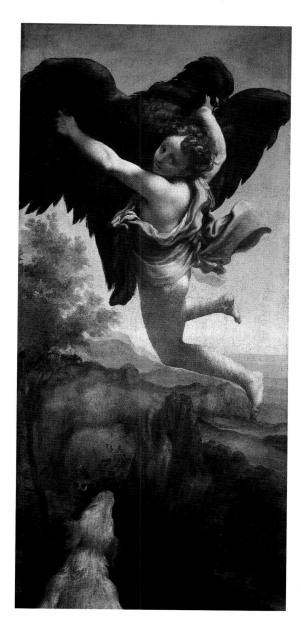

Plate 8. Correggio, **Rape of Ganymede,** ca. 1532 (oil).

Plate 10. Caravaggio, **Victorious Amor,** ca. 1602 (oil).

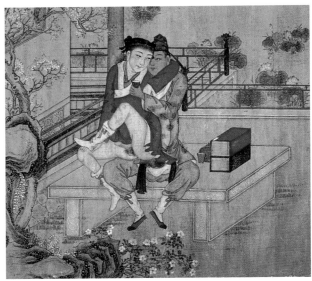

Counterclockwise from left:

Plate 11. China, **Two Men Making Love on a Terrace,** Qing dynasty (18th–19th c.) (painting on silk).

Plate 12. Riza-i Abbasi, **Two Lovers,** 1630 (miniature painting, tempera and gilt on paper).

Plate 13. Turkey, **Male Group Scene,** 19th-century (miniature painting from the **Khamsa** of Nevi Zade Atai).

Plate 14. (opposite) Giovanni Battista Tiepolo, **Death of Hyacinthus,** ca. 1752 (oil).

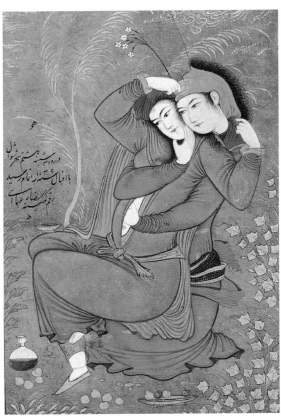

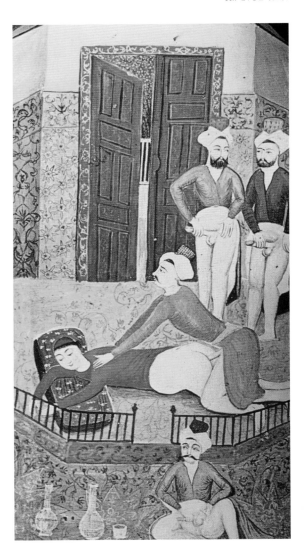

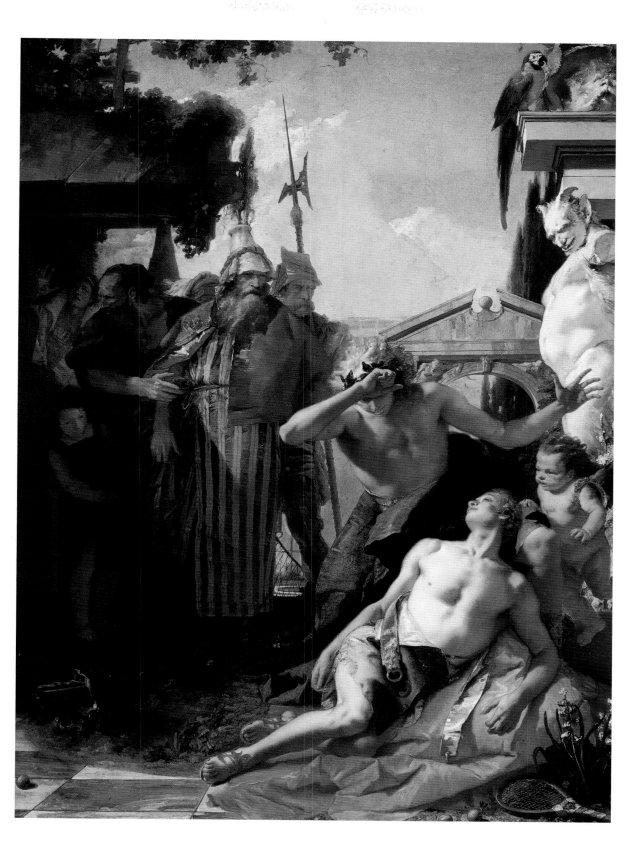

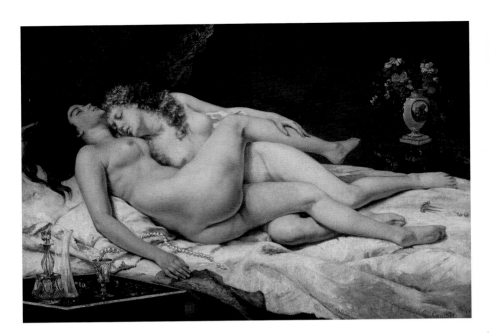

Plate 15. Gustave Courbet, **Sleep**, 1866 (oil).

Plate 16. Jean Delville, **The School of Plato**, 1898 (oil).

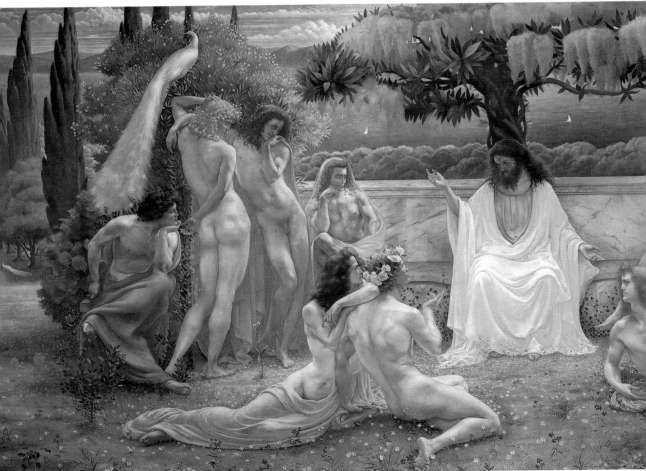

Plate 17. Tom Roberts, **Shearing the Rams**, 1890 (oil).

Plate 18. Henri de Toulouse-Lautrec, "**La Goulue**" at the **Moulin Rouge** (1891–92), oil on cardboard, 31¼" × 23¼" (79.4 × 59 cm). The Museum of Modern Art, New York. Gift of Mrs. David M. Levy. Photograph © 1999 The Museum of Modern Art.

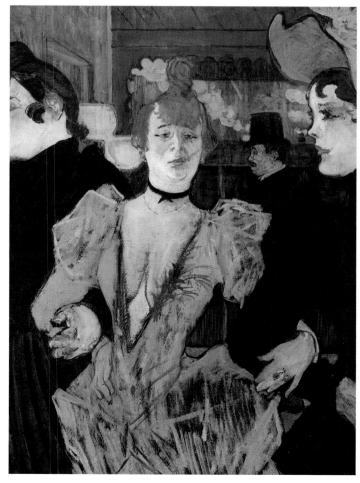

Plate 19. Leon Bakst,
**Nijinsky in "The Afternoon of
a Faun,"** 1912 (watercolor).

Plate 20. Marsden Hartley,
Painting No. 47, Berlin,
1914–15 (oil).

Plate 21. Charles Demuth, **Distinguished Air,** 1930, watercolor. $16^{3}/_{16} \times 12^{1}/_{8}$ in. (41.1 × 30.8 cm.). Collection of Whitney Museum of American Art. Purchase, with funds from the Friends of the Whitney Museum of American Art and Charles Simon, no. 68.16. Photograph Copyright © 1998: Whitney Museum of American Art.

Plate 22. Frida Kahlo, **Two Nudes in the Jungle,** 1939 (oil on metal).

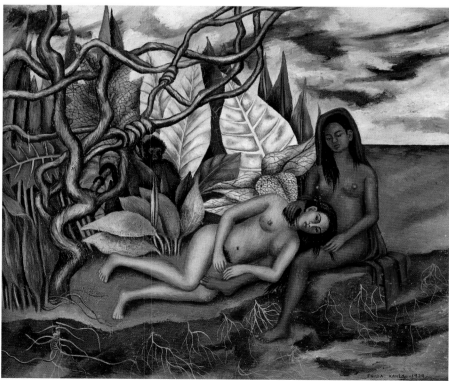

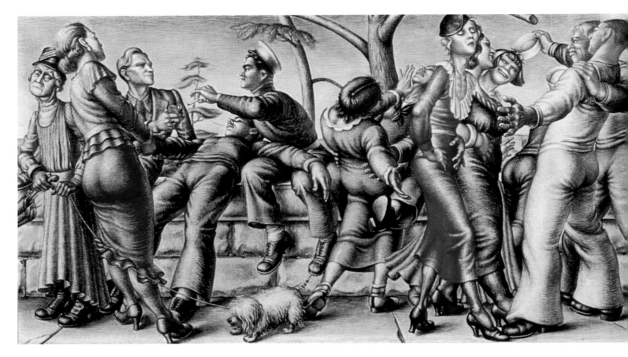

Plate 23. Paul Cadmus, **The Fleet's In!** 1934 (oil).

Plate 24. Book cover for Lilyan Brock, **Queer Patterns**, 1953.

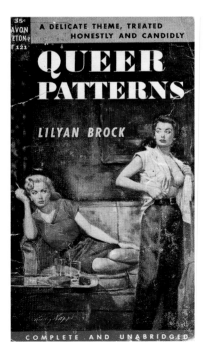

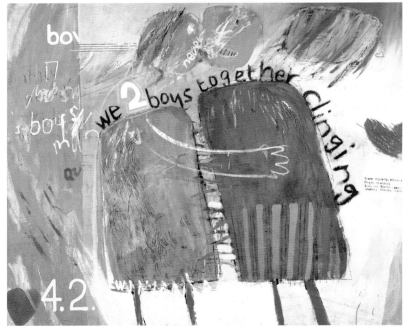

Plate 25. David Hockney, **We Two Boys Together Clinging**, 1961 (oil on board).

Plate 26. **The Advocate**, 11 November 1982.

Plate 27. David Wojnarowicz, **Bad Moon Rising**, 1989 (acrylic, photograph, and collage).

Plate 28. The NAMES Project Quilt on the Mall, Washington, D.C., 1987.

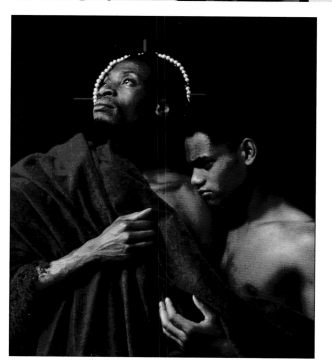

Plate 29. Gilbert & George, **Sodom**, 1997 (photocollage).

Plate 30. Rotimi Fani-Kayodé, **Every Moment Counts**, 1989 (photograph).

Plate 31. Bhupen Khakhar,
Green Landscape, 1995 (oil).

Plate 32. **Diva**, August/September 1997.

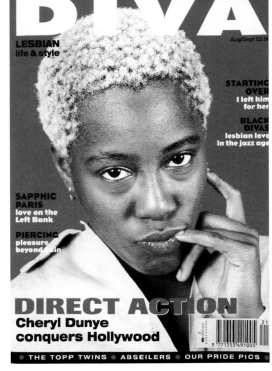

such reversals pathological or degenerate, an illness in need of treatment. But Ulrichs's insistent claim on the social stage had multiplied the voice of homosexuality from the private song of lonely Beckford's castrati to a public chorus, making the dialogue of culture permanently two-sided.

Ulrichs's carving aside, at this crucial junction art and politics intersected most fruitfully in the work, not of artists, but of historians and critics, who took up his research into the cultural lineage of homosexuality with the agenda of legitimizing its modern offspring. In this genealogical quest, history unearthed suitable ancestors while theory traced the bloodlines between past and present. As the edifice of art history began to take academic shape, one wing of the profession was occupied by homosexuals, centered around the English authors Walter Pater, John Addington Symonds, and Oscar Wilde. Coming out of Oxford University, whose influential curriculum instilled a loving knowledge of Plato and all things classical, these writers—like their much-quoted spiritual ancestor Winckelmann—saw the pagan world as a lost golden age, and the Renaissance as a silver age of partial revival. Illustrating Wilde's dictum that "criticism is the highest form of autobiography," they erected a pantheon of artists and works. Like the political movement with which they kept up varying degrees of contact, they built a foundation for group identity, pride, and change through an approach to art we might call "homophile aestheticism."

While playing midwife to the emergence of homosexual identity, homophile critics and artists were acting within the broader aesthetic movement that reigned for the last third of the century. Sensitive souls didn't have to be gay to war against the ugliness, philistinism, and hypocrisy spread by parvenu technocrats and Victorian bluestockings. Aiming to wet the conservatives' powder, the aesthetes drowned art's established function as a didactic transmitter of the status quo, and resurrected it as a realm of pure and exquisite sensation whose sole purpose is the appreciation of "art for art's sake." Seeking the Holy Grail of self-realization, artistic freedom, and spiritual beauty, they worshipped Art rather than God, restless creative artifice rather than timeless natural order. This romantically anarchic creed provoked a swift reaction from conventional critics, who defended the collective Christian and artistic traditions against any unloosing of individual passions, which they damned as a hedonistic symptom of moral decay and effeminacy.

John Addington Symonds (1840–94) was a linchpin between activism and art history, through his labors as an art critic, historian, and translator as well as a political propagandist and pioneering sexologist. Although married, he carried on a busy homosexual life, especially on "research" trips to Italy, whose joys and torments he confided in his agonized memoirs. Symonds circulated two ethical pamphlets and collaborated with the bisexual psychologist Havelock Ellis on an early classic in sexology, *Sexual Inversion*, published in 1897. Less an aesthete than a documentary historian, he published multiple volumes

mining the Greeks, the Elizabethans, and the Italian Renaissance, all fertile lodes of gay cultural heritage.

If Ulrichs was grandfather of gay liberation, Symonds was his consort as grandmother of gay studies. To establish a canon of prophets and scripture, he translated the poetry of Michelangelo, Cellini's autobiography, and Poliziano's *Orfeo*, and wrote a biography of Buonarroti. He was the first in English to denounce Michelangelo's nephew for changing the genders of offending love poems from male to female. Himself forced to soften or code some discoveries and keep his own verses ambiguous, Symonds was projecting his personal dilemma when he wrote perceptively that "the tragic accent discernible throughout Michelangelo's love poetry may be due to his sense of discrepancy between his own deepest emotions and the customs of Christian society." Though the ever-nervous Henry James once wrote to Symonds that the two of them were "victims of a common passion," he later backed off from the pamphleteer's "hysterical" utterances, projecting his own stew of fascination and panic at Symonds's risky openness into the boy-loving aesthete of "The Author of *Beltraffio*."

While Symonds helped build homophile culture as a scholar and archivist, his contemporary Walter Pater (1839–94) added new critical values and aesthetics. After a scandal over passionate letters to one of his Oxford students, the guiding spirit of aestheticism led a cautious and donnish life (though he remained friends with the disgraced Simeon Solomon, who drew his portrait); but his writings formulated a coded sensitivity to androgynous male beauty and a dreamy, eroticized mysticism. Pater's book of essays, *The Renaissance: Studies in Art and Poetry* (1873), made two seminal contributions to emerging theory. First, he called attention to homosexual artists: he praised the "wistful" boy angels of Botticelli, and pointed out the incongruity of the classical background nudes and biblical foreground of Michelangelo's *Doni Tondo*, identifying the crucial choice that faced the Renaissance between "two great traditional types" of culture and rejoicing that "Michelangelo is the disciple not so much of Dante as of the Platonists."

Second, and more far-reaching, in his famous essays on the painters Giorgione and Leonardo, Pater redefined art appreciation. Where earlier theorists had concentrated on picking up the ideological message radiated by the work of art, he shifted the focus to the individual receiver: he demanded, echoing Goethe, "What is this song or picture to *me*? Does it give me pleasure?" In this romantic emphasis on temperament, defined as "the power of being deeply moved by the presence of beautiful objects," Pater's aesthetic agenda reinforced the political activists. Disdaining universal truths for subjective feelings, he attempted to carve out a mental territory for formerly forbidden passions, to exempt the lust for physical beauty in art, or in life, from rational scrutiny or moral judgment. Stretching the book's topics to medieval romances and his beloved Winckelmann underscored Pater's intention to treat "the re-

naissance" not simply as a period, but an attitude, which he identified through history with an "assertion of the liberty of the heart" and a "spirit of revolt against the moral and religious ideas of the time."

Contemporaries, both friend and foe, spotted the subversive motivation behind Pater's aestheticism—and his book offered the first lightning rod for what we would now call a homophobic backlash. In his original conclusion, he exhorted young men to "burn with the hard, gem-like flame" of an intense ecstasy inspired by "great passions"—the sort of coded exaltation of secret desires that the reviewer Mrs. Oliphant maliciously labeled, using her own code, "perfectly consistent with [the sentiments] of a delicate Oxford don." Following more blunt censure from prominent clergy, in his second edition (1877) Pater deleted the offending conclusion altogether. But even three years later, his flaming aesthetes were the butt of a satirical cartoon in the magazine *Punch*, showing a John Bullish country squire disgusted by his young gallery-companion's effusive comment, "Before a Botticelli I am mute."

Pater's retreat in 1877 was a tactical move in his campaign for election to the poetry chair at Oxford, competing against Symonds and a more orthodox candidate, which was fanned into a public firestorm by Pater's archenemy John Ruskin, the most prolific and popular Victorian art critic. Ruskin observed the same great cultural dichotomy as Pater—what Ruskin's comrade Matthew Arnold called the Hebrew versus the Greek, the sweetness of divine obedience against the light of individual reason—but championed the opposing side, rejecting the "licentious" Renaissance in favor of a moralizing Gothic Revival. Ruskin and his allies charged Pater and Symonds with spiritual slackness and excessive interest in male beauty: the Reverend Richard Tyrwhitt attacked Symonds for a "polemical agnosticism based on the more unsavory aspects of Greek civilization [and] deliberately trying to undermine Christianity." Both were defeated, and the craven Swinburne, sensing the changed wind, distanced himself from the historian he derisively labeled "Mr. Soddington Symonds." But clear battle lines had been drawn, and the skirmish was only a temporary setback in the victorious march of aesthetic, pagan, and individualistic art through the next two decades.

DECADENTS AND REALISTS,
1880–1900: OSCAR WILDE

In the cultural jungle of the Eighties and "Gay Nineties," aesthetes and realists flourished side by side, their opposite approaches producing complementary blooms of gay sensibility. Realism documented the prose life of urban dance-halls and brothels as well as sporting country lads, while aestheticism imagined the poetic refinements of the elite; its rank offshoots, the symbolists and decadents, added to that hothouse epicureanism an obsession with the most occult,

even fatal pleasures, a morbid gothicism whose literary archetypes were Wilde's Dorian Gray and the French author Joris-Karl Huysmans's reclusive sensualist des Esseintes. Both schools had to fend off increasingly hostile courts and legislatures, which ultimately cut down some of the era's finest cultural flowers.

Oscar Wilde (1854–1900), Pater's disciple at Oxford, rose to infamy as the quintessential avatar of aestheticism, later caught in the tightening legal noose. Though best known as a novelist and comic playwright, the dazzlingly witty Wilde was also a poet, art critic, and political commentator; his lectures across Canada and America spread the stereotype of the flamboyant fop whose trademark lilies and green carnations became shorthand for homosexuality. He practically invented camp, the archly exaggerated strategy for sneaking radical speech onto the public stage: by treating serious matters frivolously and frivolous ones seriously, he disguised his earnest social critique as farce. But Wilde was as often passionately sentimental and, like Pater and Symonds, deeply autobiographical. His poems pay homage to Guido Reni's baroque Saint Sebastian and the usual suspects among the Greek gods, and so do his characters: the "Young King" of an 1891 poem presses a furtive kiss on the brow of a marble Antinous, just as Wilde kissed Alfred Douglas, a vacuously handsome young Oxford lord who was the great, and disastrous, love of his life.

In one essay, "The Portrait of Mr. W.H.," Wilde proposed that the mysterious dedicatee of Shakespeare's bisexual sonnets, identified only by initials, was a seventeen-year-old lover of the playwright named Willie Hughes. In "outing" the bard, Wilde was ventriloquizing his own fantasies: he asked his friend Charles Ricketts to paint a version of the boy's imaginary portrait in authentic Renaissance style. "W.H." also haunts the monumental effigy of Shakespeare at his Stratford birthplace, modeled by Lord Ronald Gower from 1881 to 1888: the sculptor, a traveling companion of Symonds, asked his friend Wilde to unveil the completed statue. Gower, another elite homosexual lampooned for his aestheticism in the magazine *Vanity Fair*, later turned to art history and wrote a biography of Michelangelo.

Though much of the aesthetes' poetic history went over the heads of the general public, they proselytized their art in the burgeoning print media, propelling journalism and book publishing into controversial content and sophisticated design. Popular magazines like *The Savoy* and *The Yellow Book* sported the group's bylines to the point where real gentlemen were afraid to be seen reading them; when Charles Kains-Jackson, editor of *The Artist*, accepted too many suggestive pieces by homosexuals, including poems by Symonds and Alfred Douglas, he was fired. Journals were illustrated in a late symbolist style, joining cryptic sphinxes to lushly menacing floral ornament in repeated whiplash curves. The most familiar artist of this *art nouveau*, or self-consciously "new art," is the ambisexual prodigy Aubrey Beardsley, whose perverse, often Japanese-

inspired drawings after Wilde's play *Salome* and other works tinged with decadent eroticism are extravagantly graphic in both senses of the word.

Charles Ricketts also collaborated with Wilde on illustrated books of his poem *The Sphinx*. Following Bonheur and Klumpke as the first male artist couple, Ricketts and his lifelong companion and coworker, Charles Shannon, produced woodcuts, paintings, and theater designs, including touching portraits of each other: the bearded Ricketts depicted himself as Jupiter to Shannon's clean-shaven Cupid. The hyperactive pair also published an arts magazine, *The Dial*, played patron and host to their artistic circle; and collected the newly influential art reaching Europe from its colonies and commerce in India, Persia, and especially Japan, reopened to foreigners in 1854.

Wilde's 1891 novel, *The Picture of Dorian Gray*, forecast the same doom for his dashing but dissipated bisexual antihero that was soon to overtake this halcyon moment of open expression. Receiving a portrait of himself, the sensitive ephebe with the Greek name is tempted by his arch-aesthete Svengali, Lord Henry Wotton, to wish that the painting might grow old instead of him. Mysteriously granted this prayer, Dorian remains for decades an unblemished Adonis despite abandoning himself to debauchery and selfish pleasures. In this roman à clef, Ricketts was the model for the artist Basil Hallward, who pours into the magical portrait his unspoken love toward the sitter, and Ronald Gower for the sensualist dandy Lord Henry. Although only Dorian's heterosexual affair with an actress is described, even she is steeped in gender ambiguity: his infatuation deepens when Sibyl plays Shakespeare's Rosalind, cross-dressed as the boy Ganymede. In the end, dead of remorse and self-loathing, he transmogrifies into the scarred and pustulent image so long hidden in his attic. That locked room anticipates the modern closet, and the portrait, though only imaginary, became the era's most powerful image of the fateful links between beauty and damnation. It remains a grisly metaphor for the divided self, the splitting of passion and outward respectability, still demanded of many homosexuals.

THE SYMBOLIST INTERNATIONAL

Threads of sympathy and collaboration knitted England's artists to a web of symbolists and decadents stretching from Paris to Brussels, Sicily and Boston. The French poets Paul Verlaine and Arthur Rimbaud, who jointly wrote a "Sonnet to the Asshole," were sketched together on an 1872 visit to London, but the couple's native capital was permanent host for the opulent cultural banquet, recalled nostalgically as "La Belle Epoque," which lingered until World War I. Verlaine's own doodles catch him and Rimbaud ensconced with drinks and pipes in a café like those along the grand boulevards where titled swells strutted, debated new art, and mixed with younger working-

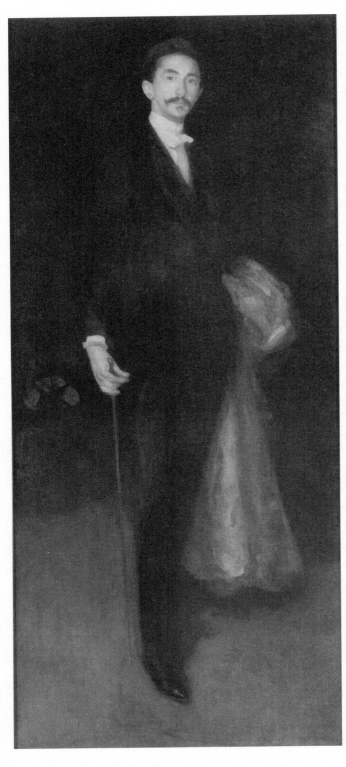

class men and model-prostitutes, as the outcast lovers themselves sank into that absinthe-soaked bohemia.

Wilde's continental alter ego was Count Robert de Montesquiou, a poet, critic, and sometime artist who cut an ostentatious swath through Paris society. His 1892 portrait by the Anglo-American James Whistler (fig. 5.13) carried the unseen image of Dorian Gray to real-life extremes: stylish props like the kid gloves, cane, and luxurious chinchilla cape mark the haughty and impossibly willowy aesthete as a dandy, like his younger Argentine lover Gabriel Yturri. In this costume homosexual men, at least those with money and taste, dared present themselves on the public stage: by embodying the picture's typical Whistlerian title, *Arrangement in Black and Gold,* which declared form superior to content, gentlemen simply acted as if their irrelevant inner "flaws" were trumped by the faultless perfection of their tailor. Montesquiou's fastidious ideal long dominated men's fashions, and he inspired two of the era's defining fictional aesthetes. The Duc des Esseintes in Huysmans's novel *A Rebours* ("Against the Grain," 1884), who devotes his hermetically sealed life to seeking ever more exotic sensations from art, science, and nature, was almost flattering, but Montesquiou was miffed when his friend Marcel Proust borrowed his mannerisms and quips for Baron Charlus, a more explicitly gay Lord Henry in the multivolume saga *Remembrance of Things Past.*

The outpouring of symbolist painting and graphics echoed literary fascination with the androgyne, whose mysterious omnisexuality recalled Ulrichs's third sex, and with the metaphysical links between beauty and spiritual uplift. Already by 1866, the French magazine *Le Décadent* drew art, sex, and religion together in its enthusiasm for current cultural evolution: "Man is becoming more delicate, femi-

nine, and divine." Here, as across the channel, such Wildean shenanigans did not go unchallenged. Octave Mirbeau was merely the most strident critic to draw the familiar equation between decadence, deviance, and degeneracy. His satirical 1895 newspaper sketch imagined a repentant painter who realizes, in half-deranged horror, that the decadent writers have "poisoned an entire generation. . . . Their heroes reek of sodomy, neurosis, and syphilis. . . . The poison is in my blood. . . . I keep hearing a voice in my head saying, 'Lilies, lilies!' "

Montesquiou's friend Gustave Moreau, an early French symbolist, was yet another reclusive bachelor, whose imaginary realms of misty enchantment, peopled by winged fairies and densely encrusted with bizarre decorative details, lit a beacon for many followers. Beginning in the 1870s, his panoply of favorite subjects—eroticized male androgynes and menacing femmes fatales like Salome—constantly hint at what his carefully covered tracks never quite confirm. Among classical and biblical ephebes like Narcissus and Saint Sebastian, he illustrated a novel scene of *The Angels of Sodom* staring down through the smoky aftermath of the sinful city's cataclysmic destruction; with the poignant ambivalence of a repressed homosexual who destroyed personal papers and forbade any biography, he paints the avenging spirits as a pair of androgynes hovering arm in arm. Odilon Redon followed suit with his phantasmagorical pastels of rank landscapes haunted by almost comically sexual monsters, including the homoerotic *Death of Orpheus* and a languid Sebastian.

In Jean Delville's *School of Plato* (color plate 16), the Christlike philosopher presides over a symposium in a peacock-filled garden overlooking the sea, surrounded by intent male disciples with the epicene proportions and hairstyles of the Borghese Hermaphrodite. Some drape arms around each other like the Greek nudes in Michelangelo's *Doni Tondo*, their languid embraces rendered beatific by a soft glowing light that recalls Girodet. Delville too painted the *Death of Orpheus*, whose oracular head, still singing though severed and impaled on his lyre, floats out into an ocean of eternal bliss. Orpheus, well known even before Symonds translated Poliziano's tragedy (fig. 3.6), became a mythic hero both for the symbolists, who idolized his mystical artistic powers, and for modern homosexuals, whose turn from women to men was so often avenged by the maenads of an unforgiving society.

The symbolists' fascination with spirituality drew many to the Catholic Church. The French novelist and self-styled prophet Joséphin Péladan promulgated rules for a mystical confraternity of artists dedicated to reviving Catholic piety and the occult beauty of the androgyne, especially the sfumato-veiled *Saint John the Baptist* of Leonardo da Vinci (fig. 3.4). Their annual alternative exhibit, the Salon de la Rose+Croix, admitted only paintings, like Delville's, that followed orders. One of the more gifted Rosicrucians fused their spiritual impulse with his passion for boys: Charles Filiger, a friend of Paul Gauguin, applied that artist's thick black outlines and stained-glass colors to nude angels and Baptists of a gravely Byzantine stiffness (like Simeon

5.13. (opposite) James A. M. Whistler, **Arrangement in Black and Gold: Portrait of Robert, Comte de Montesquiou-Fezensac**, 1892 (oil).

Solomon, Filiger dropped from public view after a homosexual scandal). Believers and nonbelievers alike adopted the Roman androgyne Sebastian as the patron saint of homoerotic religiosity: writers gushed over the suffering martyr in Renaissance altars by Reni and Sodoma (fig. 3.10), inspiring modern versions from artists like Moreau and Jean-Jacques Henner. Sebastian was the Christian twin to Orpheus, both offering angelic archetypes of beauty and nobility under duress.

Homoerotic mysticism seeped into architecture, notably in the Boston circles of Ralph Adams Cram, the American champion of Gothic Revival whose firm designed New York's Episcopal cathedral, Saint John the Divine. To this day gay men are stereotypically fond of the Anglican faith, for reasons from social climbing to sincere spirituality to the high-church theatrics of "Anglo-Catholic" worship, whose incense and robes verge on camp excess. King Ludwig II was deposed as both insane and homosexual when he threatened to bankrupt Bavaria with his outlandish subsidies to the Bayreuth theater for Richard Wagner's solemnly sacred operas and his own Gothic castle Neuschwanstein, slathered with Wagnerian mosaics. The English architect Charles R. Ashbee pioneered the more practical and domestic Arts and Crafts style, but his homoerotic brotherhood of monastic collaborators sprang from the same ideals of male fellowship and missionary purpose exalted by Wagner's Knights of the Holy Grail.

Outside of church, symbolists and decadents were also obsessed with seductive yet fatal women from myth and legend—Medusa, sirens, the Sphinx—dripping with jewels over a smorgasbord of period trappings from Byzantium or medieval romance. Images of these pitiless vampires, born of Baudelaire and Swinburne, lured the heterosexual male audience with a mixture of titillation and cold comfort. By condemning the female as the monstrous emblem of suffocating danger, they calmed modern men's anxiety over women's political and economic challenges. But these female images also offered—in their hermaphroditic coupling of feminine body and masculine powers—a psychic analogue to "third sex" lesbians, which a sexually alternative audience viewed with favor. Shelley and Solomon effused over the Uffizi's Caravaggesque head of Medusa (then credited to Leonardo), whose snaky-haired glance could turn men to stone; Pater located her power in "the fascination of corruption" and slyly characterized her singularly grand and "inverted" features.

Two artists who specialized in grotesque lesbian images were Fernand Khnopff and Félicien Rops—both, like Delville, from Belgium, whose Flemish soil, nourished by Hieronymus Bosch, proved fertile ground for symbolism's incongruous juxtapositions and inscrutable scenarios. Moreau's pupil Khnopff filled his silent, brooding paintings and softly dreamy crayon drawings with masks and sphinxes that may allude to his incestuous love for his sister. *My Heart Weeps for Olden Days* (fig. 5.14), his frontispiece for a volume of symbolist poetry, is set before the mist-shrouded home of Bruges's medieval Beguines, a

5.14. Fernand Khnopff,
frontispiece for **My Heart
Weeps for Olden Days**, 1889
(pastel drawing).

lay order of women whose Christian love, theoretically celibate, evoked erotic fantasy. In the foreground a lone beauty, her eyes half-shut in blissful inwardness, meets the lips of her own reflection in a mirror—an image of narcissistic self-absorption, exalted by the decadents while blasted by hostile psychologists as the metaphorical root of lesbian (and gay male) desire.

Rops depicted scenes from both contemporary lesbian fiction and actual brothels; to dignify one etching of graphic lesbian sex, he claimed to be copying a bas-relief found in ancient Herculaneum—though his alibi is betrayed by the caption "Sappho" in misspelled Greek. He was invoking another popular literary avatar of decadent sexuality, a female Orpheus who even got credit for inspiring the first lesbian experiments of a young woman sculptor—perhaps a distant echo of Harriet Hosmer—in Dubut de Laforest's novel *Mademoiselle Tantale.* Sapphic women were considered less newsworthy than inverted men, though the ever-splenetic Octave Mirbeau accused the sensuously clustered females in paintings by Edward Burne-Jones of displaying symptoms of "masturbation, lesbianism, or tuberculosis."

5.15. Wilhelm von Gloeden, **Youths in Classical Dress,** ca. 1890s (photograph).

Photography contributed its share of homoerotic fantasy when the new medium, struggling for recognition as more than a lowly technical shortcut, aped the themes and elaborate staging of academic art. The homosexual German baron Wilhelm von Gloeden (1856–1931), taking the common journey south in search of both health and eros, settled in Sicily's Taormina in the 1880s. Together with his cousin Wilhelm von Plüschow, who introduced him to photography, he alternated souvenir postcard views of Mediterranean landscape with portraits of local peasant boys. His male images vary from straightforward portraiture to flimsily allegorical groupings like figure 5.15, a costumed imitation of classical pastorales littered with reminders of bacchanalian rites: panpipes, garlands, and the Dionysian panther skin. The fantasy element may now seem to jar with the sharp focus, but at the time his quasi-documentary style lent authenticity to his evocations of the long-lost Hellenic world: he could one-up Delville's Platonic academy by setting true descendants of the ancient Greek colonists among the actual hills and marble terraces once occupied by their ancestors.

These arcadian images found a ready market among a network of well-heeled tourists like

5.16. F. Holland Day,
Saint Sebastian, 1907
(photograph).

Wilde, who passed through in search of Mediterranean pleasures. Von Gloeden's sales catalogs show that he offered two versions of the same male sitters—draped for the parlor, uncovered for the bedroom—but even his more decorous works were snapped up by homophile aesthetes, reproduced in *The Studio* and admired by Leighton. A sentimental pilgrimage down the Sicilian coast to photograph the grave of his countryman and kindred spirit August von Platen, author of romantic poems to illicit male love, forged a new visual link in the lengthening chain of gay apostles.

Von Gloeden's counterpart in America, F. Holland Day (1864–1933), treated the same subjects with an elegant, more self-consciously "pictorialist" style. Another Bostonian like Cram with links to English aesthetic circles—he copublished *The Yellow Book* and American editions of Wilde and Beardsley—Day added to von Gloeden's catalog of youthful models an eclectic range of poetic types: Christian ephebes like Christ and *Saint Sebastian* (fig. 5.16); doe-eyed Middle Easterners like the boy prodigy Kahlil Gibran, his mystic protégé; and handsome black Americans costumed as African warriors who were, despite colonial undertones, exceptionally sympathetic for their day. His swarthy, curly-haired Sebastian, pinned in a voyeuristic close-up, no doubt alludes to Wilde's poem on Reni, while his head upturned in the swooning erotic ecstasy of a soft-focus platinum print resembles Khnopff's grainy, yearning women.

Day's Boston was the first beachhead of aesthetic culture in America, with Harvard as its Oxford; homophile supporters included the classical scholar and connoisseur Edward Perry Warren, a Beacon Hill neighbor of Day and Cram. While living in an Ashbeesque brotherhood in Britain, he and his companion John Marshall bought up ancient art, always with an eye toward erotic iconography; among their finds was the Roman silver bowl with homosexual scenes still named the *Warren Cup* (fig. 1.24), and the antiquities they sent home added male nudes to the collection of Boston's Museum of Fine Arts. Whether classicists or medievalists, Boston homophiles preached against hometown puritanism; Warren wrote of his museum donations as "truly a paederastic evangel."

TRIBULATIONS AND TRIAL

Though never quite proverbially "banned in Boston," Day suffered the kind of critical shots warning that homophile aestheticism on both sides of the Atlantic was on a collision course with the ship of state. Von Gloeden's souvenirs had trouble clearing customs, and von Plüschow was arrested for corruption of minors. In the 1880s, the British public felt assaulted by the open publication of homosexual pornography like *Sins of the Cities of the Plain* and by a succession of sex scandals that exposed affairs between royalty or high officials and as-

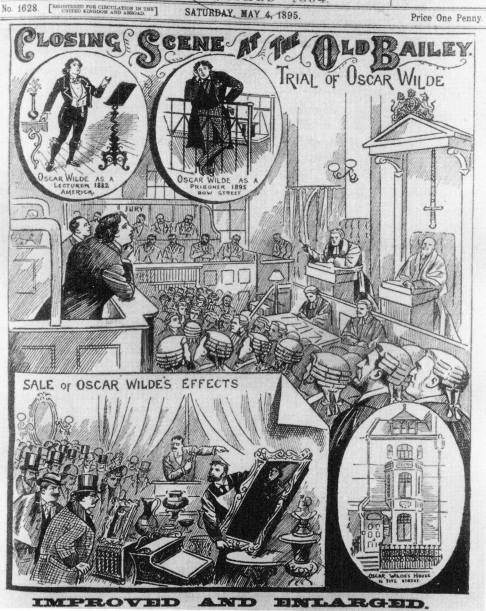

5.17. Trial of Oscar Wilde, cover of The Illustrated Police News, May 4, 1895.

sorted valets, grooms, and telegraph delivery boys. The social threat posed by secret intercourse between the governing aristocracy and the seamy underclass aroused Henry Labouchère, who pushed through Parliament an 1885 amendment criminalizing any "gross indecency" between men, even if private and consensual (women remained exempt).

The two fleets collided in 1895, when Wilde was publicly insulted by the Marquess of Queensberry, Alfred Douglas's outraged father. Against advice to flee the country rather than contest Queensberry's accusation that he was a sodomite, Wilde endured three trials that dragged his sexual escapades into court. He defended himself brilliantly: challenged to explain what Douglas had meant in a poem about "the love that dare not speak its name," he replied with the full battery of ammunition developed since Winckelmann—classical, biblical, and Renaissance—extolling it as "such a great affection . . . as there was between David and Jonathan, such as Plato made the very basis of his philosophy, [which] dictates and pervades great works of art like those of Shakespeare and Michelangelo." The jury, unimpressed by this eminent family tree, sentenced him to two years' hard labor.

The Illustrated Police News coverage of the trial (fig. 5.17) demonstrates the surging power of a shrill popular press to shape mainstream opinion. Centered amid vignettes of his foppish performances and prison misery is the climactic courtroom verdict, in which all eyes are aimed at the shameful pervert, whose economic and personal ruin is further highlighted by the auction of his household goods. Such scandalmongering was nothing new to the tabloids: in 1893 *The Police Gazette* had featured a lurid drawing of two well-dressed contemporary women embracing on an overstuffed Victorian couch, with the horrified headline, "GOOD GOD! THE CRIMES OF SODOM AND GOMORRAH DISCOUNTED."

Magazines like *The Yellow Book*, too close to Wilde for comfort, suffered losses after his trial. Wilde emerged from prison a broken man and sailed into French exile under the alias of Sebastian Melmoth, borrowed from Reni's forebearing victim. Like his friend Simeon Solomon, he found solace for neglect in drink, and like him died destitute, a deathbed convert to Catholicism. In the short run, Wilde's tragic morality tale cast an apocalyptic cloud over homosexual expression for the next half century. But in the longer view, both his sparkling camp persona and his wrenching account of unjust imprisonment in "The Ballad of Reading Gaol" anointed him the patron saint of modern gay sensibility.

LATER REALISM

5.18. (opposite) Thomas Eakins, **The Swimming Hole,** 1885 (oil).

Alongside homophile aestheticism ran a parallel stream that continued to draw from the artistic and social springs of French realism, though it found its most compelling outlets in the English-speaking world. In contrast to the artifice and

mysticism affordable to a privileged few, realist artists spoke from a more democratic standpoint. Even when their style pushed beyond the photographic, their impulse was documentary: focusing on the urban working classes or the simple pleasures of country and seaside, some indulged a faintly condescending but sincere worship of the handsome and manly proletarian, others the straight male curiosity about girls on their own. Since any whiff of Wildean homosexuality might sic the cultural attack dogs, many of these artists veiled the heavy breath of desire not only in their work but in themselves. They achieved widespread recognition for a vision of robust virility—the athlete not the aesthete, the outdoors rather than the interior, the nude rather than the fop—by idealizing it into a spiritually healthful camaraderie, as officially innocent of its own lustier potential as the artists seemed, or claimed, to be.

Among the most eloquent spokesmen for this homophile realism, though he scarcely understood or acknowledged his own motivations, was the American Thomas Eakins (1844–1916). Aside from scattered mythical subjects by

Benjamin West and Thomas Sully, and biographical hints in the early history painter Washington Allston, Eakins's pictures of men at play, boating, and boxing, especially *The Swimming Hole* of 1885 (fig. 5.18), mark the United States's first contribution to male sexuality in art. His French training flourished when transplanted to a nation, still rough around the edges, that saw in realism's down-to-earth objectivity a vision of Yankee pragmatism and common sense. Going further here than in other paintings, where he still costumed adolescent ephebes with Virgilian reed flutes, Eakins attempted to translate classical pastorale into a new language. The boys and men frolicking near his home in Philadelphia—the Quaker "City of Brotherly Love"—are enthusiastically stripping off not only their own clothes, but the nostalgic trappings of European tradition. But history, while fading, remains visible: the figures' monumental pyramid invokes the sculptures of a Greek temple pediment, and the cocky youth at the apex holds his arm akimbo like Donatello's Renaissance *David* (fig. 3.1).

Eakins painted himself as the bearded adult dogpaddling at the lower right, gazing at the boyish spectacle from a distance just as he did in life. Unmarried till forty, with a reputation for crotchety obliviousness to the emotions of others and himself, he poured his love of beauty into images whose uncompromising bluntness frightened both the public and his executors, who destroyed embarrassing evidence. *The Swimming Hole*, like many works, was based on numerous photographs of the teacher and his pupils, nude or in Greek drapery; though Eakins justified his methods as scientific, his original patron refused to accept the completed picture, deeming it too immodest for a Victorian parlor. Ironically, Eakins's greatest scandal was heterosexual: his stubborn insistence on exposing female students to naked male models got him dismissed from the Pennsylvania Academy of the Fine Arts, making him a bitter martyr to the realist credo of direct observation.

The Swimming Hole's distinctively American male arcadia echoes many a line by Eakins's warm friend and frequent portrait sitter, the pioneering poet Walt Whitman (1819–92). Whitman's ecstatic paeans to an ebulliently expanding and ruggedly democratic society earned him the affectionate title of national bard, but "the good gray poet" was also hotly censored for his pulsating eros. It was shocking enough that his interlinked epic, *Leaves of Grass*, which debuted in 1855, relied on heterosexual embrace to symbolize utopian dreams of individual and continental fecundity; worse (or better, depending on the reader), he later added a section titled "Calamus" that openly rhapsodized "the dear love of man for his comrade, the attraction of friend to friend" felt by "we two boys together clinging . . . on the turf or the sea-beach dancing." Once burned, twice shy: when John Addington Symonds wrote hoping for an admission that the "Calamus" poems reflected his own love life, Whitman denied well-documented youthful affairs with a streetcar conductor and anonymous denizens of New York—his "city of orgies, walks and joys," then exploding

into the metropolis of an immigrant continent, with young clerks, dock and tavern boys, and a commercial subculture mirroring the capitals of Europe.

Eakins and Whitman's deep sympathy began when the invalid poet moved to nearby Camden, New Jersey, for nursing, and resulted in numerous photographs as well as an oil portrait (1887) that became Whitman's favorite. Eakins was esteemed for profound psychological insight into his sitters, especially his affectionate sensitivity to mature men (perhaps reflecting his dependent love for his own father), which shows through in the combination of cottony beard and avuncular yet craggy face. But the inner sources of their mutual admiration must remain, in a picture, poignantly mute: their shared vision of masculine love and the shared pain of rebels against puritan prudery.

Whitman's hearty outdoor ideal also touched Winslow Homer, whose oils and watercolors of sailors and soldiers, and sometimes pairs of masculine women, radiate same-sex intimacy, though often with a darker emotional tinge. As a newspaper illustrator in the Civil War, he sketched the same scenes that inspired Whitman, then an army nurse, to write of the heartbreaking camaraderie among young fighters facing death. This secretive and solitary nomad also chronicled Southern blacks, an enlightened project in the era of official segregation, projecting onto the muscular Africans of the Caribbean the same tropical heat that northern Europeans found in the Mediterranean. The American dandy John Singer Sargent made his career in England, where he filled sketchbooks with the handsome nude models he shared with Leighton, though whether the cautious bachelor also bedded them remains an open question. His position as portraitist to high society left little scope for overt homosexuality in his art, though he did paint the author Violet Paget (Vernon Lee) and her female companion looking duly mannish.

In England Sargent could see work by a kindred spirit, Henry Scott Tuke, a popular realist often praised as "The Painter of Youth." His high-keyed, vividly fresh renderings of seaside boys and young men swimming, fishing, or racing treat Eakins's theme with the loose brushwork and open-air light effects of the French impressionists. Tuke painted Ronald Gower and befriended Kains-Jackson and the homosexual poets, known as Uranians for their devotion to the Ulrichs third-sex theory, who penned ballads to boys bathing. Gerard Manley Hopkins called his literary youths "summer's sovereign good" with the same passionate affection that suffuses Tuke's nudes; Wilde put image into action, writing from the French Riviera in 1898, "Even at Napoule there is romance: it comes in boats, and takes the form of fisher-lads." Their common theme resonates with the vision of Edward Carpenter, the British anthropologist and socialist who campaigned for a political utopia based on Whitman's manly egalitarian comradeship.

Homophile realism quickly spread through the far-flung British Empire, finding a particularly fond reception in Australia—like the United States at that time, a vast country of untamed bush and desert, whose isolated gold

prospectors and ranchers lived by an ethic of male bonding that dates back to the island's 1788 settlement as a penal colony. Sodomy among prisoners deprived of women gave way to affections between "mates," who often paired up for work and life in a hearty physical bonhomie and mutual loyalty that might easily spill over into lovemaking. This frontier world was immortalized by Tom Roberts, whose *Shearing the Rams* of 1890 (color plate 17) was quickly enshrined as an icon of national identity. His epically scaled tableau of the yearly ritual at an outback sheep station is not overtly erotic, nor was Roberts himself inclined to men. But these rugged shavers, bent to their task like handsome giants out of Courbet, stroking their passive furry beasts in a position of mock intercourse, suggest more than his stated desire to ennoble the spirit of "strong masculine labour."

The guiding spirit was Whitman, who corresponded with homophile circles in Sydney around the poet and lecturer John Le Gay Brereton, on whose ears Whitman's idealization of passionate male friendship resonated with a unique national echo. *Leaves of Grass* often sings of "mates," which remains the universal Australian term of endearment; Roberts's ranchhands were viewed by an audience to whom Whitman had expressed his enthusiasm for "life in the bush and the gum trees and shearing and many a mate"—the sporting "adhesiveness" that also saturates softly brushed arcadian bathers by Roberts and Sidney Long. Another influential import was religion, the mother country's homoerotically tinged ritual that also captivated Ralph Cram: George Walton's *The Acolyte* (1889, Sydney) spotlights a fresh-faced Aussie lad in a feminizing cassock, one of Tuke's dreamy blond bathers robed for his Sunday stint as an Anglican choirboy.

France itself, the birthplace of realism, created few male images to equal this English-speaking flood, though Frédéric Bazille was heading in that direction, with summery open-air scenes of nearly naked bathers and wrestlers, before his untimely death. But the impressionists, who exhibited from 1874 to 1886, catered to the bourgeois appetites of their patrons—mostly respectable family men whose most daring forays into the sexual demimonde were to licensed houses of prostitution—by serving up tasty glimpses of the women finding emotional solace together after their impersonal and often boorish customers went home. Edgar Degas, though a cranky misogynist who mocked Wilde, endowed working women, including the employees of bordellos where he sketched, with an unsparing dignity. His monotype prints recording kissing and cunnilingus alongside more routine intimacies were later used to illustrate Guy de Maupassant's *La Maison Tellier*, a lighthearted tale of a "madame" and her mutually amorous "girls." Degas's contemporary Édouard Manet painted several versions of the courtesan Nana, well known from Émile Zola's harshly naturalistic novels, though not the lesbian subplot offsetting her sordid relations with male clients.

Of the later French artists known as post-impressionists, many continued

the female theme. Count Henri de Toulouse-Lautrec, whose swirling curves and poster-flat colors influenced art nouveau and advertising, adopted as his turf the Parisian bohemia of Montmartre, the cabarets, dance halls, and brothels where a lesbian (and gay male) working-class culture was taking shape. Though born with a title, Lautrec, spiritually exiled by poor health and deformity, felt sympathetic to outcasts and freaks, eagerly sketching Wilde during his trial. *"La Goulue" at the Moulin Rouge* (color plate 18), a glamorizing "celebrity portrait" of the popular nightclub entertainer Louise Weber, catches the top-knotted and décolleté diva making a grand entrance with her dancer girlfriend on her left arm—a gesture that amounted to flaunting their relationship. Like Degas, Lautrec often worked in brothels; at least fifty paintings plus drawings and lithographs record the many stages of seduction, from women waltzing together to sometimes older and blowsy couples kissing, caressing, and sleeping (his gallery discreetly relegated these to a back room, to Lautrec's disgust). The lusty heterosexual sculptor Auguste Rodin encouraged his female models to pleasure each other while lolling about his studio, then drew their interlocked bodies for illustrations to Baudelaire's *Flowers of Evil*; and the symbolist Paul Gauguin, whose stormy attachment to fellow artist Vincent van Gogh has erotic undertones, fled to Tahiti, where he painted not only women together but the Polynesian *mahu*, or male berdaches, suggesting a barely realized bisexuality.

5.19. Louise Abbema, **Portrait of Sarah Bernhardt,** 1878 (bronze medallion).

While male artists examined lesbians, women were beginning to picture each other. The flamboyant actress Sarah Bernhardt (1844–1923), though legendary for her male conquests, inspired—and responded to—theatrical passions in both sexes. She kept up a lifelong intimacy with the artist Louise Abbema (1858–1927), who fittingly scored her first Salon success with an 1876 portrait of Sarah. Like Rosa Bonheur and Anna Klumpke, for decades Abbema and Bernhardt, herself an exhibiting sculptor, exchanged likenesses in carving, painting, and photography—these last whimsically inscribed "TO LOUISE ABBEMA, THE GREATEST ARTIST, FROM SARAH BERNHARDT, THE OTHER GREATEST ARTIST." Abbema exhibited her bronze relief bust of Bernhardt (fig. 5.19), based on the

5.20. Alice Austen, **Julia Martin, Julia Bredt and Self Dressed Up As Men,** 1891 (photograph).

oil, in 1878: though accurately transcribing the frilly dress and trademark curly mop of an international matinee idol, Louise, whose Montmartre studio was a haven for lesbians in tweeds and cropped hair, here paid public tribute in the medium of ancient imperial medallions to the same mutual affection that inspired Sarah to cast the two women's clasped hands.

Among her thousands of genre shots of comfortable middle-class life on rural Staten Island, the New York photographer Alice Austen (1866–1952) captured the woman-identified world then becoming possible within polite society. Austen was twenty-five—already a late age to be unmarried—when she and two friends dressed in drag for the snapshot in figure 5.20. Though she claimed years later that "we did it just for fun," the phallic cane of the seated "gent" symbolizes a masculine independence that Austen (on the left, with cigarette and fake mustache) actually achieved, living all her life with a female companion with whom she later operated a tearoom. Like Bonheur, Austen could afford not to exhibit or sell such intimate photographs, which adds to their value as a documentary of the emerging lesbian world, a poignant reminder of its limitations. Eunice Lipton's narrative of her frustrated attempt to recover the lost paintings of Victorine Meurent, Manet's favorite model, attests to the neglect that overtook a poorer creative lesbian.

AFTER WILDE: THE EMERGING GAY CULTURE

By exposing the mushrooming homosexual underworld, Oscar Wilde's trial galvanized society. It alarmed traditionalists, who mobilized against the new subculture; it energized gay people themselves, who realized how pernicious their oppression was and how potentially strong their voice; and it alerted entrepreneurs to an exploitable market for commercial art and entertainment. This coalescing energy propelled the final quantum leap in gay culture: the birth of organizations and publications run by and for gay men themselves

(and, a few decades later, lesbians), from political and social groups to scholarly journals and more popular media such as magazines and inexpensive art reproductions—through all of which the highbrow aestheticism of Pater and Wilde, developed by and for the elite, percolated down to the new mass urban society.

The epicenter of this eruption was Berlin, and its prime mover was the gay doctor Magnus Hirschfeld, who set off a triple-pronged flow of political activism, scientific study, and historical research. His Scientific-Humanitarian Committee (WHK), founded in 1897, was the first league to propagandize for homosexual rights. Allied to the WHK were the Institute of Sexual Science, the first sexology think-tank (forerunner of today's Kinsey Institute), which amassed a library of some twenty thousand books and thirty-five thousand images, and the scholarly *Journal for Sexual Intermediates*, the first devoted to what we would now call "gay and lesbian studies." The journal, which resurrected forgotten artists and other homosexual figures, from antiquity to Winckelmann, opened its second annual issue (1900) with a memorial portrait of the recently deceased Rosa Bonheur, whose caption paid tribute to her as a "pronounced example of a sexual intermediate" (*Zwischenstufe*, Hirschfeld's equivalent to the "third sex").

5.21. **Youth in Aesthetic Interior,** 1907 (photographic illustration for Elisar von Kupffer, **Heiland Kunst**).

Thanks to Hirschfeld's voluminous research reports, we also know something of the cultural tastes of ordinary homosexuals in his own day. His richly visual "field notes" from Europe and America record that his subjects often decorated their homes with copies of Renaissance Sebastians and Michelangelos and such classical sculptures as the *Praying Youth*. These men were the first "creative consumers," appropriating the past to cobble together a sense of shared identity and historical legitimacy. A densely layered testimony to this new canon of cultural quotations is the photograph of a youthful ephebe strumming a lute in a well-appointed modern interior (fig. 5.21), composed in 1907 by the boy-loving German artist Elisar von Kupffer for his book

Heiland Kunst, or "Art the Saviour." The plethora of objects that Kupffer chose to furnish his idyllic fantasy of the aesthetic life bear out Hirschfeld's observations. Of antique prototypes, Hirschfeld mentions Praxiteles' *Hermes;* the photo substitutes the same sculptor's *Apollo.* And on the wall over the antique chair hangs a reproduction of a Sebastian whose original is attributed to Giorgione, the very artist around whom Pater wove his theory of art as pleasure.

This homosexual market was soon served by magazines, the first of which, *Der Eigene* ("The Exceptional"), started publishing illustrated articles on current artists and writers plus homosexual cultural history in 1898. Eight years later, it ran an advertisement for inexpensive mail-order reproductions of a French painting by Hippolyte Flandrin (fig. 5.22), a dusky close-up of a nude youth by the shore with his head resting on his knees in melancholy solitude. The 1835 original, already adapted by von Gloeden and F. Holland Day, became a pinup boy as perennially popular in twentieth-century gay culture as the *Apollo Belvedere* was from Sodoma to Winckelmann. Nor was this the first such commercial offer: an 1893 notice in *The Artist* had offered a mass-produced "cast statue" of Antinous for an affordable three pounds ten shillings, and knowing Oxford students in Alfred Douglas's day papered their dormitories with prints of Simeon Solomon's *Love Among the Schoolboys.*

Kupffer's fantasy of one such interior is itself a photograph, a more sophisticated descendant of Bonheur's home snapshots and Austen's pranks. The new medium's humbler progeny also included magazine illustration and formal

portraiture, by which homosexual men, particularly transvestites (a term coined by Hirschfeld), began to make their own images public to raise consciousness or boost sales. One of Hirschfeld's early supporters, a titled refugee from Austrian sexual oppression, had a photograph of himself in drag published in the 1902 *Journal* (fig. 5.23). As the autographed note below his sumptuously draped alter ago explains, Baron Hermann von Teschenberg volunteered to be "exposed" this way in hopes of furthering acceptance of his "true nature." Teschenberg's sartorial sister Julian Eltinge, a professional female impersonator who built an avid American public more for commercial gain,

Durchdrungen von der Richtigkeit und dem Werte Ihrer Bestrebungen, nicht aus Eitelkeit oder anderen unlauteren Motiven, stelle ich Ihnen das Bildnis, welches) meine wahre Natur enthüllt, nebst meinem Namen zur Veröffentlichung im Jahrbuch gern zur Verfügung.*

Hermann Freiherr von Teschenberg.

5.23. Portrait of Baron Hermann von Teschenberg (photograph, **Journal for Sexual Intermediates**, 1902).

advertised his/her ambiguous allure through souvenir photographs and sheet music covers.

Similar images circulated in turn-of-the-century Argentina, Gabriel Yturri's homeland, whose capital, Buenos Aires, was then ballooning into the metropolis of South America. We know of these lost snapshots of popular drag queens through police reports on the homosexual subculture that took root there in the wake of the epic immigration also transforming North America and Australia. A few decades behind its European models, this suspiciously watched community developed the same networks and public cruising areas, spiced with distinctive Latin touches like the lavish cross-dressing rooted in the fiesta of Carnival. Similar habits prevailed throughout Hispanic America: in 1901 the commercial artist José Guadalupe Posada illustrated published broadsheets that poked *macho* fun at 41 Mexico City *maricónes* (effeminate homosexuals) arrested at a drag ball (a lesbian bar was raided next).

In the 1870s, Pater had pitied the homophile aesthete that "for this nature there is no place ready in [the world's] affections." By the turn of the new century, though the world still did not approve of homosexuals, it could no longer exclude them from the public eye. Sigmund Freud had begun publishing the case studies that would transfuse his medical colleagues' long-standing obsession with sexual affections of all stripes into the veins of society. And Wilde, Whitman, and Hirschfeld had ushered in all around the globe the rudiments of a new affectional community: self-aware homosexuals who were not only demanding political toleration but publishing their own media, making and marketing their own images, and sifting the past for icons and ideas to define and validate themselves. Symonds was waxing nostalgic about the Renaissance rediscovery of antiquity when he wrote wistfully of that brief moment in arcadian Italy where "it seemed as if the phallic ecstasy might revive." But he was really talking about his fervent hope for a re-revival of pagan eros in his own northern, Christian, and bourgeois present. From his generation onward, the love that for centuries had dared not speak its name would never shut up—and the rest of society would be forced to respond to this creative self-declaration.

MODERNISM, MULTIPLICITY, AND THE MOVEMENT: 1900–1969

If nineteenth-century gay and lesbian culture progressed by a series of quantum leaps, in the twentieth its path was more like a pendulum. As activists labored to build a supportive subculture, explore new identities, and increase their visibility, Western societies swung between tolerance and hatred. In Barcelona, gay French writer Jean Genet witnessed a 1933 mishap in Spain's civil war that revealed the tragicomic side effects of liberal and conservative crossfire. When street fighting destroyed a public urinal favored for cruising by transvestites, a contingent of locals decked out in silk dresses, their heads shrouded by classic lace mantillas, marched in a mock-funeral procession to lay a bouquet of roses over the ruins.

Those shell-shocked drag queens, staggering on high heels across a bullet-ridden square, choreographed in miniature a cataclysmic century ricocheting from shock to novel shock. The two most destructive wars of all time and the unique horror of atomic weapons, plus economic depression and the rise of ruthlessly efficient totalitarian governments, were all magnified by science and technology, which multiplied into a global engine driving travel, communications, and business. Capping the airplane, automobile, radio, film, and television, in 1969 the United States landed a man on the moon; the country's preeminent combination of military, industrial, and consumer power granted this period the title of "the American century."

All this change produced a babel of competing voices about politics, art, and sex: medical science propounded theories of homosexuality, ranging from acceptance to anathema. Both within nations and around the increasingly interlinked world, multiplicity brought movement, with gays and lesbians in the vanguard of expatriates seeking freedoms inaccessible at home. Sweeping democratization—women's rights, revolutions in China and Russia, and rumblings of decolonization—set the stage for a chronic tension between optimism and angst, between the open embrace of liberalizing and cosmopolitan influences, from Hirschfeld to hippies, and the nostalgia for old order that bred xenophobia and fear of all difference, from Hitler to America's anticommunist witch-hunt. Until the 1930s, progressive forces seemed ahead

in this tug of war, but the rise of conservative fascism tipped the balance of power disastrously.

Cultural conflict produced artistic crisis: a widespread, aching awareness that the new mass industrial society had made traditional myth and art irrelevant. The problem of narrative—what stories are worth telling?—set off a frantic search for new subject matter, paralleled by the problem of finding a new style—how to communicate those stories effectively to modern audiences? The three trunks of nineteenth-century art branched into polemically opposed "isms": classicism led to abstraction, and romanticism to surrealism, while realism, though thrown on the defensive, held the fort of social comment and documentation. Though gays and lesbians participated in all these trends, they found the most congenial outlets for self-exploration in realism, or in experiments with psychological introspection or mixing words and images—and in the emerging commercial arts, including the gay market.

The terms of debate were set by the movements known as modernism, born in Paris and raised in New York. Ringleader Gertrude Stein wrote that cubism needed to be invented because "faith in what the eyes were seeing" had evaporated: Einstein's relativity theory made the visible surface of the world pale before its hidden atomic structure, graspable only through mathematics, while Sigmund Freud made outer actions less compelling than their unconscious motivations. The result was restless novelty and experiment, especially with abstraction, which aimed to elevate art above mere objects and anecdote, to express the universal truths of pure form—an art-for-art best known in Piet Mondrian's grids. Sex garnered little attention: for artists fascinated by an impersonally mechanized utopia, the only erections that mattered were skyscrapers. Homosexuality fared a bit better among those who clung to figuration: though two founding fathers, Picasso and Matisse, were straight in life and work, a third, Duchamp, redefined image making as a conceptual game, driving a wedge of ironic self-consciousness and erotic ambiguity for camp subversion.

Despite all this ferment and renewal, the fine arts were gradually knocked off their pedestal by the well-financed commercial media of magazines, film, and television. Mass popular culture diverged from the elite arts in content and style, as advertising sought to bathe consumer products and personalities in glossy sex appeal. By the pop 1960s, a more inclusive attitude toward visual images no longer laddered them into "high" and "low," but arrayed them side by side like equal wedges of a pie, all borrowing ideas and personnel—many of them gay—even as they competed for "market segment."

The heyday of modernism that provides the borders of this chapter exactly overlaps the formative gay period from Hirschfeld to Stonewall. But during these same years, Western culture was itself deflected by a breakdown of old boundaries amid increasing globalism. As yet there will be little to say about Africa, Islam, and India, all preoccupied by struggles against colonial

domination, or of China, too racked by successive revolutions to innovate in the arts. Only Japan, already enthusiastic about the foreign culture that occupied it after World War II, showed the first clear signs of gay cross-fertilization.

PARIS 1900: LESBIAN HEAVEN

Though Paris was no longer the lone star in the cultural galaxy, the creative and tolerant glow of the City of Lights continued to attract an extraordinary constellation of avant-garde artists until the fireball of World War II. Proust, Montesquiou, Bernhardt, and many painters, surviving links to "the capital of the nineteenth century," were joined by a host of younger expatriates. Women outnumbered men as wealthy and talented lesbians began to build an independent subculture, whose favorite gathering places were private salons and the cafés and bookstores of the bohemian Left Bank. Their overlapping cliques earned Paris a new reputation as the "sapphic capital" whose originality and patronage reigned over the birth of modern art.

Of the two widest circles, one orbited around American author Natalie Barney, known as "The Amazon," whose garden featured a Greek temple for lesbian rites, from readings of Sappho's works before toga-clad guests to her many romantic trysts; lovers and guests were photographed in fancy dress or undress. Barney's salon twinkled with local literary lights, from Proust to Colette and André Gide, supplemented by foreigners like James Joyce and Djuna Barnes. The unofficial painter to this lesbian court was Barney's American lover Romaine Brooks (1874–1970). The duo kept up a fond though stormy relationship for more than forty years, inventing a flexible lifestyle that permitted them other affairs and infatuations—many of whom Brooks painted, as she did the occasional gay male friend, like poet and artist Jean Cocteau.

Brooks monogrammed her work with a wing tethered by a rope, her self-dramatizing image as a grimly determined survivor who could never fully shed the psychic burden of a monstrous childhood. On her crazed mother's sudden death in 1902, Brooks inherited a fortune but remained prickly and aloof. She exhibited until 1925, but often refused to part with her work, and devoted her reclusive later years to writing a vengeful autobiography illustrated with nightmarish line drawings. She specialized in portraits of herself and female friends and lovers, rendered in a stark Whistlerian palette of grays and blacks. Some sitters hid their lesbianism behind the façade of upper-crust fashion plates; others flaunted their deviance, as in *Peter, a Young English Girl* (1924) in her necktie and cropped hair. Montesquiou hailed Brooks as a "thief of souls" who could pierce her subjects' personalities, but her brooding portrayals are equally projections of herself. While her subject matter established her as the fountainhead of self-consciously lesbian art, her symbolist style was already old-fashioned.

Brooks's romance with the Italian poet Gabriele d'Annunzio became a triangle when the fickle d'Annunzio fell for Ida Rubinstein, a Russian Jewish dancer-actress who in turn lusted after Brooks; the sticky liaison inspired work from all three. Figure 6.1, *Le Trajet* ("The Arc"), is a stylized depiction of the nude Ida in a deathly trance, her impossibly gaunt body (Romaine's favorite type) collapsed on a sharp-pronged white form—part iceberg, part shark—that hurtles across an inky blue sky like a human comet, as brilliant but cold as Brooks herself. Rubinstein commissioned Claude Debussy to write music for a mystic religious drama d'Annunzio penned for her, *The Martyrdom of Saint Sebastian*; at the 1911 premiere she scandalized Paris by starring as the nearly naked title character, the familiar gay icon whose androgyny suited Rubinstein's waif-like physique.

The same late symbolist aesthetic inspired British sculptor Jacob Epstein's tomb for Oscar Wilde in the Paris cemetery of Père Lachaise, a limestone tower surmounted by a visibly male sphinx evoking Wilde's mystical poem. No sooner was it unveiled in 1912, after tussles with customs, than the monument became a gay pilgrimage site; to this day it stays blanketed in offerings of flowers and multilingual graffiti that bear out the prophecy from his "Ballad of Reading Gaol" engraved on the back: "His mourners will be outcast men, / And outcasts always mourn." So many tourists chipped off souvenirs that the block had to be restored in 1992, but has already lost its second genitalia.

Meanwhile, a few blocks from Barney and Brooks, another expatriate

6.1. Romaine Brooks,
Le Trajet, ca. 1911 (oil).

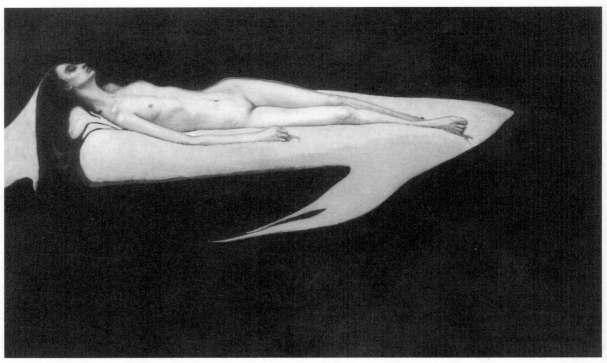

American duo, writer Gertrude Stein (1874–1946) and her companion, Alice Toklas, presided over a friendly rival salon. Though the two couples socialized, they never felt quite comfortable: when Stein showed up at Brooks's studio to have her portrait painted sporting the new Roman crewcut that was to become her trademark, the more conventional Romaine sent her home. Stein invented a fragmented, repetitive, often barely comprehensible narrative style that paralleled cubist art in such notorious lines as "Rose is a rose is a rose." Her literary innovations, plus her critical and financial support of writers and artists, won Stein fame as the century's premier lesbian artist and the midwife of modernism. Like Wilde's tomb, her own, around the corner in Père Lachaise, is a magnet for art lovers and lesbians.

Stein welcomed more men, both straight and gay, European and American. Her favorites were the twin pillars of modernist painting, Pablo Picasso and Henri Matisse, who attest to the perennial appeal of lesbians to heterosexuals. The Spaniard Picasso began in Toulouse-Lautrec's footsteps as a chronicler of racy Montmartre nightlife; in *Le Moulin de la Galette* (1900), the crowd includes female couples dancing and caressing each other. By the time he finished his portrait of Stein in 1906 (fig. 6.2), Picasso had begun to stylize the face into a geometric mask based on African sculpture, a step toward the revolutionary abstractions of cubism. Stein's imposing bulk, both regally self-contained and hunched forward in keen but unblinking curiosity, perfectly captures the image she wanted to bequeath to posterity. She extolled the portrait in print—"For me, it is I, and it is the only reproduction of me which is always I, for me"—and shrewdly donated it to New York's Metropolitan Museum of Art.

Stein's role as patron and publicist, shared with her bisexual brother Leo, continued the line of wealthy orchestrators of creativity that descends from Beckford and Walpole. Stein also inspired her pre-Toklas fling Etta Cone and Etta's sister, Claribel, to purchase contemporary art; the well-heeled spinsters' collection formed the nucleus of the Baltimore Museum's modern wing. The genteel Cones favored Picasso's rival Matisse, who pioneered a contrasting modernism of brilliant flat color and calligraphic line, equally abstract but more dedicated to the comforts of the senses both in style and subject. Matisse's early works *The Dance* and *Joy of Life* display rings of nude women frolicking in Edenic landscapes; the title of one study of bathers, *Luxe* ("Luxuriousness," 1907) invokes Baudelaire's hymns to female sensuality, an interest Matisse and Etta shared.

One of Romaine Brooks's crushes, the Princess de Polignac, opened her considerable purse to pay for the theatrics of Sergey Diaghilev (1872–1929). Stein's male equivalent as a nurturer, he began as editor of the magazine *World of Art*, spearhead of the prerevolutionary ferment known as Russia's Silver Age, around which clustered the painter of male nudes Kuzma Petrov-Vodkin and the poet Mikhail Kuzmin, whose *Wings* became the bible of gay Russians. But,

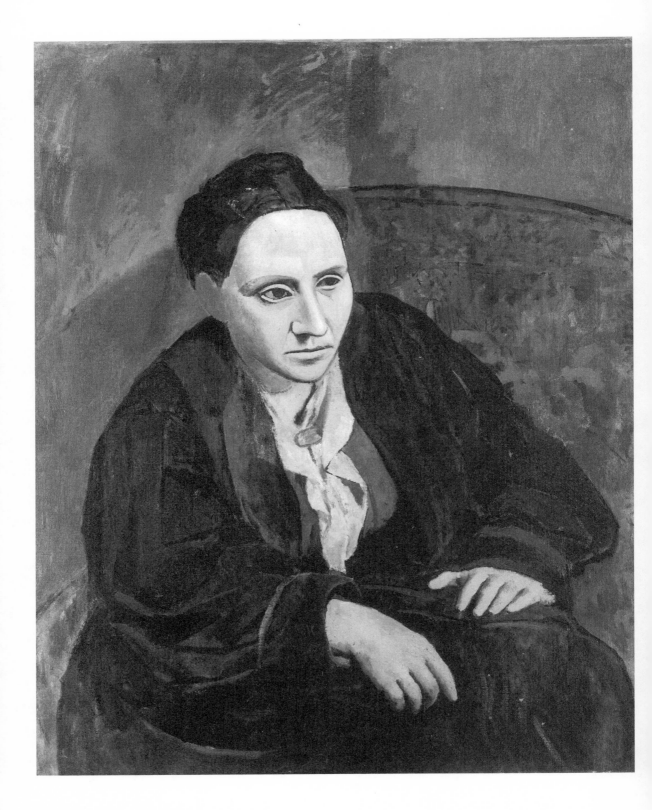

Diaghilev wrote, "I found my true vocation—being a Maecenas," as impresario of the Ballets Russes, a traveling dance troupe that electrified prewar Europe. Sweeping away the white tutus and prettified myths of Russian imperial ballet, Diaghilev replaced them with primitive or contemporary settings, music by modernists like Igor Stravinsky, opulent scenery and costumes by the painter Leon Bakst (an effeminate dandy)—and a businessman's eye for the box-office value of sex and scandal.

Among Diaghilev's many affairs with his dancers, the most melodramatic was Vaslav Nijinsky, a prodigy whom the doting fairy godfather transformed into the first male superstar, in provocative roles like the randy adolescent satyr in a ballet to Claude Debussy's *The Afternoon of a Faun* (1912). Bakst's iridescent costume sketch (color plate 19) captures the fey half beast in the final moment when, rejected by nymphs he was peeping at, he seized a scarf one left behind and jerked his loins into it in a masturbatory release of frustrated desire. This climax was all too literal for the Paris premiere audience—who knew full well the offstage lover of this solitary ephebe—setting off a critical outcry in which the sculptor Auguste Rodin leapt to defend Nijinsky.

Though heterosexual, Rodin was the master of expressionistic male nudes (which caused rumors about his own orientation) and had spent long hours sketching Nijinsky for a sculpture inspired by Michelangelo's *David*. The project never progressed beyond plaster and bronze mock-ups, in part because after one posing session the jealous Diaghilev caught artist and model sprawled across a bed. If anyone was going to portray Diaghilev's love, it would be the loyal Bakst, whose design, besides its practical function, was also an intimate personal testimony: an image of a beloved youth drawn by a sympathetic friend for the supervising patron, a touching reprise of the artistic three-way in Girodet's version of Anacreon (fig. 5.7).

BERLIN AND LONDON:
MASCULINE AND FEMININE

If Paris still had more art, Berlin had more sex—or at least, more public gay culture, with social clubs by the score. But what made Germany unique was its mushrooming political organizations and mass media: Magnus Hirschfeld's Scientific-Humanitarian Committee, founded in 1897, soon opened branches in Austria and the Netherlands. His journal and *Der Eigene* were joined by popular magazines whose Grecian illustrations echoed the classically draped bronzes of arm-in-arm boys by sculptors like Gerhard Marcks and Sascha Schneider. Ironically, this very openness caused Germany to suffer more open conflict than other countries over homosexuality in the saber-rattling prelude to World War I.

National military manpower was a burgeoning obsession during the dual

6.2. (opposite) Pablo Picasso, **Portrait of Gertrude Stein,** 1905–6 (oil).

scramble for dominance in Europe and colonies abroad. If boys were to grow up vigorous enough to carry what Rudyard Kipling called "The White Man's Burden" of world empire, they had to be trained in the athletic male comradeship that led from summer camp to army camp. Programs to promote physical culture, from nudism to the Boy Scouts, spread across western Europe, Scandinavia, and overseas. But making healthy bodies required recognizing the body, which aroused suspicion: however innocent in theory, sunny snapshots of beefcake horsing around at a nude beach could obviously be read differently by different audiences. Taking the offensive, poet Stefan George tried to co-opt nationalism for the gay cause, casting homosexuality as a return of "Hellenic chivalry" that would produce ideal soldiers. In this virility sweepstakes, not only national honor was at risk, but national survival: conservatives countered that degeneracy in both sexes lay behind the plummeting birthrate.

The touchiest institution was the military itself. In the most stunning scandal of Kaiser Wilhelm II's reign, a wave of courts-martial, blackmail, and suicides exposed dozens of homosexuals in the army and diplomatic corps;

6.3. "New Prussian Coat of Arms," cartoon in Jugend (Munich), October 28, 1907.

Neues preußisches Wappen
(Liebenberger Entwurf)

A. Weisgerber (München)

published attacks on Wilhelm's inner circle provoked high-profile libel suits that raised public awareness of sexuality as the Wilde trial had in England. The highest-ranking victims were Prince Philipp zu Eulenberg, ambassador to Vienna, and Count Cuno von Moltke, the general commanding Berlin. Their romance was pilloried in cartoons like figure 6.3 when the long-simmering "Eulenberg Affair" boiled over in 1907 thanks to Maximilian Harden's fiercely progressive weekly *Die Zukunft*. Captioned "New Prussian Coat of Arms," this crowned shield is flanked by a bacchic Eulenberg, holding a harp (he was a talented amateur), who tickles the chin of a simpering Moltke. The musician's words of endearment, reported in court by Moltke's ex-wife, are written on the scroll: "My sweetheart, my loverboy, my one and only cuddly-bear."

Hirschfeld testified for Harden, just as Adolf Brand, the fiery publisher of *Der Eigene*, endured court battles and obscenity shutdowns to "out" prominent officials; both hoped to raise tolerance by

overcoming the tragicomic sexual ignorance of people like Frau von Moltke. But their tactics backfired, since the public interpreted their revelations in the terms of aesthetic degeneracy set by Harden, who tarred Eulenberg as an "unhealthy, late-Romantic visionary." The newly strengthened forces of moral purity and nationalism next targeted lesbians and feminists, in cartoons mocking their mannish assertiveness and unpatriotic refusal to bear children.

Despite attacks, most German gays prospered, like the art historian Johannes Guthmann and his lover Joachim Zimmermann, whom the late impressionist Max Slevogt painted twice as a couple: nude in 1912, formally dressed in 1915. Nor were foreign gays discouraged: the American painter and poet Marsden Hartley (1877–1943) made fast friends with Gertrude Stein but was soon lured to Berlin by the homoerotic hypermasculinity that had embarrassed the army. There he fell for Karl von Freyburg, a young officer who fulfilled the fetishistic fantasies of boots, uniforms, and brass bands that Hartley revealed in his orgasmic enthusiasm over a military procession: "The tension was terrific and somehow most voluptuous in the feeling of power . . . when passion rises to the full and something must happen to quiet it."

Something, alas, did quiet his passion: Freyburg's death in action early in the Great War, which the grief-stricken artist memorialized in *Painting No. 47, Berlin* of 1914 to 1915 (color plate 20). Within the colorful geometric fragments of a wavy German flag, this "portrait," based on Wassily Kandinsky's abstractions and cubist collage, only half-conceals the white-plumed helmet, spurs, and initials of the lost beloved, and his age at the time, twenty-four; the halo around his helmet canonizes him as a secular saint, a soldier Sebastian. Hartley's mourning picture simultaneously stretches and exploits the limits of abstraction: he went as far as he could toward pure form yet still retains some identifiable subject for personal expression, while safely obscuring that controversial gay message behind the supposed elimination of references to the "real world."

Once war forced his return to less tolerant small-town North America, sexuality retreated in Hartley's life and art, from a combination of personality, age, and discretion. Secretive and ambivalent about homosexuality, he penned an essay admiring Leonardo da Vinci's psychic ability to divorce his art from his repressed passions, just as much of Hartley's own love life remained fantasy: he pined for, but merely painted, the sailors and lobstermen of New England and Nova Scotia, brawny shirtless men with hairy chests and small heads, swaggering archetypes of physicality. A writer himself, he sympathized with the equally tormented gay poet Hart Crane, whose 1933 suicide he commemorated in *Eight Bells Folly*, a testimony to their shared frustrations.

Greater acceptance and self-expression were preached in Britain by the genteel bohemians of the Bloomsbury group, writers and artists who pioneered a freethinking modernism under the name of the London neighborhood where they socialized around 1905. This interrelated and sometimes

incestuous family, who seized every opportunity to loosen the corsets of lingering Victorianism, indulged in an erotic and aesthetic merry-go-round. Stephen Tomlin, a bisexual sculptor married to Julia Strachey, cast a bust of the historian Lytton Strachey and another of novelist Virginia Woolf, whose feminist sainthood rests on her miraculous essay *A Room of One's Own*, protesting the roadblocks to female creativity. Though her gospel labels love between women "that vast chamber where nobody has yet been," Woolf entered it in 1922, when she began a long affair with author Vita Sackville-West while both women were married. Virginia's sister, Vanessa, and Vanessa's husband, critic Clive Bell, championed the visual arts along with the Stracheys' cousin Duncan Grant, whose busy gay life complemented his domestic ménage à trois with Vanessa and Clive and Vanessa's children by both men.

Grant, Bloomsbury's "official artist," painted his handsome lover, economist John Maynard Keynes, as well as a college mural of men bathing (1911) that evokes lyrical athleticism; later he churned out watercolor drawings of nude models or tricks. Duncan and Vanessa contributed designs to Roger Fry's Omega Workshops, a descendant of the Arts and Crafts movement aimed at applying modernism to the decorative arts while preserving handicrafts against mass production. Their focus on the domestic interior as an artistic arena—from textiles and pottery to mantelpieces—rather than monumental public commissions was a validation of the "feminine" sphere consistent with their overturning of all gender conventions.

London, basking in the Edwardian afternoon of the world's greatest empire, was also intensifying as an international hub for gay and lesbian artists. Foreign gay painters at the Omega Workshops included Alvaro Guevara from Chile and the South African Edward Wolfe. Also in residence for extended periods was the New Zealander Frances Hodgkins, who traveled and lived with other women painters at home and in Paris. Crisscrossing the globe on a sexual and artistic odyssey was to grow ever more common, but not until it had been abruptly interrupted by the gathering catastrophe.

GREAT WAR, GREAT CHANGES

When Austria declared war in 1914, Britain's Sir Edward Grey sighed prophetically, "The lights are going out all over Europe." The Great War of 1914 to 1918, as it was known until eclipsed by the Second World War a generation later, wreaked cataclysmic social and cultural changes around the globe. Mass technological warfare devoured 10 million troops and collapsed the autocratic dynasties of Austria-Hungary, Russia, and Germany into the gassy trenches of the most appalling carnage in history. Hartley's threnody to Freyburg was echoed in shell-shocked dirges by the English poets Wilfred Owen and Siegfried Sassoon, mourning the flower of world manhood mowed down in

the prime of life. Those who survived, both doughboys and civilians, had been irrevocably exposed to broader horizons by wartime advances in transport and communications: airplanes, radio, and the mass media of photojournalism and newsreels. In the words of a popular ditty, "How ya gonna keep 'em down on the farm / Now that they've seen Paree?"—or if they'd merely seen the antics in the U.S. Navy, which included sailors dancing together, as recorded (and inadvertently publicized) in naively morale-boosting postcards like "Christmas on the High Seas," distributed by the Young Men's Christian Association (YMCA). American president Woodrow Wilson's ideal of democratic nationalism, embodied in the peace treaty creating new republics, was not lost on Europe's colonies across those seas, which began a half century of agitating for independence.

When the lights came back on, a demoralized West found itself adrift in conflicting currents that eddied in all directions at once. The postwar climate, watered by moral and aesthetic uncertainty, proved fertile for renewed growth of a gay community and shed more light on sexuality throughout society—not all of it favorable. Three images from the year 1919, made in New York, Toronto, and Berlin, offer a cross section of viewpoints among artists, adversaries, and advocates.

That year witnessed an infamous act of desecration by the Frenchman Marcel Duchamp, a leader of the iconoclastic dada movement founded by painters fleeing the horrors of war in neutral Switzerland and, like Duchamp, New York. One of the most radical and enigmatic modernists, he scribbled a mustache and goatee on a cheap postcard of Leonardo's revered *Mona Lisa*, retitling it *L.H.O.O.Q.*, which when pronounced in French sounds like "she's got a hot ass." His disrespectful graffiti act out the manifesto that declared, "Dada spits on everything, Dada is bitterness laughing at everything that has been accomplished and sanctified." Revulsion at the tragic collapse swirling around them led to a nihilistic loss of faith in all the failed pieties, logical systems, and lofty claims of church, state, aesthetics, and science. Dada took a childlike glee in breaking every frayed social cord, staging madcap soirées of art and performance whose message was that such apparent opposites as sense and nonsense, design and chance, or male and female are inseparable parts of a single antic and messy reality. Claiming that anything could be art, Duchamp promoted this anarchic Taoism by signing and exhibiting a "ready made" ceramic urinal.

Duchamp was a conventional ladies' man, but he began as a cubist painting vaguely lesbian nudes, and his work betrays a lifelong flirtation with desire, gender ambiguity, and cross-dressing that dovetails with dada's nose thumbing. *Mona Lisa*, in the Louvre Museum, was already a staple in Parisian press cartoons that mocked politicians as effeminate by pasting their faces on her; more personally, Duchamp had an aesthetic crush on Leonardo as a fellow genius, equally cerebral and secretive. In his 1911 psychobiography of the old master,

6.4. Marcel Duchamp, **Belle Haleine, Eau de Voilette,** 1921–66 (collage; photograph by Man Ray).

the rising analyst Sigmund Freud followed Walter Pater in declaring Leonardo a sublimated homosexual. If *Mona Lisa* was, as they claimed, a self-portrait, Duchamp was "outing" Leonardo, making a visual pun on the nineteenth-century definition of a gay man as a female soul in a male body. His pencil underlined the androgyny of Leonardo, of all creative artists, and hence of Duchamp himself, and hinted at its erotic side in the naughty caption.

A year or so later, Duchamp invented his own female alter ego, Rrose Sélavy ("Eros, c'est la vie"), who signed many of his works. "She" made her visual debut when Duchamp had the American Man Ray photograph him in drag as a matronly lady in a tasteful cloche hat who appeared on the label of an imaginary perfume bottle (fig. 6.4). Though Ray's portrait is charming and droll, images as such were no longer Duchamp's main focus; he increasingly abandoned the craft of painting for esoteric projects more concerned with pure ideas than with the traditional pleasures of object making. His drastic redefinition of art as conceptual rather than perceptual, along with his bad-boy high jinks, continue to serve as the beacons for today's postmodernists.

One dada polemic called for "no more painters, no more writers, no more religions, no more police." But the police, at least, weren't going to give up without a fight, in which images served as ammunition. The photograph in figure 6.5 was taken in 1919 by the Toronto vice squad to document one of myriad prosecutions for sexual indecency in the Canadian boomtown's public lavatories. Men had solicited in toilets since Simeon Solomon's London, but the camera multiplied state capacity for surveillance and evidence. Forensic photography provided, literally and figuratively, the lens through which officialdom focused public attention on homosexuals: not as a coherent community made up of thinking and feeling individuals, but as isolated and depersonalized deviants. Concerned only to demonstrate that "they" do things "like that," these clinically detached snapshots reduced a complex personal experience to a provable illegal act. We would never learn from such images that both Wilde and Whitman visited Toronto in the 1880s, or that their latter-day readers remained in touch with a vibrant European and American gay network.

While gay artistic culture is missing, culture in the anthropological sense is abundantly visible: like all negative images since the molly prints, this photograph, perhaps the earliest record of modern "gay space," gives us precious details of the physical setting and sexual rituals of gay life, fleshed out by a written narrative. The court file with figure 6.5 reports laconically that the Crown Attorney's informant observed the defendant "sitting on the [water]

closet seat and peeping through a small hole in the partition"—through which another man put his penis and the accused "commenced to suck it." Today we would label this handy orifice a "glory hole," and might even admire it as one of the inventive strategies through which the gay subculture subtly carved out its own niche in the city environment.

Because hostile outsiders might innocently pass through a public toilet or park, gay space had to remain implicit and imaginary, less architectural than theatrical. Initiates "performed" for one another in coded costumes and scripts—including the campy euphemism "tearoom"—and even adjusted the "stage" lighting (artist Neel Bate recalled how, in 1940s New York, "fellows would go through the [Riverside] park in the daytime and carefully knock out all the lamps so it would be dark at night"). The danger of being caught "in the act" of this clandestine mating dance was both thrilling and chilling: though not "art" in the traditional sense, forensic images circulated among a limited but powerful audience in the police station, courthouse, and newsroom, who could punish the men "captured" on film with prison and social disgrace.

But the gay community, growing more sophisticated in return, also began to exploit the new media to shape its public image—to counter *They* are like that" with "*We* are *not* like that" or "*We* *are* like that and it's all right." In 1919 Magnus Hirschfeld's Berlin team took advantage of the abolition of imperial censorship to produce the first film propagandizing for sexual liberation. Figure 6.6 is a climactic frame from *Anders als die Anderen* ("Different from the Others"), which dramatized the injustice and fear visited on gay men by Germany's long-targeted sodomy law, Paragraph 175, through the blackmailer who strikes its hero, a dandyish musician named Paul, and his younger boyfriend. In this scene the extortionist, featuring the lurid eye makeup and exaggerated expressions of early silents, is gripped from behind by the tight-lipped Paul, who courageously denounces him, though the public scandal leads to his banishment from the concert stage and suicide. Hirschfeld appeared in an epilogue, lecturing the audience on the moral of this all-too-common tragedy and counseling his motto, "Knowledge conquers prejudice." That knowledge is not merely sociological, but cultural: Paul's fashionable aesthetic apartment is decorated, albeit on the shoestring budget of a home movie, with the same coded historical precedents, like a classical sculpture of Cupid, recorded in Hirschfeld's field trips and Elisar von Kupffer's photography (fig. 5.21).

Sweden, where Hirschfeld disciples had lectured, produced several artists whose erotic sailors and athletes

6.5. Public toilet stall, Toronto, 1919 (police photograph).

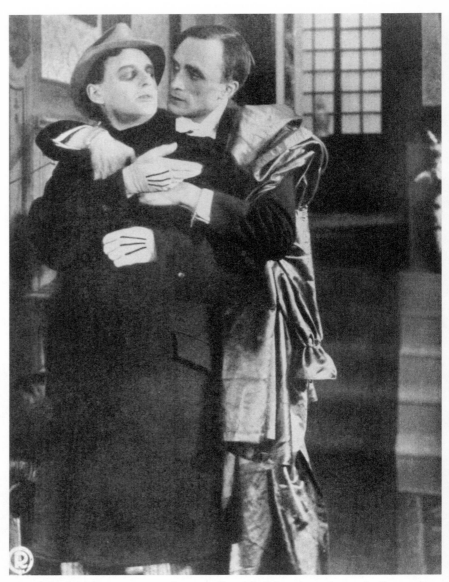

6.6. Richard Oswald (director), **Anders als die Anderen,** 1919 (film still).

paved the way for an even earlier gay film, *The Wings* (1916), in which visual art is central to the plot. In this lost version of a novel (only the script and a few stills remain) an artist falls in love with his apprentice and, spurned by the youth, dies in delirium before his own statue of his beloved. For this portrait, filmmaker Mauritz Stiller borrowed real-life sculptor Carl Milles's bronze of a slender neoclassical ephebe who merges, like Ganymede, into the wings of an eagle that descends into his yearningly upraised arms. Such open lyricism fore-shadowed the reputation of Sweden and Denmark after World War II as havens for free sexual expression, both on and off the silver screen.

Stiller and Hirschfeld were riding the wave of the future: though sneered

at as disreputable lower-class amusement when they debuted in the 1890s, "the movies" soon became a worldwide craze, with Hollywood, California, as the industry's postwar powerhouse. Over the course of the century, film—which is, after all, a "moving picture"—and its offshoots (television and video) have inexorably eroded the prestige of traditional painting and print media, usurping the visual arts' long-standing role as society's prime source of narrative, of mythic stories and shared fantasies, even knowledge of the world. The rich and complex history of homosexuality in film can be mentioned here only when it intersects broader artistic currents; the classic survey of the medium is Vito Russo's *The Celluloid Closet*.

Gay activism was but one wing of a broad sexual reform movement waging related struggles over women's rights and access to pregnancy control. Family-planning pioneer Margaret Sanger opened the first New York clinic in 1916; her British counterpart, Marie Stopes, followed suit in Britain in 1921. Not only were contraception and abortion illegal, but even information about them fell under the ban on obscenity: Sanger was saved from one lawsuit by the death of postal agent Anthony Comstock, who inspired the epithet "comstockery" for his rabid vendetta against sexual material in the mails. Decades of court challenges gradually eliminated restrictions on free speech, opening doors for mass communication about intimate matters. Suffragists too began to taste victory: British women got the vote in 1918, Americans in 1920.

These reforms were not specifically about homosexuality (though of course they benefited lesbians), but any relaxation of gender controls gave other sexual minorities more breathing room. Liberals around the world were exhilarated when Russia's socialists, taking advantage of wartime chaos to depose the czar in 1917, ushered in a short-lived heyday of reform, abolishing laws against abortion and sodomy. The sudden thaw released a torrent of avant-garde activity in both fine arts and the new mass media of advertising and film. But, while individuals like the innovative filmmaker Sergey Eisenstein were gay, eros had little role in the propaganda of a revolutionary workers' utopia.

BETWEEN THE WARS:
THE LOST GENERATION
AND SURREALISM

As the world woke up from the nightmare of war, much of Europe nursed an economic and political headache, while America shook off its hangover with a decade-long party known as the Roaring Twenties. The Jazz Age bubbled with a heady permissiveness, especially for women: the "New Woman," who could vote and enter the professions, was smart, competent, and "masculine," often adopting a mannish wardrobe. The United States had catapulted to the rank

of world industrial colossus, and not even prohibition of alcohol could crimp the newly affluent consumer society's frivolous flappers and dapper gentlemen. American expatriates, still including many lesbians and gay men, flooded back to Europe seeking artistic and sexual modernism, while Duchamp was but the first of many Europeans to repay the visit as the cultural balance tipped westward. The party ended with a bang, the stock market crash of 1929, setting off the Great Depression that bisected the period between the world wars. Unemployment and government turmoil inspired a realist art dedicated to contemporary social comment and confronted both the left and the right with thorny questions of sexual politics.

The romantic "Lost Generation" was headquartered in Paris, where newcomers flocked around the living legends of the Stein and Barney salons and cafés irrigated such fountains of modernist literature as Ezra Pound, James Joyce, and Ernest Hemingway. Though these titans were straight, the prevailing joie de vivre encouraged the sexual as well as artistic avant-garde, from gay Britons and Americans to the Italian painter Filippo de Pisis. Unburdened by a sodomy law, the French needed little gay politics, but cultural activists fought for an elusive social acceptance (Catholics pressured the government to shutter the short-lived magazine *Inversions* in 1924). The greatest weapon in that struggle was their vaunted literary tradition, which now broached the subject openly: Proust's *Sodom and Gomorrah* (1921) introduced the dandy Charlus, while André Gide, who had met Wilde in the African boy-lovers' haven of colonial Algiers, spoke out in his essay *Corydon*, written earlier but published only in 1924. Gide's platonic dialogue echoes Winckelmann to justify classical pederasty by appeal to Greek sculpture, foreseeing (through propagandistically rose-colored glasses) that "when the day comes to write a history of homosexuality in relation to the plastic arts, it will be seen to flourish not during the periods of decadence but, on the contrary, during those glorious, healthy periods when art is most spontaneous and least artificial."

Male writers and artists were often dependent on the burgeoning community of creative lesbians, such as the lovers and bookstore owners Adrienne Monnier and Sylvia Beach (publisher of Joyce's *Ulysses*). Djuna Barnes, a writer and visual artist, commissioned a photograph of herself (fig. 6.7) about 1926 from Berenice Abbott, her sister American in Paris, where Barnes set up with her lover, the sculptor and graphic artist Thelma Wood. Portrayed in a revealing mix of man-tailored tweeds and the metallic period sleekness of her turban and pearls, the poised and forthright Barnes penned several novels illustrated with her own comically exaggerated drawings; her *Ladies Almanack* (1928) was a coded spoof of sapphic circles.

Abbott (1898–1991), who was outspoken about everything but her closely guarded lesbian life, had met Barnes in New York along with Duchamp and Man Ray, whom she followed to France, becoming the quasi-official camera portraitist of lesbian circles as Romaine Brooks was in paint. But aside from

6.7. Berenice Abbott,
Portrait of Djuna Barnes,
1926 (photograph).

subject matter, Abbott and Brooks were poles apart—as the next several images from sapphic Paris all differ from one another, setting forth the period's multiplicity of styles and viewpoints, media and patronage. In her elegant yet spontaneous images of grandes dames like Barnes, Abbott strove for sharp-focus realism and freedom from feminine stereotypes: admonished that nice girls didn't frequent the déclassé districts where she liked to work, Abbott snapped, "I'm not a nice girl, I'm a photographer." She was sought after by androgynous tastemakers like the lovers Jane Heap and Margaret Anderson, editors of *The Little Review,* and Janet Flanner (who sent home *The New Yorker's* "Letters from Paris" for fifty years) and her lover, as well as by gay men from Jean Cocteau to novelist René Crevel. In contrast to her male mentor Ray,

whose photo of Barnes is gauzily romantic, Abbott all but invented the lesbian lens, gazing at these "new women" in sympathetic identification.

Abbott's privileged sitters coexisted and sometimes mingled with the public commercial culture, which became romantically familiar through the Hungarian-born photographer Brassaï, who snapped working-class lesbian and gay bars and dance halls. Thanks to faster film and smaller equipment, Brassaï could achieve a journalistic immediacy: he shot two couples dancing in a crowd at the nightspot called Magic City from the middle of the dance floor, as if he were a participant, filling the frame with period details like bee-stung lips and a rakish tweed cap. The pairs, one male and one female, all glance at the camera, perhaps with suspicion but clearly at home on their own turf. Brassaï's documentary objectivity, even when posing formal portraits of drag queens and cross-dressed women, demystified the territory: his 1933 picture book, *Paris de nuit*, popularized a "Paris by night" resembling Jean Genet's slightly later "underworld" novels, where ordinary urbanites mix with pimps, queens, and eccentrics of all stripes. For two generations he shaped the cliché of anything-goes bohemia, now less shocking than benignly colorful: outsiders felt less threatened by peeking in, and the locals felt less inclined to shrink from exposure.

Among fashionable patrons of the avant-garde, homosexuality was not only tolerated but chic: a whiff of the sexually outré, especially sapphism, could wreathe the arts in the heady perfume of sophistication. The Ballets Russes's 1924 *Les Biches*, a send-up of a swank modern houseparty, featured a trendy subplot of two women discovered frolicking together behind a couch. Marie Laurencin was the perfect choice to design the sets and costumes, which were as lighthearted as her flowery paintings of doe-eyed girls (*biche* means "doe") in affectionate pairs and groups. Though not a lesbian, she cultivated a pastel sensibility, often dismissed as "feminine," that proved ideal for these frivolous flappers, worlds away from the tweedy career women of the day.

Surrealism, which was all the rage between the wars from its Paris birthplace to the Americas and even Japan, also loved sex—except for gay sex. As founding guru André Breton declared in its 1924 manifesto, the movement carried forward the liberating experiments of its older sister dada with all experience that seems random or irrational, seeking to express "the real functioning of the mind." Through free association and automatic writing or drawing they produced fantastic imagery conjuring up imagination, dream, and desire, and dissected the uncanny with the medical tool of theories about the mind—particularly Freud, whose twenty-odd volumes made psychoanalysis a household word.

Early in the century, while still struggling for recognition, Freud's bombshell ideas undermined repressive psychology and sparked a healthy debate about sexuality, creativity, and the pursuit of happiness. Psychoanalysts mapped the concealed conflicts between our Apollonian conscious mind and

its dark twin, the Dionysian and instinctual unconscious, drawing implications for mental illness, art, and eros. Neurotic behavior was a symptom of repressed desires or traumas, which could be cured by excavating buried pain; one way to dig up memories was analysis of dreams, the visible tip of the mental iceberg; and that submerged childlike unconscious retained the androgynous unity that underpinned both artistic creativity and desire. Not surprisingly, two of Freud's major historical studies put under the microscope tormented gay artists: Leonardo and Michelangelo. Freud acknowledged bisexuality as a universal potential (though ideally abandoned after adolescence), comforting one worried mother in 1935 that "homosexuality is assuredly no advantage, but it is nothing to be classified as an illness." His followers, however, later institutionalized a homophobic orthodoxy that drew the first arrows of post-Stonewall activists.

Surrealism's most gifted artists—Duchamp, Salvador Dalí, Max Ernst, and Man Ray—helped legitimize unconscious eros, following Breton's hedonistic exhortation "Love as much as you like." But, as with Laurencin's critics, the specter of a potentially degrading "femininity" raised its misogynistic head. These mostly heterosexual men followed the lead of Breton, whose frigidity toward gays froze out gay subject matter (except, perhaps, for Giorgio De Chirico's bathers). Breton subjected the novelist René Crevel, the group's only admitted gay writer, to a mock trial and expelled him; Crevel put his head in the oven and died in Dalí's arms. Though a surrealist sympathizer, the protean Jean Cocteau kept his head by keeping his distance. Alongside his literature, films, and stage scenarios, he drew constantly, publishing a book of faux naive line drawings of the Paris scene in 1923. His whimsical, spidery vignettes of sailors; his Ballets Russes collaborators Bakst, Diaghilev, and Nijinsky; anonymous queens dancing in a bar; and his own lover Raymond Radiguet preserve a rare insider's view of the bohemian subculture spoofed by *Les Biches* and documented by Brassaï.

Many women were attracted to surrealism—Meret Oppenheim's fur-lined teacup is a beloved icon of the movement's willful and sexy absurdity—but few felt welcome. They criticized the men for idolizing an "eternal female" that limited women to the passive role of muse, a blank screen on which to project male fantasies. Argentine-born Leonor Fini (1908–96), who migrated to Paris in 1932, once let on, "I could never stand the dogmatic and inquisitional way the group approached its work," and much of her lesbian-themed painting was produced after she drifted away from them. Fini, who never married, explored eroticized women, nude or half-dressed—sometimes in lithographs illustrating pornographic classics like *The Story of O* and the Marquis de Sade, at other times imagining contemporary scenes like figure 6.8, *Le Long du chemin* ("All Along the Way").

In this silent encounter in a railway compartment, the drawn window-shade is printed with dancing putti who foreshadow the orgiastic outcome of

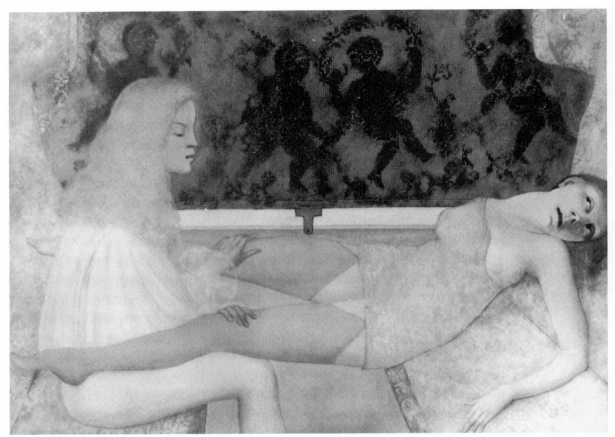

6.8. Leonor Fini, **Le Long du chemin**, 1966 (oil).

tentative foreplay between two dreamily yearning young women. With detached anticipation, the left figure parts the legs of her reclining companion, who throws back her head, eyes agog in a swelling ecstasy. Later pictures replace innocent youth by witch or dominatrix types, with the same inward faces, ambiguous scenarios, and awkwardly sensuous expectation. In contrast to her Polish-French male contemporary known as Balthus—whose notorious 1934 *Guitar Lesson* and other voyeuristic portrayals of pubescent girls and predatory women radiate sinister suggestions of rape or male neurosis—Fini offers an alternative view of female sexuality: equally inscrutable and icily cool, but imaginatively identifying with her painted women as consensual subjects, not merely as objects.

The Frenchwoman Claude Cahun (1894–1954) linked her writing and photography with surrealist ideas, but like Fini was too mercurial to be a full-fledged member. Figure 6.9, one of the illustrations to her autobiographical book *Aveux non avenus* ("Cancelled Confessions"), marks the culmination of her relentless self-portraiture. These photomontages, made in collaboration with her lover Suzanne Malherbe (who signed her own work with the male name "Marcel Moore"), extend surrealist collage. Snipping fragments from larger

wholes, they pasted them in unlikely juxtapositions to create arcane symbols whose associations tease out dreamlike reflection—a technique also dear to the bisexual German dadaist Hannah Höch. Gaping jaws suggesting a Freudian fanged vagina, her own mouth multiplied into flower petals, and her portrait behind bars sealed with a heart-shaped lock all hint at desire and danger. The caption typically plays with deceptive appearances and the inner self that makes sense of cryptic flux: "Here the executioner takes on the look of a victim, but you know what to believe." Despite the difference in medium, her moody tone and inward focus share more with Romaine Brooks's late-symbolist paintings than with Abbott's objective photography.

Cahun shed her Jewish and gender heritages by trying on a series of pseudonyms, settling on a French forename that can be either male or female. She snapped herself in dozens of personae, from kewpie doll to Buddha to suited bull dyke; her theme of life as performance led to work in the theater. Masks,

6.9. Claude Cahun, *Ici le bourreau. . . .*, from *Aveux non avenus*, 1929 (photomontage).

disguises, and mirrors, like the constant metamorphosis of her own image from pink crewcut to shaved head, were comments on the artificial and shifting nature of identity, respoken every time she and Malherbe made one of their dramatic entrances to their packed salon. Masks stood for both the inner mystery of the psyche and the need for public role playing, the conflicted search for authenticity that faced many women as they moved into the male world of work; as she wrote in *Aveux*, "I shall never finish lifting off all these faces." Trapped by Nazi invasion, she narrowly escaped execution for playing the role of a resistance fighter; only today has she reclaimed her place in the ongoing influence of surrealism, as a foremother of the punk style among fashion models and younger lesbians.

GERMANY AND ENGLAND: "LIFE IS A CABARET"

Germany under the liberal Weimar Republic boasted the biggest and most vibrant gay culture yet: by 1932 Berlin had two dozen gay publications, a bookstore, and three hundred bars, bathhouses, and clubs, about a tenth of them exclusively lesbian. Among their patrons

was the cross-dressing screen idol Marlene Dietrich, who immortalized androgynous and cynical hedonism in films like *The Blue Angel*. The freewheeling atmosphere brought back many foreigners, like British gay painter Sir Francis Rose, who wrote that it was "impossible for a young man to go out in the centre of Berlin without being accosted." This commonplace event was illustrated by Christian Schad, whose drawings of men cruising public lobbies, street corners, and bars are more gently humorous than those of the era's master satirist George Grosz. When Marden Hartley returned in 1921—the year Hirschfeld convened his World League for Sexual Reform—he could have met Schad and Otto Dix, a noted expressionist whose saturated watercolors portray the tinseled glamour of drag bars like the world-famous Eldorado. British author Christopher Isherwood chronicled his expatriate adventures in *Berlin Stories*, which inspired the musical and film *Cabaret*, the quintessence of this decadent and frenetic era for English-speaking audiences.

Activists continued to unearth historical precedents: *Der Eigene* ran a story on Frederick the Great in 1925, and a 1930 cover of its sister publication, *Eros*, featured the medieval German sculpture of Christ's intimacy with Saint John (fig. 2.3). For better or worse, the richly fertilized embryo of gay male culture had now multiplied enough to divide into factions. Adolf Brand, publisher of both magazines, ran cartoons caricaturing his rival Hirschfeld—a splintering tendency that has bedeviled the gay community, like other social movements, ever since. Brand also saw that his swelling audience could profitably be broken into different market segments: *Der Eigene* covered politics, while *Eros* offered literature and nude photography.

Lesbians caught up with the male subculture on a smaller scale, with women's clubs and magazines like the biweekly *Die Freundin* ("Female Friend," 1924 to 1933), which published cover photos of cross-dressing women, bar advertisements, and articles from politics to drag fashion tips. Women artists chronicling the club scene included Loulou Albert-Lasard and Schad's female counterpart, Jeanne Mammen (1890–1976), a successful commercial artist who provided drawings and watercolors for lesbian publications as well as mainstream books and fashion magazines, and illustrated the sapphic poems of Pierre Louÿs, *Songs of Bilitis*. Figure 6.10 depicts a boyish woman in top hat à la Dietrich, her arms akimbo, with her femme girlfriend hugging her shoulder. Their tipsy, leering smiles and waving streamers capture the aura of cheeky frivolity, with its desperate undertone of dancing on a time bomb. That anxiety turned out to be justified: Mammen was banned by the Nazis along with the magazines she worked for, and much of her output was destroyed.

In more sedate London, the sexual crusading of Bloomsbury aroused vocal opposition. The respected if congenitally butch author Radclyffe Hall and her sculptor lover Una, Lady Troubridge, shuttled between England and France, where Romaine Brooks painted the monocled and frock-coated Una's portrait,

6.10. Jeanne Mammen, **Costume Ball, Berlin,** ca. 1930 (pencil and watercolor).

a cruel send-up of her stiff masculinity (Una refused to pay for it). In 1928 Hall published *The Well of Loneliness,* the first novel not only sympathetic to lesbianism but pleading for toleration. Despite the book's suitably anguished tone and tragic self-sacrificing finale, and the Bloomsbury defense, British courts banned it as obscene, and the pair went into self-imposed exile. The novel, which became a cornerstone of lesbian culture, pays homage to the pioneer generation

of role models in its thinly veiled portrait of Natalie Barney as the author's mouthpiece, Valerie Seymour.

Another English beneficiary of earlier spadework was the painter Gluck (Hannah Gluckstein): she was the tomboy "Peter" painted by Brooks, who cropped her hair, dressed like a man, and took a neutered name mirroring Hall's heroine "Stephen" Gordon. Cushioned by wealth, she relished acclaim among the titled and fashionable while insisting with prickly courage on her simple right to exist as she chose, wearing her androgynous nonconformity as a badge of honor. Her cool, geometrically stylized work suited the tastes of the mildly artsy elite, from hyperrealistic floral bouquets to portraits, both informal and official, and dramatically spotlighted entertainment scenes.

By this second generation, patterns of subject and style were becoming hereditary in lesbian (and gay male) culture. Like Brooks, Gluck hated to part with her pictures (and sometimes bought them back) because they were so personal: as biographer Diana Souhami put it, "she chronicled her life in paint." Her many portraits of herself, friends and lovers (including her partner Edith Shackleton Heald, the first female reporter in the House of Lords), recalling Cahun, attest to the hunger for images of a love still banned from public view. And in formal terms, Gluck's art, again like Brooks (and Hall), was stylish but not avant-garde: gays and lesbians tended to favor middle-of-the-road figurative art, because image making was for them a path to self-definition on which experimental abstraction offered little help.

While Duncan Grant was nearly alone among British male artists who dealt professionally with their own sex, amateurs were busily creating a more popular, if clandestine, gay image. For decades the architect Montague Glover took snapshots of his everyday life, including his lover and their friends alongside assorted "rough trade" from the gay street culture. Sometimes he aspired to imaginative "art," like posing two swimming companions squaring off for a fistfight; but even these playful narratives remained within the private frame of a family album. Though seldom explicit to the point of obscenity, documents of erotic networks could still incur risks: similar German albums were preserved by police raids. Men of the interwar generation, or their embarrassed heirs, often destroyed the evidence; but, since many survived until well after Stonewall, when archives and libraries encouraged them to donate memorabilia, from this point on we can glimpse the homemade icons deposited in ordinary gay men's psychic image bank.

NEW YORK IN BLACK AND WHITE

When Marcel Duchamp fled World War I for New York, he found America eager for a breath of modernist fresh air. He was taken up by the circle of patrons, artists, and writers around the painter and hostess Florine Stettheimer, a

spinster with a bemused fondness for gay men and sophisticated gender play: she painted Duchamp's portrait in 1923 seated next to his alter ego, Rrose Sélavy, whose adjustable pedestal he operates with a toylike crank. New York had sheltered an openly gay popular culture since Whitman, and Duchamp joined the busy traffic between high and low, especially to the burgeoning black subculture of Harlem.

Among the outstanding natives was the Pennsylvanian Charles Demuth (1883–1935), now stateside after diabetes curtailed his jaunts to Stein's Paris and Hartley's Berlin. Wealthy, educated, and a fastidious dandy in the already quaintly old-fashioned mode of Walter Pater, Demuth gained fame with saturated watercolors of flowers and entertainers, and with symbolic "poster portraits" in which he struggled like his friend and sitter Hartley to fuse the personal and the abstract. Like many of his pictures, *Distinguished Air* of 1930 (color plate 21) illustrates literature (aping Baudelaire, he favored lesbian characters, from Émile Zola's Nana to Frank Wedekind's Lulu). Embroidering on his source, a Weimar chronicle by the gay American Robert McAlmon, Demuth depicts an art gallery where a group admires Constantin Brancusi's *Princess X* of 1916. Among them, a sailor and a man in evening dress link arm in arm, and a bowler-topped man with a cane ignores his female companion and the art to glance appraisingly at the sailor. The cane identifies Demuth, who had a childhood limp, while the almost comically phallic princess-as-penis, a transatlantic *succès de scandale*, subtly alludes to the turmoil over Freudian sexuality, abstract art, and shifting gender roles.

Though sometimes called Demuth's "coming out" picture, *Distinguished Air* was the only work that breached the wall between his private and public selves. He never dared to exhibit his more confessional work, a series of erotic subjects too explicit for contemporary proprieties. The sailor in *Distinguished Air* is a polite brother of Demuth's many other tars who dance together, fondle one another's cocks while urinating, or get caught in tense interrogation by a cop. The towel-clad men, including himself, prowling New York's Lafayette Baths testify to the popularity of the bathhouse, an import from Europe's urban sanitation reforms that provided gay male city-dwellers on both continents a new playground for public nudity and sexual contact.

While they document gay haunts at firsthand, there is little love in these pictures, only anonymous pickups and voyeuristic encounters, like the surreptitious glance in *Distinguished Air.* They seem to reflect Demuth's own emotional life, which he shrouded behind what Duchamp called "a curtain of mental privacy." Besides poor health, social pressure remained an obstacle to romantic fulfillment: Alfred Stieglitz, whose New York gallery nurtured many modernists, kept Demuth at arm's length, as he had Hartley and F. Holland Day, possibly out of homophobia. (Ironically, Stieglitz married Georgia O'Keeffe, the founding mother of feminist art, who was probably bisexual.) Adding the lingering belief, even among inverts themselves, that their condition was a

neurosis best suppressed, McAlmon created his artist character Ogden (based on Hartley but even more like Demuth), who "gets most of his erotic satisfaction through the eyes."

In the postwar decade, New York's African-American community, swollen by the great northward migration out of rural poverty, was enjoying its golden age as capital of an emergent black culture. From palatial drawing rooms and posh nightclubs to the illegal speakeasies that flourished during the national experiment with alcohol prohibition, the Harlem Renaissance offered a creative magnet and a tolerant oasis. With opportunities denied in the segregated

6.11. James VanDerZee,
Beau of the Ball, 1927
(photograph).

South came aspirations: the New Negro, like the New Woman, would be financially independent, competent, and cultured. Artists and writers basked in the support of a prosperous educated elite, whom the charismatic activist W. E. B. Du Bois dubbed "the talented tenth." In her Sugar Hill mansion, heiress A'Lelia Walker hosted elaborate soirées for her female lovers and a salon open to gay male friends and artists. Gay critic and editor Alain Locke played the impresario role, channeling white patronage into his own community and orchestrating support for writers like Langston Hughes, black America's poet laureate (who hid his sporadic gay affairs even from friends).

Highlights of the social season were costume dances held at cavernous ballrooms like the one immortalized in Duke Ellington's jazz standard "Stompin' at the Savoy." As in Rosa Bonheur's Paris, public gatherings still had to obtain a police permit for guests who appeared in drag, competing for prizes in lavish outfits. One radiantly chic contest queen was posed by James VanDerZee, Harlem's reigning photographer, as the "Beau of the Ball" in 1927 (fig. 6.11). Though the punning title lets us in on the joke, far from caricaturing, VanDerZee glamorizes his sitter just as he did A'Lelia Walker and legions of heterosexuals. Among a people struggling for respectability, the willingness and skill to measure up to bourgeois standards trumped sexual nonconformity. In a striking combination of tolerance and complacency, *Ebony* magazine, the voice of the black middle class, later enthused: "The men who don silks, satins and laces for the yearly masquerades are as style-conscious as the women of a social club planning an annual charity affair or a society dowager selecting a debutante gown for her favorite daughter."

Though gays were integrated into African-American life, Richard Bruce Nugent sorely tested the limits of acceptability. Nugent dabbled in poetry, painting, caricature, and theater, but most enjoyed shocking his more traditional brethren with open promiscuity and sensational images. He helped found and illustrate the short-lived magazine *Fire!* (1926), in which his autobiographical story "Smoke, Lilies, and Jade" told of a black Harlem artist discovering his bisexuality when he falls for a young Hispanic Adonis, whose nude body he describes with near-pornographic fever. Nugent's 1930 drawings for Oscar Wilde's play *Salome* connect with a European homosexual tradition too foreign to black America, and too tinged with camp theatrics, to win much support from a community inspired by Locke's call for racial uplift to disprove the hoary stereotype of oversexed lowlifes.

With black culture briefly in vogue downtown, the persistent racial barricades lowered, and Demuth and Duchamp joined the white tourists flocking to Harlem nightspots. Gertrude Stein's gay friend Carl Van Vechten, a campy white novelist and photographer, served as publicist for the talented tenth, though mainstream attention was a mixed blessing: the queen of Renaissance authors, Zora Neale Hurston, salted gratitude with skepticism by dubbing her white supporters "Negrotarians." Stein collaborated with composer Virgil

Thomson on the opera *Four Saints in Three Acts;* awed by the diction of African-American singers, Thomson insisted on an all-black cast. Swathed in cellophane costumes by Stettheimer and following a scenario invented by Thomson's lover, Maurice Grosser, a realist painter, they scored a triumph. But by the time *Four Saints* debuted in 1934, the Depression had set in, repeal of Prohibition had cost Harlem some of its raunchy cachet, and this early crossbreed of black, white, and gay had begun to wilt.

In these same years, New York was also becoming a showplace for two other art forms, both of which carried heavily gendered baggage. In America as throughout the Westernized world, women challenged the masculine mystique in architecture, the most permanent medium, while some gay men found a lucrative niche for their stereotypically feminine creativity in the ephemeral new arts of the marketplace.

Commercial art penetrated the global visual arena in step with expanding industrial corporations, who commissioned designs for mass-produced consumer products and the visual package of media images in which they continually rewrapped and marketed their wares. Mobilizing graphic design, fashion styling, and photography, advertising has swollen to a flood of images all but drowning out traditional fine arts media. These new fields, which reward artistic flair with access to glamour and tacit tolerance, have attracted legions of "design queens"—wage-earning descendants of the Victorian aesthetes—ever since the German immigrant Joseph C. Leyendecker modeled America's original Arrow Collar Man on his breathtaking Canadian lover, Charles Beach, in 1907. Advertising psychology rests on sex appeal, on awakening the fetishistic desire to own or to buy whose sexual undercurrent sparks the dual meaning of "possession." And who would know better than gay men—whose struggle against society's sexual codes had taught them to read every image as a propagandistic invention—how to fan that spark, to visualize and orchestrate its flaming allure.

No doubt Leyendecker jumped at the Arrow publicist's mandate to create "not simply a man, but a manly man, a handsome man—an ideal American man." In omnipresent ads and covers for the weekly *Saturday Evening Post,* he minted Madison Avenue's prototype of suave masculinity, whose Arrow shirts and collars, plus patent leather shoes and sleek surroundings, embodied a nonchalant yet smoldering charisma that drew thousands of fan letters from girls. Even so, like the idealized flesh of the nudist movement, the eroticized body posed the ticklish problem of homophobia; his solution was to flirt with the phallic glow of upscale glamour yet remain noncommittal. While some of Leyendecker's brilliantined studs are safely accompanied by equally chic women, others are alone together: a mass audience might imagine the warmly lamplit chumminess of two male models taking place in some exclusive men's club, but a blank background permitted gay viewers to project their own brand of domestic bliss. To this day, marketing exploits ambiguity to stimulate the

eyes, the genitals, and the wallets of the most prospective buyers while turning off the fewest.

As gay men colonized commercial art, women, many of them lesbians, were infiltrating the male preserve of architecture. Most successful was California's Julia Morgan, unmarried and fond of tailored suits—ironically best known for San Simeon, her palatial monument to the male ego of publisher William Randolph Hearst. The specialty of interior design, linked to the traditionally female domestic sphere, more readily accepted women (and gay men). New Yorker Elsie de Wolfe is credited with inventing this profession, which was promoted by her sapphic compatriot Ethel Power, editor of *House Beautiful* magazine. Even Romaine Brooks tried her hand at modish interiors in Paris, where the Irishwoman Eileen Gray designed buildings and furniture. Gender and orientation seem not to influence architectural style, since these designers are so diverse. But they can impact on patronage: women like the pair of doctors who ordered a Berkeley house together from Morgan, or the Manhattan socialites who had de Wolfe renovate their Colony Club, understandably sought designers sympathetic to their emerging sisterhood.

THE CRASH: DEPRESSION, FASCISM, AND REACTION

Between the crash of the New York stock exchange in 1929 and the defeat of the Spanish Republican brigades by General Francisco Franco in 1939, gay culture suffered from the twin setbacks to liberal democracy worldwide: economic depression and the political rise of powerful and intrusive governments. In Italy, Germany, and Spain, economic hardship played into the hands of fascists, whose conservative ultranationalism preached state control of everything from industry to the media, art, and sex. Once Adolf Hitler was named German chancellor in 1933, his totalitarian and paranoid regime set out to extinguish a supposed conspiracy of Jews, leftists, and the artistic and erotic avant-garde. Gay bars were padlocked, lesbian magazines shut down, and Magnus Hirschfeld's institute sacked while propaganda photographers recorded Nazi youth gleefully burning its unique library.

The fascists enforced strictly retrograde social roles: their ideal of heroic national virility was the so-called Aryan male sculpted by Arno Breker, while women were to bear babies for war. To whip up the public against dangerously antisocial images, the Nazis staged a mammoth traveling exhibit titled "Degenerate Art"; opening in Munich in 1937, it hung up for ridicule hundreds of modernist works, confiscated from museums, on walls scrawled with inflammatory captions like "Decadence exploited for literary and commercial purposes." Otto Dix's 1923 portrait of the jeweler Karl Kralls, which accurately caught the outspoken gay man's mincing posture, was exposed in this aesthetic

pillory, along with a pair of affectionate 1920s portraits by the expressionist Karl Hofer depicting *Two Male Friends* and *Two Female Friends*.

When cultural propaganda and terrorism didn't suffice to inculcate its jingoistic ideals, the regime dragooned uncounted thousands of gay men into the concentration camps operated with grisly efficiency through the Second World War. Creating history's most macabre visual symbol of homosexuality, the death-camp bureaucracy printed a poster illustrating the inmates' color-coded insignia—a pink triangle on every gay, a yellow Star of David on every Jew—which obsessively ranked each group's priority for the gas chambers that exterminated more than 10 million souls. The pink badge of shame would later be appropriated by the post-Stonewall generation as a badge of honor signifying the fight against all antigay oppression.

Germany's image of the nude male was mirrored across the 1930s political spectrum. Socialist realism, the Soviet Union's official style, glorified brawny workers even as Stalin, turning totalitarian, recriminalized male sex as a decadent vestige of capitalism. Among the democracies, Washington followed Paris in adorning the New Deal bureaucracy with Greek allegories. In 1936 German gay photographer Herbert List caught a pair of males in a French public sculpture with their metaphorical pants down, slyly preempting their official dignity by shooting their bare backsides. But that same year, the forced abdication of England's King Edward VIII to marry the divorced Wallis Simpson, later the Duchess of Windsor, made clear that royal and parliamentary elites were not amused by challenges to their sexual authority. Populist pressure also rose: as moving pictures, amplified by sound in 1927, became a mass art form, moralistic watchdogs in pulpit and press agitated for censorship. Desperate to preserve its audience, Hollywood adopted a self-censoring code of decency in 1930; for a half century, producers banished all but minor and stereotypical gay characters, while enforcing a squeaky-clean offscreen image that kept gay directors and stars in the closet.

Reaction against this renewed conservatism attracted many controversial idealists to socialism. A trio of Cambridge undergraduates signed on as Soviet spies, among them Anthony Blunt, a gifted art historian who passed along secrets from his professional pinnacle as curator of the Royal Collection, for which Queen Elizabeth II knighted him. Blunt's motivations, like his closeted gay life, remain cloaked in confusion and irony: he acted from a romantic desire to revenge the sexual hypocrisy and greed of Britain's rulers, yet the dandy in him sincerely admired the upper crust, and the pragmatic careerist avoided any published whiff of radicalism that might bar his path to Buckingham Palace. His espionage revived the medieval links between sodomy, heresy, and treason so scandalously that after his cover was blown the government waited decades to strip his knighthood, for fear of revealing how diabolically it had been duped.

Left and right came to blows in the Spanish civil war of 1936 to 1939, in

which conservative Catholic forces under Hitler's ally Franco ousted a progressive democracy despite the international volunteers chronicled by Hemingway. Suppressing public eros up to his death in 1975, Franco left little breathing room for gay painters like Gregorio Prieto. The great martyr to his inquisition was Federico García Lorca, Spain's best-loved author since Miguel de Cervantes, whose harsh yet uplifting dramas wept for a spiritually and sexually stultified nation. For his freethinking ideas on sex, politics, and religion the fascists assassinated him, aborting his plans to write more directly about homosexuality; Lorca's executioner reportedly bragged that he "fired two bullets into his ass for being a queer."

Lorca's illustrated verse anthology *Poet in New York* rejoices in the open American society he visited in 1929 to 1930; the section titled "Ode to Walt Whitman" was accompanied by Lorca's own surrealistic photocollage of Whitman's snowy beard swarming with butterflies (a pun on *mariposa*, Spanish slang for a homosexual). Lorca had sketched his fantasies, including erotic sailors, since his student days when he fell in love with painter Salvador Dalí. Their shared obsession with the nude Sebastian, eerily prophetic of Lorca's own fate, resulted in a photograph of Dalí as the martyred saint and a Lorca drawing of the bound sufferer who encapsulated gay men's anguished isolation. Though Dalí would comfort the dying René Crevel, he spurned Lorca and later married, and his paintings and films, while saturated with sexual innuendo, turn their psychic back on his gay youth.

Surrealism struck a chord throughout Spanish America, though muted by imported Mediterranean machismo. One exception, whose example still hovers over Mexican gay artists, was the bisexual Frida Kahlo (1907–54), a flamboyant stalwart of the left married to the equally revolutionary muralist Diego Rivera. But her art is emphatically personal, not political: crippled by childhood polio and a later bus accident, Kahlo endured a grueling succession of operations, miscarriage, and abortion, and her autobiographical sketchbooks and paintings, many of them dreamlike self-portraits, allegorize and exorcise her sufferings. Her self-image as a gritty and passionate survivor took ambiguous forms like symbolic twins or hermaphrodites decked with popular folklore; these mystifying juxtapositions, hinting at harsh psychic truth, led André Breton to hail her work as "a ribbon around a bomb."

Kahlo's visual chronicle occasionally touches on lesbianism, as in *Two Nudes in the Jungle* (color plate 22). Though she was devoted to the swaggering Rivera, they led independent lives spiced by mutual infidelities. We know too little about Kahlo's female liaisons to say what personal experience might be reflected in this idyllic scene of a sapphic couple, one caressing the other's head lying in her lap; but the overscaled jungle foliage, its roots visible like an X-ray, throbs with the life force transmitted in that tender gesture. The pair's stylized faces recall native Aztec and Mayan sculpture, which modernists sought to mine as the Renaissance did antiquity, as the alternative heritage of

a truly national art, free from colonial European models—a polarity suggested by the women's contrasting complexions. In an image more primeval than confessional, Kahlo, herself of mixed ancestry, elevates her love to an archetype of the universal Eden promised by the movement for *Mexicanidad*.

REALISMS IN DEPRESSION AMERICA

Thirties America resounded with leftist and labor agitation for a panoply of social welfare reforms; sympathetic artists devised social realism, which focused on the struggling Everyman. Reginald Marsh's etchings, including *Chop Suey Dancing* of 1929, depicted flapper-clad women and other same-sex couples in a cheap New York nightspot; but as in Mexico the best-known realists, like Marsh and Thomas Hart Benton, were straight, and homosexual reform was not on the radical agenda. Paul Cadmus (b. 1904) was the only realist who made his own gay surroundings a central theme of his career, at considerable cost. Sometimes he waxes lyrical, as in drawings and prints of young men, or the allegorical tribute to his gay literary mentor, E. M. Forster, painted with anachronistic accuracy in the painstaking old-master medium of egg tempera. More often, his images glare at human foibles with a satire that spares homosexuals no less than complacent suburbanites or strikebreaking goons. A contemporary moralist in antique garb, he joins the eye of Hogarth to the technique and muscled poses of Signorelli.

Cadmus's *The Fleet's In!* (color plate 23), one of a trilogy of monumental sailor scenes, depicts New York's cruisy Riverside Park with trademark irreverence and documentary precision. Under the pickle-faced glare of an elderly Mrs. Grundy, raunchy sailors on shore leave consort with floozies while, in the left background, a slick-haired Leyendecker man offers one fellow a cigarette. His plucked eyebrows, rouge, and multiple rings tip off the knowing that he is what was then called a "fairy," trying to make a pickup, as does his red necktie, all signs of costume and style that gay men invented to recognize one another. Though commissioned by the government, when the scene was displayed in Washington, public outcry provoked the assistant secretary of the Navy to yank it off the gallery wall. The controversy guaranteed notoriety; Cadmus later remarked, "I owe the start of my career to the admiral who tried to suppress it." The glass slipper of Stonewall transformed this once outcast Cinderella into the dowager princess of modern gay tradition, still spry and perennially popular.

The picture's bawdy caricature offended the official image of the sailor as a wholesome manly hero, but to the gay audience it pleasingly fleshed out an erotic ideal that mesmerized Cocteau, Demuth, Lorca, and Hartley. Several generations worshipped the fit and footloose adventurer, horny and available with no strings attached, as the ultimate icon of gay male fantasy. Cadmus's al-

tarpieces to this cult idolize the same tight-stretched outfits over firm behinds that stirred the uniform-fetishist Hartley (in a letter to Robert McAlmon from World War II New York) to enthuse queenily over "all the navies in white duck, and the thighs and arses something to tell Mother about—simply wonderful."

Cadmus's genre scenes document gay and mixed milieus at home and abroad, from parties in Greenwich Village, a longtime gay bohemia, to a YMCA locker room. The Y offered single men and travelers of modest means a clean room, wholesome recreation, and moral uplift—plus, unintentionally, another opportunity for nudity and sexual contact. *Fantasia on a Theme by Dr. S.* (1946) lampoons the denizens of Fire Island, the wilderness beach fast becoming a gay hideaway, who include a sunburned lesbian couple, a muscle-bound sailor wanna-be, and a limp-wristed fairy. This canvas personified the island's magic allure as a precious haven where gay New Yorkers could let their hair down. The Whitney Museum, then located in the Village, kept selling out its postcards of the picture: it fell on the eyes of gays, accustomed to cultural crumbs, like aesthetic manna.

Other figurative painters of the 1930s, united by a loose-knit gay circle in the United States and France, ranged from social realists to the "romantic realists," whose psychological mysteries verged on surrealism. Twinkling in this constellation of minor stars were Cadmus's close friend Jared French and his wife, Margaret; Americans George Tooker and Bernard Perlin; the Russian émigré artist and theater designer Pavel Tchelitchew, who painted his American lover Charles Henri Ford, an early gay novelist and filmmaker; and the Manila-born Eurasian Alfonso Ossorio, whose early confessional images depicted male friends and lovers before he turned to abstraction.

A crucial link in this chain of connections was Lincoln Kirstein: the well-connected heir to a Boston fortune, he assumed Diaghilev's mantle as patron and impresario, offering or wangling commissions for creative friends. He fell for Cadmus, who didn't reciprocate, then married Paul's sister as a "beard" while continuing the gay affairs he admitted after her death. A founder of the New York City Ballet, Kirstein imported the premier modern choreographer George Balanchine—who was voraciously straight, unlike his coworkers. Theater folklore maintains that Tchelitchew's masterpiece of ectoplasmic children at play, *Hide and Seek* (1942), includes between the central girl's legs a "portrait" of dancer Nicholas Magallanes's penis.

Although George Platt Lynes (1907–55) studied photography with Man Ray, he postponed art for a youthful career as an international playboy: Cadmus's triple portrait of curator Monroe Wheeler, his lover Glenway Westcott, and Lynes casts Glenway as odd man out of an awkward love triangle. Later Lynes became a trendsetting professional whose severely elegant, theatrically lighted, and costumed bodies made him the darling of upscale fashion magazines like *Vogue* and *Harper's Bazaar*. His surreal scenarios evoke a voyeuristic

aura of peeping at half-hidden fantasies, which Kirstein viewed as the perfect qualification for minting the image of his dance company. Figure 6.12 captures two male stars, Magallanes and Francisco Moncion, in a breathtakingly sensuous caress from Balanchine's *Orpheus*. Sensuous to patron, dancer, and artist; but the ancient demigod's lyre offers an obligatory fig leaf for same-sex nakedness, reassuring their mainstream audience that this is art, not life.

To ease the tension such limits imposed on gay expression, Lynes kept his mainstream public in the dark about his more explicit private creations. Sometimes borrowing his daytime studio setups after hours, he posed nude studies and fanciful tableaux of Greek myth that broke fresh ground for male imagery; after World War II, he contributed some to the Swiss gay magazine *Der Kreis* under a pseudonym. Attempts to reach an international audience echoed an urge to link up across time: one portrait of Lynes seated beneath a Hartley painting and perusing a book on Michelangelo presents a layer cake of gay cultural history. Terminally ill and panicked over his posthumous reputation, Lynes destroyed many erotic negatives but sent the prints for safekeeping with his friend Alfred Kinsey.

Lynes's public forte, fashion photography, displays gay men's prominence in the commercial arts, a "feminine" world of glitter and style where their aesthetic and erotic sensibilities could polish the image of any product. His gay colleagues and friends included the Russian-American George Hoyningen-

6.12. George Platt Lynes, **Nicholas Magallanes and Francisco Moncion in "Orpheus,"** 1950 (photograph).

Huene and the Englishman Cecil Beaton, a camp gentleman and unfailingly flattering society photographer. When the royal family needed a makeover after the Windsor divorce, his lens turned even sweetly plump Queen Elizabeth (now the Queen Mother) into a gauzy backlighted "movie star."

WORLD WAR II AND ITS AFTERMATH

After staggering over the epic watershed of the Second World War, the twentieth century found its global cultural streams flowing in different directions. Among the dwindling corps of veterans who look back on it as "the last good war," some might be surprised to know that one of its aftershocks was an energizing jolt to gay and lesbian community. The United States alone mobilized 20 million men and women, whose service exposed them to others of the same sex and tastes, often for the first time and away from the eye of village watchdogs. The great ports through which troops shipped out and returned from Asia and Europe—San Francisco, Los Angeles, and New York—became magnets for gays, many of whom never went home again. From London to Australia's Brisbane, the military outposts of the British Empire spawned the same exhilarating unfamiliarity spiced by desperate camaraderie, which encouraged same-sex intimacy. The army was officially homophobic, but boys will be boys, especially when there are no women around and *someone* has to play the hulaskirted leading lady for the Christmas skit in Gauguin's sunny South Pacific.

Like their military sisters, women in civilian life tasted an exceptional independence as, left alone at home and eager for patriotic service, they filled in for male draftees in offices and war plants. Their "can do" patron saint was Rosie the Riveter, created by the popular illustrator Norman Rockwell as a muscled young woman in overalls, proudly clutching her phallic equipment. Her cult was a godsend to lesbians, who jumped at the chance to wear men's clothes and do men's work as an escape hatch from conventional marriage. In a suitable visual pun, Rockwell based Rosie's pose on a Sistine Chapel prophet by Michelangelo—the past master at women inspired by men.

To report and later to enshrine the titanic struggle, the Allied nations commissioned war artists, who added to the staple gladiators of official art sympathetic vignettes of ordinary grunts bonding in combat, toil, and loss. In Australia's capital of Canberra, painters such as William Dobell produced documentary scenes for the armed forces memorial. Elsewhere known as a scathing social satirist, Dobell, who was gay, here indulged his fondness for outdoorsy male bonhomie in a cartoonlike social realist style. Fittingly for a national shrine, he refracted patriotic comradeship through the Whitmanic lens carved by Tom Roberts and John Brereton, and sharpened by the gay London-born Frederick Reynolds, an admirer of Henry Scott Tuke who immigrated to Australia at the turn of the century.

Dobell's mate in the 1940s Sydney School and fellow pioneer of openly gay sensibility was Donald Friend, a master draftsman whose military assignments served him too as an excuse to celebrate rugged if expressionistic virility. After the war, he turned his adoration for handsome roughs toward sculpture student Colin Brown: he confessed to his diary, "My whole life is Colin," and paid thickly textured tribute in a series of portrait sketches and paintings (Sydney, Art Gallery). The mercurial artist needed love, or at least romantic infatuation, to inspire him, and ricocheted from one ill-starred affair to the next in London, Nigeria, Ceylon, and Bali—where he set up a lavish open house served by native houseboys and became an authority on Balinese art. Though he bristled at being labeled "the Gauguin of Australia," the shoe fit: an early builder of multicultural bridges both erotic and artistic, Friend learned African bronze casting and melded his European heritage with Asian and Pacific motifs. He also published handwritten illuminated manuscripts, including the bisexual Restoration play *The Farce of Sodom*, by the Earl of Rochester, a maternal ancestor.

Far more drastically than the First World War, the second holocaust redrew political and cultural maps. With Europe in ruins, the hub of world art shifted to the United States, mainly New York. Triumphant Yanks were everywhere, occupying Germany and Japan and overrunning local cultures with imported Americana; there could be no turning back from the common destiny of global encounters and conflicts that war had thrust forward. And over all this uncertainty hung the mushroom cloud of Hiroshima: the atomic bomb, symbolizing the possibility of total human destruction, sent a haunting shiver of doom down humanity's collective spine until the Cold War between the West and its Soviet rivals collapsed in the late 1980s.

The truncated life and career of Japan's most world-renowned novelist, Yukio Mishima (1925–70), represents the flip side of the intercultural coin minted by Donald Friend. Mishima too fused competing cultural ideals: the revival of interest in Japan's homosexual history (sparked by Jun'ichi Iwata and Kumagusu Minakata in the 1930s), all but forgotten in the Meiji era's rush to Westernize, and the flood of foreign images under postwar occupation. Though married, this hypermasculine bodybuilder, who praised muscle over mind, grew ever more misogynistic; a chauvinistic critic of defeatism, he nostalgically tried to resurrect the samurai ethic of male eros and military sacrifice as a model for renewed national glory. After a failed paramilitary attempt to urge Japan to rearm, he committed ritual hara-kiri and was then beheaded by his lover.

In Mishima's early autobiographical masterpiece, *Confessions of a Mask* (1949), the young gay hero's sexual awakening is aroused by a sadomasochistic image: Guido Reni's painting of Saint Sebastian writhing in agony brings on his first orgasm. This erotic worship, melding Western spirituality with samurai passion, pleads for lifting the stigma from homosexuality—while, as the

book title suggests, shedding the masks of passive heterosexual conformity that postwar Japan forced everyone to wear, at the cost of both individual fulfillment and collective power. Narcissistic and exhibitionistic, Mishima flirted all his life with martyrdom. He had himself photographed nude by Eikoh Hosoe (fig. 6.13) for a picture book titled *Barakei*, or "Ordeal by Roses"—where he arches in ecstasy under the thorny bloom's caress, his gaze thrown back upon a vaguely Grecian centaur—and as a bound Sebastian pierced by arrows. Though his dramatic suicide was an impotent protest, no doubt Mishima saw it like the narrator of *Confessions*, who fantasized about Reni's saint, "In no way was his a pitiable fate. Rather it was proud and tragic, a fate that might even be called shining"—the inevitable apotheosis of Mishima's equation between virility, homosexuality, ecstasy, pain, and death. Quixotic and unrepeatable, Mishima was a harbinger of ever-increasing cultural exchange.

6.13. Eikoh Hosoe, **Portrait of Yukio Mishima** (photograph from **Barakei** ["Ordeal by Roses"], no. 38, 1961).

THE FIFTIES: PARANOIA AND PLENTY

Postwar American culture was an unstable alloy of abundance and anxiety. Complacent in triumph, the democratic industrial world saw its life as ideal, and yearned to roll back the social clock; yet that nostalgia was also fed by the gnawing fear of apocalypse. Women were urged to return to "normalcy," which meant nurturing consumer capitalism's cozy image of the nuclear family. Most Rosies were eager to trade their rivet guns for the appliances of mass-produced suburbia, spawned by the automobile and nursed on commercial television, which soon overflowed movies as the universal fount of images. TV avoided sex and politics in favor of idyllic fantasies like the polemically named *Father Knows Best*; but the Cold War, belying that bland optimism, fueled

conservative nationalists who feared a communist behind every door—especially the closet. Conjuring the ancient specter of the homosexual as traitor, blackmailed into betraying national security, conservatives grew hysterically intolerant of dissent. In 1950 Senator Joseph McCarthy accused the Truman administration of "harboring sex perverts in government," setting off a witch-hunt against a supposed global left-gay conspiracy nicknamed the Homintern (with ironic hypocrisy, McCarthy's ally J. Edgar Hoover, the federal police chief, was himself a closet case).

This zealously uniform culture papered over sexual diversity, allowing only the closeted self-parody of the gaudy pianist Liberace or the forbidding shock of the Hollywood version of Oscar Wilde's *Picture of Dorian Gray* (1944). In an era of censorship even for steamy heterosexual novels, the film is predictably silent about Dorian's gay side, though for knowing viewers surrealist painter Ivan Albright's prop "portrait"—which putrefies into a goggle-eyed madman perilously close to the horror comics then popular with adolescent boys—is a camp icon. The campaign to erase homosexuality from art and history whitewashed even the most glaring holdout, Michelangelo: in his best-selling biographical novel *The Agony and the Ecstasy* (1961), Irving Stone brushed over the artist's passion for Tommaso de' Cavalieri by inventing a preposterous thwarted romance with a Medici princess.

The sole art form that dealt frankly with homosexuality was the mass-market paperback book, in the form of "pulp novels." Introduced in the early 1950s, these were named for the low-grade paper that kept their cost under a dollar, and were considered "cheap" in both senses of the word: by spreading the pool of literature to a wider public, they seemed to lower the cultural water table. Many were, in fact, unabashedly lurid and sensational; since voyeuristic straight men were the largest readership, lesbian tales, most written by men, far outsold gay male titles. To catch the eye at a drugstore newsstand, many featured full-color cover art, like the tense confrontation of stripping butch and pouting femme on Lilyan Brock's *Queer Patterns* (color plate 24).

These covers, like the plots inside, spotlighted tormented passion, fearful pursuit, or violent retribution in a nocturnal demimonde straight out of the era's bleak crime fiction and film noir, and were embellished with steamy banners like "Their affair was doubly forbidden—but they couldn't give it up!" These over-the-top, wildly inaccurate "tough broads" usually ended badly, by suicide, alcoholic oblivion, or abandonment, a sop to mainstream audiences that framed titillating soap opera as morality tale: Brock's variation ends with the blonde attending the murdered brunette's funeral. Gays, still hungry for self-images even if they were always cast as doomed outlaws, eventually bought a few female authors enough success to insist on more sympathetic plots. Ann Bannon, a cult favorite and lifeline to isolated lesbians, recalled of her heroines, "They loved hard and lost hard. But they won a few. And they didn't die."

The reigning avant-garde of 1950s high art, known as the New York School, held court at Greenwich Village bars like the Cedar Tavern. Seminal ideas spilled from alcohol-fueled exchanges, both aesthetic and erotic, among artists, critics, and writers—several gay or lesbian. Their poet laureate was Frank O'Hara, archly open about urban gay life in his verses, also an art critic and Museum of Modern Art curator. As commercial galleries became crucial incubators of new talent, key homosexuals included John Myers, a father hen who made the Tibor de Nagy Gallery a welcoming nest, and lesbian dealer Betty Parsons. Though the art crowd superficially tolerated nonconformity, their overriding obsession with machismo, with proving that art wasn't "sissy," left little room for real understanding; Parsons defended her gay clients against discrimination from other painters.

In a conservative climate no longer receptive to images dealing with social issues, these painters turned inward. The triumph of abstract art set back gay expression by rigorously excluding any narrative subject, or fragmenting found objects to deny their meanings. Art was to be about art, nothing else, and would lay bare mythic, universal human feelings through the sheer evocative impact of form and color. For gay artists like Bradley Walker Tomlin and Theodoros Stamos, who already felt they had to mask their desires, abstraction made an aesthetic virtue of a social necessity; formalist photographers Edward Weston and Minor White excluded their male portraits from publication. Though a few took coded stabs at gay sensibility, like Tomlin's 1950 *Number 9: In Praise of Gertrude Stein*, their full story cannot yet be told, since several living legends remain closeted.

"Color field" painters aimed to induce an optical or spiritual trance with mural-size expanses of saturated hues, while abstract expressionists carried on the surrealist liberation of unconscious feelings by spontaneous gestures: the violent slashes of Franz Kline and Robert Motherwell were marks of their heroic quest. Abstract expressionists talked a good game about expressing the inner self, but the "selves" of painters like Jackson Pollock, pressured toward conventional masculinity, often seemed to parody cowboy movies. Pollock drank like a fish and drove like a maniac—compensating, perhaps, for his sporadic gay temptations—and died crashing into a tree. His technique of action painting, dripping energetic loops and splatters straight from the artist's hand, camouflaged more than it revealed: unless viewers knew—and the married Pollock wasn't talking—they couldn't make out just what his interior odyssey was discovering.

A slightly younger cluster, forerunners of pop art, reacted against pure abstraction by sneaking back figurative elements, but deliberately chose banal and seemingly random images from the mass media and the trash heap, which they collaged with playful irony. Eclectic recycling permitted what psychiatrists call "approach avoidance": artists could make daring allusions yet safely deny any personal investment in those quotations. O'Hara's intimate friend

6.14. Jasper Johns, **Target with Plaster Casts,** 1955, encaustic, collage, assemblage; 51″ x 44″ (129 x 111cm.). © Jasper Johns/licensed by VAGA, New York, NY.

and collaborator Larry Rivers sardonically titled his knockoff of David's portrait of Napoleon *The Greatest Homosexual.* Unlike his defensively macho cohorts, Rivers, whose raunchier work exploited heterosexual shock value, was comfortable experimenting with bisexuality in what he called his "queer period"; the picture's jokingly false title spoke about gayness, but only through nonsensical "bad boy" innuendo. Yet he could be touchingly sincere, while still indirect: *The Studio* images O'Hara as his male muse.

Revelation and disguise mixed most uneasily in Robert Rauschenberg and Jasper Johns, who shared life in a New York studio from 1954 to 1960, starring with another male couple, composer John Cage and dancer Merce Cunningham, as the four horsemen of the art apocalypse. The quartet collaborated across media, promoting shared assumptions derived from Duchamp: anything can be art if an artist says it is, and the creative process should play down

subjectivity in favor of the whimsical impersonality of chance. Johns (b. 1930) seized on mundane icons like the American flag to create waxy canvases and assemblages that defined a painting as an object, not a representation of some other object or of the emotions that object might arouse. He made self-concealment an aesthetic cornerstone, declaring "I don't want my work to be an exposure of my feelings," yet it teems with enigmatic puns, coded references to eros among his friends and lovers.

Across the top of *Target with Plaster Casts* of 1955 (fig. 6.14), tiny boxes enshrine disconnected body parts. Because a target is a geometric shape, most critics praised the assemblage in formal terms. But the casts are from a male body, including a penis, and viewing these snippets through secretive orifices—each equipped with a wooden flap recalling a door, perhaps even a closet—echoes the glory-hole gaze of frustrated gay men, suffering like Sebastian as the target of Cupid's arrows yet condemned to mere glimpses of erotic contact. Similar hints are dropped in *Painting with Two Balls*—whose paired "testicles" peek out from a slit in the scumbled canvas, shyly breaking the officially neutered façade of modernist art—and in portraits of the universally loved O'Hara.

In the same year as *Target*, Rauschenberg (b. 1925) produced *Bed*, a messy "combine" of found objects that transmuted into art the very sheets and folk-style quilt on which he and Johns had been sleeping; these two works now seem like a pair of bookends testifying to the couple's love and to the limits on expressing it. His sculpture *A Pail for Ganymede* (fig. 6.15), at first glance a Duchampian sheet-metal-and-crank contraption, is also a sly art-historical in-joke, referring to the painting where Rembrandt reduced the Greek ephebe to a urinating baby. The title is both a smokescreen and a clue, deflecting suspicions about the artist's own meaning onto an old master while signaling to those with a special interest in the now-obscure myth.

Similar quotations pepper his drawings, collages, and silkscreen prints: the plethora of images lifted from journalism, classic art, and physique magazines embraces towel-draped athletes, suggestive headlines, and a Leonardesque androgyne published by Pater. He edged closest to confession in a 1960 series illustrating Dante's *Inferno*: on the drawing for Canto 14, where sodomites run barefoot over burning sand, he traced his own foot. On rare occasions, he has been more forthcoming than Johns about their affair, recalling in a bemused 1990 interview, "It was sort of new to the art world that the two most well-known, up-and-coming studs were affectionately involved." But neither could be explicit then, and old habits die hard: when lesbian critic Jill Johnston's 1996 psychobiography of Johns flatly called him Rauschenberg's lover (after painter Cy Twombly), Johns refused to let his work appear in the book.

6.15. Robert Rauschenberg, **A Pail for Ganymede,** 1959, construction; 20" x 6" x 5". © Robert Rauschenberg / Licensed by VAGA, New York, NY.

European reins on gay expression were looser, if only slightly. The most daring spokesperson was the French author Jean Genet, whose novel *Querelle of Brest*, illustrated by Jean Cocteau in 1947, and film *Chant d'Amour* ("Love Song," 1953) worshipped the familiar icons of sailors and prisoners. A petty thief before finding his literary voice, Genet was proud of his renegade politics and set his scenes in the seamy underworld of film noir and pulp novels. A group of artists who wanted to treat gay themes but stay out of jail emerged in Soho, London's counterpart to Greenwich Village; Irish-born Francis Bacon (1909–92) was the doyen of this bohemia, whose habitués were chronically hung over after carousing with young drifters. Bacon made his reputation for expressionistic brutality with signature studies of howling popes and grappling bodies deformed, amputated, or flayed like slabs of meat. His anguished sufferers seemed to release the postwar existential scream against nuclear despair; their universal theme of all-too-human violence soon established him as an old master for the modern age.

Like many of Bacon's nudes, *Two Men on a Bed* of 1953 (fig. 6.16) was adapted from scientific studies of figures in motion by photographer Eadweard Muybridge, also a source for Thomas Eakins. Shifting their context from arena to bedroom, Bacon transformed a pair of wrestlers into lovers—though their coupling is more savage than tender, the grimace of bared teeth suggesting a sadomasochistic encounter trapped in the symbolic bars of a wiry cage. Bacon made no secret of his love life, but like Johns and Rauschenberg he resisted biographers, relying on the historical pedigree of his sources to deflect attention from his subversive alterations—even in later nudes where the matte expanses of high-key background are broken by Pollock-like white splatters that suggest ejaculation over barely concealed masturbatory fantasy. The strategy worked: in 1975 he became one of the handful of living artists ever awarded a solo exhibit at New York's Metropolitan Museum. While the artist flirted with autobiography, the critics did not. Bacon commemorated the death of his lover, George Dyer, from a drug and alcohol overdose in *Triptych May–June 1973*, whose horrific panels depict a naked ghoul vomiting in the sink and dying on the toilet; the Met's wall label coyly identified Dyer only as a "close friend and model."

At home, Bacon had to navigate a social glacier as chilling as New York's: McCarthyite homosexual prosecutions hit Britain from 1950 to 1954. But the strikingly different upshot of this government scandal proved a landmark in the evolution of public opinion in the English-speaking world. A parliamentary commission produced the 1957 Wolfenden Report, which declared consensual homosexuality a victimless crime. Though it took ten years to repeal the sodomy law, this recommendation marked the first thaw of a liberalization that warmed throughout the decade, a prelude to Stonewall that at first opened more cracks in Europe than in North America.

6.16. (opposite) Francis Bacon, **Two Men on a Bed,** 1953 (oil).

ALTERNATIVE VOICES: BEATS, HOMOPHILES, AND POPULAR CULTURE

In one of his lyrical poems Tennessee Williams, the reigning but closeted queen of postwar American playwrights, eloquently pinpointed the hunger for images of self and community among those denied cultural recognition of their passions—and why authorities sanitize such potentially subversive signposts. "The Dangerous Painters" imagines a museum lined with pictures whose subjects, though left unspoken, are able to evoke, in his coded satyr metaphor, "the goatlike cry of 'Brother!' " which "is worse than the shouting of 'Fire!', contains more danger. For centuries now it has been struck out of our language." Williams's own epiphany of artistic brotherhood is revealed in his ecstatic ode to Sodoma's *Saint Sebastian* (fig. 3.10), redolent of fantasies by Wilde and Mishima. Unfortunately, this self-loathing alcoholic was born too soon to escape the oppression he envisioned so acutely; the specter of forbidden desire haunts his plays, painful mirrors of his life. But his cry in the desert of sexual uniformity was not alone: several infant voices, including a reemergent gay and lesbian community, were piercing the conspiracy of silence in science, journalism, literature, and art.

Science boosted sex with penicillin—which reduced venereal disease to a treatable nuisance—and with sexology, synonymous in the public mind with Alfred Kinsey, founder of the Institute for Sex Research that bears his name. The discoveries of this tireless and nonjudgmental researcher, drawn from huge samples, stirred a whirlwind of controversy. His two tomes, *Sexual Behavior in the Human Male* (1948) followed by a female counterpart, replaced three fixed orientations with a seven-point continuum from exclusively homosexual to all heterosexual, and dropped the bombshell statistic that, whatever they might call themselves, 37 percent of American men had some gay experience, and 19 percent of women. Kinsey hid his own bisexuality, lest his work be dismissed as special pleading for the obvious conclusion that, if homosexuality was so common, it wasn't "unnatural." Sensitive to art as well as science, he was an inveterate collector of visual erotica, ancient and modern (including prints by George Platt Lynes); his worldwide trove, now in the institute's Indiana archive, remains an untapped reservoir of "dangerous painters."

Social taboos slowly toppled as court cases carved out greater freedom for sexual matters, from pornography to abortion and contraception. *Playboy* magazine's ideal—the unattached bachelor with upscale tastes in sex as in cars or wine—fostered a consumer attitude toward sex, as a pleasure to be enjoyed outside marital roles; though its nude centerfold aimed at straights, its swinging philosophy encouraged erotic experiments. Once sex became a print topic, gays elbowed into the conversation: Gore Vidal's *The City and the Pillar* (1948), describing chic Hollywood and New York parties of gay painters and musicians, drew vitriolic criticism, but historical novelists like Marguerite

Yourcenar and Mary Renault reached an avid gay audience with heavy-breathing tales set safely in ancient Greece or Rome.

One avant-garde coterie waded more deeply into gay waters: the Beats, who coalesced near New York's Columbia University around gay poet Allen Ginsberg and bisexual novelist William Burroughs. While the masses clamored for suburbia's promised land, the Beats were lionized by an alienated minority who saw in the vacuous boondocks not escape but exile. Recalling "the psychic hunger of my generation," Joyce Johnson, companion of novelist Jack Kerouac, explained that by the late 1940s "thousands were waiting for a prophet to liberate them from the cautious middle-class lives they had been reared to inherit." The Beats' howl of protest against a "square" mainstream pricked up the ears of gays and lesbians and amplified their feeling that, in an era of stultifying conformity, it was a privilege to be branded an outlaw.

Cynical yet romantic, these "hip" and "cool" dropouts avoided surrender to convention via restless adventure (typified by Kerouac's picaresque *On the Road*) and spontaneous creativity featuring much feverish writing on drugs or drink. They took any path to uninhibited expression, to "letting it all hang out"—including free love of all stripes, which led to innumerable romantic triangles, mental wards, and jail cells. Ginsberg chronicled the rebellion in outrageously confessional poetry like "Please Master Fuck Me Now Please"; visual art played a supporting role. Ginsberg fell in love with his eventual companion Peter Orlovsky upon glimpsing a painting of Orlovsky by a mutual friend, and took constant snapshots as the group roamed a sprawling circuit from New York to San Francisco, Paris, Mexico, and Tangiers (a notorious home-away-from-home for gay artists like Tennessee Williams and Maurice Grosser, who painted portraits of native men; Frenchman Jean Genet; and Britons Cecil Beaton and Francis Bacon). Though the Beats splintered by 1960, the mass media caricatured their disaffection into a diluted model of bohemia that reverberated through both jazzy urban "beatniks" and rural countercultural hippies for two decades.

San Francisco's Beat magnets like the City Lights bookstore overlapped gay centers in North Beach. The dean of Bay Area poets, Robert Duncan, preached the Beat gospel of mysticism and sexual freedom, but differed in putting down deep domestic roots with the artist known as Jess (Collins). Together the duo explored the overlapping of words, images, and gay life: Jess painted Duncan's portrait, which they then photographed with both men beside it (since Duncan died, Jess has moved on to painstaking collages of lush, partly erotic fantasy). North Beach relished fixtures like "The Widow Norton," a popular drag performer and founder of the Imperial Court of North America, whose eye-popping balls are now a fixture on the national gay social circuit. Under Norton's offstage moniker, José Sarria, he campaigned for city supervisor in 1961, the first openly gay candidate for public office.

While Sarria's nerve was fortified by San Francisco's unique density of gays

and lesbians, California was but the first chapter in a long-running saga: the re-birth of gay community organizing. Across Europe and North America, the in-ternational network woven by Magnus Hirschfeld and shredded by fascism began to reknit into the banner of "homophile" activism. Harry Hay started America's first ongoing men's group, the Mattachine Society, in Los Angeles in 1950; it soon spread to other cities, as did its nationwide female counterpart, Daughters of Bilitis, founded five years later in the Bay Area. Seizing on the mass media as a key weapon against hostility and silence, many organizations published monthly magazines. These began modestly, bound by restrictions on production and distribution: the first lesbian newsletter, Los Angeles' short-lived *Vice Versa* (1947), was put out by the pseudonymous Lisa Ben in carbon copies laboriously typed by hand. But their trickle swelled to the tide of today's gay press, delivering to the socially and culturally isolated a vision of themselves more accurate and profound than outsiders could or would pro-vide.

Many periodicals covered the arts and cultural history alongside current events: the Daughters of Bilitis house organ *The Ladder* (1956 to 1972), a pio-neering arena for lesbian writing, solicited "theoretical and critical appraisals of the visual arts." And most were illustrated with drawings, snapshots, and car-toons aimed at creating a positive gay iconography—though postal censor-ship and concern for a "respectable" public image kept them more suggestive than explicit. ONE, Inc., founded in Los Angeles as a latter-day Hirschfeld In-stitute with a library, archive, and study program, debuted America's first gay male journal, *ONE* magazine, in 1953; its landmark 1958 lawsuit against cen-sorship opened the mails to explicitly gay materials.

Stateside voices had contact with simpatico cousins overseas as American expatriates flowed back to Europe and Africa: Paul Cadmus's *Bar Italia* of 1955 lampoons four screaming queens, including one African-American, visiting a Roman café. Europe's first postwar gay group formed in the Netherlands, to foster political action in a wholesome social environment; still known as the Center for Culture and Recreation (COC), it published the journal *Vriendschap* from 1948, soon joined by Germany's *Der Weg* (1952) and the French *Arcadie* (1953), whose membership also held protest meetings against cultural silence. The Swiss *Der Kreis* focused more internationally, printing work by Lynes and Cadmus.

This coalescing community created a mass popular audience for "hot" male images. While gay and lesbian editors rehashed the old debate whether activist journals should dilute politics with pleasure, rival producers filled the demand for nudity and erotica through the commercial, if initially backstreet marketplace. Physique magazines, centered in Los Angeles, were the fuse for this visual explosion. Under cover of the venerable physical culture movement, monthlies like *Tomorrow's Man* and *Adonis* printed reams of body-builders and sportsmen in the scantiest of G-strings that would pass censor-

ship; Bob Mizer, publisher of the classic *Physique Pictorial*, set up the Athletic Model Guild in 1945 to connect would-be poster-boys with artists and photographers. Magazines also commissioned narrative illustration, which aimed at "fine art" though it mostly hit kitsch. Subscribers lionized George Quaintance, whose paintings ransacked history—from Mexican ranchers to pre-Columbian Incas and the usual Greeks—for soft-core pretexts to display nearly nude men wrestling or relaxing in settings strikingly parallel to novels by Renault and Yourcenar.

More explicit imagery wasn't far behind, but until pornography laws relented, erotica had to be homemade. A New York interior designer by day, Neel Bate (1917–89) turned into the underground artist "Blade" in his off hours, illustrating his own poems and stories full of all-American fraternity boys, sailors, and truckers; his magnum opus was a multipanel tale, *The Barn*, "published" in 1948. Like a frame from a comic book, figure 6.17 sketches one

6.17. Blade (Neel Bate), Scene from **The Barn**, 1948 (ink drawing).

moment in this miniseries as a motorcyclist, offered shelter in a farmboy's barn, takes advantage of their rain-soaked intimacy to initiate the eager innocent into oral sex. The graphic yet artlessly tender image of their literal roll in the hay is matched by dialogue whose corn-fed charm disarms its raunchiness. Tall biker breathlessly urges boy: "Run your tongue on down, kid, yeah. . . . Sure you never ate a guy's DICK before? You take to it like a duck to water, Mmmm. . . ." Bedazzled kid replies: "You know better 'n me! Am I doing it . . . SUCK-ING it all right?"

Distribution was crude and secretive: Bate's friend George Platt Lynes photographed each page and made a dozen sets of prints, which they sold "under the counter" through a gay bartender. The fate of their joint venture reveals that paranoia was all too justified: the vice squad raided the bartender's apartment and confiscated all the copies; Lynes's negatives escaped, but Bate was too intimidated to reprint them. Ironically, the men in blue launched the purloined *Barn* on

its legendary lavender odyssey: pirated copies turned up for decades as far off as the Philippines. Though powerless to profit from this wholesale plagiarism, Bate joined many of his contemporaries in recalling the era fondly. While conceding that post-Stonewall openness was well worth the tradeoff, he rued the lost sense of an underground fraternity: "Through being clandestine, things were a lot more fun—you felt more 'in.'"

The world champion trendsetter in gay erotica was Tom of Finland (Touko Laaksonen, 1920–92). He actually was Finnish and was first aroused to pencil his trademark hard-muscled, lanky, effortlessly randy studs by the German soldiers who occupied his homeland in World War II. Mushrooming in popularity after his first U.S. publication in 1957, he graduated from physique magazines to his own books and drawings and a Los Angeles image factory,

6.18. Tom of Finland, **Sauna-Bar.** ca. 1966 (drawing).

carried on after his death by the Tom of Finland Foundation. With unabashed hedonism, he obsessed over a narrow range of types with special gay appeal: cops, cowboys, and leatherclad bikers like the officially straight screen fantasy James Dean (fig. 6.18). These meticulously drawn and lovingly stippled hunks, always smooth-skinned and impossibly endowed, combine cocksure erotic magnetism with an innocent, even romantic joy in each other's company, whether in a sauna or a barracks; their fetishistic trappings crystallized the "clone" fashions that identified Euro-American gay urbanites into the 1980s.

Alternative sexuality also surfaced in "underground" cinema as early as 1947, when Kenneth Anger spent a weekend using pilfered navy film stock to record his adolescent fantasy of being gang-raped by that standard macho archetype, the sailor. While praised by Cocteau, *Fireworks* was purposefully trashy: following photography, a popular technology was now in the hands of amateurs, who could turn out home movies on a shoestring for "art house" audiences. By focusing on offbeat subcultures, as in Anger's 1963 *Scorpio Rising*, which fetishized the leather and denim rituals of the Hell's Angels motorcycle club, this anarchic genre—popularized by '60s enfant terrible Andy Warhol—challenged the tunnel vision of high art and commercial art alike.

THE SIXTIES: TURMOIL AND TUMESCENCE

"The Sixties" still stands for an earnest yet exuberant assault on conventional pieties and prejudices, and almost everyone who lived through that tumultuous decade felt obligated to take sides in its raging culture wars. Gay troops surged forward, reinforced by parallel battalions of social activists in a ragged but noisy front for individual and group liberation, equality, and tolerance of diversity. Martin Luther King Jr.'s 1963 March on Washington demanding African-American civil rights set the pace, alongside reborn feminists, Vietnam War protesters, and countercultural hippies, their mantra of free love accompanied by the contraceptive pill—which, like penicillin, made pleasure less risky. Reflecting this contentious pluralism, the arts served up a smorgasbord of both impersonal late-formalist abstraction—which held little appeal to gay tastes—and the humorous dishes of "happenings" and pop art, more nourishing to anarchic appetites. Gay sensibilities infiltrated British and American pop, which used Johns's and Rauschenberg's Duchampian recycling either to celebrate or subvert modern mass culture.

Thanks to the Wolfenden Report's decorseting of England in the "mod" Sixties, the British painter, photographer, and stage designer David Hockney (b. 1937), a generation younger than Francis Bacon, could be recognized as a gold-medal prodigy despite using his student work as a tool for self-discovery—the first Western artist to "come out" so openly, early, and contin-

uously, and with such a cornucopia of literary and visual models already in his curriculum. Literature, including theater, has often inspired Hockney; painted quotations allow him to avoid mere illustration yet insert deeply personal narrative messages into his pictures, which provide a visual diary of his individual gay odyssey.

Hockney's early works show him sampling a menu of identities and attitudes, like any youth exploring adulthood; his references often invoke Whitman, the patron saint of male camaraderie. The playfully rude *Adhesiveness* of 1960, where two abstracted cutouts lock in mutual fellatio, illustrates the bard's term for sexual attraction and identifies the figures by the same numerical code that Whitman devised for recording tricks in his diary (1 = A, 2 = B, and so on) as "W.W." (Walt himself) and the willing acolyte "D.H." Sometimes he is flamboyant (*Going to Be a Queen for Tonight*), sometimes lyrical, as in the 1961 *We Two Boys Together Clinging* (color plate 25). Titled with a line from Whitman's romantic "Calamus" series, it shows just that: scruffy cartoons of Hockney and his then-beloved (4.2 or D.B., for "Doll Boy"), hugging as the shamanic verse wraps them in a mantle of cultural blessing.

Ever footloose, Hockney immigrated to Southern California in 1963, still charting the course of his own experience as he joined the Hollywood "good life." Grandly scaled portraits of his wealthy patrons and prominent artist friends, lounging in their backyard pools and airy sunlit interiors, carry on Romaine Brooks's tradition of celebrating a cultured elite. He still drew more personal gay themes, but with maturity these shifted from defensive declarations to domestic vignettes; images like one man soaping the back of his partner were revolutionary for what gay art historian Kenneth Silver called their "sweet and happy ordinariness." In a pop raid across social and media boundaries, he borrowed one male pose from the locally published *Physique Pictorial* magazine.

Hockney admired Bacon, but his art has proved a crowd-pleaser for diametrically opposite qualities: nonchalant hedonism, wit, and an accessible, at times toylike style splashed with luscious color. He gives us an agreeable world, decorative but seldom passionate—permeated by a persistent flatness of space, tone, and emotions. In one double portrait, the art critic and curator Henry Geldzahler and his male companion are in the same room but ignore each other; in another, Christopher Isherwood, who settled in California after Berlin, and his lover artist Don Bachardy keep the same curiously bland distance. While some critics fault Hockney's impassivity, taking desire for granted could also be a sign of progress. Some emotions are no great loss: here, at least for a privileged few, gay eros is no longer a tormenting riddle to be solved, but simply a reality to be lived.

While Hockney was sunbathing in California, the archpriest of pop, Andy Warhol (1928–87), was playing impresario for the motley acolytes inside his infamous New York Factory, where the peak of cocky American affluence fed an anything-goes scene of drugs, androgyny, and polymorphous perversity. A

child of the advertising age (he was a commercial artist first), Warhol hung on society's collective wall his trademark repetitions of such mundane objects as soup cans and Brillo boxes, and similarly mass-produced icons like film star Marilyn Monroe. By making the ordinary chic, these appropriations comment, obliquely and ironically, on the collapse of boundaries between high and mass art, and on modern obsessions with the glutted and artificial popular culture of consumer goods and media-manipulated celebrity. Warhol branched out from painting to film with the first of several hundred low-rent classics, *Blow Job*, in 1963. With titles like *Flesh* and *Couch* (starring Allen Ginsberg and his lover) these outrageous improvisations, some set on Fire Island, offhandedly integrated gayness into a cult of the grungy and offbeat. Fellow gay painter Robert Indiana starred in *Eat*, chewing a mushroom; in his own work, he rang stiffened variations on Marsden Hartley's homoerotic German paintings, calling them his "Hartley Elegies."

The mass media at first lambasted pop art: a 1966 *Time* magazine essay hysterically alerted the U.S. public to the old bugbear of the Homintern and its supposedly vengeful threat to "normal" masculinity, implicating pop because it "insists on reducing art to the trivial." By trivial *Time* meant camp, and that, as critic Susan Sontag laid out in her seminal 1964 essay "Notes on 'Camp,' " meant extravagance, effeminacy, and obsession with surface appearances. There was more than a hint of subversive Duchampian genderfuck in Warhol's fright-wigged public face—as filmmaker Emil de Antonio chided him, "You play up the swish; it's like an armor with you"—and his entourage attracted plenty of more flamboyant trash, like transvestite starlet Holly Woodlawn. But actually, like Hockney, Warhol's characteristic attitude was deadpan, an autistic stare accompanied by a vaguely noncommittal "Wow"; he replied to questions about his work with a mumbled, "No meaning."

With increasing success, Warhol became a celebrity himself; dubbed "court painter to the Seventies," he chronicled the guests at that glitzy party, including Truman Capote and Hockney. Critics still argue whether his silkscreen disco queens satirize or celebrate the world of money, glamour, and style, which he gleefully bought into by founding the hip magazine *Interview*. The jury is also out on his legacy to gay culture, but seems to be leaning toward Oscar Wilde's self-imposed verdict: that he put his genius into his life and only his talent into his work. Warhol's talent forced the inner circle to admit a blatant swish, but the import of his "Oxidation Paintings," made by having his boyfriends urinate on canvas, lies less in the artistic product than in the bodily process and its implied social links. Never political, and more a voyeuristic dandy than an enthusiastic homosexual, he did return the favor of fame by playing mentor to younger gay artists Keith Haring and Jean-Michel Basquiat. Yet he remained the court jester, unable or unwilling to say plainly that his imperial patrons had no clothes, and fussing over their evanescent fashions with a weirdly passive cool.

New York's performing arts complex at Lincoln Center reveals how far gay forces had penetrated the bastions of culture by the Sixties. Lincoln Kirstein commissioned Philip Johnson to create a gold and red jewelbox for his ballet company's home, the New York State Theater; two generations of opera queens and balletomanes have promenaded beneath the lobby's colossal Elie Nadelman sculptures of half-nude female couples. That this is a gay space by a gay architect, for a gay patron, with lesbian ornament, was never acknowledged—Kirstein and Johnson, like their patrons, long remained closeted—but the men cruising the room like characters out of Demuth had seen Lynes's photos of City Ballet, or underground shots of dancers in skin magazines, and they knew the score not only musically but socially. The worst fears of the McCarthyites had come true: an international gay network was in place, in constant communication, and some of its members were eager to burst out of secrecy and demand acceptance.

In 1964, a tiny band of activists picketed Philadelphia's Independence Hall in the first gay and lesbian demonstration. In 1967 the Los Angeles *Advocate* was founded as a community newsletter, poised to become, as its banner declared after Stonewall, "the national gay newsmagazine." The following year, as Europe and America were rocked by student protests, mainstream theater dipped its toes in gay waters with *Boys in the Band*, a black comedy unsparing about the toll of gay oppression. But hopes for social change soured in a violent backlash: civil rights leader Martin Luther King Jr. and presidential candidate Robert Kennedy were assassinated; Warhol, shot by a disgruntled feminist, survived. Despite these setbacks, gays made patchwork progress: the first U.S. state repealed its sodomy law in 1961, and Britain in 1967, inspiring Canada in 1969, the year West Germany at last dropped its hated Paragraph 175. The lifting of all censorship on pornography in Denmark made it briefly the world capital of erotic films whose titles, like *I Am Curious*, encouraged sexual experiment.

In 1969 came the Stonewall Riot itself. Though it has given its name to an era and a culture, Stonewall was no sudden spark, but a lens focusing scattered and smoldering rays of desire. Tennessee Williams had foretold this kindling in his poem "The Dangerous Painters," which declared, "Revolution only needs good dreamers." He was speaking of visual artists, but more broadly, of all art freed from its "gilt and velour insulation" to ignite the cry of "Brother!" He called that long-suppressed heritage "stored fuel for a massive indignation" that, in his apocalyptic finale, burns down the museum and its city. While the bonfires at Stonewall were lit in Manhattan trash cans, they were stoked with the fuel laid up by three generations of gay and lesbian dreamers. Like the biblical Moses, Williams could see the promised land but not enter it. But he, and all the prophets since Wilde and Hirschfeld, had brought their wandering band to the threshold of a vast social and artistic territory.

POST-STONEWALL, POST-MODERN

I n the wee hours of June 28, 1969, New York's Greenwich Village witnessed a motley crew of transvestites, street people, and ordinary patrons unexpectedly fight back against a routine police raid of the Stonewall Inn. Yelling the spontaneous slogan "Gay Power!" they barricaded the cops inside the bar and threatened to burn it down, while dancing to the chant, "We are the Stonewall girls." Their impromptu public performance shook together camp, politics, and revenge into a vitriolic cocktail. As the city's *Daily News* reported, "Queen power exploded with all the fury of a gay atomic bomb. Queens, princesses and ladies-in-waiting began hurling anything they could lay their polished, manicured finger nails on. . . . The lilies of the valley had become carnivorous jungle plants." Less snidely, and with more intimate understanding, Beat poet Allen Ginsberg rejoiced, "They've lost that wounded look that fags all had ten years ago."

The pent-up cultural energy unleashed by Stonewall electrified homosexuals, who insisted on a positive "gay" identity and on "coming out" to protest their outcast status noisily. News of the riot also jolted Europeans into stepping up existing efforts: within the year activists in Britain and Germany had linked up with their American brothers and sisters, followed by France, the Netherlands, and the Commonwealth. Throughout the West, the contemporary gay and lesbian liberation movement has spawned a rich subculture—local, national, and international—embracing political groups and social services, bars and clubs, and an artistic cornucopia of theaters, galleries, and media. Alongside ethnic minorities and women, the gay community has mixed its distinctive spice into an increasingly pluralistic cultural stew. While its unfamiliar flavors upset conservative stomachs, this simmering cauldron has also whetted the world's appetite for more varied artistic fare. What Stewart Hardman of London's gay Adonis Gallery enjoys about postcolonial Britain applies from Canada to Australia, Paris to Peoria: "The country is more colorful now—not just racially, but lifestyle."

The new movement's first group image was the forty-foot mural installed in New York's Firehouse, early headquarters of the Gay Activists Alliance, in

1971 (fig. 7.1). The photomontage adorned one of the earliest publicly declared gay spaces, a home for community functions from political meetings to dances, and it defined and celebrated that community's emerging philosophy, politics, and cultural heritage. Its agitprop images rhythmically overlap gay protest marches with heroes of related liberation struggles like black activist Huey Newton, and cultural icons like Plato and Walt Whitman, all stenciled with slogans of gay struggle to evoke a romantic vision of justice for all.

This collaboration between artists of two generations captures the transition from homophile to gay culture. The older painter, New Yorker John Button (1929–82), had already built a career in the era when his male nudes had to remain a private sideline; emboldened by change, he managed in later years to combine mainstream success, honesty about his personal life, and service to his newfound community. His British coworker, Mario Dubsky (1939–85), was just young enough to have come out during the tumultuous 1960s, marked by agitation for social change from feminists, black power advocates, and Vietnam War protesters, and by the psychedelic free-love and grassroots spirit of hippie counterculture, synonymous with the Woodstock music festival that followed only months after Stonewall. For his generation, images were weapons in a campaign to propagate the attitude declared by German filmmaker Rosa von Praunheim's groundbreaking 1971 documentary, *It's Not the Homosexual Who's Perverse But the Society in Which He Lives.*

7.1. John Button and Mario Dubsky, mural at the Firehouse, New York, 1971 (photocollage; destroyed).

At first, openly gay artists like Dubsky worked mostly within their own community and addressed a minority audience. They did so partly by choice—for the exhilaration of struggle toward a new social ideal—but partly by necessity. The art "establishment," like the rest of society, has taken several decades to move from indifference or hostility to embracing feminist and gender variations with a trendy vengeance. Despite lingering nasty objections, gay images and artists are now visible from New York's Madison Avenue galleries and advertising agencies to the Berlin City Museum, the cartoon magazines of Tokyo, and a mail-order gallery in Bangkok.

Any attempt to chart this burgeoning territory faces several hurdles. One is sheer size: it is no longer possible to name all the players when a recent book on Australian lesbian artists covered four dozen women, merely the tip of one country's talented iceberg. Another is too little time: the present still swirls too close at hand for us to make out the long-term patterns of its conflicting currents. And a third is diversity—of sex, race, politics, and class. When asked, "Is there a gay aesthetic?" film historian Vito Russo answered, "No, and I've got one." Gay people's myriad self-images fit no single shared mold of subject matter, style, or media. The "gay community" is really a gaggle of related clans, often at loggerheads with one another, and now divided into three generations: elder statesmen from before Stonewall confront young turks who, having barely known old-fashioned silence, are more inclined to take gayness for granted, in life and art.

Unlike earlier chapters, then, this survey of contemporary gay and lesbian art parades no detailed chronology of styles and personalities. Rather than plotting time, it maps space: not only the geographical terrain of Western society and its borders with the rest of the globe, but also the "cultural spaces" that incubate visual culture in its broadest sense. Alongside concrete landmarks like art galleries, museums, and community centers, this tour of the cultural landscape points out the imaginary realms of criticism, the media, and academia. And all these spaces enfold a paradox. Like other groups set apart by sex or ethnicity, the post-Stonewall subculture exists in dynamic tension with mainstream institutions of art, money, and power; yet it is but one island in the sea of that surrounding culture, buffeted by the same currents that flow through the mainstream. That culture is postmodern in style, postcolonial in politics, and, increasingly in the West, postindustrial and digital.

Even at the close range of three decades, we can already see that the early 1980s formed a watershed beyond which the bubbling fountain of gay culture began to flow in discernible directions. Mario Dubsky's GAA mural was destroyed in a fire not long before the artist himself was consumed by the conflagration of AIDS, which broke out in 1981—along with a new generation of artists, thinkers, and entrepreneurs who called themselves "queer" rather than "gay." Since then, the channels of gay culture have grown ever more institutional, intellectual, and international.

Once a community long confined to anonymous urban centers felt free to set up social institutions, smaller towns and even rural areas sprouted gay and lesbian support services, cultural and political groups, and media. As they mature, these organizations have gradually shifted their goals from transformation to integration, from a revolutionary overhaul of society to realistic reforms. Aiming at legal equality, civil rights, and access to the mass consumer lifestyle, the hippie activist has evolved into the professional insider.

But "inside" has its own problems: by the 1980s, the mighty river of twentieth-century modernism had run its course, fanning out into a swampy stylistic delta labeled, for lack of a better term, postmodernism. The art world seemed to lose its way in the widening cultural crisis and—with the mass media and electronic images lapping at its heels—zigzagged frantically from one trend to the next. Galleries and critics took up gay and lesbian art sincerely, if a bit desperately, as they ran for any ground still above the rising tide of competition for the public's visual attention. And they justified this sometimes shocking inclusiveness with complex intellectual theories, often invoking the gay French philosopher Michel Foucault.

As gay culture crosses international borders, it travels along the new routes laid down after the breakup of European colonial empires. Mounting migration, the global economy, and instant communications have reshaped the cultural and political landscape, blazing paths of influence and resistance in every direction. The European-American model of gay identity and culture continues to expand and consolidate; in turn, the nations of Africa, Asia, and Latin America have altered Western society both from without and, via their expanding communities abroad, from within.

In a single generation, homosexuality has vaulted to an openness and legitimacy scarcely imaginable in Western society since Constantine's Rome, or elsewhere since Renaissance contact. Bigotry is no longer politically acceptable in Britain, Germany, or the Netherlands, which permits gay marriage. Though America is more conflicted, its president addresses gay banquets, and the staid *New Yorker* magazine loosened up enough to plaster a 1996 cover with one of its signature cartoons, a parody of a World War II victory photograph replacing the straight couple with two swooning sailorboys who deep kiss in Times Square. Annual marches for civil rights have spread from Manhattan to Manila and have evolved into more festive celebrations. Amsterdam's is literally the splashiest, with revelers decked in drag and leather parading thousands of boats around the canals; Sydney's spectacular Gay Mardi Gras is a tourist attraction second only to the Australian metropolis's futuristic opera house.

This triumphal progress has not been free of stumbling blocks: AIDS and censorship still threaten, and the social stratosphere of corporate boardrooms and national office hovers out of reach. But gays and their images are everywhere, from lesbian performance art to public monuments and private por-

traits. If their pattern has often been "two steps forward, one step back," that can go a long way—it just takes extra energy. Many examples of that creative energy will be drawn from New York, partly because of this author's experience, but also to provide some journalistic detail on a necessarily sketchy canvas. And because, while gay art is international, America has been the largest exporter of cultural styles, from sexual liberation to music, film, and the Internet. Since the city of Stonewall remains one of the country's art and media epicenters, tremors there register shocks felt around the globe.

MAKING ART, MAKING COMMUNITY

Throughout the 1970s, monumental commissions like the Firehouse mural were few and far between. The fledgling minority community, concentrating its meager guns against a host of social enemies, could only afford more urgent visual needs: documentary photography, portraiture, and the ephemera of political action, from newsletters to banners—plus a burgeoning market in erotica. Movement artists aimed to shatter the long-standing wall of invisibility, define and celebrate their shared identity, and challenge stereotypes—as declared in the titles of two 1980s photography books, Lisa Kanemoto's *We Are*, a portrait gallery of San Franciscans, and Stephen Stewart's scrapbook of his cross-America travels, *Positive Image*. Commercial television and movies triggered arts activism as they ventured into gay subjects, often less than sympathetically. In 1979 New York arts columnist Arthur Bell led a picket line against filming of the murder mystery *Cruising*, which starred Al Pacino as an undercover cop prowling a sensationalized version of Manhattan's gay netherworld. Protests against negative coverage including "zaps," or surprise raids of television stations, led to the 1985 founding of the Gay and Lesbian Alliance Against Defamation (GLAAD) as media-image watchdog.

Photography has played a key role, chronicling who gay people were and who they were becoming, both for themselves and for the larger society. Washington, D.C., native Joan E. Biren, known as JEB (b. 1944), led the first generation, snapping every pride march, protest, and cultural festival around the northeast. Like Cathy Cade in San Francisco and counterparts in each major city, she provided a gallery of the community in action, plus genre scenes of daily life—bars, lovers, families. Much reproduced in the gay and especially lesbian press, JEB's images were also published as inexpensive calendars and in her 1979 book *Eye to Eye: Portraits of Lesbians*, immortalizing cultural heroines and anonymous women at work and at play. The two women hoisting an auto engine in figure 7.2 have both "news value"—reporting untraditional female careers—and the intangible value of art's power to inspire and validate.

Painting too holds up an encouraging mirror to this new culture: less pub-

7.2. JEB (Joan E. Biren),
Lori and Valerie Working at Wrenchwoman, 1978
(photograph).

lic than photography, it is equally political in the private realm, offering patron and artist alike a tool for individual and shared self-understanding. At a 1996 slide talk, Chicagoan Lorraine Inzalaco explained: "I consider my subject matter of 'Women Loving Women' not only a simple and direct telling of my own life story, but an attempt to contribute to a very vast number of women finding a voice in the world." She was speaking to the New York club called Artgroup, which encourages those voices, both professional and amateur, through lectures, art classes, and exhibitions. San Francisco's Queer Cultural Center sponsored a 1998 exhibit of self-portraits by leading local artists, including Lenore Chinn, that testify to the continuing psychic appeal of personal imagery.

The portrait of a New York activist couple, Arnie Kantrowitz and Dr. Lawrence Mass, by David Alexander (b. 1943), adds new dimensions to a cozy domestic scene in a riot of Matisse-like color and flat patterns (fig. 7.3). The couple are both writers and activists, Kantrowitz a GAA veteran and Mass a founder of Gay Men's Health Crisis. Like JEB's work-suited dykes, they announce identity through fashion: short hair and beards shed the stigmatized "fairy" for unapologetic masculinity. The theme of "the new man" is multiplied by visual symbols pinned up around the picture-within-a-picture: the venerable gay icons of Michelangelo's *David* and Walt Whitman overlap the protest buttons that are gay liberation's war medals—one emblazoned with the movement's pink triangle, adapted from the Nazis. Though paintings like this do not circulate in uptown galleries or garner press attention, they serve a vital function within the community—as do the artists. Alexander plays Romaine Brooks to the Natalie Barney of his companion, poet Richard Howard; together they continue the tradition of celebrating their own cultural circles in word and image.

Whether through community or commercial outlets, most artists need display spaces that offer access to the public. Though often precarious in a small market, the (largely male) gay galleries have provided moral as well as fiscal support: dealers play not only business agent but nurturing parent, encouraging younger artists and developing an audience. During the 1980s art boom, San Francisco, Los Angeles, and Chicago all supported gay dealers, and New York briefly had five; few survived as mainstream venues opened to gay arts. Their grandfather is New York's Leslie-Lohman Gallery: partners Charles Leslie and Fritz Lohman, who set out twenty-five years ago to assist struggling painters by throwing "art parties" in their SoHo loft, opened a public space in

7.3. David Alexander, **Portrait of Arnie Kantrowitz and Lawrence Mass**, 1990 (oil).

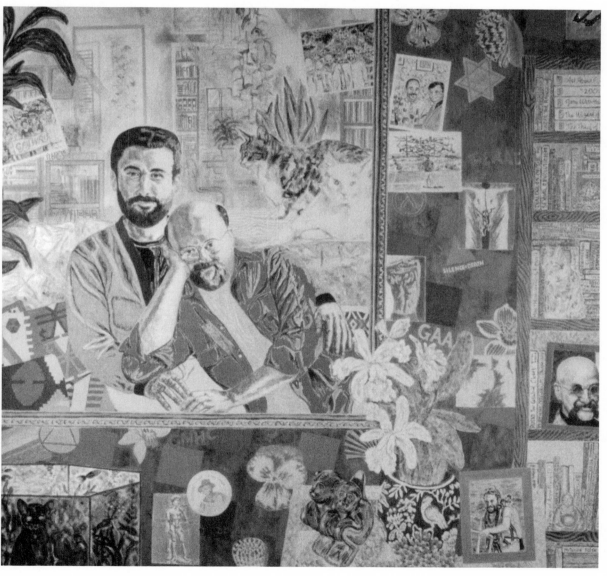

1975. They keep up a steady stream of group and solo shows, both male and female, featuring artists like Texas native Delmas Howe, who balances a "straight" career with cowboy-themed erotica flaunting the gay subtext of that universal icon, the Marlboro Man. Gallery activities embrace publishing: Leslie wrote a book on Baron von Gloeden (fig. 5.15) and reprinted the long-lost work of Blade (fig. 6.17).

Europe's three leading gay art cities boast similar outlets. Berlin's Galerie Janssen is equal parts showroom, bookstore, and video rental, all dedicated to its motto, "Everything about the male in art"; the leather-oriented Rob of Amsterdam had branches in New York and later in London. The British capital's most recent emporium, Adonis Gallery, shows a worldwide roster from the Netherlands and the United States. When Stewart Hardman opened in 1995, he took the novel step of advertising in the London Underground stations; they balked at such "provocative" billboards but accepted them after a token "toning down."

Artists also reach gay audiences on the walls of gay clubs, stores, and community centers. Anderes Ufer, an early gay restaurant-bar in Berlin, has showcased gay and lesbian artists for twenty years; even in smaller cities like Utrecht, the Netherlands, the gay café shows local camerawork. Community

7.4. Keith Haring, bathroom mural, Lesbian and Gay Community Services Center, New York, 1989.

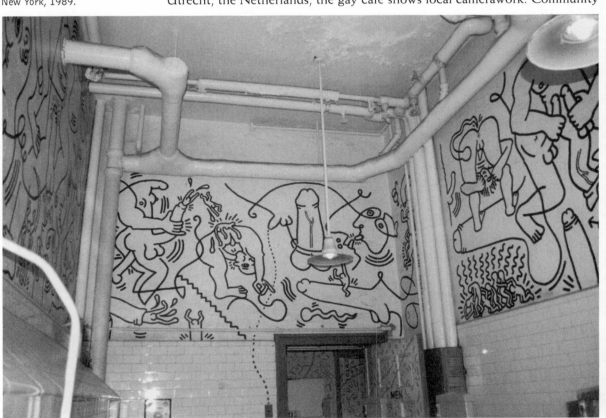

centers exhibit art for political as well as aesthetic reasons: the grande dame of gay centers, Amsterdam's COC, set out in 1948 to instill group pride and individual self-esteem by displaying for its visitors the cultural traditions and current creative accomplishments of "their own kind." Paris's Centre Gai et Lesbien, a storefront coffeehouse in the gay Marais quarter, rotates the work of French and foreign photographers.

New York's Lesbian and Gay Community Services Center, in Greenwich Village, staged the most elaborate "happening" in 1989, inviting some fifty artists to create site-specific installations to brighten its rundown building. Multimedia constructions draped the halls and stairwells, from a gay "world map" to the Chinese calligraphy for "gay love" and reproductions of Japanese lesbian woodcuts. Most were fragile and temporary, since the building was due for renovation, though a bathroom mural by the late pop superstar Keith Haring (1958–90) seems on its way to landmark status (fig. 7.4). On the whitewashed walls above the men's toilet stalls, Haring frescoed a dreamlike cosmic playpen in which his trademark black-outlined gingerbread babies leapfrog over, penetrate, or suck various parts of each other, a frolicking pastorale updated to the pissoir.

The Center also houses the National Museum of Lesbian and Gay History, which exhibits memorabilia and photographs, but the first and only fine-art center is Berlin's Schwules Museum (Gay Museum), founded in 1985. With a permanent collection ranging from paintings to posters to classic drag outfits, a film and television archive, and a library, the museum mounts temporary exhibits and publishes catalogs and a journal. Though modest in scale, it reinforces its hometown's position as gay culture's eldest sister: to celebrate the centennial of Magnus Hirschfeld's movement, curator Andreas Sternweiler led a team of scholars who organized a mammoth 1997 historical and art survey called (quoting Christopher Isherwood) "Goodbye to Berlin?" Their title was ironic: since German reunification in the last decade, the metropolis that once attracted Marsden Hartley is again a magnet for foreign gay artists, like Canadian Richard Lukacs and American Hunter Reynolds.

As the present recedes into the past, the urgent task of salvaging a fragile tradition is being taken up by museums, archives, and libraries. A few successful gay artists have set up personal foundations in their wills, among them Tom of Finland, Andy Warhol, and photographer Robert Mapplethorpe; the Leslie-Lohman Gay Art Foundation, an extension of New York's gallery, offers safekeeping for endangered images in less wealthy hands. As Charles Leslie tells it, "We still encounter one horror story after another about a gay man dying, a family who's never been fully aware of his collection coming in and going bonkers, sending it out to the city dump." Archives and libraries preserve and exhibit original works as well as personal memorabilia and arts publications; one of the largest is the International Lesbian and Gay Archive in Los Angeles, heir to the collections of the 1950s homophile institute, ONE Inc. Others

stretch from Quebec and Toronto to Australia; those specializing in women include New York's Lesbian Herstory Archives, Spinnboden in Berlin, and the Lesbisch Archief of Amsterdam.

LESBIAN FEMINISM

Lesbian art arose hand in hand with the feminist movement, whose latest wave was swollen to public notoriety by Kate Millett's *Sexual Politics*, written the year of Stonewall. Best known as an author and founder of the National Organization for Women (NOW), Millett is also a visual artist, denouncing sexist oppression through both text and image. Her new generation hungered for images of female achievement and passion, so long invisible. Isabel Miller's discovery of a painting by a forgotten nineteenth-century artist, Mary Ann Willson, in a folk art museum inspired *Patience and Sarah*, a lesbian historical novel fondly reprinted since 1969. Miller embroidered a touching love story around the lives of Willson and her companion, who shared a life in frontier New York, and imagined "Patience" painting the biblical embrace of Ruth and Naomi as a love gift.

Feminism offered lesbians the support of half the population for their common goals as women, and the tactics that encouraged separatist institutions for art and politics carved out a safe space for "women-identified women." The feminist art magazine *Heresies* put out a lesbian issue in 1977, and Judy Chicago's 1979 sculptural installation *The Dinner Party*, a room-sized pantheon of feminist history, included among the thirty-nine guests with individual place settings at its triangular table-cum-altar several amazon saints, from Sappho to Natalie Barney. In contrast to Millett's emphasis on gender roles as arbitrary social invention, this shrine typified "essentialist" art, deriving its imagery and style from women's anatomy and biology. Each plate is molded into an archetypally "feminine" form of vaginal or floral curves, and the handmade crockery and needlework mats upend the traditional hierarchy of media, exalting a heritage of female creativity long downgraded as craft, not art.

But feminism also posed lesbians a dilemma: whether to throw their lot in with other women, or with gay men. The sometime misogyny of their gay brothers triggered mutual distrust, while they had to face down the homophobia of their straight sisters: when Millett and her friends publicly came out, NOW almost imploded in a panic that they would feed the stereotype of activists as "dykey" man-haters. And besides, lesbians had their own agenda: the first group show in New York, at the experimental 112 Greene Street Workshop in 1978, grew from the frustration of curator Harmony Hammond, while working on *Heresies'* lesbian issue, with the lack of sapphic networks. Her influential assembly featured seventeen artists whose styles ranged from geometric abstraction to hand-sewn agitprop. Criteria for selection were less aesthetic

than psychological: the question she asked prospective artists was, "What does the work tell you about yourself?"

Hammond (b. 1944) displayed one of her own abstract sculptures, variously constructed of wrapped fabric, pottery, and basketry. The padded and tinted slits of *Swaddles* (fig. 7.5) might evoke vagina or womb, but these early works did not aim at a literal lesbian subject matter; instead, like Chicago, they questioned sex and creativity through media and symbolism. Hammond credits the women's movement for the insight that materials and methods can be gendered, which set off critical alarms in the 1970s; as she later reminisced, "If a gallery person came to visit, you'd hide the sewing machine and take out the brushes." Bundled like a baby yet seven feet tall, elbowing its way off the wall to claim the surrounding floor space, *Swaddles* gives physical presence to the ideal lesbian body, both assertive and tender, preached by writer Monique Wittig.

Like many other exhibitors, Kate Millett incorporated words into her visual manifestoes, from drawings to political installations, to share her urgent self-discoveries. This yearning to narrate stories yet untold—long a hallmark of gay culture—pulled many visual artists toward the new medium of performance art, a hybrid of image and theater. As her white-powdered alter ego, "The 7,000-Year-Old Woman," Betsy Damon pioneered feminist performance, claiming a street corner in New York's financial district with a scattering of sand and pantomiming shamanistic rituals. She told the tales of an ancient ma-

7.5. Harmony Hammond, **Swaddles**, 1979 (wood, cloth, gesso, latex, and foam rubber).

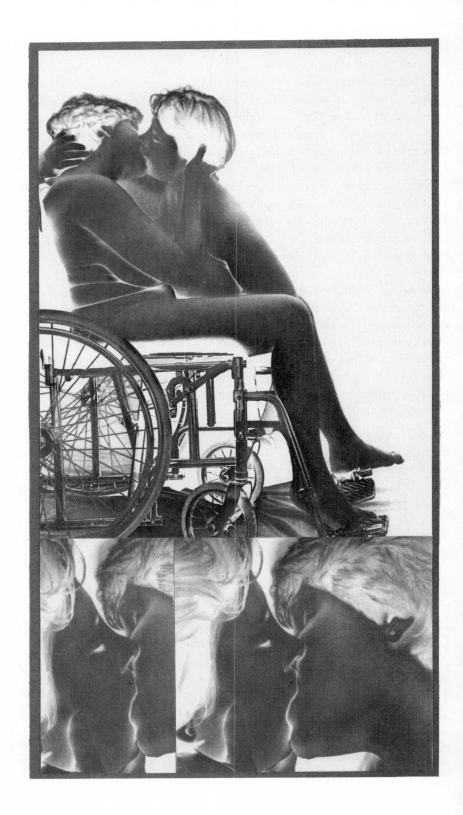

7.6. Tee A. Corinne,
A Woman's Touch, 1979
(solarized photocollage).

triarchal Eden, an anthropological legend dear to feminists; whether any such primeval society ever existed was almost beside the point, which was to stop traffic on Wall Street and force passersby to contemplate all the timeless wisdom and female power shut out by the steel-and-glass canyons of macho modernity.

Camera and graphic artist Tee Corinne (b. 1943) broke ground for lesbian photography as both historical document and erotic fantasy: her celebrations of women's passion in nonmale terms layer frank sexual acts with elaborate symbolism. She has published erotica and portraits in such lesbian feminist magazines as *Sinister Wisdom*, as illustrations for fiction and album covers, and in her own books like *Yantras of Womanlove* (1982). Figure 7.6, a photocollage from 1979, poses two nude lovers in a triple kiss; one sits in a wheelchair, part of a conscious effort to expand the narrow canon of traditional female beauty. Corinne often repeats an image to create visual rhymes and exploits the halo effect of solarization for an aura of magical intensity. She also built up the arts community by teaching "ovulars" (female "seminars"), taking a traveling slideshow on lesbian art history coast to coast in the 1970s, and later by reviewing art books for the gay press and spearheading gay and feminist caucuses in arts organizations.

Lesbian art has slowly grown in resources and public profile since 1979, when small groups scattered around the country coordinated fifty simultaneous events, billed as the Great American Lesbian Art Show, because they couldn't afford to mount a single large exhibition or send it on tour. Now the San Francisco–based Lesbians in the Visual Arts provides services and publications, while New York's gay center hosts a monthly support group and a women-only life-drawing class. And in 1992 straight feminist scholar Eunice Lipton's *Alias Olympia* sympathetically explored parallels between her own life and the obscure career of Victorine Meurent, the probably lesbian painter who modeled for Manet.

PRESS AND PUBLISHING: A CRUCIAL LIFELINE

As Urvashi Vaid wrote in her *Virtual Equality* (1995), "The gay and lesbian press not only reported on the community, it helped to create it." For a blinkered minority, print media are a beacon shining through the darkness of isolation and ignorance. Newspapers and magazines—with their photography and graphics, contemporary arts coverage, and cultural history—and books by and about artists often provide the first glimpses of a positive identity and community; in many countries where an open gay marketplace is not possible, they remain the sole source of images. Publishers now cater to multiple audiences, from the serious few who frequent museums and galleries to those seeking mass-market erotica at the corner sex shop.

What sprang up as a few volunteer efforts has blossomed into thousands of local, national, and global periodicals. In the early decades, some had to brave censorship: London's *Gay News*, sued for blasphemy by a right-wing crank, dragged its case all the way to the House of Lords in 1979. *The Advocate*, America's senior newsmagazine, founded in 1967 around a Los Angeles mimeograph machine, has long featured artist profiles, cultural essays, and exhibit reviews; in 1981 it sponsored a New York exhibit showcasing several dozen artists who had appeared in its regular "Portfolio" spreads. Publications are also patrons, commissioning photographers and graphic designers: though limited at first to newsprint, they gradually added color, and *The Advocate* staged its own photo shoots. One 1982 cover (color plate 26) fantasized a rooftop party in midtown Manhattan, including a drag soprano from a gay opera company, painter David Alexander, community activists, and hunky cub reporters—a whimsical cross section of gay lives and styles in the first flush of self-invention.

London's upscale *Gay Times*, a monthly magazine incorporating *Gay News*, prints art columnists who bridge the gay and mainstream press, especially the ubiquitous Edward Lucie-Smith. Emmanuel Cooper is simultaneously a *GT* critic, ceramic artist, and historian: his *Sexual Perspective* (1986) provided the first panoramic overview of gay art in the modern era. Lesbian newspapers, which began in the 1970s with angry countercultural titles like *The Furies*, have evolved into similar monthlies for women. *Gay Times*'s twin sister, *Diva*, boasts coverage of the lesbian art scene by Atlantic-hopping author Cherry Smyth, while the main French monthly, *Lesbia*, shines its editorial spotlight on historical artists such as Louise Abbema and Claude Cahun.

For books, the United States alone now has a score of gay and lesbian publishing houses, which print art and photography alongside literature and non-fiction. They commission new illustrations and keep classics alive: Gay Presses of New York reissued the landmark half-century-old gay novel *The Young and the Evil* with its original illustrations by Pavel Tchelitchew, and Naiad Press (founded by *Ladder* editor Barbara Grier) reprints 1950s lesbian pulp. Germany's Rosa Winkel ("Pink Triangle"), founded in 1975, has produced the illustrated catalog for "Goodbye to Berlin?", a series from the Schwules Museum, and Andreas Sternweiler's revelations about Renaissance culture. Aubrey Walter of England's GMP (Gay Mens Press) edits a unique long-running series of monographs on British and overseas artists, which has boosted gay art's public profile and sales appeal.

The question of sales raises the chill of economic reality: culture is a business, and an audience is also a market. Minority publishers had to work overtime promoting their wares to a small and still embryonic community: in 1986 GMP codirector David Fernbach lamented that his first forays into gay books were proving "a little too arty for the general gay market and a little too gay for the general art market—so instead of doubling our market, we tend to fall be-

tween two stools." Some publishers subsidize their "arty" projects with profits from more commercial sidelines, mainly the gay mass media's bread and butter, male nudes and erotica: in Berlin, Galerie Janssen publishes photography and drawings of gorgeous men while Bruno Gmünder specializes in travel guides and steamy magazines. Ruefully acknowledging the tradeoff between prestige and profit, Egmont Fassbinder, head of the city's more literary firm Rosa Winkel, says of Gmünder, "If they get a manuscript that won't sell, they send it to me."

One kind of manuscript that sells is the comic book, a hybrid of pictures and dialogue beloved worldwide, whose gay roots stretch back to the underground booklets of Blade and Tom of Finland. Comics answer to the dual yearning for epic stories with larger-than-life adventurers and for sympathetic yet humorous tales of everyday folks, which mainstream film and soap opera still fill only hesitantly. Characters run the gamut from the goofy sex pigs of German Ralf König to the butch working-class heroine of Diane DiMassa's *Hothead Paisan* and Alison Bechdel's "politically correct" *Dykes to Watch Out For*. New Yorker Howard Cruse, editor of the groundbreaking *Gay Comix*, has expanded from his popular all-gay strip, *Wendel*, into full-scale graphic novels like *Stuck Rubber Baby* (1996), a serious epic of the civil rights movement starring a gay hero. The cartoonlike art known as *manga* and its animated film versions are a craze all across Japan's popular culture, serialized in magazines and anthologized in hefty paperbacks imitated throughout east Asia; gay strips labeled *shonenai*, or tales of boy love, range from science fiction to realistic teen melodrama. Named by the Edo-era graphic artist Hokusai to describe lighthearted caricatures in a sketchy style, manga have grown to resemble Western comics but with less talk, more action—a jazzy update of the woodblock print, which also mixed words into flat linear images.

Since Gertrude Stein's Paris, bookstores have served as the cultural clearinghouses of the gay community. Major Western cities boast at least one for men or both genders, and often a supportive feminist emporium. The largest, like Berlin's Prinz Eisenherz and Amsterdam's Vrolijk, stock thousands of titles in a babel of languages, set off sections for art books, and offer one-stop shopping for mass-market posters, calendars, and cards. Paris's Les Mots à la Bouche and others hang art above the shelves and host book parties, which—like one at New York's A Different Light in 1997 for photographer Robert Giard's *Particular Voices*, his fifteen-year portrait project of celebrity gay and lesbian writers—are as near as gay culture gets to a state dinner. Retailers reinforce their suppliers as shock troops in the battle for freedom of press and images: Toronto's Glad Day Books sued Canadian customs for confiscating "obscene" illustrated publications from south of the border.

THE EIGHTIES: FROM GAY TO QUEER

By the 1980s, the campaign for acceptance was tasting small but real victories: in the United States, gay and lesbian candidates were elected to local and state office, cities outlawed discrimination, and gays were included in planning the national Holocaust memorial. But just as gay culture's momentum began to snowball, a triple blow knocked it in new directions: the AIDS (Acquired Immune Deficiency Syndrome) epidemic, a conservative political backlash personified by America's Ronald Reagan and Britain's Margaret Thatcher, and postmodernism. The Eighties were boom years for a glamorous elite, who financed a chic art scene until the 1987 stock market plunge; but for the gay movement, the disco party of the previous decade, the carefree adolescence of a utopian counterculture, was over. Continued integration, maybe even survival, depended on large permanent organizations to press the gay agenda; like it or not, the community had to grow up. Hippie-leftist leadership gave way to specialized and professional academics, entrepreneurs, and fundraisers, who shifted their goals from changing the system to getting a place at the table.

Nothing made gays run for the shelter of solid institutions more than the tornado of AIDS, which touched down suddenly in North America in 1981. Still incurable, this sexually transmitted plague cut a rapid swath of devastation: in major U.S. cities, up to half of gay men were infected. Shell-shocked by catastrophic losses, among them a host of pioneering artists and writers, communities were forced to divert resources from aesthetics to survival. Ironically, this tragic blow also gave homosexuality a public face, prying even beloved celebrities from their closets; and despair spawned activism and art. Film idol Rock Hudson was outed when he died in 1985, galvanizing his fellow Hollywood star Elizabeth Taylor to found AmFAR (American Foundation for AIDS Research), which helped make sympathy for the suffering, symbolized by red ribbon badges, respectable within the influential celebrity circuit. The pandemic soon hopscotched worldwide; though advance warning softened the impact, Europe and Australia responded in kind.

Compounding that shock, the very ground beneath gay culture was rocked by the seismic shift from modern to postmodern, signaled by the renaming of "gay" as "queer." The first wave of liberationists had dedicated themselves to digging up forgotten or suppressed artists and works; now a younger generation aimed more sophisticated theoretical weapons at that mounting historical tinder. The biggest guns in their intellectual arsenal were French, especially the historian Michel Foucault (who died of AIDS in 1984), along with his fellow gay author Roland Barthes, Jacques Derrida, and Jacques Lacan. Their writings on culture and psychology reject the purely formal values and styles of twentieth-century art and question the very existence of gay identity throughout history.

The postmodernists' ambitions are political: to expose the incestuous relations between desire, power, and images. Their central insight is that even when authority walks softly, it carries a big metaphor: the control over culture, which enforces uniformity of thought as well as behavior. Foucault stood Rousseau and Hirschfeld on their heads. Against their credo that "men are born free" with innate desires that are everywhere the same, he claimed that individual identity is not so much biological as cultural, or "socially constructed." Homosexuality—like any sexual, ethnic, or class category—is artificial: its definition changes as societies shift their tactics to "edit out" threatening minorities. Art is a party to the conspiracy—no mere passive mirror of reality, but propaganda broadcasting a partisan vision. Postmodern theory resists that social mind control, hoping to drive a wedge for change by "deconstructing" or taking apart the values and internal contradictions lurking in all cultural images. While it has not completely jettisoned the modernist aesthetic, nor much filtered down to the lesbian in the street, it has radically expanded the boundaries of what artists can make, and what critics can say about it.

ACADEMIA: THE IVORY TOWER OPENS ITS CLOSET

The university has provided a crucial beachhead for gay culture: professors are rewarded for developing new ideas and passing them on to an audience of future leaders. Gay and lesbian studies has matured dramatically since the Gay Academic Union, founded in New York in 1973, sponsored lectures and art shows, but newly open scholars had their work cut out for them. As late as 1984 John Pope-Hennessy, an eminent bachelor authority on Renaissance art, disdainfully lambasted critics who insisted on reading Donatello's graceful bronze *David* in light of the sculptor's homosexuality; doing so, he sneered, "left a little trail of slime on a great work of art." Though the closeted British knight would have never admitted it, his evasive put-down was probably motivated by internalized homophobia and social embarrassment, reinforced when his brother James, also gay, was murdered, reputedly by a trick.

By 1977 a trickle of scholarly research had breached the dam of denial around figures like Caravaggio and Winckelmann enough to permit the first gay and lesbian panel at the yearly conference of the College Art Association (CAA), North America's professional group for artists and art historians. In the 1980s, the trickle became a flood of articles and books eager to drag easels out of the closet, from Benvenuto Cellini to Frida Kahlo. And the ivied halls opened their doors: CAA's Women's Caucus now acknowledges lesbian art and artists, and the conference's second gay panel in 1986 soon became an annual event, inspiring similar sessions by its British counterpart, the Association of Art Historians. In 1989 CAA approved a Gay and Lesbian Caucus, which pre-

sents panels, mounts exhibitions, and published a bibliography for the mushrooming printed record (1994); its officers spearheaded a 1996 issue of *Art Journal* whose title crowed, "We're Here: Gay and Lesbian Presence in Art."

Once postmodernism made it "in" to be "out," and claimed intellectual work as political activism, queer studies gained a foothold across many disciplines. The first U.S. school to establish a gay studies department was City College of San Francisco (1989), whose faculty boasts a full-time art historian, Jonathan David Katz. The Netherlands has three state-funded programs: the University of Amsterdam, where gay studies date back to the 1970s, has long provided a home to the archive for gay and lesbian documents nicknamed Homodok, which maintains computer files on artists. By the late 1980s, university presses like Columbia and serious general publishers like Cassell put their prestige behind whole series of gay/lesbian books; in 1991 the City University of New York inaugurated the Center for Lesbian and Gay Studies, a research institute dedicated to "promoting scholarship that facilitates social change," with lectures, conferences, and publications that embrace the visual arts.

Taking its aesthetic cue from the evergreen Marcel Duchamp, queer theory inspired a coolly cerebral art, historically and aesthetically self-conscious

7.7. Millie Wilson, **Fauve Semblant (Peter, A Young English Girl)**, 1989 (installation view).

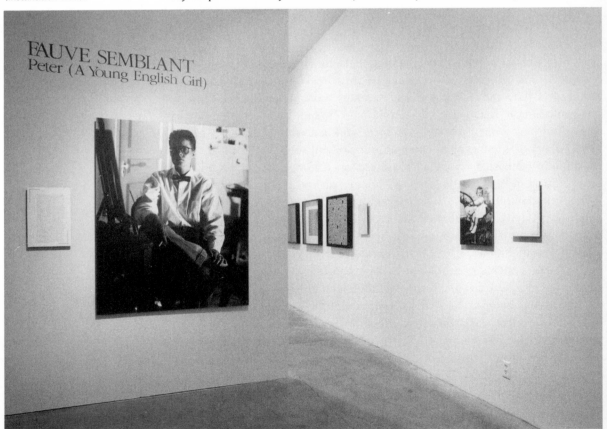

and often as conceptual or literary as visual. Postmodernists shifted from making a mere object to making a critique of objects themselves, to "queering" the process of creating art and history. One standard-bearer, Californian Millie Wilson (b. 1948), created an emblematic installation in 1989 titled *Fauve semblant (Peter, A Young English Girl)*. Figure 7.7 shows one corner of this room-sized installation, complete with wall texts and fake memorabilia, that reconstructed a fictitious lesbian artist; Wilson photographed herself as Peter. The audience is invited to peel away layer upon layer of learned borrowings and jokes: Romaine Brooks did paint a portrait of a female called Peter—actually the English artist Gluck—though the bow-tied New Woman imagined by Wilson has a "life" more modern than either of those godmothers. Millie-as-Peter pays homage to an ongoing lesbian tradition while ironically demonstrating how each individual collages a personal identity and style out of available models. With her then-lover Catherine Lord, Wilson organized "Something Borrowed," a 1995 display of favorite images collected by southwestern U.S. lesbians, from family albums to pulp novels, juxtaposed with comments on what each meant to its owner. Like an archive exposed in a gallery, this potpourri of art, popular culture, and anthropological fieldwork both preserves and writes history even as it points out the artifice and fragility of visual records.

Contemporary queer culture is fraught with multiple paradoxes and ironies. Postmodernists owed their freedom of speech to an activism founded on identity politics, which assumed some shared gay nature yearning to "come out" from beneath repression; yet just as acceptance seemed within reach, they questioned whether there was a "we" to grasp it. At the same time, the more gaydom became integrated into mainstream politics and culture, the more artists and writers emphasized their "queerness," their outsider status. And they proclaimed their championship of the excluded and downtrodden in an abstruse jargon indecipherable without a Ph.D. As the millennium turns, postmodernists and queers so saturate academia and the arts that conservatives attack "tenured radicals," while Stonewall survivors fret that buying in to establishment prestige has meant selling out the old gay agenda. Like any trend approaching middle age, postmodernism itself is now ripe to be shunted aside by culture's endless oedipal evolution, but its genes will be dominant at least into the next generation.

AIDS

Like other creative fields, the world of visual artists, curators, dealers, and critics has been decimated by AIDS; yet it is also forced to the front lines in the battle to control public images of the disease through patronage, exhibitions, and the press. After the initial shock of the epidemic wore off—or perhaps, as one path toward overcoming that shock—artists set out to address its emo-

tional and political toll. Campaigns against ignorance and for a cure were stalled by a crafty virus and a public still hostile to the plague's main victims among sexual and ethnic minorities, sadly providing ample time to ferment an art steeped in elegy and outrage. AIDS art speaks in many voices, from personal confession and mournful reportage to political protest and cultural criticism. Queer studies cut its eye teeth on AIDS: theorists like Cindy Patton and Douglas Crimp of postmodernism's flagship magazine, October, mounted a scathing attack on the hostility behind media images of sex and illness, revealing how the earliest pictures, like photographs in medical journals, isolated and scorned AIDS sufferers just as Renaissance printmakers did to syphilitics.

Art and activism formed a Foucaultian alliance. ACT UP, founded in New York in 1987 to protest official apathy through confrontational street theater, spawned chapters in Paris and other hard-hit world capitals; among its debut productions was a window display at New York's New Museum juxtaposing portraits of prominent bigots and their antigay rhetoric with photographs of Hitler's henchmen on trial at Nuremberg. Collectives like Gran Fury and Toronto's General Idea turned out in-your-face political graphics—most memorably the slogan "Silence=Death"—whose boldness set the style for the next five years. From Los Angeles to Amsterdam, advertising campaigns for safer sex leavened their life-or-death earnestness with irreverent wit: one German series turned condoms into eyeglasses and a shining sun. The international group Visual AIDS designed the red ribbon that became the "logo" of the cause and spearheads projects to exhibit and document ailing artists' work.

Though the art establishment took its share of criticism for bias and denial, positive responses were quick in coming, including benefit art auctions in New York for groups like Gay Men's Health Crisis at such prestigious galleries as Leo Castelli. A 1987 collaborative sale for AmFAR rounded up six hundred artists at seventy-two galleries, lasted six months, and raised several million dollars; with a kickoff reception at Sotheby's auction house, the event was toney enough to garner a donation from the normally discreet Robert Rauschenberg. The Visual AIDS team inspired the worldwide "Day Without Art," an annual memorial since 1989 during which hundreds of museums and art centers remove works from their walls or sponsor educational programs. "From Media to Metaphor" (1992) at New York University's Grey Art Gallery, curated by Robert Atkins and Tom Sokolowski, cofounders of Visual AIDS, was among the most moving of myriad exhibits spotlighting art about AIDS or by artists with the disease; the latest was a gigantic international showcase planned for Geneva in 1998.

Exhibits run the gamut from the gruesome conceptualism of Barton Benes, who uses crematorium ashes and his own infected blood as art materials, to the painterly elegance of Ross Bleckner, whose starkly simple black canvas juxtaposes its chilling title, 16,301 + As Of January 1987, with a funeral bouquet. In his successful but truncated career, David Wojnarowicz (1954–92) created

outspoken art, videos, and performances dramatizing his disgusted realization that, having contracted HIV, which causes AIDS, "I'd contracted a diseased society as well." In collages like *Bad Moon Rising* of 1989 (color plate 27), he butted images of traditional martyrdom, here a Renaissance-inspired Saint Sebastian, up against American dollar bills to indict mounting greed and mourn forgotten spirituality. Also a powerful writer, Wojnarowicz often added words to his images, but in this work the densely layered insets of magnified germs and homemade "dirty pictures" are allowed to bear silent witness to hypocrisy and squeamishness. His bluntness deliberately collided with authority: when he penned a catalog essay for Nan Goldin's 1991 AIDS show that savaged conservative politicians, they pressured the National Endowment for the Arts into revoking a grant to the Manhattan host gallery.

Hunter Reynolds takes a radically different approach with *Patina du Prey's Memorial Dress*, an ongoing art-cum-performance project in his native America and Europe. The title object is a tight-bodiced, bouffant black ball gown stamped in gold with thousands of names of the AIDS dead. Since 1992, Reynolds has displayed the empty dress, and other stitched and collaged variations on "the fabric of memory," as static gallery exhibits. But the sewing comes to life when Reynolds squeezes his muscled, hairy torso into the strapless sheath and revolves silently like a graveyard mannequin in some unnerving ritual. Sometimes he escalates to pouf-guerrilla tactics, waltzing down city streets and crashing gallery openings, a modern-dress shaman invoking the transgendered healing rites of the ancient berdache.

The NAMES Project Quilt, conceived by San Franciscan Cleve Jones, has ballooned into the largest gay art project in history (color plate 28). Taking their cue from a venerable folk art, grieving survivors stitch cloth panels memorializing lost loved ones and decorate them with personal symbols and mementoes; units ranging from homemade simplicity to baroque whimsy are pieced into an outsize tapestry in a communal "quilting bee." First displayed in its entirety on the national Mall in Washington, D.C., in 1987, the Quilt has traveled to dozens of cities; it has now reached forty thousand panels covering the area of twenty-four football fields. Embodying the 1970s mantra "The personal is the political," it puts a human face on the mounting death statistics in order to move both makers and viewers: it consoles hushed visitors, who lay floral tributes as if on a pilgrimage to sacred relics, while raising consciousness and money. Though criticized as "soft" in both materials and attitudes, the Quilt has inspired local clones from U.S. college campuses to New Zealand.

The art of AIDS embraces photography and film, including documentaries from England, France, and Canada. It also crosses ethnic and gender boundaries: lesbians, though less susceptible to the disease, have expressed solidarity through visual collectives like Dyke Action Machine. For the multiple afflicted communities, creativity has proved a tragic necessity, an exorcism of loss. Limited progress in treatment and prevention has recently deflated

some of the movement's urgency and anger. But the Quilt keeps growing, and is now too enormous to display all at once—a reminder that AIDS will blip on our cultural radar for the foreseeable future.

PENETRATING THE MAINSTREAM

In 1980 critic John Perreault was interviewed for an *Artforum* piece on gay art—titled "I'm Asking: Does It Exist? What Is It? Whom Is It For?"—that opened serious mainstream coverage of a decade-old movement. His short answer to the first question was: Yes, but not yet. And the prophecy soon came to pass: gay and lesbian artists and images migrated in droves from the fringes to the centers of cultural chic, epitomized by New York's scruffy East Village where, as gay columnist Michael Musto recalled, "Everyone was straining to be terribly underground while striving to become terribly famous." Fitfully, then eagerly, the art establishment bestowed its largesse through gallery and museum patronage, government, and the press: by 1996 the Andy Warhol Museum hired Visual AIDS's Thomas Sokolowski as director and sponsored a symposium on "Andy Warhol's Sex." Gay performance art, theater, and film have all garnered state and federal grants. Yet twin clouds hang over this rags-to-riches saga, contrasting ironically: sexual art remains a red flag to conservative bulls, while gays wonder whether acceptance has wrought transformation or assimilation, equality or conformity.

The trail had been blazed by older artists like Hockney, Bacon, and Warhol, with a posthumous boost from Romaine Brooks. At her death in 1970, she willed her work to Washington's National Collection of American Art, whose memorial retrospective the next year publicized her mythic lesbian circle, just then slipping from living memory. Film also helped breach the wall of silence, notably in innovative postwar Italy. Luchino Visconti's trilogy on gay historical themes between 1969 and 1973 treated Nazis, Thomas Mann's pederastic novella *Death in Venice*, and Wagner's mad patron King Ludwig of Bavaria. His compatriot Pier Pasolini, a poet and painter as well as filmmaker, violated the Mediterranean social compact by making homosexuality a public issue; some blamed his sordid unsolved murder on political enemies, others on a sexual pickup gone sour.

In the early '80s, New York's Robert Samuel Gallery built one of the first bridges between underground and upper crust; owner Sam Hardison advertised "male image" rather than "gay" art, but his turf was clearly defined when invitations to a 1983 opening for the leather-and-western photographer Schreiber specified "black tie, elegant cowboy or nude." Hardison gave exposure to an eclectic stable, especially in photography—probably the most popular gay medium, and an art then in creative ferment, thanks in part to his wealthy friend Sam Wagstaff, a trendsetting gay collector. George Dureau

showed a nude portrait of football player Dave Kopay, among the few sports stars to come out, whose pose paid one of myriad modern homages to Hippolyte Flandrin's ever-popular *Solitude* (fig. 5.22). Other camera work ranged from the punk-grunge school of Peter Hujar and Wagstaff's protégé Robert Mapplethorpe to the tender lyricism of Duane Michals, who often combines images with texts by or about gay poets like Whitman and Constantine Cavafy. Many, like Arthur Tress, shared elements of surrealistic fantasy, though Joel-Peter Witkin's scummy reworked snapshots of cadavers, including the affectingly macabre kiss of two male skulls, must have made the homophobic André Breton turn over in his grave.

This sophisticated body of work soon pricked up the aesthetic ears of journalists and curators. After John Perreault broke the ice, New York's alternative weekly the *Village Voice* hired another out critic, Robert Atkins, whose outspoken column from 1987 to 1994 earned him the unofficial title of "Mr. Gay Art." In 1982 the city's modest but cutting-edge New Museum mounted the eclectic "Extended Sensibilities: Homosexual Presence in Contemporary Art," the first such show explicitly devoted to gay and lesbian artists. The recognition provided the two dozen exhibitors—from Harmony Hammond to sculptor Scott Burton, the younger lover of the Firehouse painter John Button—an encouraging shot in the arm.

The show's brightest international stars were two Englishmen collaborating under the moniker Gilbert & George, who have shifted from cheeky performance pieces inspired by British music hall to hand-tinted photocollages up to fifteen feet long. Whatever their medium, these deadpan clowns (b. 1943, 1942) jumble the cosmic with the mundane, beautiful boys with bathroom humor; their scatological 1977 series was titled *Obscenity*. In *Sodom* (color plate 29), the artists themselves embrace stiffly but honestly, naked as naughty schoolboys yet retaining the humdrum wristwatches and eyeglasses of middle-class middle age. But the picture's true obscenity is the page from a popular catechism printed behind them, which condemns "the sin of Sodom"; at the bottom the artists bend over and bare their backsides in the ultimate gesture of disrespect for the textbook's sanctimonious blather. Even when eros is not so overt, it is implicit in their lifelong partnership, witnessed by their joint signatures at the bottom right. Whether couples in life or merely in work, numerous other artists of a gay sensibility have been drawn to collaborate, including the French surrealistic photographers Pierre et Gilles, who fuse Hollywood kitsch with religious icons like Saint Sebastian, and the whimsical American painters David McDermott and Peter McGough.

New York's Whitney Museum of American Art has led the pack since its Marsden Hartley exhibit of 1980 acknowledged the coded gay content revealed by Michael Lynch in the Canadian gay journal *Body Politic*; a 1987 show similarly outed Charles Demuth. In 1991 the bellwether Whitney Biennial, a group survey of current trends, dedicated one room to a multimedia *AIDS Time-*

line by the Toronto collective Group Material; by 1993 almost one in five invited artists was gay or lesbian. Not to be outdone, the Guggenheim Museum gave twin retrospectives in 1995 to gay artists Felix Gonzalez-Torres and Ross Bleckner, spotlighting their strikingly different responses to AIDS. That same year, Biennial veteran Nayland Blake helped curate "In a Different Light," a thoughtful overview of gay and lesbian artists both living and dead, at the University Art Museum in Berkeley, California; this welcome mat at a prestigious state college sealed the consensus that a thematic study of sex and gender could offer the general public a useful perspective on contemporary issues.

The child prodigies of the 1980s international scene were Keith Haring and the former hustler Jean-Michel Basquiat, young upstarts with attitude who were welcomed by art lovers ever hungry for what critic Robert Hughes calls "the shock of the new." Protégés of Andy Warhol, both rose fast and died young: Haring of AIDS and Basquiat, child of Haitian and Puerto Rican immigrants, of a drug overdose. Haring got his start scribbling graffiti on subway walls, exuberant cartoonlike doodles of dancing dogs, babies, and faceless but infectiously joyful grown-ups of all persuasions. His signature graphic style—equally appealing to activists, ordinary consumers, and posh corporate advertisers—earned him a brief blaze of stardom in the galaxy of popular culture. Galvanized by AIDS, he was more socially conscious than Warhol: besides his community center mural (fig. 7.4), he designed posters for gay causes, including ACT UP, in between jetting around the world to supervise outdoor murals and the Pop Shops where he sold designer T-shirts and other mass-market wares.

While some gay artists became mascots, others remained pariahs—though as Diaghilev proved, notoriety can be good for the box office. In 1992 the University of California at Santa Barbara insisted on erecting a wall to block passersby's view of an exhibit by Patrick Angus, whose darkly crude oil and pencil vignettes capture dingy hustler bars and porno theaters; student uproar over this censorship attracted record-breaking crowds. Photographer Robert Mapplethorpe became the emblematic victim of lingering hostility. Open and active about his AIDS diagnosis before succumbing in 1989, he grafted the cool sleekness of one favorite forefather, George Platt Lynes, onto the raunch of another, Tom of Finland, to create elegant celebrity portraits, flower still lifes, and purposefully provocative male scenes. The art elite was titillated by his hot men, often African-Americans or sadomasochists radiating racial and sexual exoticism. He dared the public to confront a self-portrait in leather sticking a whip up his rectum, and succeeded—until 1989, when Washington's Corcoran Gallery canceled his traveling retrospective for fear of losing federal funding. The tour went from bad to worse: in Ohio, police padlocked the show.

Though a Cincinnati jury cleared the Contemporary Arts Center of obscenity charges, the trial was only one skirmish in an ongoing war against state

financing of "smut"; when a young Chicago art student satirically painted Mayor Harold Washington in a dress, outraged local politicians "arrested" the painting. Nationwide, this bitter campaign is spearheaded by conservative religious lobbyists and politicians like Senator Jesse Helms. Their favorite whipping boy is the National Endowment for the Arts, the federal funding agency; three of the "NEA Four," performance artists who became a cause célèbre when their grant proposals were rejected for explicitly sexual content in 1990, were gay or lesbian. Though the Endowment's budget is puny by European standards, in 1991 Congress debated nine proposals to restrict the subject matter or moral fiber of future grantees.

Europe, with a stronger tradition of public patronage, has been less conflicted in accepting gay art. The Netherlands supports a busy and tolerant scene, regularly reviewed in the press: Gilbert & George received a 1996 exhibition at Amsterdam's Stedelijk Museum of their *Naked Shit Picture*, French S/M photography has hung in the Rotterdam Kunsthal, and among many AIDS exhibits was the 1997 "Safe Sex/Safe Art" display of student poster designs. Germany enjoyed the earliest and most extensive cooperation between gay curators and public institutions: the 1984 "Eldorado" exhibit at Berlin's City Museum broke new ground in the study of gay and lesbian daily life, dredging up rare illustrations from prints of nineteenth-century cruising grounds to the first homosexual magazines. Goethe Haus, the nation's overseas cultural embassy, exported a 1997 art exhibit and film series to New York with the tongue-in-cheek title "Not Straight from Germany," proudly including a newly restored print of Magnus Hirschfeld's pioneering film *Anders als die Anderen*.

The largest gay show ever, 1997's "Goodbye to Berlin?," was developed by the city's Schwules Museum but housed in the venerable Academy of Arts; with funding from the state lottery, its international team was able to amass more than a thousand documents, photographs, and paintings from medieval Switzerland to Warhol. The historical survey was accompanied by a contemporary male group show organized by two stalwarts of Berlin gay art, Rinaldo (Hopf) and Martin von Ostrowski, who paints himself as his genderfuck alter ego Queen Louise. The vision of Ostrowski presiding over the chic gallery opening in his signature frilly pink gown, balancing a tiara on his crewcut, must have had the ghost of Baron von Teschenberg—who hoped to promote future acceptance by publishing his transvestite snapshot in Hirschfeld's journal (fig. 5.23)—flouncing with glee.

In Britain, London's staid Royal Festival Hall welcomed *Out in Art*, a 1986 show of five punk-expressionist painters. But two years later, in a chilling detour on the road to tolerance, Prime Minister Thatcher's conservative parliament passed Clause 28, which banned local governments from any activities that might "promote" the "acceptability" of homosexuality. This short-lived reaction didn't prevent the young lesbian painter Sadie Lee (b. 1967) from winning a prestigious British Petroleum travel grant and a 1997 solo exhibit at the

National Portrait Gallery. Lee's BP project documented the retired veterans of American striptease, like bespangled Dixie Lee Evans, who tends the flame of this fading dance form at her Exotic World of Burlesque Museum in California (fig. 7.8). Though orthodox feminists might gasp at glorifying these grandes dames of the bump-and-grind, the image contains more wrinkles than those surrounding Evans's brassy smile. As a lesbian, Lee may share the straight male audience's erotic pleasure in gazing on female flesh, but as a woman she also admires this hardworking survivor and allows her to return that gaze with proud independence. Expanding beyond the more obviously gay subject mat-

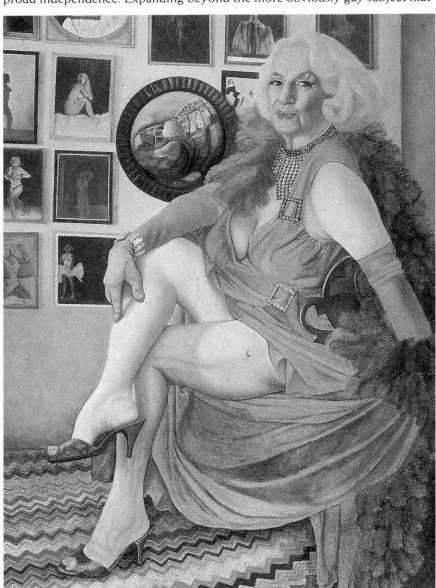

7.8. Sadie Lee, **Dixie Lee Evans—The Marilyn Monroe of Burlesque,** 1996 (oil).

ter of her early portraits of female couples, Lee implicitly promotes a "queer" appreciation of the infinite combinations of sex and gender, subject and object.

Many artists echo Lee in being unabashedly out while refusing to conform to expectations that they should limit their work to explicitly gay imagery. American Robert Gober painstakingly hand-makes baroque installations that fill whole rooms with cryptic symbols like a statue of the Virgin Mary pierced by a steel drainpipe and a waterfall tumbling down a staircase. Critics routinely note that he's gay, and some strain for a queer subtext beneath his themes of reflection, memory, and spirituality, but his obsessions are more obviously rooted in his status as a lapsed Catholic. Angeleno Lari Pittman, who splatters his sprawling canvases with ornately zany cartoon images and slogans exploring high American ideals and a raucously scatological sexuality, bristles at critics who link his decorative style or political concerns with his personal identity. You don't have to be gay to deal with eros now; nor do you have to be straight to deal with everything else.

By the late 1990s, so many barriers have fallen that gay artists, though still grateful and pleasantly surprised to penetrate another bastion of the international cultural circuit, no longer feel the same surge of exhilarated novelty. Manchester's City Art Galleries staged a 1997 show of work by seven young English painters, including Matthew Stradling's hothouse nudes out of Michelangelo and Dawn Mellor's fantasies of tough urinating women, whose publicity crowed: "In a powerful fusion of art and contemporary sexuality, this challenging exhibition provides us with the first major [British] assessment of queer culture through the visual arts." But ever since the modern avant-garde set itself to storming the establishment, winning the battle risks losing the war. The mainstream exacts a toll for entry; as another young Briton, conceptual neon artist Cerith Wyn Evans, sneered in a 1997 *Gay Times*, "Our society just converts revolt into style." Being taken into the fold means being tamed, losing the moral bite of the outsider. On the plus side, the move from protest to celebration can inspire new forms of creativity: Denmark legalized gay marriage in 1989, and the Louisiana Museum near Copenhagen displayed photographs of the 1996 "performance art" wedding of a Danish woman and lesbian American art critic Jill Johnston, staged by the art collective Fluxus.

ART IN THE PUBLIC EYE

Architecture and monumental sculpture, the largest-scale and most obvious arts, were until recently out of gay reach: the metaphor of "the closet" gives sadly apt architectural form to a long legacy of forced hiding in cramped quarters. Expensive and permanent, buildings present both a challenge to gay community resources and a slap in the face to opponents of public recognition.

The first temples of a more open and affluent cult were the cavernous discotheques that flowered in the 1970s, from Sydney to Stockholm. Middle-aged veterans now wax nostalgic over those dramatically darkened and bespangled dance palaces, where they celebrated the ecstatic yet ephemeral rites of newfound freedom, as the youthful sprouts of budding gay style and solidarity. But in the movement's first decades, identifiable spaces offered lightning rods for bigots, who picketed or even firebombed bars and churches and ripped two commemorative plaques off the Stonewall Inn.

As gay and lesbian institutions mature, they have gradually become patrons for the architecture of social centers, churches, and service agencies, styling rented quarters or their own buildings as they wish. The Los Angeles Gay and Lesbian Center runs a three-site complex including an art gallery, coffee shop, theater and meeting rooms; New York's Center bought an aging school in 1983 and raised an endowment to renovate and expand its magnetic safe harbor. All is not so rosy: the city's Lesbian Herstory Archive purchased a Brooklyn row house for its collections, but to fend off die-hard homophobes never publishes its address. And only in San Francisco, America's unofficial gay capital, whose uniquely large subculture blurs the line between "gay" and "public," has an official project set aside a gay space: the Gay and Lesbian Center within the grand municipal library, opened in 1996. Besides books, the center offers exhibits by gay artists and a ceiling mural titled *Into the Light*, depicting a staircase to a brighter future inscribed (à la Judy Chicago) with the names of historic homosexuals.

The grandest of Western architectural precedents is invoked by the Cathedral of Hope, a two-thousand-seat sanctuary planned for this Dallas, Texas, congregation of the Metropolitan Community Church (fig. 7.9). MCC is an international gay Protestant denomination founded in the United States (the most religious among Western democracies), and this ambitious commission marks an unprecedented open partnership between patron and designer. By the time the church hired architect Philip Johnson (b. 1906), the old master had grown tired of his youthful days sneaking up to Harlem clubs; in 1996 he revealed what everyone knew on the cover of the gay monthly *Out*. Though Johnson began as a sleekly functional modernist, his gilded jewelbox for Lincoln Kirstein's New York State Theater shifted to a whimsical eclecticism that made him the fairy godfather of the younger postmodern generation. The cathedral, designed with his recent partner, shapes mass and light into a muscular yet soaring form that invokes both the freedom of modern concrete and local adobe missions from Spanish days. Parishioners are still raising the projected $20 million budget; when and if they do, Johnson's coming out and swan song will assure gay culture at least a paragraph in the history of mainstream architecture.

Whether attached to buildings or looming down from a pedestal, public sculptures—the statues of heroic ancestors and cultural legends that fill town

7.9. Philip Johnson/Alan Ritchie Architects, Cathedral of Hope, Dallas, Texas (proposal model, 1998).

squares and capitols the world over with the pantheon of national history—are potent icons in the cult of shared values. Because they teach who and what deserves perpetual remembrance and honor, monuments are political statements, inciting both intense loyalty and passionate opposition. There have long been memorials to gay people, of course; they just didn't say so. The bronze depicting humanitarian activist Eleanor Roosevelt—a feminist sideshow to her presidential husband Franklin's 1997 Washington memorial—follows that tradition of deleting from official portraits any hint of sexual biography, especially tidbits like Eleanor's passion for journalist Lorena Hickock. The last two decades have witnessed some successful, if often controversial, attempts to weave a gay and lesbian thread into the tapestry of collective memory.

The mother of all monuments was commissioned in the late 1970s by the Mariposa Foundation, which offered New York a bronze group of two same-sex couples in contemporary dress, cast from live models by sculptor George Segal, to be erected in the park outside the Stonewall bar commemorating *Gay Liberation* (fig. 7.10). Installation was stalled until 1992 by endless nasty neighborhood debates over the public gay image. Straight Villagers protested that the statue would brand their urban turf with an unwelcome stigma. Gay factions lodged two objections: One, that the commission didn't go to a gay artist; at the time, the frustrated foundation could not explain that it had first approached Louise Nevelson, then America's most prominent female sculptor, a closeted lesbian who was initially intrigued by an aesthetic coming out but got cold feet. Second, the four figures were too white, too young, too stereo-

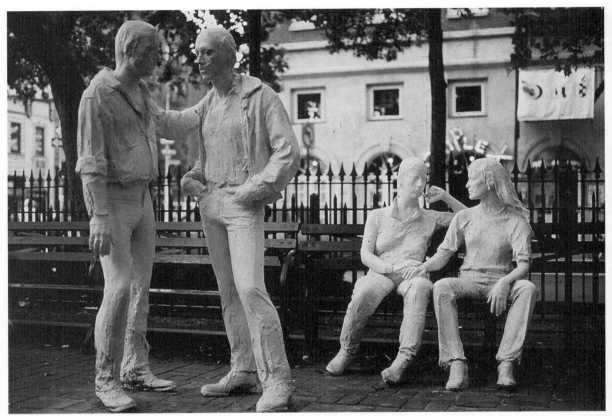

7.10. George Segal, **Gay Liberation,** 1980 (bronze figures and metal benches). © George Segal / Licensed by VAGA, New York, NY.

typical, and too sad. Though politically eager for the job, Segal was an odd choice stylistically, making a quartet of his trademark urban types, anonymous and blankly frozen. These deliberately mundane antiheroes have become a familiar fixture, but not a beloved landmark. Perhaps the ultimate problem is that a monument to gay aspirations became feasible just at the moment when Western culture lost faith in the mythic symbols that could celebrate abstract ideals in any form more uplifting than a literal realism.

Gay people can claim a share in a more appropriately somber type of memorial, those commemorating the tragic victims of the Nazis. Bearing out the postwar Netherlands' reputation as the most permissive Western nation, Amsterdam was the first city to erect a *Homomonument*, designed in 1987 by Dutch artist Karin Daan (fig. 7.11). Her giant pinkish-granite triangle, set into the pavement of a prominent square in the city's historic center, is lettered in bronze with a verse by the Dutch gay poet Jacob Israël de Haan extolling "Friendship, such a boundless desire." One point of the three-sided Nazi badge extends into a canal, providing a symbolic dock where international visitors lay floral tributes.

For Germans, monuments to Nazi atrocities are far more sensitive, amounting to an indictment of their own history. In Berlin, the regime's nerve

center, the first gay memorial was small and partisan: a reddish granite triangle on a subway wall in historically gay Nollendorf Square dedicated to "the homosexual martyrs of National Socialism." Plans for a larger semiofficial monument to Jews killed in the Holocaust have raised a heated debate over whether to recognize other victims, from gays to Gypsies, which has already forced the scrapping of a first proposal. Inclusion is also a touchy issue in America, where antigay fundamentalist Jews form a vocal political bloc. The Holocaust Memorial Museum in Washington maintains a gay and lesbian advisory panel and displays gay memorabilia, including pink triangle patches and photographs of *Cabaret*-era bars; but when similar items were displayed in New York's Museum of Jewish Heritage, Orthodox rabbis angrily filed suit to block its opening.

Gays are also leaving their mark on the public landscape through urban renewal—or, more ambivalently, gentrification. As part of a campaign to identify and honor the city's diverse ethnic enclaves, Chicago planners decided in 1997 to erect towers festooned with the gay symbol of rainbow-striped flags along North Halsted Street, lifeline of the bustling gay neighborhood. These are no monument to the past, but acknowledgment of the important role gays and lesbians now play in revitalizing declining inner cities. Fleeing provincial hometowns, they have flocked to major centers, willing to invest time, money, and taste in their often rundown refuges—from the lovingly restored gingerbread houses or "painted ladies" of San Francisco's Castro district to lesbian collectives in Brooklyn's Park Slope to the Marais quarter of Paris. In 1997 a housing development near Manchester's gay section ran an advertisement in the British *Pink Paper* showing a casually upscale thirty-something male couple

7.11. Karin Daan, **Homo-monument,** Amsterdam, 1987 (granite and bronze).

grinning domestically in front of their trim brick row house. Ironically, when these pioneers raise real estate values, they get priced out of their own new Edens by better-heeled but more conventional professionals, mockingly termed "yuppies." As Greenwich Village's century-long role as an inexpensive bohemia fades into history, all that will be left of its gay creators is their spruced-up Victorian homes and the Segal monument.

THE FRINGES OF THE FRINGE: SEXUAL MINORITIES

In 1972—just when gay moths were beginning to circle the flame of mainstream artistic success—John Waters filmed the trashy underground classic *Pink Flamingos*, starring the drag actor Divine as a three-hundred-pound turd-eating homicidal witch living in a trailer outside Baltimore. His gleeful grotesque remains a cult favorite among devotees of outlaw, discomforting, or merely alternative tastes, from drag queens to leather dykes—all those who are emphatically and uproariously *not* courting respectability. These "fringes of the fringe" are banished to the outskirts of Western gay culture for various erotic excesses: too butch, too femme, or too kinky. They are less visible because, in the marketplace of gay identity, they are minorities within a minority, and the most tightly controlled. Pedophilia is the textbook case: the North American Man-Boy Love Association, which advocates lowering age-of-consent laws, tops the list of groups not to invite to high-profile gay events, and "kiddie porn" being illegal, images of the underage are sold under the counter. But the fringes contribute their distinctive flavors to the creative pot, stretching gay art's range of sensibility, subject matter, and style.

The hypermasculine fraternity of leathermen, fetishists, and sado-masochists often operates literally at the margins of society, cruising the gruff urban underworld of public parks and backstreet hideaways that novelist John Rechy called "one vast city of night stretching gaudily from Times Square to Hollywood Boulevard"—and around the globe. A mile or two from Times Square's peepshows and hustlers, New York's crumbling warehouses and abandoned waterfront were until the past decade colonized as a gay playground: artists like David Wojnarowicz labeled the pier sheds "queer spaces" with erotic frescoes. Specialized bars and sex clubs, which date back to Weimar Berlin, became universal alongside X-rated theaters and striptease joints. This raunchy but vibrant demimonde has lately come under renewed siege from police and zoning officials, justified by AIDS but motivated by real estate. The new activist group Sex Panic! valiantly contests government and corporate efforts to sanitize the red-light districts for tourists and investors, but the juggernaut of gentrification rolls on: the piers are now a roller rink and Times Square is a theme park for Walt Disney's family-friendly entertainment.

The swaggering extremes of danger and obsession have exercised a potent

visual magnetism ever since Tom of Finland, radiating from mass-market pornography to rarefied museums and glossy advertisements. San Francisco is home to the popular erotic artist Rex, whose painstakingly stippled drawings of ultramasculine bodies and props capture the ambience of his South of Market leather zone, and to photographer-curator Mark Chester; Chicago's Leather Museum showcases work by artists like Rex and Etienne. This tight-knit community supports a host of commercial calendars and magazines like *Bear*, highlighting big hairy guys with cigars and motorcycles. In the late 1970s, macho gay street style intersected the youthful punk culture, whose deliberately crude, often angry music and art exploited the naughty paraphernalia of leather and chains; in the '80s, a watered-down punk "look" briefly caught the shifting limelight of the worldwide fashion and media circuit.

Berlin, heir to the grisly directness of German expressionism, remains a hotbed of the leather and uniform aesthetic—which ironically overlaps the latest wave of punk, the violently neofascist "skinheads" who trade fashions with gay and S/M culture while trading insults with many minorities. Photographer Andreas Fux does Mapplethorpe one better, coolly posing the shaved and tattooed brutes in his acidly colored tableaux of sexual torture against shadowless white studio backdrops, as if celebrity fashion designer Calvin Klein had launched a slick campaign to sell nipple rings and leg irons. Their unspoken story is more chilling than their visible plots: in the media age, surface beauty can add an irresistible allure to even the ugliest message. The large, scruffy canvases and assemblages of Attila Richard Lukacs (fig. 7.12; b. 1962) likewise depict sullen hulks, both hot and ominous, whose fetishized military gear raises prickly associations in a country where Hitler's party is officially *verboten*—a contradiction brought home when Lukacs exhibits his vintage photographs of Nazi executions. Lukacs typifies the far-flung internationalism of gay art now: Canadian-born, he lived a decade in Germany before migrating to New York. So does Berliner Rainer Fetting's splashy poster-paint mural *Another Murder at the Anvil II* (1979), an expressionistic commemoration of a tragedy in a Manhattan leather bar—a European report of American news bought by Australia's National Gallery of Victoria.

Some women too indulge in heavy lust and graphic depictions of it, setting off frequent skirmishes in the feminist movement's divisive "porn war." Tee Corinne and other artists eagerly demystified female genitalia and sexual congress in wide-open lesbian sex magazines with titles like *Bad Attitude* and *On Our Backs*. But they were bucking the tide of orthodox feminism, which downplayed erotic aggression and role playing in favor of an essentialist and quaintly prim image of women as more spiritual, affectionate, and egalitarian than men. Antipornography activists, outraged by the visual tradition that exposed women's bodies for male voyeurs, seek censorship of images deemed victimizing and violent; opposing voices warn of the dangers in any controls on artistic content, such as the obscenity law that Canadian border patrols in-

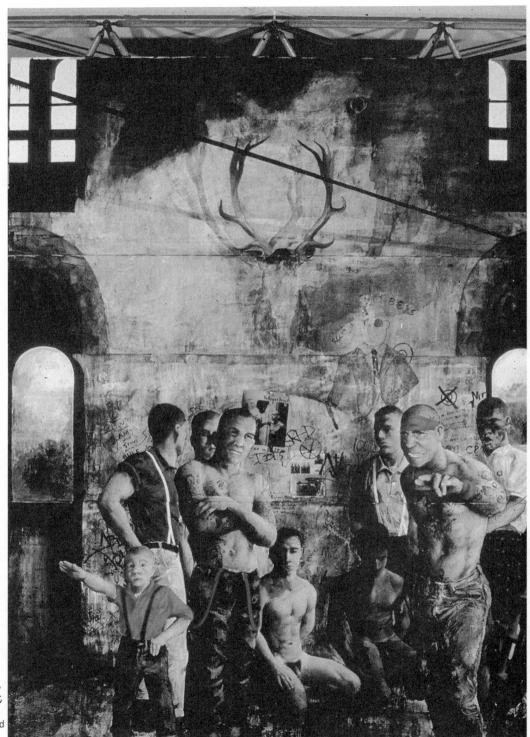

7.12. Attila
Richard Lukacs,
Authentic Décor,
1988 (oil, tar,
enamel, and gold
leaf on canvas).

voked to keep out *On Our Backs*. Many in the so-called lesbian sex mafia feel a greater kinship with men of shared tastes than with other women; as the French male leather columnist Kiki declared humorously in 1997, "We've a lot more in common with an Accursed Female [sadomasochist] than with some tacky disco poof." American art historian Camille Paglia, a bisexual, grabbed the media spotlight by tweaking "politically correct" feminists who ignore the powerful realities of fantasy and desire.

A host of lesbian photographers have celebrated this polymorphous perversity, including Jill Posener, who collected their work in an anthology with

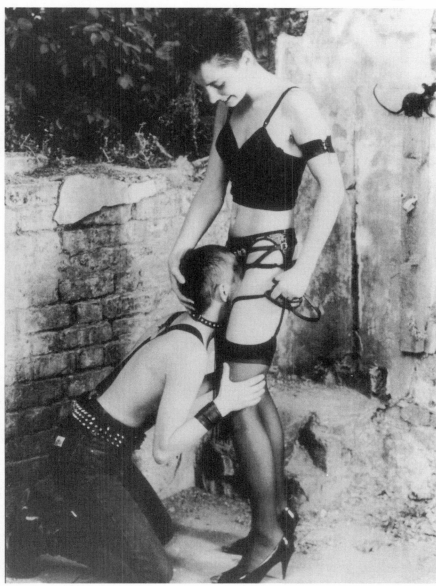

7.13. Della Grace, photograph from the series **Permission to Play**, 1989.

essays by the lesbian critic Susie Bright. One of their chosen shutterbugs was Della Grace (b. 1957), an American living in England who chronicles the sexual intimacies of slutty femmes and rough butches in leather and tattoos—women who brook no interference from stereotypes of "the gentler sex." Grace's own book, *Love Bites*, was brought out in 1991 by Gay Mens Press after women's publishers turned it down. In figure 7.13, from a series polemically titled *Permission to Play*, the buzz-cut couple pleasure each other while the image plays with the conventions of erotic photography itself. The spike heels and dog-collar borrow the trappings of a straight dominatrix, and the crumbling setting invokes an urban back alley; but the standing femme is smiling, and the toy rat nailed to the fence seems to wink "Don't take all this too seriously." Putting theory into practice with a vengeance, Grace later became transgendered, changing her/his name to Del and growing a beard—a literal "embodiment" of postmodernism's gender fluidity. The umbrella of queer identity now also shelters bisexuals, transsexuals, and even straight transvestites, and inclusion adds to its crossover potential: the catalog for *Post-Boys and Girls*, a 1990 New York exhibit exploring both straight and gay genders, accompanied one essay from a bearded gay male art critic with his portrait gowned as a Russian czarina.

The cultural flank opposite high theory and machismo is occupied by the femme and playful forces, from high dragsters to hippies, whose dress-up tradition has been linked with "queens" since France's King Henri III. Camp, transvestism, and the carnival spirit still flourish, remaining the cardinal sign of homosexuality to the outside world, especially in the theater and mass-market film comedies like *La Cage aux folles*. Picking up where the drag balls of the

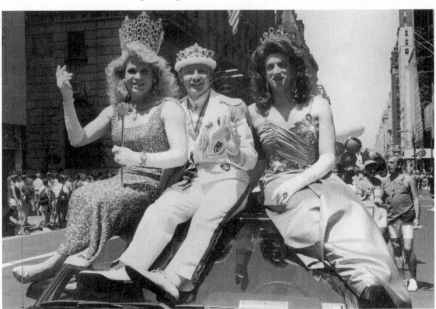

7.14. Lee Snider, **Queens For A Day (And A King, Too?)**, 1992 (photograph).

Harlem Renaissance left off, New York's chapter of the Imperial Court, one of fifty across North America, takes over swank hotels for annual fund-raisers that qualify as performance art. No pride parade is complete without its contingent of royalty, like the Manhattan queens and their snappy escort in figure 7.14, whose tacky tiaras both dignify gay public occasions and heighten the carnival atmosphere. As with fashion's "leather look," both high and commercial art have spasms of transvestite chic: bisexual Nan Goldin's garish snapshots of drag queens and androgynous punks from Boston to Tokyo led to her solo Whitney Museum show in 1996, and comic John Cleese modeled for an American Express advertisement in a smart red frock.

The Sixties counterculture that begot gay liberation survives among the Radical Faeries, apostles of pagan religion and rural simplicity given to organic farming and witchcraft rituals—with lots of glitter. Their loose network across the United States and Canada is linked via *RFD* magazine, "a country journal for gay men everywhere." One of the oldest gay periodicals still printing (founded in 1973), *RFD* features drawings, photography, and cartoons that draw gentle and eclectic images from nature, fairy tales, Asian mysticism, and ponytailed woodsmen in calico dresses. Self-exiled from mechanical urban modernity, these latter-day satyrs and swamis yearn for the innocent pansexuality of Greek pastorale and the spiritual potential of the "gay soul"—title of a book of interviews with sympathetic artists and critics by the chronicler and Jungian psychologist Mark Thompson. The Radical Faeries and their neighboring drag tribes are the aborigines of the gay world, preserving in their remote habitat the vestiges of an Edenic stage of culture, long left behind by evolution but a fragile reminder of a precious and colorful heritage.

THE ETHNIC FRINGE: GAY MULTICULTURALISM

Some battalions of the gay cultural army are stationed at a creative distance by sexual difference, others by racial and ethnic identity. As anticolonial revolutions swept Africa and Asia, the U.S. and European powers retreated from empire, but it followed them home. The backwash of immigration to the mother countries has reversed the one-way tide of influence: gay artists of non-European heritage living in Western societies are forced to confront their double "otherness," while their new hosts must in turn cope with challenges to their own "native" traditions. The fruit of this cross-fertilization has been cultural schizophrenia, whose cure demands a new map to navigate the roiling artistic oceans of a globalized world.

Perhaps we should replace the colonial metaphor, in which art and ideas radiated outward from motherland to childlike colonies, with a multicentered and reciprocal "family of man." The roots of that family tree stretch back to common imperial ancestors, but it is no longer dominated, as in our grandpar-

ents' day, by a few Western father figures keeping a tight rein on their unruly brood and bullying the neighbors. Queen Victoria's descendants have multiplied into a far-flung clan, both united and divided by their tangled genealogy. As the youngsters struggle to find their mature individual places, relations among the national branches vary from warm to frigid. What use each of these cousins makes of their joint cultural inheritance, and of one another, depends on geographical distance, shared language and history, and the influence of foreign in-laws.

This scenario casts the principal readers of this book—direct descendants of the colonial patriarchs in northern Europe and North America—as cultural brothers and sisters, who keep in close touch between the gay centers from San Francisco to Paris to Berlin. Non-Western emigrants, who have grown far more numerous and vocal in those same cities since Stonewall, take the role of half sisters. Offspring of the same cultural father, but with different native mothers, they share a family resemblance, but not their distinctive maternal legacy of unequal treatment—which inspires an art often based on themes of exile and dislocation, and fantasies of wholeness and return.

As the magnetic core of history's greatest empire, Britain led the way in adapting to this diversity, though not without reluctance and riots. The legions of Africans, Indians, and Caribbeans in England, while tugged by their own world diasporas, are increasingly at home in the newly interracial society chronicled in Stephen Frears's 1985 film about a Pakistani Londoner operating *My Beautiful Laundrette* with his Anglo boyfriend. Besides his own portraits of multicultural Britons, Sunil Gupta, a photographer of Indian heritage, put together (with lesbian critic Tessa Boffin) a breakthrough anthology of British art from the AIDS front titled *Ecstatic Antibodies* (1990). One photographer they included was Rotimi Fani-Kayodé (1955–89), who immigrated from Nigeria as a child (color plate 30). Sensitized by his Yoruba upbringing to art's power of evoking mystical forces, he layered his handsome African male subjects with lush tropical flowers and sub-Saharan body painting, masks, and jewelry; black gay critic Kobena Mercer quoted Fani-Kayodé's lover and fellow artist Alex Hirst to eulogize his brief life's work as "an exploration of the relationship between erotic fantasy and ancestral spiritual values." The beaded halo in *Every Moment Counts* is more Christian than animistic, but the communion between the rapt "saint" and his tender "acolyte" transcends all borders between sacred and profane love.

As a nation of immigrants, the United States has always preached pluralism, though progress toward that lofty ideal is blocked by chasms of misunderstanding both between and within ethnic groups—especially the forced settlers from Africa. Black gay arts now rival the Harlem Renaissance, and in 1983 poet Audre Lorde became the first African-American lesbian to address a civil rights assembly, but many in this deeply religious community still find her kind embarrassing. When scouting their minefield of divided loyalties, black

gay artists are as likely to signal sexual discrimination at home as racial discrimination outside.

Glenn Ligon's politically charged paintings and photos fuse autobiography and social history to document the pressures of growing up gay and black; his installations of 1970s bedroom furniture strewn with pornographic magazines evoke every teenager's fearful search for images and identity. Lyle Ashton Harris makes his own, artfully staging Polaroid tableaux of himself sporting various drag personas, from a Haitian revolutionary to a ballerina with a penis poking through his/her tutu. These travesties of masculinity—a point of touchy pride for black men, long stereotyped as feminine, childlike, or oversexed—cut several ways. By affecting a haughty sneer that declares maleness merely a performance, a social costume that can be taken on or off, Harris's portraits mock oppressive community demands for macho conformity, while his collages of advertising and media shots of glamorous black models and athletes both exult in his heroes' undeniable sex appeal and slyly slap its commercialized blaxploitation.

Creative gays and lesbians are visible within virtually all minorities, from oldest to newest. Through four millennia, Jews in widespread lands have wrestled with dual identities; the gays among them, who long endured biblical homophobia, are twice haunted by memory of the Holocaust. Among several gay artists whom curator Norman Kleeblatt included in *Too Jewish?*, his 1996 exhibit at New York's Jewish Museum, Deborah Kass (b. 1952) parodied Andy Warhol's celebrity portraits with a silkscreen homage to Barbra Streisand (fig. 7.15). Depicting one of stardom's first unassimilated Jews costumed for her film role as Yentl, a ghetto girl who cross-dresses to wangle a male education, the image spices its challenge to ethnic and gender invisibility with a fetishistic repetition hinting at lesbian desire.

Double and triple outsiderhood, the psychic lava of a demographic volcano, continues to flow through the arts. Hispanic-Americans, the nation's fastest growing minority, have produced museum successes like Felix Gonzalez-Torres; Los Angeles, in the heavily Spanish southwest, is home to Viva, a national network for lesbian and gay Latino artists. And the most recent wave of immigrants from south and east Asia, now lapping at the Pacific shores of the United States, Canada, and Australia, has already inspired a documentary film about gay Asian-Canadians.

THE GEOGRAPHIC FRINGE:
POSTCOLONIAL COUSINS

Beyond the immediate family, the next rings of gay and lesbian relatives are the cousins who live in formerly colonial areas. While centuries of historical tide still carry northern European influences to these distant shores, Western

7.15. Deborah Kass, **Triple Silver Yentl (My Elvis)**, 1993 (silkscreen ink and acrylic on canvas).

waves take longer to reach them and get diluted in the local cultural waters: South Africa's annual gay parade began only a decade ago, and the gay tourist map of Pretoria has captions in two native languages alongside English and Afrikaans. The closest kin live in the British Commonwealth; gays in Latin America and the former Soviet empire make up an outer ring, the first because their European pedigree traces back to the Mediterranean branch, the second because their socialist ancestors were the black sheep of the family, self-exiled and long shunned.

Everyone's favorite first cousin to visit is Australia. The parties and art shows staged for Sydney's annual Mardi Gras, the biggest mecca on the international gay carnival circuit, climax in a lavish torchlight parade where sequined dragsters jostle floats of hermaphrodite kangaroos. Most states have decriminalized homosexuality, and the National Gallery in Canberra hosted a 1994 exhibition on art in the AIDS era. The Asian connections pioneered by World War II artist Donald Friend have mushroomed as the island continent moves to dethrone its far-off British queen and build bridges to its own neighbors: Sydney is home to *OG* (*Oriental Guys*), an English-language glossy packed with art, cartoons, and steamy photographs.

South Africa, whose harsh apartheid regime quit the Commonwealth under pressure in 1961, has transformed itself into the multicultural Cinderella of the '90s. The ideology that segregated the races also frowned on homosexuals; though prejudice persists, both groups have profited dramatically from the transition to majority rule. In 1984 photographer Herb Klein published a

male "hunk calendar," followed by mail-order nude snapshots—which the police confiscated. Undaunted, in 1992 he started up the continent's first gay magazine, *Flash*, with stories and pictures featuring lots of blond Afrikaners at sunny poolsides and a few blacks. The year 1996, when Klein put out an anthology of his work, was the watershed: the country ratified a new constitution barring racial and sexual discrimination, and the Dutch embassy sponsored a traveling exhibit of gay and lesbian artists. (South Africa enjoys a close cultural link to the gay-friendly Netherlands, since its Afrikaans language descends from the Dutch of early Boer colonists.)

From Mexico to Argentina, gay political and cultural organs have sprung up in most Latin American capitals; though many have proved short-lived, Brazil boasts trailblazing academics, and artists of the Circulo Cultural Gay have presented an annual exhibit in Mexico City for ten years. But visible homosexual expression is handicapped by social attitudes inherited from the Iberian colonizers. The Spanish word *machismo*, now universal, encapsulates the demand for swaggering male dominance and contempt for passive "feminine" men and for women—one reason why gay male artists far outnumber lesbians. And, in contrast to northern Europe's tradition of noisy activism, the social compact of Mediterranean culture overlooks private homosexuality as long as it does not challenge public norms. Homegrown problems, from conservative dictatorships to social insecurity, double the pressure for discretion: where government services are overburdened or unreliable, the family remains an all-important safety net, from which most gays can ill afford to segregate themselves or flaunt their differences.

Mexico's best-known gay painter internationally is Nahum Zenil (b. 1947), whose work confronts society with his inner struggle for a positive identity in unfriendly territory. The silkscreen *Con todo respeto* ("With All Respect") (fig. 7.16) orchestrates Zenil's recurrent themes of self, family, nation, and imagination. The bearded painter himself sits in a ramshackle bus with his arm around Mexico's artistic patron saint, Frida Kahlo, whom he worships for her obsessive self-examination, surrealist eroticism, and quest for a national style or *Mexicanidad*; joining him on the bench, as in life, are his lover, Gerardo, and his elderly mother. Through the window behind her we glimpse the rural cottage of Zenil's childhood, a symbol of his refusal to give up his roots or to let them give up on him. Other images are even more fantastic: in countless self-portraits, he sprouts the wings of an angel or a devil, or plays all the roles in a wedding, including the hermaphroditic bride. Double portraits with Gerardo, who looks uncannily like Zenil, recall Kahlo's twinned self-images; their mirrorlike reunion of two halves translates the primeval homosexual myth of Plato's *Symposium* into Spanish. Zenil's skulls, Madonnas, and dolls claim for gay imagination the folk sensibility that colors Latin Catholicism—a double-edged heritage more sardonically spoofed by his gay countryman, painter Julio Galán.

Juan Davila was born in Chile in 1946, but like many Latin artists fled the repressive political climate. While living in Australia, he painted punked-out pastiches in which nude musclemen quoted from Tom of Finland kiss cartoon figures copied from pop master Roy Lichtenstein; their encounters are splattered with graffiti from psychoanalytic guru Jacques Lacan to create a cerebral but outraged and hilariously pornographic critique of modern gay identity as fragmented and commercialized. Unlike other creative foreigners who migrated directly to Europe or America, Davila took the long way around, entering the Commonwealth by the back door and working his way up to media attention in London, where the Gay Mens Press art series published his work in 1985. Davila later returned to Chile, where he detonated pan-American diplomatic protests with a sculpture of Simón Bolivar, South America's George Washington, wearing earrings and rouge.

The former communist nations, though Western Europe's nearest neighbors, are as culturally remote as second cousins, isolated after the 1917 Russian revolution when grandfather Lenin moved to the wrong side of the ideological tracks, driving away the rest of the family and spanking homosexuality as capitalist decadence. Since the Soviet Union collapsed in 1991, fledgling gay communities in Russia and its old satellites are catching up with their

7.16. Nahum Zenil, **Con todo respeto** ("With All Respect"), 1983 (mixed media on paper).

big brothers abroad—Moscow's Tchaikovsky Fund mounts art shows, film festivals, and parades—but change can be heartbreakingly slow. Though Bulgaria has sprouted a handful of private clubs and erotic video centers, as recently as 1996 the editor of a gay and lesbian publishing house had to hide from police raids for nothing more than printing a beefcake magazine. Progress also runs aground on the rocky economic transition: Western currency is scarce for importing art and news, local currency often useless. In 1992 the spunky post-censorship magazine *Dar* ("Gift") commissioned a series on gay culture from American journalists—sort of a primer for Russian activists—but its presses were stopped by a newsprint shortage.

Though these threadbare relations can spare precious little cultural yarn, both sides are making determined attempts to reknit East and West. While selecting more than seventy-five photographers for a Europe-wide photography exhibition aptly named *Lesbian Connexion/s,* to coincide with the 1998 Amsterdam Gay Games, cocurator Marian Bakker, a prominent Dutch photojournalist, made several trips to the old Soviet bloc to pick up long-unraveled family threads. Among the gay venues vying to become a stop on her traveling show's post-games itinerary was Moscow's new Triangle Center.

ASIA AND AFRICA: UNEASY NEIGHBORS

As the world shrinks to a global village, the cultures of Asia and Africa have become the neighbors down the block. Not being blood relatives, they find the nearby Western clan a nuisance, stronger and richer and offering seductive technological and intellectual candy to the kids across the street. Though the two hemispheres share a history of cultural exchange, it is forever haunted by the West's old habit of raiding the East's backyard, and attitudes toward foreign influence are ambivalent at best. The Nigerian emigré photographer Rotimi Fani-Kayodé speculated from London, "If I ever managed to get an exhibition in, say, Lagos, I suspect riots would break out." He later did, and they didn't, but he shrewdly foresaw that "I would certainly be charged with being a purveyor of corrupt and decadent Western values."

Like other social issues, the theory and practice of homosexuality are a mosaic of local and imported materials. The positive erotic traditions of classical Islam, China, and Japan, long suppressed by their more puritan descendants, are all but forgotten by the masses, though a few artists and scholars, like India's Giti Thadani, are now combing the remains for a usable past. In former colonies of Africa and south Asia, the legal codes inherited from European rule combine with popular customs to discourage gay and lesbian life. Even nations like China and Thailand, though never colonized, cannot escape modern international culture, but its inroads remain limited and often bitterly contested. An activist minority whose members view themselves through the

Western lens of identity politics has rotated its annual Asian Lesbian Conference to major cities like Tokyo since 1992. Yet four years later an infant group in the Himalaya mountains, taking the postmodern name Nepal Queer Society, sent its first letter abroad appealing for foreign aid because, director K. P. Sharma wrote, "Everybody hates us."

As in Latin America, family prevails on most lesbians and many gay men to marry, though outward conformity hardly prevents extracurricular activity: estimates of homosexuality in some Islamic areas run to 40 percent of adult men. But social duty, plus the pan-Asian emphasis on maintaining social harmony through discreet silence—aggressively enforced by authoritarian governments and by the Islamic fundamentalist revival from Egypt to Afghanistan—limit gay community and cultural exposure. Even where diversity enjoys some freedom of expression, as in India, homosexual behavior is still banished to the margins of the social and artistic terrain, as it is literally in the painting *Green Landscape*, by Bhupen Khakhar (color plate 31).

India, which celebrated a half century of independence in 1997, is both the world's largest democracy and a polyglot assortment of rural villages where those who defy age-old Hindu expectations are ostracized. One safety valve for sexually variant men is the role of the *hijra*, a secretive outcaste of transvestite eunuchs who work as entertainers, still little understood even at home. Sprouts of Western feminism and gay lifestyle in the teeming cities, including a lesbian resource center in the capital of New Delhi, are watered by the English-language press, a colonial legacy that helps an educated elite find each other. *Bombay Dost* publishes news, literature, and advertisements for an artists' support group, but its editors' statement regrets that "we cannot possibly bring you pornography or nudes"—illustrations are limited to cartoons and photographs of gay events. One of the few painters dealing with gay themes is Khakhar (b. 1934), who was encouraged by a stint in London to depict sexual oddities and fantasies including a quasi-gay episode from India's national epic, the *Mahabharata*. Around the borders of his *Green Landscape*, cut off from a lush central scene invoking the timeless countryside, men make love in a park or kiss in private against a black field suggesting nocturnal secrecy; his style combines the cartoon simplicity of David Hockney with the pattern and detail of Mughal miniatures.

These seedlings are just now spreading to India's most popular art form, the splashy film industry centered in Bombay's "Bollywood," renowned for its fantasy and spectacle. The first gay short film, by Riyad Wadia, scion of a filmmaking dynasty, was *BOMgAY* (1996), which layered vignettes of urban life—gay friends gathering for a meal and the tearoom cruisers mockingly dubbed "ammonia maharanis"—with a voiceover of gay verses by young poet R. Raj Rao. In a 1996 interview, Rao bewailed the continuing need for secrecy from his family, commenting wryly, "In the West you can talk about anything as long as you don't do it. In India, everything is okay as long as you don't talk

about it." He talked to *Trikone*, published in California for gay Indians; the subcontinent profits from such dialogue with its extended gay family in the English-speaking world, perhaps one reason why recent mainstream films have dared to talk about hijras with sympathy rather than camp, and *Fire* (1997) broached the taboo subject of unhappy arranged marriages through two sisters-in-law who leave their husbands for a life together.

Since the nineteenth-century Meiji restoration, Japan has forged a unique relationship to the West, eagerly transforming itself into an adopted sister who grew into the second biggest member of the world economic family. The attraction is mutual: American photographer Nan Goldin has recorded her friends in Tokyo's gay subculture, much like Berlin or Boston, with hundreds of bars and clubs. One popular gay artist is Sadao Hasegawa, whose sleekly airbrushed sexual fantasies absorb sources from Tom of Finland to Quaintance through a distinctively Japanese filter, flavored by the samurai and kabuki; he illustrates books and the same gay magazines that print manga cartoons. But such exuberant openness remains a foreign graft on the oaks of Asian harmony and discretion, which reject minority dissent in deed or image. Ironically, while the nation abandoned the kimono for the computer, modern machinery helps keep its gay visual pedigree in stock: the manga buyer for a Japanese bookstore in New York, warned to keep *shonen-ei* (male love) titles "under the counter," set up a Web site to reach intimidated customers anonymously.

Though east Asian gay cultures are widely diverse, all share a state of transition and sometimes conflict. In Thailand, Bangkok has exploded into a global sex capital for all orientations, its gay districts sporting a hundred clubs and baths, two dozen magazines, and sidewalk vendors hawking erotic videotapes. Thai culture is tolerant, but not accepting: it traditionally recognized a third gender, called the *kathoey*—most often an effeminate or cross-dressing man— but resists Western notions of gay identity and visibility. Censorship of sexual imagery has produced a lucrative black market in mail-order beefcake; Bangkok's Utopia Gallery, which presents "art about the male body" from southeast Asia, Japan, and the West, markets through the World Wide Web. Gay artists are safer in cyberspace: Hanoi cultural officials forced a 1995 exhibition by Vietnam's lone openly gay painter, Truong Tan, to remove all the explicit nudes.

Homosexuality is not illegal in China, but the Communists long vilified it as a contagious Western sickness. In the past decade, the leadership's headlong exit from socialist ideology to capitalist profit has left the door to tolerance quietly ajar. Two Ming-era gay novels have been reprinted with original illustrations, and in an Eastern version of the American army's "Don't ask, don't tell" policy, the handful of gay social clubs and restaurants in major cities, mostly for men, are increasingly let alone: Shanghai's main cruising park sits across the street from a police station. But avenues to free public expression remain firmly

blocked to gays, as to all critics of state policy. Since Britain handed Hong Kong back to mainland China in 1997, the island enclave's cosmopolitan gay demimonde, fueled by a decade of heady prosperity as Asia's financial nerve center, has been bracing for a crackdown. In a loosening Taiwan, where the mayor attends gay functions, a few films by Tsai Ming-Liang have broached gay subjects.

Any generalization about half of the globe flattens crucial variations, but the position of homosexuals and lesbians across Asia and Africa broadly resembles the West a generation ago. Small self-aware gay communities are emerging from the shadows and finding one another; beyond a smattering of painters and filmmakers, who still rouse controversy, their infant visual culture circulates mainly in magazines. Whether the imported saplings of Stonewall will thrive in foreign soil remains an open question.

COMMERCIAL ART AND THE MASS MEDIA

A final arena that bears watching is the popular culture of magazines and advertising, film and television, and digital communications. This artistic space is not geographical, but rather a single technological and commercial tent that blankets the entire planet. Though traditionally separated from the fine arts and ranked lower than "high culture," the mass media take up an ever-widening slice of the total visual pie; they flavor imaginations and attitudes, sating the global appetite with icons, from Mickey Mouse to Ralph Lauren, that have all but crowded out the old staples of myth and scripture. Gay men and lesbians are, like everyone else, consumers, and they form an attractive market segment increasingly wooed both by major corporations and community entrepreneurs. Advertising is capitalism's version of courtship, but marriage to the mainstream is dearly bought: in a postmodern commodity culture grown less political than the Stonewall generation, freedom of expression and individual liberty have been reduced to personal choice among brand names.

Creative gays, especially the stereotypical "design queen," remain prominent in mainstream fashion and product design, advertising photography and illustration, and entertainment; when AIDS hit, New York's design industry responded with sympathy and fund-raisers. Several trademark couturiers are gay: Halston was a fixture on the 1970s disco scene, his evenings with Andy Warhol at New York's glitzy Studio 54 chronicled in the gossip columns. When Italian stylist Gianni Versace, who also designed for theater and dance, was murdered by a young gay freeloader in 1997, Britain's Diana, Princess of Wales, and pop music superstar Elton John joined the worldwide mourners; a month later John performed at Diana's own televised funeral, for which he became the second openly gay performer knighted by Queen Elizabeth II.

In their commissions for arts and fashion trendsetters from *Vogue* to *Rolling*

Stone, photographers like Herb Ritts and Bruce Weber, who both worked for Versace, carry on the romantic elegance of George Platt Lynes and Cecil Beaton. Their popularity marks less the triumph of a specifically gay sensibility than society at large catching up with the subculture's appreciation of physical beauty. Gay men broke the ice for scantily clad athletic types in 1940s muscle magazines; once Madison Avenue realized it could exploit that sex appeal, Calvin Klein hired Weber to shoot his designer underwear on otherwise naked bodies, and every advertising model, male or female, became as achingly gorgeous as the studs in *Physique Pictorial*. Weber's 1987 Whitney Museum retrospective crowned him a modern master, all but erasing the line between elite and mass art.

Upscale products and services, from American Telephone to Tanqueray gin, increasingly target gays. But even hungry corporations are always looking over their shoulders, lest advertising that condones homosexuality set off a conservative boycott; outside a few campaigns tailored to the gay press and a brief craze for lesbian punk in the mid-1990s, mainstream ads have shrouded same-sex couples in ambiguity. One notable exception graced the long-running series *Dewar's Profiles*, testimonials for the Scotch whiskey that accompanied famous faces with thumbnail biographies. In 1989, playing discreetly on the gay male aura of refined connoisseurship that dates back to William Beckford, one profile paired art-world kingmaker Henry Geldzahler (once painted by David Hockney) with painter Scott Kilgour, snapped as the dapper curator was fondling his younger companion's shaggy curls.

By the '90s, as gays and lesbians moved from social struggle to social status, they hankered after the good life, and more of them could afford it. Creative gay companies like Waynesart and American Postcard cater to this niche market with a staggering array of arts and crafts: posters, greeting cards, calendars, rainbow flags, dolls and teddy bears, and jewelry sporting gay symbols like the lambda or the feminist double axe. These small businesses reach customers through ads in the gay press, more explicit and humorous than mainstream corporate appeals.

Lifestyle monthlies like *Out* in New York (founded 1992) and London's *Gay Times* are a second wave of gay press: though still carrying news bulletins, these are no longer "movement" publications. Most downplay activism and advocacy for breezy features on arts, entertainment, fashion, travel, and sports—how to live well "after you're out." The male market is more lucrative, but some magazines like *The Advocate* try to cover both sexes; the growing women's press is typified by London's *Diva*, which an Australian reader praised in 1997 for recognizing that "whilst lesbians love women, we want the gossip, news, product shopping that straight magazines offer." Not surprisingly for a minority associated with creative taste, gay "glossies" are well designed: they are named for the costly upgrade from newsprint to shiny paper, which sharpened art reproduction and encouraged bold, colorful graphics. Taiwan's *GL* splashes its

oversize pages with illustrated articles on manga cartoons, the Internet, and the lesbian pop music poster girl k.d. lang.

This visual sea change parallels a shift in the social current. A typical *Diva* cover from 1997 (color plate 32) spotlights artist Cheryl Dunye, acclaimed for *The Watermelon Woman*, a 1996 mock documentary that collaged her own fake antique photographs of a fictional flapper and her friends into a wry fantasy scrapbook of African-American history. Some of Dunye's invented scenes showed lesbians, as if she had unearthed a trove of forgotten sepia-toned snapshots from Harlem Renaissance godmother A'Lelia Walker's attic; she later displayed the still pictures at the Whitney Biennial. Establishment accolades earned Dunye star treatment, and although her quizzical stare and knowing smirk suggest a well-dressed bad girl, any hint of radical anger is neutralized by the frame of media celebrity, with its bold type and snappy slogans. The headline, "Direct Action," punningly shifts what that phrase would have meant to the previous generation, from politics to entertainment: alienation and protest are no longer so necessary, so chic, nor so welcome.

The mass media that enrich images with movement and sound produce fiction, documentary, and erotica both commercially and under gay auspices. Germany's Rainer Fassbinder and Spain's Pedro Almodóvar are among mainstream filmmakers who have treated gay themes; English-language studios have brought out sensitive gay dramas, drag comedies, and adaptations of classic novels like E. M. Forster's *Maurice* and Virginia Woolf's gender-bending *Orlando* (with Quentin Crisp, the last of the flaming queens, cross-dressed as Elizabeth I). Community-based gay and lesbian directors now churn out enough fiction and fact to fill an international circuit of yearly film festivals; documentaries, dating back to Rosa von Praunheim, cover topics from turn-of-the-century Paris lesbians to black and Latino transvestites in New York.

The British artist, activist, and writer Derek Jarman (1942–94) brought a painter's eye and an art historian's knowledge to movies inspired by literature and legend. *Sebastiane* (1975), which explored the sadomasochistic undertones of the martyred Roman saint, is the only film with Latin dialogue; *Edward II* adapted Marlowe's Elizabethan tragedy of royal lust, while *Caravaggio* (1986) detailed the works and loves of the bisexual baroque painter. Jarman embroidered plots and anachronistically jumbled past and present, stressing both the artifice of filmmaking and the contemporary echoes in his age-old stories. A still from *Caravaggio* (fig. 7.17) catches the tender aftermath of a knife brawl between the painter and his young beloved Ranuccio, when a friend bathes and comforts the artist's Christlike wound in a theatrically lighted vignette copied, like many scenes, from Caravaggio's own painting. Though a pale shadow of that Renaissance revival preached by the homosexual Victorian aesthetes, Jarman's historical pageants answer to the same yearning for a usable past, for new images that reclaim an ancient heritage.

Videotape and television, film's electronic offspring, have mushroomed as

7.17. (opposite) Derek Jarman (director), **Caravaggio**, 1986 (film still).

fine art, chronicle, and erotica. Tape's purely aesthetic mode, first recognized by the 1986 *Homovideo* display at Manhattan's New Museum, is now a staple of gay exhibitions; offerings range from AIDS narratives to the postmodern whimsy of Liss Platt and Diane Bonder's *Painting by Numbers* (1996), in which famous pictures come to life as they are "lesbianized." Though too much frankness can still spook advertisers, network television increasingly features gay characters in comedy and drama. The breathlessly publicized 1997 episode of American Broadcasting Company's *Ellen*, in which the heroine came out on-screen, became a nationwide media circus: protesters got it banned locally, while gay groups partied because, as noted by the Kansas City chapter chairwoman of the gay media watchdog GLAAD, "television is really where a lot of people get their ideas about other people."

In the infant medium of cyberspace, culture flows in all directions simultaneously, in a worldwide web of instant digital information, growing daily in visual sophistication. Gay Web sites include organizations, magazines, and catalog shopping; Queer Arts Resource maintains a virtual museum of historical and contemporary works (queer-arts.org). With images of gay life and chat-room contacts accessible at the click of a mouse, future teenagers will be less likely to grow up thinking they're "the only one." They can even buy pictures through gayart.com, a service that, like much of the Web, straddles culture and commerce; the Tom of Finland Foundation site markets merchandise imprinted with his drawings, and Bangkok's online Utopia Gallery leapfrogs unwelcoming national borders.

We are swamped by these images: overflowing the bounds of media, sexual orientation, and geography, they are washing away traditional painting and writing as the wellspring of stories that shape and celebrate human experience. Like any technology, mass-produced images hold the double-edged potential for liberating individual voices and propagating mindless conformity. For better or for worse, these are now the media that matter, the arts that catch the public eye and rouse its passions.

THE PRESENT AND THE FUTURE

In his fire-and-brimstone speech to the 1992 Republican Party Convention, the conservative standard-bearer Patrick Buchanan declared, "There is a culture war going on for the soul of America"—and fingered homosexual activists as one clear and present enemy. But his allies were already waging a rearguard action against victories that have opened the gates to gay and lesbian legislators, judges, performers, and artists, from New England to New Zealand. Hatred still smolders in pockets of powerful resistance, and gay inroads into the mainstream may fan the embers into white-hot rage. But as Soviet premier Mikhail Gorbachev, whose reforms led communism to the guillotine, ob-

served, a movement has succeeded not when everything is perfect, but when so much has changed that there can be no going back.

The mammoth events marking Stonewall's twenty-fifth anniversary in 1994 showcased the unprecedented acceptance and creative vitality achieved in a single generation. New York, symbolic birthplace of contemporary activism, drew more than a quarter million marchers and tourists to a cultural extravaganza embracing the international Gay Games, arts events, and a parade that carried a mile-long rainbow flag past United Nations headquarters. For older participants, sobered by struggle, this milestone could still evoke a delighted though bittersweet surprise; for younger spectators, such bountiful exuberance is the only gay world they have ever known. Europe mounts similar multifaceted festivals: the continent-wide Europride rotates its host city annually, and the 1998 Gay Games in Amsterdam, attended by the prime minister, were accompanied by art exhibitions at the world-renowned Rijksmuseum and a dozen galleries.

Gays and lesbians have taken a seat at the family table of Western culture. A few relatives are still not easy to get along with—the athletic games are forbidden to use the name "Olympics"—but London's weekly arts guide *Time Out* now devotes a section to gay listings. One 1997 headline wondered about the city's gay pride festival, "WILL IT AVOID BECOMING ANOTHER VICTIM OF ITS OWN SUCCESS?" And in fact gay culture as it has formed since the dawn of the modern era, based on oppression, secrecy, and separation, is in danger of going the way of the dinosaurs. Along with an increasing tolerance for minorities, mainstream society has itself blurred many of the rigid gender boundaries that downgraded homosexuals: something of the dandy's aesthetic refinement lies behind every upscale male consumer, and something of the assertive diesel dyke behind every woman who works. Gays have changed too, from high camp to high seriousness. Camp, the exaggerated parody of normalcy whose bitterly frivolous humor sustained the powerless since Oscar Wilde, sailed like the *Titanic* into the iceberg of social integration, which may sink everyone except a few drag queens in the lifeboats.

This cultural evolution is accelerated by a generational changing of the guard, in the gay community as all across society. Artists born since the 1960s have grown up on a steady diet of openly gay politics and images; now that sexual orientation is more a fact of life than a stigma, many feel less need to crusade about it through their work. And they drank in their cradles the milk of multicultural multimedia, the global flood of electronic images that is dissolving familiar patterns of patronage and audience—stodgy elite versus radical avant-garde—into a blur of video pixels and mass marketing. The 1997 Europride festival in Paris and the 1998 Gay Games set up Web sites, raised funds by selling T-shirts and souvenirs, and attracted corporate sponsorship in the name of diversity and dollars—just like any other commercial entertainment, from soccer matches to rock concerts.

The scope and maturity of this contemporary visual industry were displayed in summer 1998, when Stockholm hosted the first World Conference on Lesbian and Gay Culture. A four-day smorgasbord of panels, art shows, and performances was organized by the Tupilak group for queer arts workers in Nordic countries, a member of the International Lesbian and Gay Cultural Network. That network marshaled creators and critics from North and South America and Australia to report on public monuments, artists in South Africa, the global gay press, and body painting—and treated them to a film festival, a photography exhibit, and a Spanish translation of *Bent*, the gay drama set in the Nazi-era, staged by Spain's García Lorca Theater.

Though the present always seems less coherent than the past, the current richness of gay and lesbian art is, like all of postmodern culture, undeniably tentative, fragmented, and contested. As to where it will go from here, it is not the historian's task to predict the future, only to trace how we have arrived where we are: on the threshold of a new and productive chapter in the unfolding story of sexuality, society, and the arts.

The following suggestions emphasize readily available books and articles (most in English) that provide broad background or important case studies. Books on individuals are generally not listed, since they may be easily found under the artists' names in catalogs and bibliographies. Although reticence lingers, as a rule the more recent the monograph or biography the more likely it is to deal frankly with the subject's lesbian, gay, or bisexual life.

Introduction: From Stone Age to Stonewall

For general cultural reference, see Wayne R. Dynes, ed., *Encyclopedia of Homosexuality* (New York: Garland, 1990), and Claude Summers, ed., *The Gay and Lesbian Literary Heritage* (New York: Holt, 1995). For social background, a still useful one-volume survey is Vern R. Bullough, *Sexual Variance in Society and History* (New York: John Wiley, 1976). Guides to more detail include Wayne R. Dynes, *Homosexuality: A Research Guide* (London and New York: Garland, 1987); James M. Saslow et al., eds., *Bibliography of Gay and Lesbian Art* (New York: College Art Association Gay and Lesbian Caucus, 1994).

Broad works on art and eros that cover homosexuality in various world cultures include Peter Webb, *The Erotic Arts* (Boston: New York Graphic Society, 1975); Edward Lucie-Smith, *Sexuality in Western Art* (London: Thames and Hudson, 1991); Theodore Bowie and Cornelia V. Christenson, eds., *Studies in Erotic Art* (New York: Basic Books, 1970); Phyllis and Eberhard Kronhausen, *Erotic Art* (New York: Grove, 1968). For additional suggestions, see Eugene C. Burt, *Erotic Art: An Annotated Bibliography* (New York: Garland, 1989).

Numerous anthologies on gay history and culture discuss visual arts. For early gay studies, see Karla Jay and Allen Young, eds., *Lavender Culture* (New York: Jove/HBJ, 1979; reprinted 1994), especially James M. Saslow, "Closets in the Museum: Homophobia and Art History." Also Wayne Dynes and Stephen Donaldson, eds., *Homosexuality and Homosexuals in the Arts* (New York: Garland, 1992); Whitney Davis, ed., *Gay and Lesbian Studies in Art History* (New York: Haworth Press, 1994, also published as *Journal of Homosexuality* 27, 1994); Martin Duberman, Martha Vicinus, and George Chauncey, Jr., eds., *Hidden from History* (New York: Penguin/NAL, 1989).

On tribal cultures, for Oceania, see Gilbert H. Herdt, *Ritualized Homosexuality*

in Melanesia (Berkeley: University of California Press, 1984). For the Americas: Walter Williams, *The Spirit and the Flesh: Sexual Diversity in American Indian Culture* (Boston: Beacon Press, 1986); Will Roscoe, *The Zuni Man-Woman* (Albuquerque: University of New Mexico Press, 1991); Paul Gebhard, "Sexual Motifs in Prehistoric Peruvian Ceramics," in Bowie and Christenson. On Mesopotamia and Iran: Robert Surieu, *Sarv e naz* (Geneva: Nagel, 1967).

Chapter 1: The Classical World

The most comprehensive study of classical culture is K. J. Dover, *Greek Homosexuality* (New York: Random House, 1978; reprint Cambridge, Mass.: Harvard University Press, 1989), richly illustrated. Homosexual imagery forms part of a wider context in Otto Brendel, "The Scope and Temperament of Erotic Art in the Greco-Roman World," in Theodore Bowie and Cornelia V. Christenson, eds., *Studies in Erotic Art* (New York, Basic Books, 1970); in Brendel's *Etruscan Art* (New Haven, Conn.: Yale University Press, 1978); and in John Boardman and Eugenio LaRocca, *Eros in Greece* (New York: Erotic Art Book Society, 1978). For newer findings, see David Halperin, John Winkler, and Froma Zeitlin, eds., *Before Sexuality: The Construction of Erotic Experience in the Ancient Greek World* (Princeton: Princeton University Press, 1990); Natalie Kampen, ed., *Sexuality in Ancient Art* (New York and Cambridge: Cambridge University Press, 1996). For broader cultural issues, see Bernard Sergent, *Homosexuality in Greek Myth* (Boston: Beacon, 1986); Eva Cantarella, *Bisexuality in the Ancient World* (New Haven, Conn.: Yale University Press, 1992); Sarah Pomeroy, *Goddesses, Whores, Wives, and Slaves: Women in Classical Antiquity* (New York: Schocken, 1975).

Roman visual arts have been studied most comprehensively by John R. Clarke, especially his *Looking at Lovemaking: Constructions of Sexuality in Roman Art* (Berkeley: University of California Press, 1998) and articles including "The Warren Cup and the Contexts for Representations of Male-to-Male Lovemaking in Augustan and Early Julio-Claudian Art," *Art Bulletin* 75 (1993). On Roman culture, see Amy Richlin, *The Garden of Priapus: Sexuality and Aggression in Roman Humor* (New Haven, Conn.: Yale University Press, 1983), and her *Pornography and Representation in Greece and Rome* (Oxford: Oxford University Press, 1992).

Chapter 2: The Middle Ages

The Middle Ages have been the least studied period for Western homosexuality and art, perhaps because the material is so meager. The best general study of medieval eros, which includes some visuals, is John Boswell, *Christianity, Social Tolerance, and Homosexuality* (Chicago: University of Chicago Press, 1980). Additional images are shown in Boswell's *Same-Sex Unions in Premodern Europe* (New York: Random House, 1994). Visual arts on homosexual themes are discussed by Michael Camille, *The Gothic Idol: Ideology and Image-Making* (Cambridge: Cambridge University Press, 1989); Anthony Weir and James Jarman, *Images of Lust: Sexual Carvings on Medieval Churches* (London: Batsford, 1986); Ilene Forsyth, "The Ganymede Capital at Vézelay," *Gesta* 15 (1976). The link between homosexuality and pagan survival was popularized by Arthur Evans, *Witchcraft and the Gay Counterculture* (Boston: Fag Rag Books, 1978).

Chapter 3: From Renaissance to Reform

The most inclusive overview of this period is Andreas Sternweiler, *Die Lüst der Götter: Homosexualität in der italienischen Kunst von Donatello zu Caravaggio* (Berlin: Rosa Winkel, 1993). In English, see James M. Saslow, "Homosexuality in the Renaissance: Behavior, Identity, and Artistic Expression," in Martin Duberman, Martha Vinicus, and George Chauncey, Jr., eds., *Hidden from History* (New York: Penguin/ NAL, 1989). On one specific myth, see James M. Saslow, *Ganymede in the Renaissance: Homosexuality in Art and Society* (New Haven, Conn.: Yale University Press, 1986); on religious painting, Joseph Manca, "Sacred vs. Profane: Images of Sexual Vice in Renaissance Art," *Studies in Iconography* 13 (1989–90). On lesbian imagery, see the work of Patricia Simons, especially "Lesbian (In)visibility in Italian Renaissance Culture: Diana and Other Cases of *donna con donna*," in Whitney Davis, ed., *Gay and Lesbian Studies in Art History* (Binghamton, NY: Harrington Park Press, 1994).

For social background, see Alan Bray, *Homosexuality in Renaissance England* (London: Gay Mens Press, 1982), with illustrations; Guido Ruggiero, *The Boundaries of Eros: Sex Crime and Sexuality in Renaissance Venice* (Oxford: Oxford University Press, 1985); Michael Rocke, *Forbidden Friendships: Homosexuality and Male Culture in Renaissance Florence* (Oxford: Oxford University Press, 1996); Judith Brown, *Immodest Acts: The Life of a Lesbian Nun in Renaissance Italy* (Oxford: Oxford University Press, 1986). Psychoanalytic studies began with Sigmund Freud, *Leonardo da Vinci and a Memory of His Childhood* (Harmondsworth: Penguin, 1963); among more recent authors, see Robert S. Liebert, *Michelangelo: A Psychoanalytic Study of His Life and Images* (New Haven, Conn.: Yale University Press, 1983). For Spanish America, see Walter Williams, *The Spirit and the Flesh: Sexual Diversity in American Indian Culture* (Boston: Beacon, 1986).

Chapter 4: Asia and Islam

For general introductions, see Philip Rawson, *Erotic Art of the East* (New York: Putnam, 1968); Peter Webb, *The Erotic Arts* (Boston: New York Graphic Society, 1975), chapter 3; and the essays on individual cultures in Phyllis and Eberhard Kronhausen, *Erotic Art* (New York: Grove Press, 1968).

On India, Alain Danielou, *La Sculpture érotique hindoue* (Paris: Buchet/Chastel, 1973) has rare pictures; Nepalese lesbian carving is reproduced in Francis Leeson, *Kama Shilpa: A Study of Indian Sculptures Depicting Love in Action* (Bombay: Taraporevala, 1962). For more recent social and art history, see Giti Thadani, *Sakhiyani: Lesbian Desire in Ancient and Modern India* (London and New York: Cassell, 1996); some of her images also appeared in the South Asian anthology *Ratti: A Lotus of Another Color* (Boston: Alyson, 1993).

On China, Bret Hinsch, *Passions of the Cut Sleeve: The Male Homosexual Tradition in China* (Berkeley: University of California Press, 1990) offers a comprehensive sexual history; Jonathan Spence, *The Memory Palace of Matteo Ricci* (New York: Viking, 1984) discusses Ricci's engravings; Abraham Franzblau (introduction), *Erotic Art of China* (New York: Crown, 1977) has numerous illustrations. The subject was first treated by Robert H. van Gulik, *Erotic Colour Prints of the Ming Period* (Tokyo: privately printed, 1951), whose collection of images and literature is still an indispensable source for much material now lost.

On Japan, see Theodore Bowie, "Erotic Aspects of Japanese Art," in Theodore Bowie and Cornelia V. Christenson, eds., *Studies in Erotic Art* (New York: Basic Books, 1970), Tsuneo Watanabe and Jun'ichi Iwata, *The Love of the Samurai: A Thousand Years of Japanese Homosexuality* (London: GMP, 1989); and Gary Leupp, *Male Colors: The Construction of Homosexuality in Tokugawa Japan* (Berkeley: University of California Press, 1995), richly illustrated.

On Islam, Surieu, *Sarv e naz* includes some homoerotic examples. Islamic erotic art has otherwise been little studied in English apart from the Kronhausens, though some visual references are included in Arno Schmitt and Jehoeda Sofer, eds., *Sexuality and Eroticism Among Males in Moslem Societies* (Binghamton, N.Y.: Harrington Park Press, 1992). The Freer Jami has been published by Marianna Shreve Simpson, *Sultan Ibrahim Mirza's "Haft awrang"* (New Haven, Conn.: Yale University Press, 1997).

Chapter 5: From Winckelmann to Wilde

The fundamental survey of the modern period is Emmanuel Cooper, *The Sexual Perspective: Homosexuality and Art in the Last 100 Years in the West* (London: Routledge, 1994). Lillian Faderman, *Surpassing the Love of Men: Romantic Friendship and Love Between Women* (New York: William Morrow, 1981), combines literary and social history with some illustrations. Robert Aldrich, *The Seduction of the Mediterranean: Writing, Art, and Homosexual Fantasy* (London: Routledge, 1993), explores the cultural dynamics between northern Europe, the south, and beyond; essays in Peter Horne and Reina Lewis, eds., *Outlooks: Lesbian and Gay Sexualities and Visual Cultures* (New York: Routledge, 1997) cover the nineteenth century through the present. For principal female artists mentioned, see Charlotte Streifer Rubinstein, *American Women Artists* (Boston: G. K. Hall, 1982) and Whitney Chadwick, *Women, Art, and Society* (New York: Thames and Hudson, 1990).

On eighteenth-century culture, see Alan Bray (as in chapter 3), and articles by Randolph Trumbach and others in G. S. Rousseau and Roy Porter, eds., *Sexual Underworlds of the Enlightenment* (Chapel Hill: University of North Carolina Press, 1988) and in Robert Maccubbin, ed., *Tis Nature's Fault: Unauthorized Sexuality During the Enlightenment* (Cambridge: Cambridge University Press, 1987). For the Netherlands, see Louis Crompton, "Gay Genocide from Leviticus to Hitler," in Louie Crew, ed., *The Gay Academic* (Palm Springs, Calif.: ETC, 1978), and a more comprehensive study in Dutch by Theo van der Meer, *Sodoms zaad in Nederland* (Nijmegen: SUN, 1995). On neoclassicism, see Alex Potts, *Flesh and the Ideal: Winckelmann and the Origins of Art History* (New Haven, Conn.: Yale University Press, 1994); for David and Girodet, see Thomas Crow, *Emulation: Making Artists for Revolutionary France* (London: Yale University Press, 1995), and articles by Crow and Whitney Davis in Norman Bryson, Michael Ann Holly, and Keith Moxey, eds., *Visual Culture: Images and Interpretations* (Hanover, N.H.: University Press of New England, 1994).

On realism, see Dorothy Kosinski, "Gustave Courbet's *The Sleepers*: The Lesbian Image in Nineteenth-Century French Art and Literature," *Artibus et historiae* 18 (IX), 1988; James M. Saslow, "Disagreeably Hidden: Construction and Constriction of the Lesbian Body in Rosa Bonheur's *Horse Fair*," in Norma Broude and Mary Garrard, eds., *The Expanding Discourse: Feminism and Art History* (New York: Harper-

Collins, 1992). On Courbet, Baudelaire, and Swinburne, see Thaïs Morgan, "Male Lesbian Bodies," *Genders* 15 (1992); on Meurent, Eunice Lipton, *Alias Olympia* (New York: Scribner's, 1992). For Australia, see Robert Hughes, *The Art of Australia* (Harmondsworth: Penguin, 1970).

On aestheticist art and criticism, see Phyllis Grosskurth, *John Addington Symonds: A Biography* (New York: Arno, 1975); Richard Ellmann, *Oscar Wilde* (New York: Knopf, 1988); H. Montgomery Hyde, *The Annotated Oscar Wilde* (New York: Clarkson Potter, 1982); Richard Dellamora, *Masculine Desire: The Sexual Politics of Victorian Aestheticism* (Chapel Hill: University of North Carolina Press, 1990); Philippe Jullian, *Dreamers of Decadence* (New York: Praeger, 1975); Bram Dijkstra, *Idols of Perversity: Fantasies of Feminine Evil in Fin-de-siècle Culture* (New York: Oxford University Press, 1986).

On photography, see Allen Ellenzweig, *The Homoerotic Photograph* (New York: Columbia University Press, 1992); Peter Weiermair, *The Hidden Image: Photographs of the Male Nude* (Cambridge, Mass.: MIT Press, 1988); Thomas Waugh, *Hard to Imagine: Gay Male Eroticism in Photography and Film* (New York: Columbia University Press, 1996). For architecture, see Aaron Betsky, *Queer Space: Architecture and Same-Sex Desire* (New York: William Morrow, 1997); Douglass Shand-Tucci, *Boston Bohemians 1881–1900: Ralph Adams Cram* (Amherst: University of Massachusetts Press, 1995).

For Germany, see James D. Steakley, *The Homosexual Emancipation Movement in Germany* (Salem, N.H.: Ayer, 1982), with pictures drawn from period publications, and the illustrated catalogs for two exhibitions in Berlin: *Eldorado: Homosexuelle Frauen und Männer in Berlin 1850–1950* (Berlin Museum, 1984), and *Goodbye to Berlin?: 100 Jahre Schwulenbewegung* (Akademie der Künste, Schwules Museum, 1997).

Chapter 6: Modernism, Multiplicity, and the Movement

Many studies listed for chapter 5 continue into the periods of chapter 6 and 7, especially Aldrich, Betsky, Chadwick, Cooper, *Eldorado*, Ellenzweig, *Goodbye*, Horne and Lewis, Steakley, Waugh, and Weiermair. For general history of the period in America, see George Chauncey, *Gay New York 1890–1940* (New York: Basic Books, 1994); Charles Kaiser, *Gay Metropolis: New York 1940–1996* (Boston: Houghton Mifflin, 1997); Jonathan Ned Katz, *Gay American History* (New York: Avon, 1976). On film, see Vito Russo, *The Celluloid Closet: Homosexuality in the Movies* (New York: Harper & Row, 1987).

On Paris women, see Karla Jay, *The Amazon and the Page* (Bloomington: Indiana University Press, 1988), and Sheri Benstock, *Women of the Left Bank: Paris 1900–1940* (Austin: University of Texas Press, 1986); on Radclyffe Hall, see Esther Newton in Martin Duberman, Martha Vicinus, and George Chauncey, Jr., eds., *Hidden from History* (New York: Penguin/NAL, 1989). Other articles in Duberman discuss the German popular press (James Steakley) and the Harlem Renaissance (Eric Garber). On Demuth and Hartley, see their catalogs from the Whitney Museum (1980, 1987), and Jonathan Weinberg, *Speaking for Vice* (New Haven, Conn.: Yale University Press, 1993). Canadian police photos are discussed in Steven Maynard, "Through a Hole in the Lavatory Wall . . . Toronto 1890–1930," *Journal of the History of Sexuality* 5:2 (1994).

For post–World War II movements and personalities, see F. Valentine Hoo-

ven III, *Beefcake: The Muscle Magazines of America 1950–1970* (Cologne: Taschen, 1995); Steven Watson, *The Birth of the Beat Generation* (New York: Pantheon, 1995); John Gruen, *The Party's Over Now* (New York: Viking, 1972); Marjorie Perloff, *Frank O'Hara: Poet Among Painters* (Austin and London: University of Texas Press, 1979); Lee Hall, *Betty Parsons: Artist, Dealer, Collector* (New York: Abrams, 1991). Susan Sontag defined and homosexualized camp in her essay "Notes on 'Camp' " in *Against Interpretation and Other Essays* (New York: Farrar, Straus & Giroux, 1966). On pop, see Kenneth Silver, "Modes of Disclosure: The Construction of Gay Identity and the Rise of Pop Art," in *Hand-Painted Pop* (Los Angeles: Museum of Contemporary Art, 1993); Jonathan David Katz, "The Art of Code: Jasper Johns and Robert Rauschenberg," in Whitney Chadwick and Isabelle de Courtivron, eds., *Significant Others* (London: Thames and Hudson, 1993); the controversial monograph by Jill Johnston, *Jasper Johns: Privileged Information* (London: Thames and Hudson, 1996); Jennifer Doyle et al., eds., *Pop Out: Queer Warhol* (Durham, N.C.: Duke University Press, 1996).

Chapter 7: Post-Stonewall, Post-Modern

See the works listed for chapters 5 and 6 that also cover the contemporary period, including Kaiser, J. N. Katz, and Russo. For a year-to-year chronicle of cultural developments, see Mark Thompson, ed., *Long Road to Freedom: The Advocate History of the Gay and Lesbian Movement* (New York: St. Martin's, 1994). Anthologies of gay cultural studies include Diana Fuss, ed., *Inside/Out: Lesbian Theories, Gay Theories* (London and New York: Routledge, 1991); Henry Abelove, Michèle Barale, and David Halperin, eds., *The Lesbian and Gay Studies Reader* (New York: Routledge, 1993). Daniel Harris, *The Rise and Fall of Gay Culture* (New York: Hyperion, 1997), analyzes the effects of assimilation.

General introductions for women include Cherry Smyth, *Damn Fine Art: By New Lesbian Artists* (London: Cassell, 1996); Tessa Boffin and Jean Fraser, eds., *Stolen Glances: Lesbians Take Photographs* (New York: HarperCollins/Pandora, 1991); Susie Bright and Jill Posener, eds., *Nothing but the Girl: The Blatant Lesbian Image* (London and New York: Freedom Editions, 1996). The early movement was announced in the lesbian issue of *Heresies*, No. 3 (Fall 1977). See more recently Norma Broude and Mary Garrard, eds., *The Power of Feminist Art: The American Movement of the 1970s* (New York: Abrams, 1994); Harmony Hammond, *Lesbian Art: A Contemporary History* (New York: Rizzoli, 1999); and Camille Paglia, *Sexual Personae: Art and Decadence, from Nefertiti to Emily Dickinson* (New Haven, Conn.: Yale University Press, 1990).

The catalog of the exhibit at the University Art Museum in Berkeley offers essays surveying contemporary art: Nayland Blake, Lawrence Rinder, and Amy Scholder, eds., *In a Different Light: Visual Culture, Sexual Identity, Queer Practice* (San Francisco: City Lights Books, 1995). On the impact of AIDS, see Douglas Crimp, ed., *AIDS: Cultural Analysis/Cultural Activism* (Cambridge, Mass.: MIT Press, 1987); Simon Watney, *Policing Desire: Pornography, AIDS, and the Media* (London: Methuen, 1987); Rob Baker, *The Art of AIDS* (New York: Continuum, 1994). On public monuments, see Harriet Senie and Sally Webster, eds., *Critical Issues in Public Art* (New York: Icon, 1992); on public controversies, Steven C. Dubin, *Arresting Images: Im-*

politic Art and Uncivil Actions (London and New York: Routledge, 1992); on Radical Faeries, Mark Thompson, *Gay Soul: Finding the Heart of Gay Spirit and Nature* (San Francisco: HarperCollins, 1994).

On mass media and film, see Larry Gross, "Sexual Minorities and the Mass Media," in Ellen Seiter, ed., *Remote Control* (New York: Routledge, 1989); Chris Holmlund and Cynthia Fuchs, eds., *Between the Sheets, In the Streets: Queer, Lesbian, Gay Documentary* (Minneapolis: University of Minnesota Press, 1997); Martha Gever, John Greyson, and Pratibha Parmar, eds., *Queer Looks: Perspectives on Lesbian and Gay Film and Video* (New York: Routledge, 1993).

Color Plates

1. Etruscan, *Tomb of the Bulls*. Tarquinia, Museo Nazionale Tarquiniese. Scala/Art Resource, NY.
2. *Death of Orpheus*. Pompeii, House of the Vettii. Scala/Art Resource, NY.
3. *Scene from the Theater*. Pompeii, House of Pinarius Cerealis. Scala/Art Resource, NY.
4. *The Destruction of Sodom*. Monreale Cathedral, Sicily. Scala/Art Resource, NY.
5. *Union of Emperor Basil I and John*, from *The Chronicle of John Skylitzes*. Madrid, Biblioteca Nacional, Mss. Vitr. 26-2, fol. 85.
6. Hieronymus Bosch, *The Garden of Earthly Delights*. Madrid, Museo del Prado. Scala/Art Resource, NY.
7. Sodoma, *Marriage of Alexander the Great and Roxana*. Rome, Villa Farnesina. Scala/Art Resource, NY.
8. Correggio, *Rape of Ganymede*. Vienna, Kunsthistorisches Museum. Erich Lessing/Art Resource, NY.
9. School of Fontainebleau, *Gabrielle d'Estrées and Her Sister in the Bath*. Paris, Louvre. Erich Lessing/Art Resource, NY.
10. Caravaggio, *Victorious Amor*. Berlin, Gemäldegalerie, Staatliche Museen Preussischer Kulturbesitz. Nimatallah/Art Resource, NY.
11. China, *Two Men Making Love on a Terrace*. Courtesy of The Kinsey Institute for Research in Sex, Gender, and Reproduction, Bloomington, IN.
12. Riza-i Abbasi, *Two Lovers*. New York, The Metropolitan Museum of Art, Francis M. Weld Fund, 1950 (50.164). Photograph © 1977 The Metropolitan Museum of Art.
13. Turkey, *Male Group Scene*, in Nevi Zade Atai, *Khamsa* (Book of Mesnivis). Istanbul, Topkapi Palace Museum. SIPA Press/Art Resource, NY.
14. Giovanni Battista Tiepolo, *Death of Hyacinthus*. © Museo Thyssen-Bornemisza, Madrid.
15. Gustave Courbet, *Sleep*. Paris, Musée du Petit Palais. Erich Lessing/Art Resource, NY.
16. Jean Delville, *The School of Plato*. Paris, Musée d'Orsay. Giraudon/Art Resource, NY.
17. Tom Roberts (born Great Britain 1856, arrived Australia 1869, died 1931),

Shearing the Rams, 1890. Oil on canvas on composition board, 122.4 × 183.3 cm. Felton Bequest, 1932, National Gallery of Victoria, Melbourne.

18. Henri de Toulouse-Lautrec, *"La Goulue" at the Moulin Rouge*. The Museum of Modern Art, New York, photograph © 1999.

19. Leon Bakst, *Nijinsky in "The Afternoon of a Faun."* Hartford, Wadsworth Atheneum, The Ella Gallup Sumner and Mary Catlin Sumner Collection Fund.

20. Marsden Hartley, *Painting No. 47, Berlin*. Washington, Hirschhorn Museum and Sculpture Garden, Smithsonian Institution, Gift of Joseph H. Hirshhorn 1972. Photograph by Lee Stalsworth.

21. Charles Demuth, *Distinguished Air*. New York, Whitney Museum of American Art.

22. Frida Kahlo, *Two Nudes in the Jungle*. Courtesy of Mary-Anne Martin/Fine Art, New York.

23. Paul Cadmus, *The Fleet's In!* Oil on canvas, 30 × 60 inches. Collection: The Navy Museum, Washington, D.C. Courtesy DC Moore Gallery, New York City.

24. Book cover for Lilyan Brock, *Queer Patterns*. Eton Books, New York. International Gay Information Center Archives, Manuscripts and Archives Division, The New York Public Library; Astor, Lenox and Tilden Foundations.

25. David Hockney, *We Two Boys Together Clinging*, 1961, oil on board, 48″ × 60″, © David Hockney. Collection The Arts Council of Great Britain.

26. *The Advocate*, 11 November 1982 (issue 355). Photograph by Gene Bagnato. With permission of *The Advocate* © Liberation Publications Inc. November 11, 1982.

27. David Wojnarowicz, *Bad Moon Rising*. Courtesy of the Estate of David Wojnarowicz and P.P.O.W., New York.

28. *The NAMES Project Quilt*. Photo by Paul Margolies. © 1996 The NAMES Project Foundation.

29. Gilbert & George, *Sodom*. © The artist.

30. Rotimi Fani-Kayodé, *Every Moment Counts*. Courtesy Autograph ABP, London.

31. Bhupen Khakhar, *Green Landscape*. Courtesy of The Fine Art Resource, Mommsenstrasse 56, 10629 Berlin.

32. *Diva*, August/September 1997. Photographer: Sharron Wallace. Cover design: Elizabeth Grant.

Black-and-White Illustrations

I.1. George Catlin, *Dance to the Berdache*. National Museum of American Art, Washington, D.C./Art Resource, NY.

I.2. Perso-Median seal. *Two Men Copulating*. Iran, Collection M. Foroughi. © Copyright by Les Editions Nagel SA & Guillaume Briquet Geneva (Switzerland); all rights reserved in all countries.

1.1. Sosias Painter, *Achilles Binding the Wounds of Patroclus*. Berlin, Staatliche Museen Preussischer Kulturbesitz, Antikensammlung no. F2278. © 1998 BPK.

1.2. Crete, *Two Hunters*. Paris, Louvre, no. MNC 689. Giraudon/Art Resource, NY.

1.3. *Harmodius and Aristogiton*. Naples, Museo Archeologico Nazionale. Alinari/Art Resource, NY.

1.4. Group of Polygnotos, *Sappho and Attendants*. Athens, National Archeological Museum, no. 1260. Alinari/Art Resource, NY.

1.5. *Three Men Courting a Youth*. Munich, Staatlichen Antikensammlungen und Glyptothek. Photo by Blow Up SW-Fotofachlabor GmbH.

1.6. Aegisthus Painter, *Youth Brandishing a Lyre at a Suitor*. © Fitzwilliam Museum, University of Cambridge.

1.7. Douris Painter, *Zephyrus and Hyacinthus*. Catharine Page Perkins Fund. Courtesy, Museum of Fine Arts, Boston.

1.8. Circle of the Nikosthenes Painter, *Satyr Scene*. Berlin, Staatliche Museen Preussischer Kulturbesitz, Antikensammlung no. 1964.4. © 1998 BPK.

1.9. Hegesiboulos Painter, *Symposium Scene*. New York, The Metropolitan Museum of Art, Rogers Fund, 1907 (no. 07.286.47).

1.10. Brygos Painter, *Man and Youth Initiating Intercrural Intercourse*. Ashmolean Museum, Oxford, no. 1967.304.

1.11. *Scene from Euripides' "Chrysippus."* Berlin, Staatliche Museen Preussischer Kulturbesitz, Antikensammlung no. 1968.12. © 1998 BPK.

1.12. *Jupiter and Ganymede*. Olympia, Archeological Museum. Vanni/Art Resource, NY.

1.13. Polyclitus, *Doryphorus*. Naples, Museo Archeologico Nazionale. Alinari/Art Resource, NY.

1.14. Polyclitus, *Wounded Amazon*. Vatican City, Vatican Museums. Alinari/Art Resource, NY.

1.15. Lysippus, *Alexander the Great*. Paris, Louvre. Art Resource, NY.

1.16. *Alexander and Hephaestion with Hercules*. Roman, from Athens, fragment of a sarcophagus, marble, 2nd/3rd century A.D., 96 × 130.5 cm, Gift of the Alsdorf Foundation, 1983.584. Photograph © 1998, The Art Institute of Chicago. All Rights Reserved.

1.17. *Apollo Belvedere*. Vatican City, Vatican Museums. Alinari/Art Resource, NY.

1.18. *Pan and Olympus (or Daphnis)*. Rome, Museo Nazionale Romano delle Terme. Alinari/Art Resource, NY.

1.19. *Barberini Faun*. Munich, Staatliche Antikensammlungen, Glyptothek, no. 218. Vanni/Art Resource, NY.

1.20. *Sleeping Hermaphrodite*. Rome, Museo Nazionale Romano delle Terme, no. 1087. Alinari/Art Resource, NY.

1.21. *Two Women in Intimate Conversation*. London, British Museum, no. C529. © The British Museum.

1.22. *Antinous*. Vatican City, Vatican Museums. Alinari/Art Resource, NY.

1.23. *Pan Uncovering Hermaphroditus*. Naples, Museo Nazionale Archeologico, inv. no. R.P. 27700. Erich Lessing/Art Resource, NY.

1.24. *The Warren Cup*. Stanford Place Collection, on loan to Metropolitan Museum of Art, New York, no. L.1991.95. © Trustees, Stanford Place Collection. Photograph by Richard Pearson.

2.1. *Two Hyenas Embracing. Physiologus*, 12th century. New York, Pierpont Morgan Library, ms. 832, fol. 4.

2.2. *Rape of Ganymede*. Vézelay, Ste. Madeleine, first pillar on south side of nave. Foto Marburg/Art Resource, NY.

2.3. *Christ and Saint John the Evangelist*. Berlin, Staatliche Museen Preussischer Kulturbesitz. Foto Marburg/Art Resource, NY.

2.4. *Adam and Eve and Sodomites*, from *Bible moralisée*. Vienna, Österreichische Nationalbibliothek, cod. 2554, fol. 2r.

2.5. *Dante and Virgil Meet the Sodomites (Inferno 15)*, from Guido da Pisa, *Commentary on Dante*. Chantilly, Musée Condé, ms. 1424, fol. 113v-114r. Photographie Giraudon.

2.6. *Jonathan, David, and Saul*, from *Somme le roi*. London, British Library, Add. ms. 28162, fol. 6v. By permission of the British Library.

2.7. *Templar Kissing Cleric*, from Jacques de Longuyon, *Voeux du Paon*. New York, Pierpont Morgan Library, William Glazier collection (on deposit), ms. 24, fol. 93, detail.

2.8. *Richard Puller Burned at the Stake, Zürich, 1482*, from Diebold Schilling, *Die Grosse Burgunder-Chronik*. Zürich, Zentralbibliothek, Alte Drucke, Ms. A5, p. 994.

3.1. Donatello, *David*. Florence, Museo Nazionale del Bargello. Alinari/Art Resource, NY.

3.2. Fra Carnevale, *Presentation of the Virgin in the Temple*. Charles Potter Kling Fund. Courtesy, Museum of Fine Arts, Boston.

3.3. Signorelli, *School of Pan*. Formerly Berlin, Kaiser Friedrich Museum (destroyed). Giraudon/Art Resource, NY.

3.4. Leonardo da Vinci, *Saint John the Baptist*. Paris, Louvre. Alinari/Art Resource, NY.

3.5. Zoan Andrea, *Woman and Her Maid*. Milan, Biblioteca Ambrosiana. Property of the Ambrosian Library. All rights reserved. Reproduction is forbidden.

3.6. Dürer, *Death of Orpheus*. Hamburg, Kunsthalle. Foto Marburg/Art Resource, NY.

3.7. Dürer, *Bathhouse*. Paris, Bibliothèque Nationale. Giraudon/Art Resource, NY.

3.8. Hans Baldung Grien, *Witches' Orgy*. Vienna, Graphische Sammlung Albertina. Foto Marburg/Art Resource, NY.

3.9. Michelangelo, *Bacchus*. Florence, Museo Nazionale del Bargello. Alinari/Art Resource, NY.

3.10. Sodoma, *Saint Sebastian*. Florence, Palazzo Pitti. Alinari/Art Resource, NY.

3.11. Michelangelo, *Rape of Ganymede*. Courtesy of the Fogg Art Museum. Harvard University Art Museums, Gifts for Special Uses Fund.

3.12. Master C. I., *Monk and Boy*. Écouen, Musée de la Renaissance. © photo R.M.N.—Hervé Lewandowski.

3.13. Jean Mignon, *Women Bathing*. Vienna, Graphische Sammlung Albertina.

3.14. Titian, *Diana and Actaeon*. Edinburgh, National Gallery of Scotland, Duke of Sutherland loan. Alinari/Art Resource, NY.

3.15. Theodore de Bry, *Balboa Feeding Indian "Sodomites" to the Dogs. America*, Frankfurt

1590, vol. 4, pl. XXII. Rare Books Division, The New York Public Library, Astor, Lenox and Tilden Foundations.

3.16. Cellini, *Apollo and Hyacinthus*. Florence, Museo Nazionale del Bargello. Alinari/Art Resource, NY.

3.17. Caravaggio, *Musicians*. New York, The Metropolitan Museum of Art, Rogers Fund, 1952 (no. 52.81).

3.18. *The Life and Death of John Atherton*. London, British Library, no. E.167.6. By permission of the British Library.

4.1. Mughal, *Lesbian Allegory*, from *Koka Shastra*. Paris, Bibliothèque nationale, ms. Suppl. Persan 938. Cliché Bibliothèque nationale de France.

4.2. *The Destruction of Sodom*, from *The Ink Garden of Mr. Cheng*, Beijing, 1609, vol. 6, p. 43a. Photo courtesy Columbia University, Starr East Asian Library.

4.3. India, *Monk and Layman*. Photo Raymond Burnier/Archives J. Cloarec.

4.4. China, *Ménage à Trois*, from *Chiang Nan Hsiao Hsia*. Reprinted from Robert H. van Gulik, *Erotic Colour Prints of the Ming Period* (Tokyo, 1951), vol. 1, pl. XV.

4.5. China, *Two Women Making Love*. Reprinted from van Gulik, *Erotic Colour Prints*, vol. 1, pl. IV.

4.6. Japan, *Monk and Samurai Visiting Actor-Prostitutes*. Reprinted from Tsuneo Watanabe, *The Love of the Samurai* (London, 1987), by permission of GMP (Gay Mens Press).

4.7. Japan, *Servant Chuta Warms the Chigo's Buttocks*. Sanpoin Temple, Daigo (Kyoto), Japan. Reprinted from Tsuneo Watanabe, *The Love of the Samurai* (London, 1987), by permission of GMP (Gay Mens Press).

4.8. *Shah Abbas I with a Page*. Paris, Louvre, No. MAO 494. © Réunion des Musées Nationaux—photo Gérard Blot.

5.1. *The Women-Hater's Lamentation*, 1707. Guildhall Library, Corporation of London.

5.2. *Temporal Punishments Depicted as a Warning* . . . Amsterdam, Rijksmuseum, Rijksprentenkabinet.

5.3. A. R. Mengs or G. B. Casanova, *Jupiter and Ganymede*. Rome, Galleria Nazionale d'Arte Antica (Palazzo Barberini-Corsini). Alinari/Art Resource, NY.

5.4. Pompeo Batoni, *Portrait of a Young Man*. New York, The Metropolitan Museum of Art, Rogers Fund, 1903 (no. 03.37.1).

5.5. Anton Ignatz Melling, *Interior of the Royal Harem, Topkapi Palace*. From his *Voyage pittoresque de Constantinople et des rives du Bosphore* (Paris, 1819), pl. 14. Avery Architectural and Fine Arts Library, Columbia University in the City of New York.

5.6. Jacques-Louis David, *Leonidas at Thermopylae*. Paris, Louvre. Giraudon/Art Resource, NY.

5.7. Anne-Louis Girodet de Roucy Trioson, *Bathyllus Drawing a Portrait for Anacreon*. *The Odes of Anacreon* (reprint, Paris, 1864), pl. 48. Courtesy Butler Library, Columbia University.

5.8. Henry Fuseli, *Bedroom Scene*. London, Victoria and Albert Museum/Art Resource, NY.

5.9. J.A.D. Ingres, *The Turkish Bath*. Paris, Louvre. Giraudon/Art Resource, NY.

5.10. Rosa Bonheur, *The Horse Fair*. New York, The Metropolitan Museum of Art, Gift of Cornelius Vanderbilt, 1887 (no. 87.25).

5.11. Frederic, Lord Leighton, *Jonathan's Token to David*. Minneapolis, The Minneapolis Institute of Arts.

5.12. Simeon Solomon, *Bridegroom and Sad Love*. London, Victoria and Albert Museum/Art Resource, NY.

5.13. James A. M. Whistler, *Arrangement in Black and Gold: Portrait of Robert, Comte de Montesquiou-Fezensac*. Copyright The Frick Collection, New York.

5.14. Fernand Khnopff, *My Heart Weeps for Olden Days*. By permission of The Hearn Family Trust.

5.15. Wilhelm von Gloeden, *Youths in Classical Dress*. Reprinted from Charles Leslie, *Wilhelm von Gloeden Photographer* (New York, 1977).

5.16. F. Holland Day, *Saint Sebastian*. Reproduced from the collections of the Library of Congress, Washington.

5.17. *Trial of Oscar Wilde, The Illustrated Police News*, May 4, 1895. Reprinted from H. Montgomery Hyde, *The Annotated Oscar Wilde* (New York: Clarkson Potter, 1982).

5.18. Thomas Eakins, *The Swimming Hole*, 1885, oil on canvas. Fort Worth, Texas, Amon Carter Museum, no. 1990.19.1. Purchased by the Friends of Art, Fort Worth Art Association, 1925; acquired by the Amon Carter Museum, 1990, from the Modern Art Museum of Fort Worth through grants and donations from the Amon G. Carter Foundation, the Sid W. Richardson Foundation, the Anne Burnett and Charles Tandy Foundation, Capital Cities/ABC Foundation, Fort Worth Star-Telegram, The R. D. and Joan Dale Hubbard Foundation, and the people of Fort Worth.

5.19. Louise Abbema, *Portrait of Sarah Bernhardt*. Courtesy Shepherd Gallery Associates, New York.

5.20. Alice Austen, *Julia Martin, Julia Bredt and Self Dressed Up As Men*. Alice Austen Collection, Staten Island Historical Society, New York.

5.21. *Youth in Aesthetic Interior*. From Elisar von Kupffer, *Heiland Kunst: Ein Gespräch in Florenz* (Jena, 1907). Courtesy Steakley archive.

5.22. Advertisement for "Solitude," *Der Eigene*, 1906. Reprinted from *Eldorado: Homosexuelle Frauen und Männer in Berlin 1850–1950* (Berlin: Berlin Museum, 1984).

5.23. Baron Hermann von Teschenberg, photograph in *Jahrbuch für sexuelle Zwischenstufen*, vol. 4 (1902). Courtesy of the New York Academy of Medicine Library.

6.1. Romaine Brooks, *Le Trajet*. Washington, National Museum of American Art/Art Resource, NY.

6.2. Pablo Picasso, *Portrait of Gertrude Stein*. New York, The Metropolitan Museum of Art, bequest of Gertrude Stein, 1946 (no. 47.106).

6.3. *"New Prussian Coat of Arms." Jugend* (Munich), 11:45 (Oct. 28, 1907), p. 1028. Courtesy Steakley archive.

6.4. Marcel Duchamp, *Belle Haleine, Eau de Voilette* from "Boite," 1921/1966, offset lithograph. University of California, Berkeley Art Museum; purchase, made possible by a bequest from Thérèse Bonney, class of 1916. © 1998 Artists Rights Society (ARS), New York / ADAGP, Paris / Estate of Marcel Duchamp.

6.5. Public toilet stall, Toronto. RG 22-5870, York County Court Judge's Criminal Court Indictment Files, #266/1919, exhibit photograph (interior of public lavatory), Archives of Ontario, Toronto.

6.6. Richard Oswald, *Anders als die Anderen.* Collection Bert Hansen.

6.7. Berenice Abbott, *Portrait of Djuna Barnes.* Berenice Abbott / Commerce Graphics Ltd., Inc.

6.8. Leonor Fini, *Le Long du chemin.* © 1999 Artists Rights Society (ARS), New York / ADAGP, Paris.

6.9. Claude Cahun, *Ici le bourreau . . .* Reprinted from *Aveux non avenus.*

6.10. Jeanne Mammen, *Costume Ball, Berlin.* Private collection. © 1999 Artists Rights Society (ARS), New York / VG Bild-Kunst, Bonn.

6.11. James VanDerZee, *Beau of the Ball.* Copyright © Donna Mussenden VanDerZee.

6.12. George Platt Lynes, *Nicholas Magallanes and Francisco Moncion in "Orpheus."* Photograph courtesy The Kinsey Institute for Research in Sex, Gender, and Reproduction.

6.13. Eikoh Hosoe, *Portrait of Yukio Mishima.* By permission of the artist.

6.14. Jasper Johns, *Target with Plaster Casts.* Collection Mr. and Mrs. Leo Castelli. © Jasper Johns / Licensed by VAGA, New York, NY.

6.15. Robert Rauschenberg, *A Pail for Ganymede.* © Robert Rauschenberg / Licensed by VAGA, New York, NY.

6.16. Francis Bacon, *Two Men on a Bed.* Private collection. © 1999 Estate of Francis Bacon / Artists Rights Society (ARS), New York.

6.17. Blade (Neel Bate), Scene from *The Barn.* Courtesy The Leslie-Lohman Gay Art Foundation, New York.

6.18. Tom of Finland, *Sauna-Bar.* Courtesy Tom of Finland Foundation, Los Angeles.

7.1. John Button and Mario Dubsky, mural. Photograph by Richard C. Wandel, courtesy Lesbian and Gay Community Services Center, New York, National Archive of Lesbian and Gay History.

7.2. JEB, *Lori and Valerie Working at Wrenchwoman.* © 1998 JEB (Joan E. Biren).

7.3. David Alexander, *Portrait of Arnie Kantrowitz and Lawrence Mass.* Courtesy of the artist.

7.4. Keith Haring, mural. Courtesy Lesbian and Gay Community Services Center, New York.

7.5. Harmony Hammond, *Swaddles.* Denver Art Museum. Photograph by John Kasparian, courtesy of the artist.

7.6. Tee A. Corinne, *A Woman's Touch.* Courtesy of the artist.

7.7. Millie Wilson, *Fauve Semblant (Peter, A Young English Girl).* Photo by Susan Einstein. Courtesy of the artist.

7.8. Sadie Lee, *Dixie Lee Evans—The Marilyn Monroe of Burlesque.* By permission of the artist. Photo courtesy National Portrait Gallery, London.

7.9. Philip Johnson/Alan Ritchie Architects, Cathedral of Hope. Photo by Bates Photography.

7.10. George Segal, *Gay Liberation.* © George Segal / Licensed by VAGA, New York, NY. Photo courtesy Sidney Janis Gallery, New York.

7.11. Karin Daan, *Homomonument.* Courtesy Stichting Homomonument. Photo by Menne Vellinga © 1987.

7.12. Attila Richard Lukacs, *Authentic Décor.* Collection Norbert Sinski. Courtesy of the artist.

7.13. Della Grace, *Permission to Play.* Reprinted from *Love Bites* (London, 1991), by permission of GMP (Gay Mens Press).

7.14. Lee Snider, *Queens For A Day (And A King, Too?).* Courtesy Lee Snider/Photo Images.

7.15. Deborah Kass, *Triple Silver Yentl (My Elvis),* 72″ × 94″. Collection of Ruth Lloyds and William Erlich.

7.16. Nahum Zenil, *Con todo respeto* ("With All Respect"), 30.5 × 41 cm. Property of the artist. Photo courtesy Galeria GAM, Mexico City.

7.17. Derek Jarman, *Caravaggio.* Courtesy The Museum of Modern Art, New York, Film Stills Archive.

Figures in italics refer to illustrations

Abbasi, Riza-i, 149, *Plate 12*
Abbema, Louise, 201, *201*
Abbott, Berenice, 222–24, 223, 227
Abelard, Peter, 75
abstract expressionists, 245
abstraction, 208, 215, 230, 245
Abu Nuwas, 66
academia, 275–76
Achilles, 13, 14, *14*, 16–17, 27, 33, 34, 40,
 169
Achilles Binding the Wounds of Patroclus, 14,
 16–17
acolytes (chigo), 141–42, *142*
Acolyte Scroll, 141–42, *142*, 144
Actaeon, 108, *108*
activism, 182–85, 207, 221, 258, 276, 277
Adam, 69–70, *70*
Adam and Eve and Sodomites, 69–70, *70*
Adhesiveness (Hockney), 256
Adoration of the Magi (Cook Tondo) (Angelico
 and Lippi), 85
advertising, 234–35, 304, 305
Advocate, The, 272, *Plate 26*
Aelred of Rievaulx, 65, 69
Aeneid, The (Virgil), 52, 64
Aeschines, 40
Aeschylus, 27, 28
aestheticism, 182–86
Africa, 5, 125, 127, 148, 166, 208, 295,
 298–99, 301
Afternoon of a Faun, The (Debussy), 213
Agamemnon, 49
Agathon, 28
Agony and the Ecstasy, The (Stone), 244

Ai, Emperor, 134
AIDS, 261, 262, 274, 277–80, 304
Alberti, Leon Battista, 84
Alexander, David, 264, *265*
Alexander and Hephaestion with Hercules, 35, 36,
 52
Alexander the Great, 34, *34*, 35–37, *35*,
 98–99, 173, *Plate 7*
Alexander the Great (Lysippus), *34*, 36
Alexandria, 37
Amazons, 4, 31–32, *32*, 49, 106, 107
American Revolution, 153
Americas, 77, 82, 109–11, 206
amicitia, 56, 58, 62, 65, 69, 72, 79
Anacreon, 25, 171–72
Anders als die Anderen, 219, *220*
Andrea, Zoan, 91, *91*, 109
androgyny, 4, 40, 104, 182, 188, 189
Angelico, Fra, 85
Angel of the Waters (Stebbins), 1–2, 177
Anger, Kenneth, 255
Anglican faith, 190
Anthony, Susan B., 174, 177
Antinous, 45, *45*, 46, 53, 159, 163, 182,
 186, 204
Antinous, 45, 45
Antony, Marc, 15
Aphrodite, *see* Venus
Apollo, 14, 24, 30, 32–33, 35, 36, 37–38,
 40, 44, 102, 113, 151, 164, 169,
 224–25
Apollo and Hyacinthus (Cellini), 113, *113*
Apollo Belvedere, 37–38, *37*, 41, 96, 99, 103,
 159, 161, 171
Apoxyomenos (Lysippus), 44–45
apprenticeship system, 83

Aquinas, Saint Thomas, 67–68, 71, 72, 73, 104, 156
Arabian Nights, 147, 148
Arabic world, 66
architecture, 190, 234, 235, 285–86
 Gothic Revival, 165, 185, 190
 sculptures, 64–66, 285, 286–89
Aretino, Pietro, 99, 100, 101, 102, 103, 104, 112
Argentina, 206
Ariosto, Ludovico, 103
Aristogiton, 13, 17–19, *18*, 24, 43, 53, 61
Aristolaus, 19
Aristophanes, 14–15, 34
Aristotle, 34, 36, 59
Arnold, Matthew, 185
Arrangement in Black and Gold: Portrait of Robert, Comte de Montesquiou-Fezensac (Whistler), *188*, 189
Arrow Collar Man, 234
art appreciation, 184
art criticism, 113–14, 154
art history, 154, 183, 275–76
Artemis, *see* Diana
art nouveau, 186–87, 201
Artus, Thomas, 105, 119
Ashbee, Charles R., 190
Asia, 10, 82, 125–50, 166, 295, 301–4
 China, 11, 125, 126, 127–29, 132, 133–39, 140, 141, 209, 301, 303–4
 India, 125, 126, 127, 128, 129–32, 133, 140, 148, 149–50, 208, 302–3
 Japan, 125, 126, 127, 128, 132, 133, 139–46, 209, 242–43, 273, 301, 303
astrology, 101
Atai, Nevi Zade, 150
Athena, 25
Athens, 17–18, 21, 25, 30, 48
Atherton, John, 119, *119*
Atkins, Robert, 278, 281
Augustine, Saint, 42, 43, 57, 59, 60
Augustus, Emperor, 15, 44, 46
Austen, Alice, 202, *202*
Australia, 199–200, 241–42, 262, 298
Authentic Décor (Lukacs), *292*
Aztec, 109

Bacchantes (Maenads), 38, 40, 45, 48
Bacchus (Dionysus), 14, 24, 35, 38–40, 41, 45, 47, 97, 99, 102, 115, 151, 173, 225

Bacchus (Michelangelo), 96, *96*
Bacchus, Saint, 60–61, 69, 75
Bachardy, Don, 256
Bacon, Francis (artist), 249, *249*, 251, 255, 256, 280
Bacon, Francis (philosopher), 104
Bad Moon Rising (Wojnarowicz), 279, *Plate 27*
Bakst, Leon, 213, 225, *Plate 19*
Balboa, Vasco Núñez de, 110
Balboa Feeding Indian "Sodomites" to the Dogs (de Bry), 110, *111*
Ballets Russes, 213, 224, 225
Balthus, 226
Balzac, Honoré de, 173, 174
Bandello, Matteo, 104
Bannon, Ann, 244
banquet (symposium), 25–28
Barberini Faun, 39, *39*, 41
Barbus, 171
Barcelona, 207
bardassa, 149
Barn, The (Blade), 253–54, *253*
Barnes, Djuna, 222, 223, *223*
Barney, Natalie, 209, 222, 230
Barnfield, Richard, 122
Bartolommeo, Fra, 99
Basil I, Emperor, 61, 62, *Plate 5*
Basquiat, Jean-Michel, 282
Bate, Neel (Blade), 253–54, *253*, 266
Bathhouse (Dürer), 93, *94*
bathhouses, 231
Bathyllus Drawing a Portrait for Anacreon (Girodet), 171–72, *171*, 213
Batoni, Pompeo, 162, *162*
Baudelaire, Charles, 173, 174, 175, 181, 190, 201, 231
Bazille, Frédéric, 200
Beach, Charles, 234
Beach, Sylvia, 222
Beardsley, Aubrey, 186–87
Beaton, Cecil, 251
Beats, 251
Beau of the Ball (VanDerZee), *232*, 233
Beccadelli, Antonio, 84
Beckford, William, 165–66, 178
Bedroom Scene (Fuseli), *172*, 173
Beham, Hans Sebald, 93
Bell, Arthur, 263
Bell, Clive, 216
Bell, Vanessa, 216

Belle Haleine, Eau de Voilette (Duchamp), 218, *218*
Benes, Barton, 278
Benivieni, Girolamo, 81, 87
Bentley, Richard, 165
Benton, Thomas Hart, 238
Beowulf, 73
Berchorius, 71, 72
berdaches, 4–5, 109, 110, 145, 149, 201
Berg, Friedrich von, 159, 161
Berlin, 163, 182, 203, 213, 215, 227–28,
 266, 267, 283, 288–89, 291
Bernardino, Saint, 81, 84
Bernard of Morlaix, 57, 60
Bernhardt, Sarah, 201
bestiaries, 59–60, 103–4
Bey, Khalil, 175
Bible moralisée, 69–70, *70*
Biches, Les, 224, 225
Biren, Joan E. (JEB), 263, *264*
black culture, 232–34, 296–97
Blade (Neel Bate), 253–54, *253*, 266
Bleckner, Ross, 278
Bloomsbury group, 215–16, 228–29
Blunt, Anthony, 236
Boccaccio, Giovanni, 79
Boltraffio, Giovanni, 90
Bonheur, Rosa, 175–77, *175*, 187, 203
Book of Love (Equicola), 103
bookstores, 273
Bosch, Hieronymus, 78, 92, 190, *Plate 6*
Boston, 194
Boswell, James, 161
Boswell, John, 2, 53, 61
Botticelli, Sandro, 87, *87*–88, 89, 92, 184
Boucher, François, 154
Brand, Adolf, 228
Brassaï, 224, 225
Brereton, John Le Gay, 200
Breton, André, 224, 225, 237
Breton, Jules, 173
Bridegroom and Sad Love (Solomon), 181, *181*
Britain, 122, 152, 249, 283–84, 296
 London, 118, 145, 152, 155, 156,
 215–16, 228–29, 249, 266
Broc, Jean, 171, 172
Brock, Lilyan, 244
Brooks, Romaine, 209–10, *210*, 211,
 222–23, 227, 228–29, 230, 235, 256,
 277, 280
Brueghel, Pieter, 93

Bruno, Giordano, 122
Buchanan, Patrick, 308
Bückeberg, Wilhelm Friedrich Schaum-
 burg-Lippe, 163–64
Buddhism, 125, 126, 127, 129, 131–32,
 133, 139, 140, 141, 144
Buenos Aires, 206
Burke, Edmund, 160, 164
Burne-Jones, Edward, 179, 181, 192
Burroughs, William, 251
Burton, Richard, 166, 179
Burton, Scott, 281
Butler, Eleanor, 168
Button, John, 260, *260*
Byron, George Gordon, Lord, 166, 172–73
Byzantine Empire, 53, 56, 60–61, 62, 76,
 125

Cadmus, Paul, 238–39, 252, *Plate 23*
Cahun, Claude, 226–27, *227*, 230
California, 252
Callisto, 107, 108, 154
Cambacérès, Jean-Jacques, 169
camp, 156, 186, 190, 257, 309
Cantor, Peter, 57, 68
Cap and Hairpins (Moon-Heart), 138
Caravaggio (Jarman), 306, *306*
Caravaggio, Michelangelo Merisi da,
 114–17, 152, *Plate 10*
Carlini, Benedetta, 120
Carnevale, Fra, *87*
Carpenter, Edward, 199
Carriera, Rosalba, 154
Casanova, Giovanni Battista, 159, *160*
Casanova, Giovanni Giacomo, 158, 166
Castle of Otranto (Walpole), 165
castrati, 155
Cathedral of Hope, 286, *287*
Catholic Church, 79, 80, 112, 114, 119,
 124, 189
 see also Christianity
Catlin, George, 5, *5*
Cavalieri, Tommaso de', 99–100, 112, 114,
 244
Cellini, Benvenuto, 96, 112–13, *113*, 114
censorship, 101, 112, 136, 144, 236, 244,
 252–53, 258
Center for Culture and Recreation (COC),
 252
Charlemagne, King, 62
Charles I, King, 119–20

Charles II, King, 122
Chen Sen, 133, 139
Chicago, Judy, 268
Chigi, Agostino, 98, 99
chigo, 141–42, *142*
China, 11, 125, 126, 127–29, 132, 133–39,
 140, 141, 209, 301, 303–4
 Ming dynasty, 136, 137, 139
 Qing dynasty, 137, 138–39
chivalry, 58, 72–73, 142
Christ and Saint John the Evangelist, 68–69, *68*,
 228
Christianity, 10, 11, 53, 55–62, 66–70, 80,
 87, 110, 112, 148, 153
 Anglican, 190
 architectural sculptures and, 64–66
 Catholic, 79, 80, 112, 114, 119, 124,
 189
 chivalry and, 72–73
 classical myths and, 64–65, 70–71, 79,
 85, 112
 Divine Comedy and, 71–72
 paired saints in, 61
 same-sex unions and, 61–62, 68, 69
Christina, Queen, 118
Christine de Pisan, 91
Chrysippus (Euripides), 28, *28*
Chusuke, Ijiri, 143
Clarke, John, 50
classical world, 13–54
 Greece, 13–42, 43, 76, 77, 79, 159, 161
 Rome, 13, 14, 15, 34, 35, 42–54, 55, 56,
 79, 95–96
classicism, 79, 80, 89, 92, 95, 208
 see also neoclassicism
Cleland, John, 166
Clement VII, Pope, 96, 101
clothing and fashion, 123–24, 134–36,
 156, 188, 238, 304–5
Clytemnestra, 49
Cockerell, Charles, 173
Cocteau, Jean, 209, 223, 225, 249, 255
Colonna, Vittoria, 114
Columbus, Christopher, 77, 82, 109
comic books, 273
commercial art, 234–35, 240, 304–8
Communism, 139, 303
Compagnacci, 89, 101
Comstock, Anthony, 221
concentration camps, 236
Condivi, Ascanio, 87, 101

Cone, Claribel, 211
Cone, Etta, 211
Confessions (Rousseau), 164
Confessions of a Mask (Mishima), 242–43
Confucianism, 133, 136, 137, 138, 139,
 144
Constantine, Emperor, 53, 56, 59
Constantinople, 53, 56, 84, 150
Con todo respeto (Zenil), 299, *300*
Cook Tondo (Adoration of the Magi) (Angelico
 and Lippi), 85
Cooper, Emmanuel, 272
Corinne, Tee A., *270*, 271, 291
Correggio, 102, 103, 105, *Plate 8*
Cosimo I, Duke, 113
Costume Ball, Berlin (Mammen), 228, *229*
Council of Trent, 112, 113
Counter-Reformation, 112, 114
Courbet, Gustave, 173, 174, 175, *Plate 15*
court culture, 102–5
Cram, Ralph Adams, 190, 194, 200
Crane, Hart, 215
Crevel, René, 225, 237
Crimp, Douglas, 278
cross-dressing, *see* transvestism
Cruising, 263
Crusades, 66, 68, 147
Cruse, Howard, 273
cubism, 208, 211, 215
Cupid, 40, 115, 116, 171, 181, 187
Cupid (Victorious Amor) (Caravaggio),
 116–17, *Plate 10*
Cupid Carving His Bow (Parmigianino), 103,
 105, 116
Cushman, Charlotte, *2*, 177
Cutpurse, Moll, 118

Daan, Karin, 288, *289*
dada, 217, 218, 224
Dalí, Salvador, 225, 237
Damon, Betsy, 269–71
dance, 5
Dance to the Berdache (Catlin), 5, *5*
"Dangerous Painters, The" (Williams), 258
d'Annunzio, Gabriele, 210
Dante Alighieri, 71–72, *72*, 78, 89, 247
Dante and Virgil Meet the Sodomites (Guido da
 Pisa), 72, *72*
Daphnis, *38*, 39
Dark Ages, 55, 58
Daughters of Bilitis, 252

David, 73, 75, *75*, 79, 97, 117, 178–79, *179*
David, Jacques-Louis, 169, 170–71, *170*
David (Caravaggio), 117
David (Donatello), 79, 82–83, *83*, 84, 88, *96*, 100, 198, 275
David (Michelangelo), 96–97, 179, 213
Davila, Juan, 300
Day, F. Holland, *193*, 194, 204, 231
Death of Hyacinthus, The (Tiepolo), 163, Plate *14*
Death of Orpheus, Plate *2*
Death of Orpheus (Dürer), 92–93, *92*
Death of Socrates (David), 169
de Bry, Theodore, 110, 111, *111*
Debussy, Claude, 210, 213
Décadent, Le, 188–89
decadents, 185–87, 189, 190
De Chirico, Giorgio, 225
deconstructionism, 6, 275
Degas, Edgar, 200
"Degenerate Art" exhibit, 235–36
Delville, Jean, 189, Plate *16*
Demuth, Charles, 231–32, 233, 281, Plate *21*
Denmark, 220, 258, 285
Descartes, René, 81
Destruction of Sodom, The, 128, *128,* Plate *4*
de Viau, Théophile, 122
de Wolfe, Elsie, 235
Diaghilev, Sergey, 211–13, 225, 282
Diana, 14, 19, 20, 32, 49, 52, 66, 91, 95, 105–6, 107–8, *108,* 121, 154, 171
Diana and Actaeon (Titian), 108, *108,* 127
Diana and Callisto (Titian), 107, 108
Diane de Poitiers, 106
Diderot, Denis, 152
Dietrich, Marlene, 228
digital communications, 304, 308
Dinocrates, 36–37
Diocletian, Emperor, 99
Dionysus (Bacchus), 14, 24, 35, 38–40, 41, 45, 47, 97, 99, 102, 115, 151, 173, 225
"Discourse on the Manners of the Ancient Greeks Relative to the Subject of Love" (Shelley), 172
Distinguished Air (Demuth), 231, Plate *21*
Diva, 305, 306, Plate *32*
Divine Comedy (Dante), 71–72, *72,* 89
Dix, Otto, 228, 235
Dixie Lee Evans—The Marilyn Monroe of Burlesque (Lee), 284, *284*

Dobell, William, 241–42
Donatello, 83–84, *83,* 87, 100, 116, 117, 198, 275
Doni Tondo (The Holy Family with Saint John the Baptist) (Michelangelo), 97, 184, 189
Dorians, 17
Doryphorus (Polyclitus), 30–31, *31,* 35, 37
Douglas, Alfred, 186, 196, 204
Dover, K. J., 6
drag, *see* transvestism
droleries, 76
Drouais, Jean-Germain, 171
Dubsky, Mario, 260–61, *260*
Duchamp, Marcel, 208, 217–18, *218,* 222, 225, 230–31, 233, 246, 276
Duncan, Robert, 251
Dunye, Cheryl, 306
Duquesnoy, Jérôme, 121
Dureau, George, 280
Dürer, Albrecht, 92–93, 92, 93, *94*
Dyer, George, 249

Eakins, Thomas, *196,* 197–98, 199, 249
Eclogues (Virgil), 65, 102, 115
Edward II, King, 75
effeminacy, 8, 40, 48, 104, 124, 135, 145, 156, 161, 183, 257
Egypt, 34
Eigene, Der, 204, 213, 214, 228
Eisenstein, Sergey, 221
ekphrasis, 32
"Elegy Written in a Country Churchyard" (Gray), 165
Ellis, Havelock, 183
Eltinge, Julian, 205–6
England, 122, 152, 249, 283–84, 296
London, 118, 145, 152, 155, 156, 215–16, 228–29, 249, 266
Enlightenment, 6, 152–53, 158, 164
entertainment industry, 155
Epaminondas, 19
ephebes, 22, 31, 33, 38, 40, 45, 115
Epstein, Jacob, 210
Equicola, Mario, 103
erastes, 17, 19, 22, 25, 26, 28, 31, 38, 43, 48, 170
Ernst, Max, 225
eromenos, 17, 22–23, 26, 27–28, 30, 31, 36, 38, 170
Eros, 13, 19, 23, 27, 30, 35, 83
Eros, 228

erotica, 101–2, 112, 137–38, 166, 194,
 252–55, 258, 291
Estrées, Gabrielle d', 107
Etruscans, 33–34, 42
Eugene of Savoy, Prince, 123, 153
Eulenberg, Philipp zu, 214, 215
Euripides, 28, 28, 48–49
Eurydice, 40, 71, 92
Evans, Cerith Wyn, 285
Eve, 69–70, 70
Every Moment Counts (Fani-Kayodé), 296,
 Plate 30

Fani-Kayodé, Rotimi, 296, *Plate* 30
Fanny Hill (Cleland), 166
Fantasia on a Theme by Dr. S. (Cadmus),
 239
fascism, 235–37
fashion and clothing, 123–24, 134–36,
 156, 188, 238, 304–5
Fauve Semblant (Peter, A Young English Girl)
 (Wilson), 276, 277
Federigo II Gonzaga, Duke, 102
feminism, 168, 174, 177–78, 221, 291
 lesbian, 268–71
Ferrara, 102
Ficino, Marsilio, 87
figurines, 3, 41
Filiger, Charles, 189–90
film, 219–21, 236, 255, 280, 304, 306
Fini, Leonor, 225–26, 226
Firehouse mural, 259–60, 260, 261, 263
Fire Island, 239, 257
Fireworks, 255
Flandrin, Hippolyte, 204, 204, 281
Fleet's In!, The (Cadmus), 238, *Plate* 23
Florence, 83, 84–87, 95, 114, 163
 Officers of the Night in, 83, 84–85, 87,
 89, 101
Florentine Codex (Sahagún), 110
Fontainebleau, 105, 107
Fontino, Luigi, 99
Foucault, Michel, 262, 274, 275
Fountain of Youth, The (Beham), 93
Fragrant Stuff from the Court of Spring (Moon-
 Heart), 138
France, 65, 66, 105, 122, 169–70, 200–201
 Paris, 156, 170, 209, 222, 267
 Revolution in, 153, 169
Francis Xavier, Saint, 143, 146
Frederick the Great, 163, 166, 228

Freud, Sigmund, 14, 90, 206, 208, 218,
 224, 225
Freyburg, Karl von, 215, 216
Friend, Donald, 242
Frustration (Utamaro), 145
Fry, Roger, 216
Fuseli, Henry, 172, 173
Fux, Andreas, 291

Gabrielle d'Estrées and Her Sister in the Bath,
 Plate 9
galleries, 265–66
Galli, Jacopo, 96
Ganymede, 24, 27, 43, 46, 50, 52, 53, 57,
 63, 70–72, 83, 84, 85, 87, 96, 104,
 113, 120, 154, 159, 169, 220, 247
 Ganymede and Hebe (Rubens), 121
 Jupiter and Ganymede (ancient statue),
 29–30, 29
 Jupiter and Ganymede (Mengs or
 Casanova), 151, 159, 160–61, 160
 Rape of Ganymede (church carving),
 64–65, 64
 Rape of Ganymede (Correggio), 102–3,
 105, *Plate* 8
 Rape of Ganymede (Michelangelo),
 99–100, 100
Ganymede and Hebe (Rubens), 121
García Lorca, Federico, 237
Garden of Earthly Delights, The (Bosch), 78,
 Plate 6
Gauguin, Paul, 5, 189, 201
Gautier, Théophile, 175
Gaveston, Piers, 75
gay identity and culture, 101, 104, 151,
 156, 161, 182–83, 259–63, 308–10
 activism, 182–85, 207, 221, 258, 276,
 277
 multiculturalism, 295–97
 sexual minorities, 290–95
 see also third sex; transvestism
Gay Liberation (Segal), 287–88, 288
Gay Times, 272, 305
Geldzahler, Henry, 256, 305
Genet, Jean, 207, 249, 251
George, Stefan, 214
Germany, 62, 73, 76, 213–15, 227–28,
 267, 283, 288–89, 291
 Berlin, 163, 182, 203, 213, 215, 227–28,
 266, 267, 283, 288–89, 291
 Nazi, 235–36, 280, 288–89, 291

ghazal, 149

Ghazali, Mehmet, 150

Gide, André, 222

Gilbert & George, 281, 283, *Plate 29*

Gilgamesh, 8

Ginsberg, Allen, 251, 257, 259

Girodet de Roucy Trioson, Anne-Louis, 171–72, *171*, 173, 189, 213

Giustiniani, Vincenzo, 116–17

Gloeden, Wilhelm von, 192–94, *192*, 204, 266

Glover, Montague, 230

Gluck (Hannah Gluckstein), 230, 277

Gober, Robert, 285

Goethe, Johann Wolfgang von, 159, 165

Gogh, Vincent van, 201

Goliath, 83, 84, 96, 117

Gomorrah, 57

Gorgidas, 19

gothicism, 165, 186

Gothic Revival, 165, 185, 190

Gower, Ronald, 186, 187, 199

Grace, Della, *293*, 294

Graf, Urs, 93

Grand Tour, 161–63

Grant, Duncan, 216, 230

gravitas, 43

Gray, Eileen, 235

Gray, Thomas, 163, 165

Great Voyages, The (de Bry), 110

Greece, ancient, 13–42, 43, 76, 77, 79, 159, 161
 spread of ideas from, 14, 33–34

Green Landscape (Khakhar), 302, *Plate 31*

Grien, Hans Baldung, 93, 95, *95*

Grosser, Maurice, 251

Grosz, George, 228

Guido da Pisa, 72, *72*

Gutenberg, Johannes, 82

Guthmann, Johannes, 215

Hadrian, Emperor, 45, 46, 182

Hafiz, 149

Haft awrang, 149

Hall, Radclyffe, 228, 229, 230

Hammond, Harmony, 268–69, *269*

Handel, George Frideric, 155

Harden, Maximilian, 214, 215

Hardison, Sam, 280

Hardman, Stewart, 259, 266

harems, 148, 166, *167*

Haring, Keith, *266*, 267, 282

Harmodius, 13, 17–19, *18*, 24, 53, 61

Harmodius and Aristogiton (Tyrannicide Monument) (Kritios and Nesiotes), 17–18, *18*, 19, 21, 30, 43

Harris, Lyle Ashton, 297

Hartley, Marsden, 215, 216, 228, 231, 232, 239, 257, 281, *Plate 20*

Hawthorne, Nathaniel, 178

Hay, Harry, 252

Heald, Edith Shackleton, 230

Hector, 16

Hellenistic culture, 34–37, 38, 39, 41, 45, 80

Helms, Jesse, 283

Henri III, King, 105, 106, 119

Henry IV of Castile, King, 76

Hephaestion, 34, *35*, 36, 99, 181

Herculaneum, 46

Hercules, 19, 23, 27, 36, 37, 87

hermaphrodites, 7, 15, 41, 104
 hyenas, 59–60, *60*

Hermaphroditus, 35, 38, 41, 47, *47*

Hermes, 41

herms, 14, 47

Hesiod, 13

Hinduism, 125–26, 129–32

Hipparchus, 18, 25

Hippias, 18

Hirschfeld, Magnus, 203, 204, 205, 206, 213, 214, 219, 220, 228, 235, 267

History of the Art of Antiquity (Winckelmann), 159, 161

Hitler, Adolf, 235, 291

Hockney, David, 255–56, 257, 280, *Plate 25*

Hofer, Karl, 236

Holy Family with Saint John the Baptist, The (Doni Tondo) (Michelangelo), 97, 184, 189

Homer, 16

Homer, Winslow, 199

Homomonument (Daan), 288, *289*

homosexuality, use of term, 182

Hopkins, Gerard Manley, 199

Horace, 42, 56

Horse Fair, The (Bonheur), *175*, 176

Hosmer, Harriet, 177, 178, 179

Hosoe, Eikoh, 243, *243*

Houssaye, Arsène, 174

Hua Ying Chin Chen, 133–34

Hujar, Peter, 281

humanism, 79, 80, 82, 84, 85, 95

Hurston, Zora Neale, 233

Huysmans, Joris-Karl, 186, 188

Hyacinthus, 24, *24*, 32–33, 38, 44, 102, 113, *113*, *Plate 14*

hyenas, 59–60, *60*

Hylas, 87

Hymen, 36, 99

Iceland, 73

Ici le bourreau. . . . (Cahun), 226–27, *227*

identity, homosexual, *see* gay identity and culture

Idylls (Theocritus), 27

Iliad, The (Homer), 16

Ildefonso Group, 46

Illustrated Police News, *195*, 196

Imagines (Philostratus), 32–33

impressionists, 200

Inca, 110

India, 125, 126, 127, 128, 129–32, 133, 140, 148, 149–50, 208, 302–3

Indiana, Robert, 257

Indonesia, 125

Industrial Revolution, 152

Inferno (Dante), 71–72, 247

Ingres, Jean-Auguste-Dominique, 169, *174*, 175

Ink Garden of Mr. Cheng, The, 128, *128*

In Memoriam (Tennyson), 179

Inquisition, 80, 117–18, 122

Institute of Sexual Science, 203

interior design, 235

Interior of the Royal Harem, Topkapi Palace (Melling), 166, *166*

inversion, 182

Inzalaco, Lorraine, 264

Iolaus, 19, 23

Iphigenia in Tauris (Euripides), 48–49, *Plate 3*

Isherwood, Christopher, 228, 256

Ishtar, 8

Islam, Muslims, 10, 66, 77, 82, 125, 126, 127, 128, 129, 146–50, 208, 301, 302

Island of the Hermaphrodites (Artus), 105, 119

Italy, 76, 102–4, 235
 Florence, 83, 84–87, 89, 95, 101, 114, 163
 Milan, 102
 Naples, 117
 Rome, 13, 14, 15, 34, 35, 42–54, 55, 56, 79, 95–96
 Venice, 84, 85, 102

James, Henry, 178, 179, 184

James I, King, 104, 118, 120

Jami, Abdul-Raman, 149

Japan, 125, 126, 127, 128, 132, 133, 139–46, 209, 242–43, 273, 301, 303
 Edo period, 140, 143–44, 145

Jarman, Derek, 306, *306*

JEB (Joan E. Biren), 263, *264*

Jefferson, Thomas, 153

Jerome, Saint, 56, 59

Jess (Collins), 251

Jesuits, 127

Jesus, 58, 68–69, *68*, 89, 228

Jews, 9, 66, 68, 77, 297

Johns, Jasper, 246–47, *246*, 249, 255

Johnson, Joyce, 251

Johnson, Philip, 258, 286, *287*

Johnston, Jill, 247, 285

John the Baptist, Saint, 89–90, *90*, 97, 115, 189

John the Evangelist, Saint, 58, 68–69, *68*, 71, 228

Jonathan, 73, 75, *75*, 178–79, *179*

Jonathan, David, and Saul, 73–75, *75*

Jonathan's Token to David (Leighton), 178–79, *179*

Jones, Cleve, 279

Journal for Sexual Intermediates, 203, 205, *205*

Julia Martin, Julia Bredt and Self Dressed Up As Men (Austen), 202, *202*

Julius II, Pope, 96, 97, 100

Jupiter (Zeus), 14, 24, 27, 34, 35, 50, 52, 53, 70–71, 83, 107, 108, 121, 154, 187

Jupiter and Ganymede (ancient statue), 29–30, *29*

Jupiter and Ganymede (Mengs or Casanova), 151, 159, 160–61, *160*

Justinian, Emperor, 53, 59, 60, 61

kabuki, 143, 144

Kahlo, Frida, 237–38, 299, *Plate 22*

Kaisei suikoden, 145

Kamasutra (Vatsyayana), 125, 129, 131

Kanemoto, Lisa, 263

Kantrowitz, Arnie, 264, *265*

Kass, Deborah, 297, *298*

Keats, John, 172

Kerouac, Jack, 251

Kertbeny, Károly Mária, 182

Keynes, John Maynard, 216

Khakhar, Bhupen, 302, *Plate 31*
Khayyám, Omar, 147, 149
Khnopff, Fernand, 190–92, *191*, 194
Kinsey, Alfred, 240, 250
Kirstein, Lincoln, 239, 240, 258, 286
Klein, Herb, 298–99
Klumpke, Anna, 176, 187
knighthood, 58, 72–73, 142–43
Kobo Daishi, 139, 141
Koka Shastra, 125, *126*, 131, 148, 150
Koran, 66, 146, 147
Krafft-Ebing, Richard von, 182–83
Kritios, 18, *18*
Kupffer, Elisar von, 203–4, *203*, 219

Labouchère, Henry, 196
Ladder, The, 252
"La Goulue" at the Moulin Rouge (Lautrec), 201, *Plate 18*
Laius, 28
Lateran Council, 67
Latini, Brunetto, 72
Laurencin, Marie, 224, 225
Laws, The (Plato), 26
Leaves of Grass (Whitman), 198, 200
Lee, Sadie, 283–85, *284*
Leighton, Frederic, Lord, 178–79, *179*, 194, 199
Leonardo da Vinci, 87, 89–90, *90*, 96, 100, 101, 114, 184, 189, 190, 215, 217–18, 225
Leonidas at Thermopylae (David), 170–71, *170*
Leopold Wilhelm, Archduke, 121
lesbian, use of term, 21, 181
Lesbian Allegory, *126*
Lesbian and Gay Community Services Center, *266*, 267
lesbian feminism, 268–71
Lesbos, 20
Leslie, Charles, 265–66, 267
Leyendecker, Joseph C., 234
L.H.O.O.Q. (Duchamp), 217
libertinism, 122, 153
Li Chengqian, 136
Life and Death of John Atherton, The, 119, *119*
Lincoln Center, 258, 286
Lippi, Fra Filippo, 85
Lipton, Eunice, 202, 271
List, Herbert, 236
Lohman, Fritz, 265–66

London, 118, 145, 152, 155, 156, 216, 249, 266
 Bloomsbury group in, 215–16, 228–29
Long du chemin, Le (Fini), 225–26, *226*
Lori and Valerie Working at Wrenchwoman (JEB), 263, *264*
Lost Generation, 222
Lot, 57, 60, 147, 166
Louis XV, King, 153, 154
Louis XVI, King, 169
Loves of Jupiter (Correggio), 102
Lucian, 15, 36, 98
Lucie-Smith, Edward, 272
Ludwig II, King, 190
Lukacs, Attila Richard, 291, *292*
Luther, Martin, 111, 112
Lynch, Michael, 281
Lynes, George Platt, 239–40, *240*, 250, 252, 253, 258
Lysippus, *34*, 35, 36, 44–45

McAlmon, Robert, 231, 232, 239
McCarthy, Joseph, 244
McDermott and McGough, 281
Macedonia, 34, 36
Maenads, 38, 40, 45, 48
Maes, Nicolas, 121
magazines, 154, 204, 252–53, 304, 305
mahu, 5, 201
maithuna, 129–30
Male Group Scene, Plate 13
Malherbe, Suzanne, 226–27
Mammen, Jeanne, 228, 229
Man and Youth Initiating Intercrural Intercourse, 26, *27*
Manet, Édouard, 200, 202, 271
manga, 273
Manichaeanism, 9
Mann, Horace, 163
Man Ray, 218, *218*, 222, 223–24, 225
Mantua, 102, 104
Mapplethorpe, Robert, 281, 282
Marble Faun, The (Hawthorne), 178
Marie-Antoinette, 168, 169
Marlowe, Christopher, 118, 121
Maron, Antoine, 159
Marées, Hans von, 181
Marriage of Alexander the Great and Roxana (Sodoma), 98–99, 181, *Plate 7*
marriages, 168
 same-sex, 61–62, 68, 69, 117

Marsh, Reginald, 238
Marshall, John, 194
Marx, Karl, 174
Mary II, Queen, 122
Mass, Lawrence, 264, *265*
Matisse, Henri, 211
Mattachine Society, 252
Maya, 109, 110
Mead, Margaret, 6
Medici family, 83–84, 85, 88, 89, 122
Meiji, Emperor, 146
Melling, Anton Ignatz, 166, *166*
Ménage à Trois, 134, *135*
Mengs, Anton, 159, *160*
Mercury, 41
Mesopotamia, 8
Metamorphoses (Ovid), 70
Mexico, 109–10, 120, 299
Michelangelo Buonarroti, 1, 77, 87, 89,
 96–97, 99–101, *100*, 112, 114, 116,
 117, 120, 179, 184, 189, 213, 225,
 241, 244
Michelet, Jules, 79
Middle Ages, 10, 53, 55–78, 80
 Dark Ages, 55, 58
 fifteenth century, 76–78
 homoerotic poetry in, 63, 67
 Romanesque era, 62–66
 same-sex unions in, 61–62, 68, 69
Mignon, Jean, 105, *106*
Milan, 102
Miller, Isabel, 268
Milles, Carl, 220
Millett, Kate, 268, 269
minorities, sexual, 290–95
Mirbeau, Octave, 189, 192
Mishima, Yukio, 242–43
Mizer, Bob, 253
modernism, 208, 211, 216, 235, 262
modernity, birth of, 151–206
Modi, 101, 103, 112
Moguls (Mughals), 125, *126*, 127, 148,
 149–50
mollies, 145, 155, 156, 158, 182
Mollies Club, 155
Moltke, Cuno von, 214
Mona Lisa (Leonardo), 217, 218
Monk and Boy, 103–4, *104*
Monk and Layman, 130, *130*
Monk and Samurai Visiting Actor-Prostitutes,
 140–41, *141*

Monnier, Adrienne, 222
Montaigne, Michel de, 107
Montesquiou, Robert de, *188*, 189, 209
Monteverdi, Claudio, 120
Moon-Heart, Master, 138
Moreau, Gustave, 189, 190
Morgan, Julia, 235
Morgan, Thaïs, 181
Moschos, 88
movies, 219–21, 236, 255, 280, 304, 306
Mughals, *see* Moguls
Muhammad, 146, 147, 148
multiculturalism, gay, 295–97
Musicians (Caravaggio), 115, *116*
Muslims, *see* Islam, Muslims
Musto, Michael, 280
Myers, John, 245
My Heart Weeps for Olden Days (Khnopff),
 190–92, *191*
mysticism, 149, 189–90

Nadelman, Elie, 258
NAMES Project Quilt, 279, 280, *Plate 28*
Naples, 117
Napoleon I, Emperor, 169–71
Narcissus, 47, 85
Narcissus (Boltraffio), 90
National Endowment for the Arts (NEA),
 283
Nattier, Jean-Baptiste, 156–57
navigation, 82
Nazi Germany, 235–36, 288–89, 291
Neoclassicism, 151, *158*, 159–61, 164, 169,
 177–78
Neoplatonism, 87, 88, 112, 130, 149
Nesiotes, 18, *18*
Netherlands, 121, 157–58, 252, 262, 276,
 283
Nevelson, Louise, 287
New Guinea, 4, 5
"New Prussian Coat of Arms," 214, *214*
New York, 230–34, 242, 280, 290
 Firehouse mural in, 259–60, *260*, 261,
 263
 Lesbian and Gay Community Services
 Center in, *266*, 267
 Lincoln Center in, 258, 286
New York School, 245
*Nicholas Magallanes and Francisco Moncion in
 "Orpheus"* (Lynes), 240, *240*
Nicias, 33

Nijinsky in "The Afternoon of a Faun" (Bakst),
 Plate 19
Nijinsky, Vaslav, 213, 225
Nouvelle Justine, La (Sade), 168
Nugent, Richard Bruce, 233
Núñez de Balboa, Vasco, 110

Odyssey, The (Homer), 16
Oedipus, 28
O'Hara, Frank, 245–46, 247
O'Keeffe, Georgia, 231
Olympus, 38, 39, 44
Omega Workshops, 216
ONE, Inc., 252, 267
onnagata, 145
On Painting (Alberti), 84
On the Sodomitical Vice (Cantor), 57
Oppenheim, Meret, 225
Oration on the Dignity of Man (Pico della
 Mirandola), 81
Orestes, 28–29, 46, 49, 73
Orfeo, L' (Poliziano), 87, 92, 102, 120, 189
Orlovsky, Peter, 251
Orpheus, 40, 48, 71, 92–93, 92, 120, 189,
 190, Plate 2
Orpheus (Balanchine), 240, 240
Ostia, 50, 51, 52
Oswald, Richard, 220
Ottoman Empire, 150, 166
Out (magazine), 286, 305
Ovid, 56, 57, 70, 164
Ovide moralisé, 70–71
Ovidius moralizatus, 71
Owen, Wilfred, 216
oyama, 145

Pacific cultures, 4
paganism, 53, 55, 56, 57, 59, 66, 76, 79,
 87, 97, 112, 183
Pail for Ganymede, A (Rauschenberg), 247,
 247
Painting No. 47, Berlin (Hartley), 215, Plate 20
palaestra, 23
Paleolithic era, 3
Pan, 36, 38, 38, 39, 41, 44, 47, 47, 88, 88
Pan and Olympus (or Daphnis), 38, 39
Pan Uncovering Hermaphroditus, 47, 47
Paris, 156, 170, 209, 222, 267
Parker, Mary, 168
Parmigianino, Francesco, 103, 105, 116,
 121

Parsons, Betty, 245
Pasolini, Pier, 280
Patch, Thomas, 163
Pater, Walter, 181, 183, 184–85, 186, 190,
 203, 204, 206, 218
Patience and Sarah (Miller), 268
Patina du Prey's Memorial Dress (Reynolds),
 279
Patroclus, 13, 14, 14, 16–17, 27, 40, 169,
 173
patronage, 115, 123, 163, 165–66, 177,
 211
 in Greece and Rome, 15–16, 43
Patton, Cindy, 278
Paul, Saint, 53, 57, 59, 60
Pausanias, 19, 24–25, 26, 28, 33, 38
Péladan, Joséphin, 189
Pelops, 28
Pericles, 21, 25
Permission to Play (Grace), 293, 294
Perreault, John, 280, 281
Persia, 8–9, 125, 127, 148–49
Peru, 9, 109
Petrarch, Francesco, 79
Petronius, 44, 48
Phaedrus, 13
Phaedrus (Plato), 84, 96, 161, 172
Phidias, 25, 114
Philip II, King, 107, 109, 113
Philip III, King, 73
Philip IV, King, 75–76
Philippe of Orléans, 123, 125, 165
Philippines, 139
Philips, Katherine, 124
Philosophy in the Boudoir (Sade), 168
Philostratus, 32–33
photography, 176, 192, 204–5, 240,
 263–64, 280–81
Physiologus, 60, 60
physique magazines, 252–53
Picasso, Pablo, 208, 211, 213
Pico della Mirandola, Giovanni, 81, 87
Picture of Dorian Gray, The (Wilde), 187, 244
Pierre et Gilles, 281
Piers Plowman, 67
pillow books, 140
pink triangle, 236, 288, 289
Pirckheimer, Willibald, 92, 93
Pisistratus, 25, 30
Pittman, Lari, 285
Pizarro, Francisco, 110

Plato, 13, 15, 19, 26, 27, 28, 29, 30, 41, 46, 53, 87, 182, 183
 Phaedrus, 84, 96, 161, 172
 Symposium, 25, 40, 87, 90, 299
Pliny, 21, 25, 39–40, 44, 59
Plüschow, Wilhelm von, 192, 194
Plutarch, 19, 48
Polignac, Princess de, 211
Poliziano, Angelo, 87, 92, 102, 117, 120, 189
Pollock, Jackson, 245
Polyclitus, 31–32, *31, 32*
Polynesia, 5, 201
Pompeii, 46–47, *47*, 50
Ponsonby, Sarah, 168
pop art, 245, 257
Pope-Hennessy, John, 275
pornography, 101–2, 112, 137–38, 166, 194, 252–55, 258, 291
Portrait of Arnie Kantrowitz and Lawrence Mass (Alexander), 264, *265*
Portrait of a Young Man (Batoni), 162, *162*
Portrait of Baron Hermann von Teschenberg, 205, *205*
Portrait of Djuna Barnes (Abbott), 222, *223*
Portrait of Gertrude Stein (Picasso), 211, *213*
"Portrait of Mr. W.H., The" (Wilde), 186
Portrait of Yukio Mishima (Hosoe), 243, *243*
Posada, José Guadalupe, 206
postcolonial cultures, 297–301
post-impressionists, 200–201
postmodernism, 262, 274–75, 276–77
pottery, 9, 20, *20*, 22–24, *22, 28*, 34
Power, Ethel, 235
Prague, 105
Praunheim, Rosa von, 260, 306
Praxiteles, 39–40, 204
Precious Mirror of Ranking Flowers (Chen), 133, 139
Presentation of the Virgin (attrib. Carnevale), 85, *87*
Priam, 16
Priapus, 38, 42, 47–48
print media, 82, 154, 156, 186, 271–73, 304–8
 magazines, 154, 204, 252–53, 304, 305
Prix de Rome, 169
Protestants, 121
 Reformation, 80, 111–12
Proust, Marcel, 188, 222
psychoanalysis, 224–25

public toilet stall, 218–19, *219*
Pulci, Luigi, 96
Puller, Richard, 76–77, *77*
pulp novels, 244
Purgatory (Dante), 72
Puritans, 122
Pygmalion, 2
Pylades, 28, 29, 46, 73

Quaintance, George, 253
Queens For A Day (And A King, Too?) (Snider), *294*
Queer Patterns (Brock), 244, *Plate 24*

rabbit, cult of, 136–37
Radiguet, Raymond, 225
Radical Faeries, 3, 295
Rais, Gilles de, 76
Rao, R. Raj, 302–3
Rape of Ganymede (church carving), 64–65, *64*
Rape of Ganymede (Correggio), 102–3, 105, *Plate 8*
Rape of Ganymede (Michelangelo), 99–100, *100*
Raphael, 96, 101, 114
Rauschenberg, Robert, 246–47, *247*, 249, 255, 278
realism, 151, 173–74, 181, 185, 196–202, 208, 238–39
 Socialist, 236, 239
Records of the Cut Sleeve, 11, 137
Redon, Odilon, 189
Reformation, 80, 111–12
Rembrandt van Rijn, 121, 247
Renaissance, 10, 76, 79–124, 125, 127, 136, 151, 153, 183, 184–85
Renaissance, The: Studies in Art and Poetry (Pater), 184
Renault, Mary, 251, 253
Reni, Guido, 117, 123, 186, 190, 242, 243
Restoration, 122
Reynolds, Hunter, 279
Ricci, Matteo, 127–29, 139
Richard Puller Burned at the Stake, Zürich, 76–77, *77*
Ricketts, Charles, 186, 187
Rimbaud, Arthur, 187
Rinaldo (Hopf), 283
Rivera, Diego, 237
Rivers, Larry, 246

Roberts, Tom, 200, *Plate 17*
Rochester, Earl of, 122
Rocke, Michael, 85
Rockwell, Norman, 241
rococo style, 124, 144, 153, 154, 158
Rodin, Auguste, 201, 213
Rolluin, François, 166
Romanesque era, 62–66
Romano, Giulio, 101, 102, 103, 112
romanticism, 151, 158, 164–68, 169, 171,
 172, 174, 181, 208
romantic realists, 239
Rome, 13, 14, 15, 34, 35, 42–54, 55, 56,
 79, 95–96
Roosevelt, Eleanor, 287
Rops, Félicien, 190, 192
Rose, Francis, 228
Rosicrucians, 189
Rosie the Riveter, 241, 243
Rousseau, Jean-Jacques, 6, 153, 164
Ruan Ji, 136
Rubaiyat (Khayyám), 147
Rubens, Peter Paul, 120–21
Rubinstein, Ida, 210
Rudolf II, Emperor, 105, 106
Rushton, Robert, 173
Ruskin, John, 185
Russia, 300–301
Russo, Vito, 221, 261

Sackville-West, Vita, 216
Sade, Marquis de, 166–68, 173, 225
Sahagún, Bernadino de, 110
Saikaku, Ihara, 142–43, 144
Saint John the Baptist (Caravaggio), 115
Saint John the Baptist (Leonardo), 89–90, *90*,
 189
Saint Matthew Inspired by an Angel (Caravag-
 gio), 115
Saint Sebastian (Day), *193*, 194
Saint Sebastian (Sodoma), *98*, 99, 250
Salai, 89, 90, 100, 114
Salon, 169
Salon de la Rose+Croix, 189
same-sex unions, 61–62, 68, 69, 117
samurai, 142–43, 144, 242
San Francisco, 251–52, 286
Sanger, Margaret, 221
Sappho, 19, 20–21, *20*, 53, 106, 120, 174,
 181, 192, 209
Sappho and Attendants, 20, *20*

Sargent, John Singer, 199
Sarrasine (Balzac), 173
Sarria, José, 251
Sassoon, Siegfried, 216
Satan's Harvest Home, 156
Satires (Ariosto), 103
Satyricon (Petronius), 44, 48
satyrs, 27, 41, 48
Satyr Scene, 24, *24*, 27
Saul, King, 73, 75, *75*
Sauna-Bar (Tom of Finland), 254, *254*
Savonarola, Girolamo, 89
Scene from the Theater, Plate 3
Schad, Christian, 228
School of Pan (Signorelli), 88, *88*, 90
School of Plato (Delville), 189, *Plate 16*
science and technology, 79, 82, 152, 153,
 154, 207, 250
Scientific-Humanitarian Committee, 203,
 213
sculptures:
 architectural, 64–66, 285, 286–89
 by women, 177–78
Sebastian, Saint, *98*, 99, 190, *193*, 194, 210,
 215, 237, 242, 243, 247, 279
Segal, George, 287–88, *288*
Sergius, Saint, 60–61, 69, 75
Servant Chuta Warms the Chigo's Buttocks,
 141–42, *142*
Shah Abbas I with a Page, 146–47, *147*, 149
Shakespeare, William, 107, 118, 120, 186
Shannon, Charles, 187
Shearing the Rams (Roberts), 200, *Plate 17*
sheelah-na-gig, 65–66
Shelley, Percy, 172, 190
Shintoism, 126, 140
shunga, 140, 146
Signorelli, Luca, 88, *88*
Silver, Kenneth, 256
Simons, Patricia, 91
Sistine Chapel ceiling (Michelangelo), 97,
 112, 114, 241
Sleep (Courbet), 174, 175, *Plate 15*
Sleeping Hermaphrodite, *40*, 41
Smyth, Cherry, 272
Slevogt, Max, 215
Snider, Lee, *294*
social contract, 6, 153
socialism, 236
Socialist realism, 236, 239
social reform, 173–74

Society of the Dilettanti, 162–63
Socrates, 25, 169
Sodom, 57, 60, 69, 71, 78, 128, *128*, 147, 153, 166
Sodom (Gilbert & George), 281, *Plate 29*
Sodom, or the Quintessence of Debauchery (Rochester), 122
Sodoma, Il (Gianantonio Bazzi), 97–99, *98*, 101, 181, 190, 250, *Plate 7*
Sokolowski, Thomas, 278
Solitude (Flandrin), 204, *204*, 281
Solomon, Simeon, 179–81, *181*, 184, 190
Solon, 25
Somme le roi, 73–75, *75*
Sontag, Susan, 257
Sophocles, 26–27
Souhami, Diana, 230
South Africa, 298–99
Soviet Union, 236
Spain, 65, 66, 77, 117, 118, 125, 207, 235
 Americas and, 109–11, 120
 civil war in, 236–37
Sparta, 19
Speculum caritatis (Aelred), 65
Squarcione, 48
Stablemaster, The (Aretino), 104
Stanton, Elizabeth Cady, 174
Stebbins, Emma, 1–2, 177
Stein, Gertrude, 208, 211, *213*, 215, 222, 233–34
Steinberg, Leo, 105
Sternweiler, Andreas, 267
Stettheimer, Florine, 230–31
Stewart, Stephen, 263
Stieglitz, Alfred, 231
Stiller, Mauritz, 220
Stoicism, 13, 53
Stone, Irving, 244
Stone Age, 3, 8
Stonewall Riot, 2, 10, 258, 259, 260, 261, 309
Stopes, Marie, 221
Strachey, Julia, 216
Strachey, Lytton, 216
Strato, 15, 23, 26
Streisand, Barbra, 297
Suetonius, 15, 44, 166
Sufi mysticism, 149
Summa theologica (Aquinas), 67, 73
Summer Moon (Leighton), 179

surrealism, 208, 224, 225, 226, 227, 237, 239
Swaddles (Hammond), 269, *269*
Sweden, 219–20
Swimming Hole, The (Eakins), *196*, 198
Swinburne, Algernon, 181, 185, 190
symbolists, 185–90, 209
Symonds, John Addington, 183–84, 185, 186, 189, 198, 206
symposium, 25–28
Symposium, The (Plato), 25, 40, 87, 90, 299
Symposium Scene, 25, *26*

Tantrism, 126, 129, 131, 132
Taoism, 125, 133, 138
Target with Plaster Casts (Johns), *246*, 247
Tchelitchew, Pavel, 239
television, 306–8
Templar Kissing Cleric, 75, *75*
Templars, 75–76
temples, 29–30
"Temporal Punishments Depicted as a Warning to Godless and Damnable Sinners," 157, *157*
Tennyson, Alfred, Lord, 151, 179
Teschenberg, Hermann von, 205, *205*
Thadani, Giti, 130, 301
Thailand, 132, 303
theater:
 Greek, 28–29
 Roman, 48–49
Theban Band, 19, 28, 31, 61
Theocritus, 27
thiasoi, 19–20, 21
third sex, 5, 7, 104, 182, 188, 199
 androgynes, 4, 40, 104, 182, 188, 189
 hermaphrodites, 7, 15, 41, 59–60, *60*, 104
 see also transvestism
Thompson, Mark, 295
Thomson, Virgil, 233–34
Three Men Courting a Youth, 22, *22*
Tiberius, 44–45
Tiepolo, Giovanni Battista, 163, *Plate 14*
Timarchus, 15
Titian, 102, 107, 108, *108*, 120, 127
Toklas, Alice, 211
Tomb of the Bulls, 33, *Plate 1*
Tomb of the Diver, 33
Tomlin, Bradley Walker, 245
Tomlin, Stephen, 216

Tom of Finland, 254–55, *254*, 267, 282
Topkapi Palace, 148, 166, *166*
Toulouse-Lautrec, Henri de, 201, *Plate 18*
Trajet, Le (Brooks), 210, *210*
transvestism (cross-dressing; drag), 7, 104, 107, 135, 156, 205, 206, 207, 233
 berdaches, 4–5, 109, 110, 145, 149, 201
 female, 118, 176, 202, 228
 oyama, 145
tribal societies, 3–5
Tribuna of the Uffizi, The (Zoffany), 163
Triple Silver Yentl (My Elvis) (Kass), 297, *298*
Troubridge, Una, Lady, 228–29
Tuke, Henry Scott, 199, 200
Turkey, 125, 148, 150, 166
Turkish Bath, The (Ingres), *174*, 175
Two Hunters, 17, *17*
Two Hyenas Embracing, 59–60, *60*
Two Lovers (Abbasi), *Plate 12*
Two Men Copulating, 8–9, *9*
Two Men Making Love on a Terrace, Plate 11
Two Men on a Bed (Bacon), 249, *249*
Two Nudes in the Jungle (Kahlo), 237–38, *Plate 22*
Two Women in Intimate Conversation, 41, *41*
Two Women Making Love, 137–38, *137*
Tyrannicide Monument (*Harmodius and Aristogiton*) (Kritios and Nesiotes), 17–18, *18*, 19, 21, 30, 43
Tyrwhitt, Richard, 185

ukiyo-e, 144, 145, 146
Ulrichs, Karl Heinrich, 182–83, 188, 199
Union of Emperor Basil I and John, Plate 5
urban culture, 63, 117, 152
 in Asia, 136, 143
 early, 8, 55–56
 in Middle Ages, 80
urban renewal, 289–90
Urnings, 182
Utamaro, Kitagawa, 145

Vaid, Urvashi, 271
VanDerZee, James, *232*, 233
van Dyck, Anthony, 104–5, 117
Van Vechten, Carl, 233
Varchi, Benedetto, 99–100
Vasari, Giorgio, 80, 97, 99, 101
Vatsyayana, 131
Venice, 84, 85, 102

Venus, 14, 35, 40, 41, 47, 63, 96, 105
Verlaine, Paul, 187
Victoria, Queen, 132
Victorious Amor (Cupid) (Caravaggio), 116–17, *Plate 10*
Victory (Michelangelo), 100, 117
Vidal, Gore, 250
videotape, 306–8
Virgil, 42, 43, 52, 56, 64, 65, 71, 72, *72*, 102, 115
Virtual Equality (Vaid), 271
Visconti, Luchino, 280
Visual AIDS, 278
Vitruvius, 37
Voltaire, François de, 152, 153, 163

Wagner, Richard, 190
wakashu, 142
Walpole, Horace, 163, 165
Ward, Edward "Ned," 155, 156
Warhol, Andy, 255, 256–57, 258, 267, 280, 282, 297
Warren, Edward Perry, 194
Warren Cup, 51, *51*, 194
Watanabe, Tsuneo, 140
Weber, Bruce, 305
Well of Loneliness, The (Hall), 229–30
Westcott, Glenway, 239
We Two Boys Together Clinging (Hockney), 256, *Plate 25*
Wheeler, Monroe, 239
Where Do We Come From? (Gauguin), 5
Whistler, James A. M., 188, *188*, 189
Whitman, Walt, 198–99, 200, 206, 218, 237, 256, 281
Widow Norton, 251
Wilde, Oscar, 11, 151, 181, 183, 186–87, 194, 199, 200, 203, 206, 218, 222, 233, 244, 257
 tomb of, 210
 trial of, *195*, 196, 201, 202
Wilhelm II, Kaiser, 214
William III, King, 122
Wilhelm Meister (Goethe), 165
Williams, Tennessee, 250, 251, 258
Williams, Walter, 5
Wilson, Millie, *276*, 277
Winckelmann, Johann Joachim, 11, 151, 158, 159–61, 164, 165, 166, 169, 183, 184, 203, 222

Wings, The, 220
witchcraft, 93–95, 168, 169
Witches' Orgy (Grien), 93, 95, *95*
Wojnarowicz, David, 278–79, 290,
 Plate 27
Wolfenden Report, 249, 255
Wollstonecraft, Mary, 168
Woman and Her Maid (Zoan Andrea), 91, *91*,
 109
Woman's Touch, A (Corinne), *270*, 271
Women Bathing (Mignon), 105, *106*
Women-Hater's Lamentation, The, 151–52, *152*,
 156
women's rights, 168, 174, 177–78, 221,
 291
 lesbian feminism, 268–71
Wood, Thelma, 222
Woolf, Virginia, 216
World War I, 213–14, 215, 216–17, 221
World War II, 236, 241, 242
Wounded Amazon (Polyclitus), 31–32, *32*

Xenophon, 26
Xi Kang, 136

yaro, 140–41, *141*, 144–45
YMCA, 217, 239
Yourcenar, Marguerite, 250–51, 253
Youth Brandishing a Lyre at a Suitor, 23, *23*
Youth in Aesthetic Interior (von Kupffer),
 203–4, *203*
Youths in Classical Dress (von Gloeden), 192,
 192
Yturri, Gabriel, 206

Zenil, Nahum, 299, *300*
Zephyrus, 24, *24*, 30, 32–33
Zephyrus and Hyacinthus, 24, *24*
Zeus, *see* Jupiter
Zimmermann, Joachim, 215
Zoffany, Johann, 163
Zola, Émile, 200, 231
Zoroastrianism, 9, 148